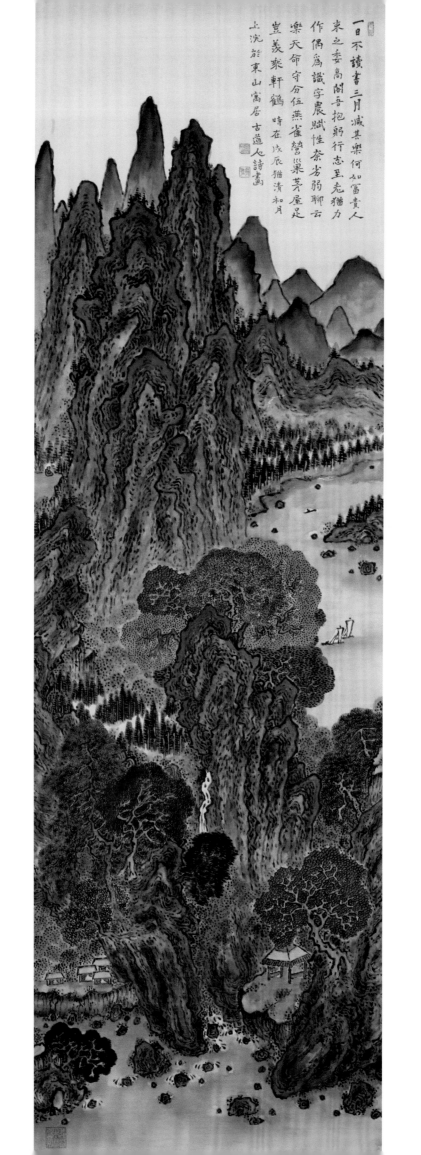

ANDREAS MARKS

# THE ART AND LIFE OF FUKUDA KODŌJIN

## JAPAN'S GREAT POET AND LANDSCAPE ARTIST

WITH AN ESSAY BY PAUL BERRY

TRANSLATIONS OF CHINESE POEMS BY JONATHAN CHAVES

MINNEAPOLIS INSTITUTE OF ART

TUTTLE Publishing

Tokyo | Rutland, Vermont | Singapore

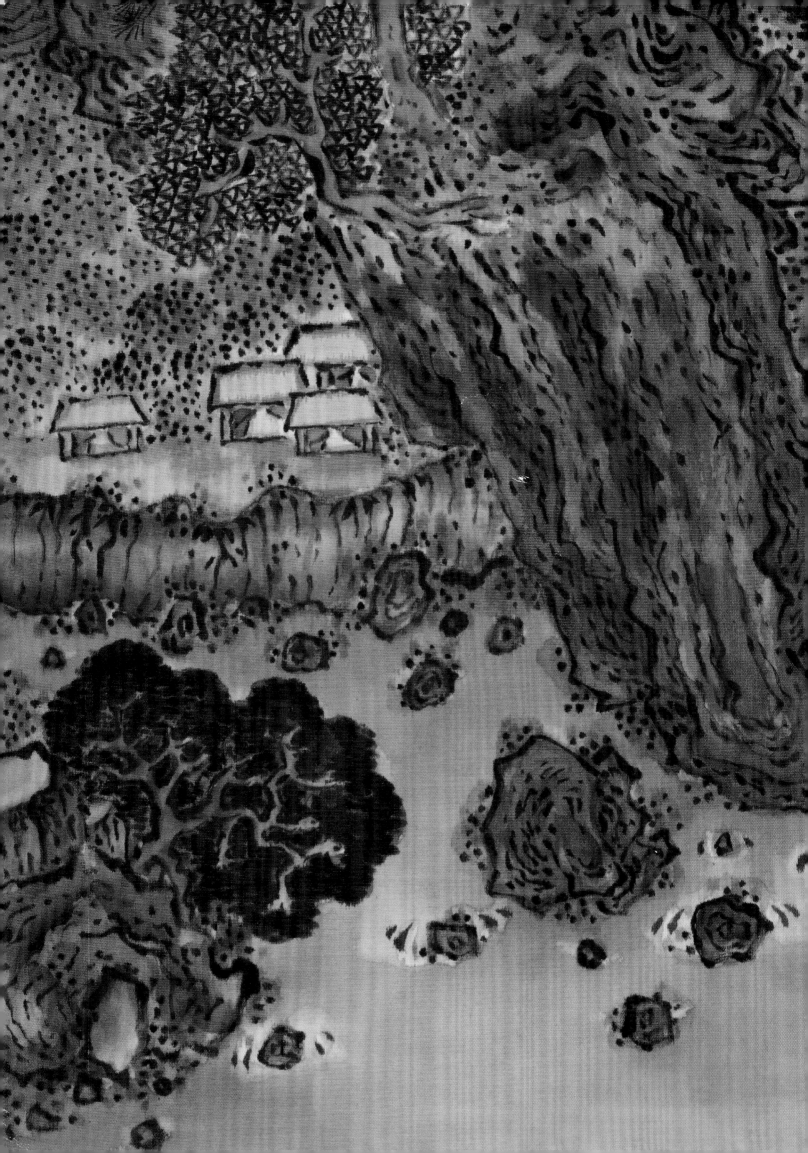

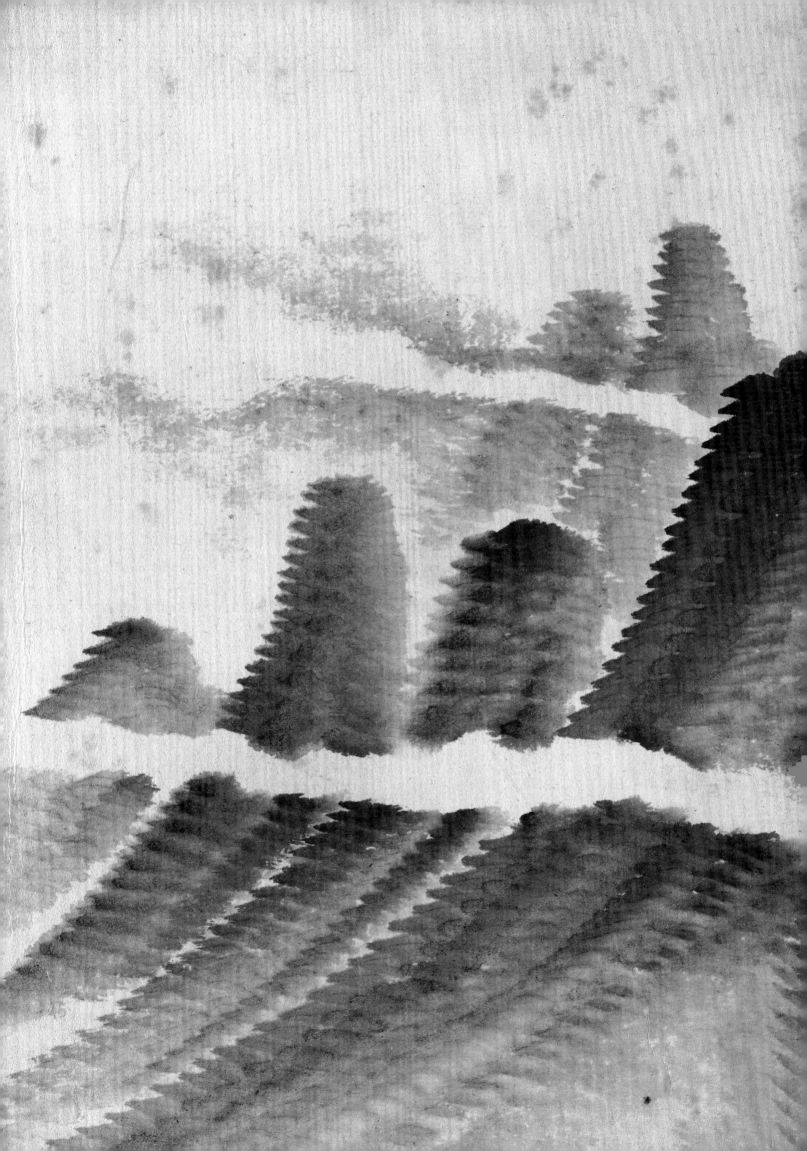

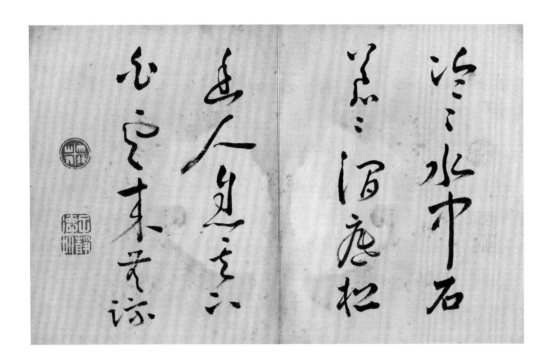

(14)

冷冷水中石
蒼蒼澗底松
幽人息其下
白雲來無踪

Crisply splashing, stream against its rocks;

Hoary, green, pines at valley bottom.

The Hidden One reposes under these,

White cloud that comes by and leaves no trace.

FOLLOWING SPREAD:

(DETAIL) NO. 5 *Album of What Exists,* leaf 8

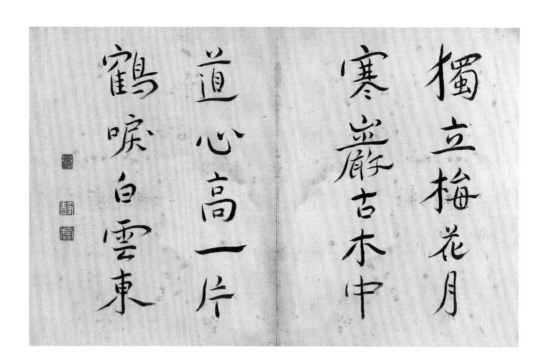

(12)

獨立梅花月　　　I stand alone beneath a plum-tree moon,

寒巌古木中　　　On cold cliff amid the ancient trees.

道心高一片　　　Of my Heart of the Way here is one noble piece—

鶴唳白雲東　　　The cries of a crane, heard from east of white clouds.

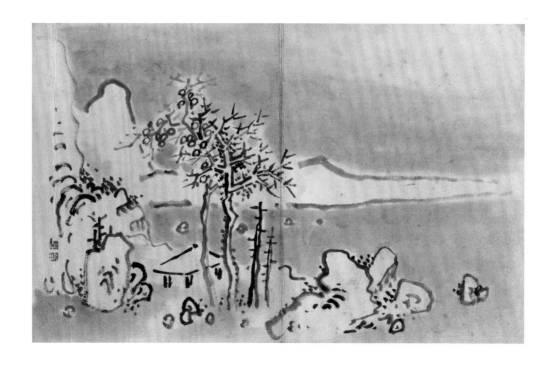

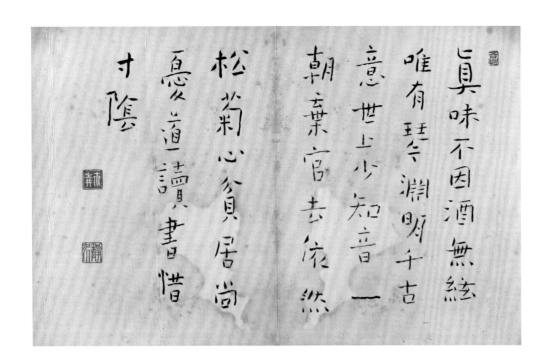

(10)

| | |
|---|---|
| 眞味不因酒 | True Flavor comes not from wine; |
| 無絃唯有琴 | Only without strings do you have a real lute! |
| 淵明千古意 | The feeling of [Tao] Yuanming for a thousand ages |
| 世上少知音 | Has few "knowers of the music" here in the world. |
| 一朝棄官去 | One day he just quit his office, |
| 依然松菊心 | And returned to his pine-chrysanthemum heart. |
| 貧居尚憂道 | Living in poverty he mourned the decline of the Way, |
| 讀書惜寸陰 | Finding precious every moment for reading books. |

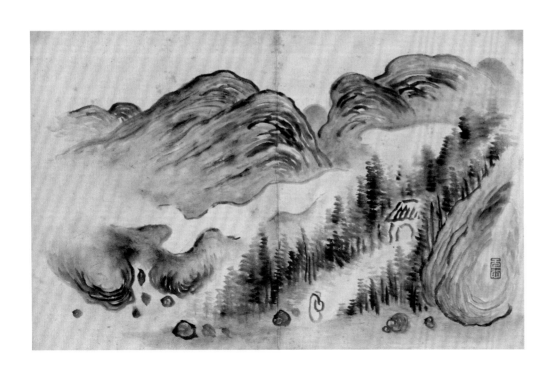

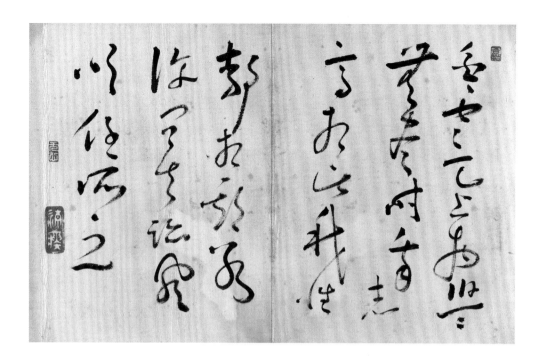

(8)

| 白雲天上物 | White clouds are things up in Heaven, |
|---|---|
| 悠悠無盡時 | They come and come without ever ending. |
| 我志高相比 | My aspiration is still higher than this, |
| 我性靜相期 | And my nature is as serene as this. |
| 若復問其跡 | Should you ask where the traces are that I leave, |
| 風吹任所之 | Where the wind blows, that is where I go. |

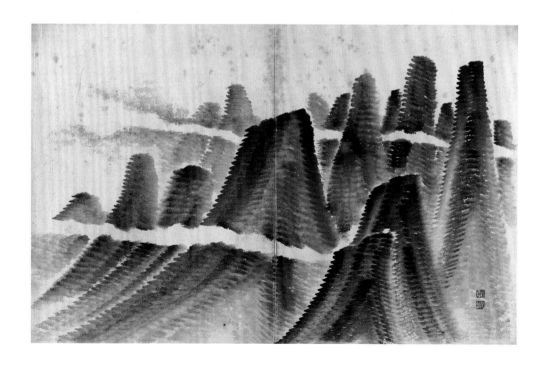

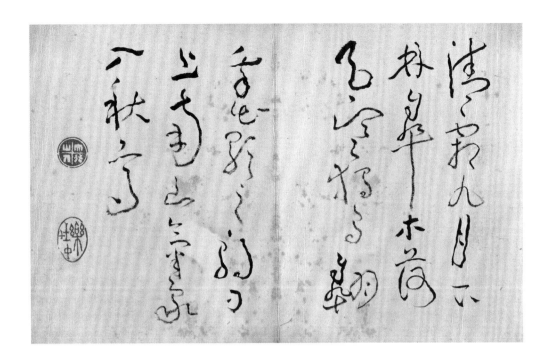

(6)

清霜九月下林皋　　Pure frost in the ninth month descends upon the wooded slope;

木落天寒獨鳥翔　　Trees shed, weather is frigid, just one bird now soars.

我必歌之影句上　　I must sing of this, imaging all in my verses:

南山氣象入秋高　　The atmosphere of the Southern Mountains enters autumn, high.

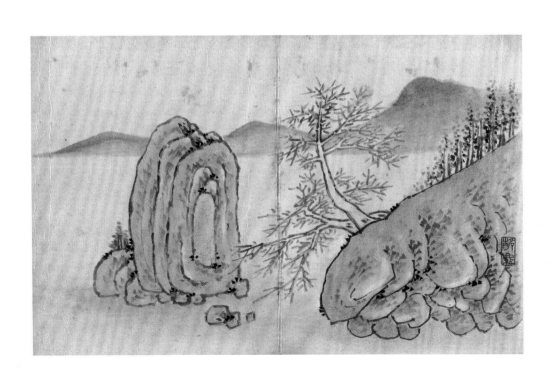

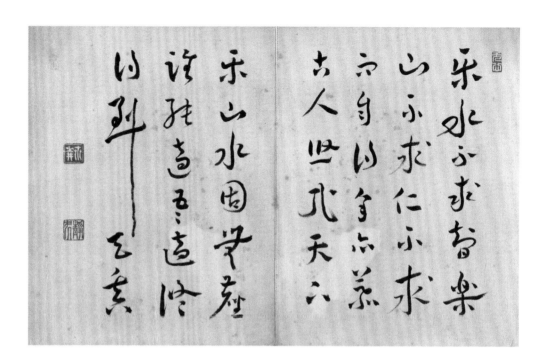

(4)

| 樂水不求智 | I love streams but do not seek knowledge; |
| 樂山不求仁 | Love mountains but do not seek humaneness. |
| 不求而自得 | Do not seek them—but master them myself: |
| 余亦慕古人 | Indeed I admire the men of old! |
| 悠哉天下樂 | Ah, how expansive the joy of the world! |
| 山水固無塵 | Mountains and streams of course lack any dust. |
| 誰能適吾適 | Who can enjoy my joy, |
| 終得到天真 | And end by reaching Heavenly Truth? |

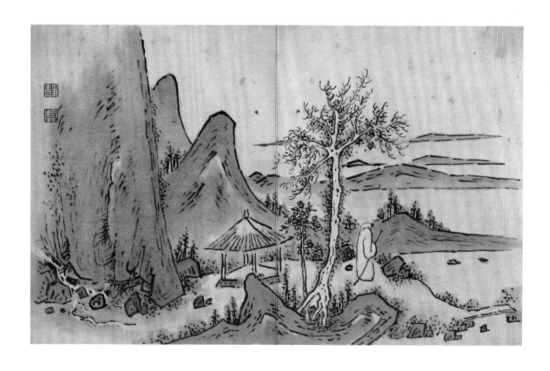

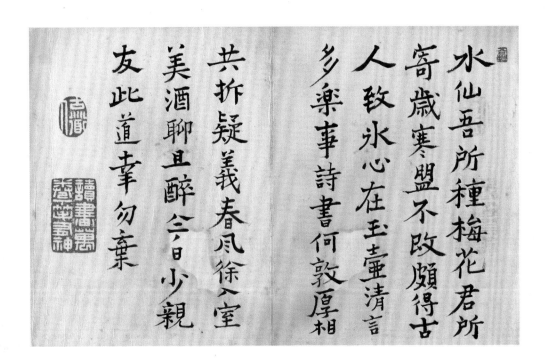

(2)

| | | | |
|---|---|---|---|
| 水仙吾所種 | 詩書何敦厚 | Narcissus is what I have planted; | Poems and books, how full of gravitas, |
| 梅花君所寄 | 相共折疑義 | Plum blossoms are what you have sent. | As together we solve tough passages. |
| 歲寒盟不改 | 春風徐入室 | Our Alliance for Cold Weather never changes: | Spring winds slowly enter the house, |
| 頗得古人致 | 美酒聊旦醉 | We have mastered the purport of the ancients! | Fine wines get us drunk in daytime. |
| 冰心在玉壺 | 今日少親友 | Our ice-pure hearts in their jade jar, | Few are my friends these days; |
| 清言多楽事 | 此道幸勿棄 | Our high-minded words full of joyous things, | This Way thankfully will never be abandoned. |

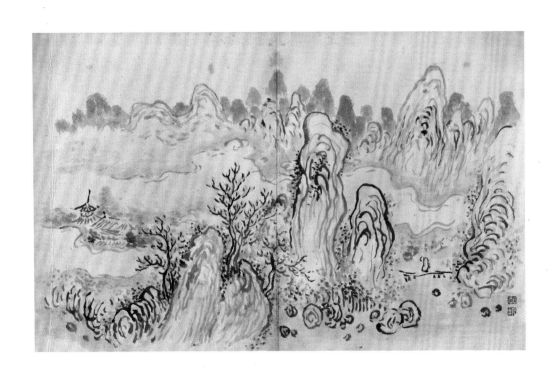

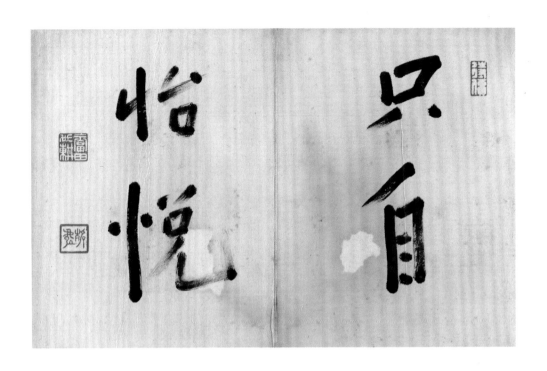

(FRONTISPIECE)

只自怡悦          I merely please myself.

NO. 5

*ALBUM OF WHAT EXISTS*

c. 1907

The Kura Art Gallery, Kyoto

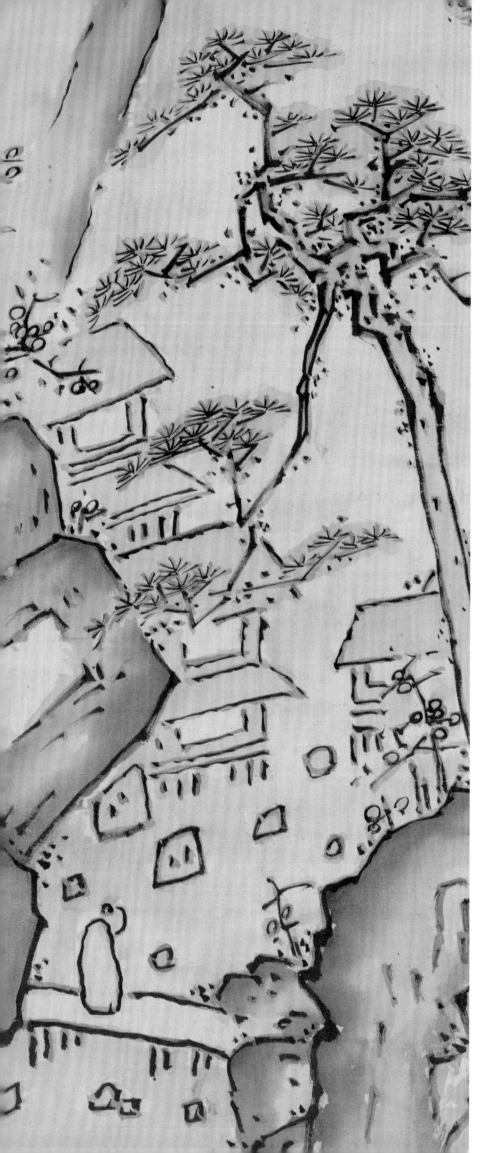

The second direction is characterized by polychrome landscape paintings to which Kodōjin applied washes of pale color, sometimes in combination with light ink (no. 9–12). Examples of this style appear until 1914, although in the early 1910s his color palette became more vivid with the use of oranges, pinks, and reds. From August to October 1908 he noted the location "Hermitage Taking Pleasure in All of This" (*Gakuze yūkyo*) on two of his paintings, and *Pine Trees between Cliffs* (no. 10) from August 1910 lists "A Place with Yellow Leaves in White Clouds" (*Hakuun kōyō sho*). Both places might refer to the area where he lived, but they may also have been locations he visited in or outside Kyoto. *Excursion under Pine Trees* (no. 11) has a poem that must have been very popular with his admirers since he later reproduced it on at least four calligraphies and on another landscape.

(DETAIL) NO. 12 *Landscape in Pale Red*

THE YEAR 1907 WAS A FORMATIVE ONE in Kodōjin's painting career and is represented by more than ten paintings, a comparatively large output for the artist. By this time, there was not only interest in his poetry but also an expanding market for his paintings, which would account for his increased production. The reason for this growing recognition is unclear, although it could be conjectured that it was connected to his move from Saga in Kyoto's west to Takagishi in the east near the Eikandō temple whose abbot, Ryōgen, if we remember, had invited Kodōjin to Kyoto six years previously. Their friendship must have deepened, thereby prompting this move.

Kodōjin was very enthusiastic about their new home in Kyoto's celebrated Higashiyama area, and he acknowledged this on his paintings with various poetic names. Two paintings dating to April have the locations "Perched in Azure Mountain Hut" (*Seiheki sanbō*) and "Tower of Watching Out for Immortals" (*Bōsenrō*) (the latter is mentioned in subsequent poetry). On one painting from around April to June he speaks of being at the "Azure Tower" (*Hekirō*), and in another from July "In the White Clouds at Takagishi" (*Hakuun Takagishi sho*). We can therefore assume that he moved in April, not in May as proposed by the scholar Matsumoto Akira (Matsumoto 2004, p. 92).

The small *Album of What Exists* (no. 5) of c. 1907 is the earliest of the fifteen albums known by the artist. The majority of these albums date from the 1930s and are identical in format, with a frontispiece, six leaves of alternating paintings and calligraphies, and a postscript. *Album of What Exists* adopts the same format, but rather than a postscript in prose he concludes with a poem. All of the poems were composed especially for this album and not found in any of Kodōjin's poetry anthologies. In subsequent albums he often signed the calligraphy pages and only sealed the paintings. Interestingly, Kodōjin's signature is not found in this album, the artist opting instead to disperse eighteen different seals throughout.

The six paintings in *Album of What Exists* are all ink landscapes. They offer a range of scenic views and how to render them, including, for the first time, a Mi Fu-style mountain range that he would frequently revisit throughout the remainder of his career. Three of the six landscapes picture a lone scholar—the recluse who abandoned his ranks to retire into the mountains—a popular concept in Chinese painting that Kodōjin appropriated here.

Kodōjin's landscape painting experiences a stylistic change at this time, with a diversification and branching out into two main directions. In the first, he employs only ink and accentuates the mountains in washes of gray ink (no. 5–8). Using subtle gradation, Kodōjin imbues his rugged mountains and withered trees with greater depth and volume. He works in this mode of monochrome landscape, most notably in 1907, and sporadically returns to this approach until early 1912. All of these hanging scrolls are inscribed with original poetry. That on *Seclusion at a Stream* (no. 6), for instance, alludes to the renowned White Lotus Society that was founded by the Chinese Buddhist monk Huiyuan (334–416) for the purpose of bringing monks and laity together in Buddhist practice. Huiyuan had the temple Donglinsi built at the foot of Mount Lu in 386 and vowed that he would never roam beyond the Tiger Stream that bordered the complex. One day, however, Huiyuan was so deeply engrossed in conversation with two departing friends that he inadvertently crossed the stream with them. When he realized that he had broken his vow, they all erupted into laughter.

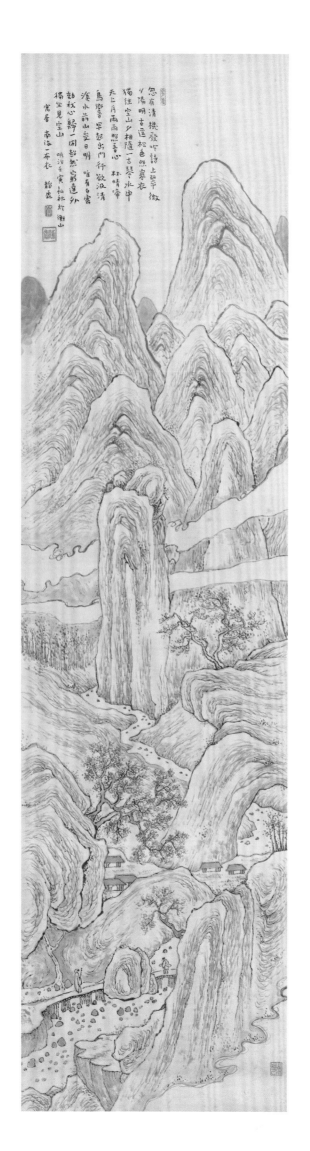

33

| 1 | 2 | 3 | 4 |
|---|---|---|---|
| 忽有清機發 | 獨往空山夕 | 林晴啼鳥響 | 唯有白雲動 |
| 吟詩上翠微 | 相隨一古琴 | 早起出門行 | 我心歸一聞 |
| 夕陽明古逕 | 水中天上月 | 欲汲清渓水 | 超然窮達外 |
| 松色照寒衣 | 雨雨照吾心 | 前山受日明 | 獨坐見空山 |

(RIGHT TO LEFT)

1 Suddenly pure inspiration strikes—
Chanting poems I climb the blue-green slopes.
Evening sun glows down the ancient path;
Pine tree colors illumine my cold robe.

2 Alone I go up the empty mountain—evening,
And all I bring is my ancient lute.
In stream water, in the sky—two moons,
And this pair now glows within my heart.

3 Sky over forest clears, singing birds echo,
Up early I am out the door to walk.
I want to draw water from the clear stream
As the mountains ahead receive the sun's light.

4 Only white clouds are moving,
My spirit returns to a point of ease,
Transcendent—beyond failure or success,
Sitting alone viewing the empty mountains.

NO. 4

*QUIET SETTING OF A MOUNTAIN CREEK*

July 1902

Gitter-Yelen collection

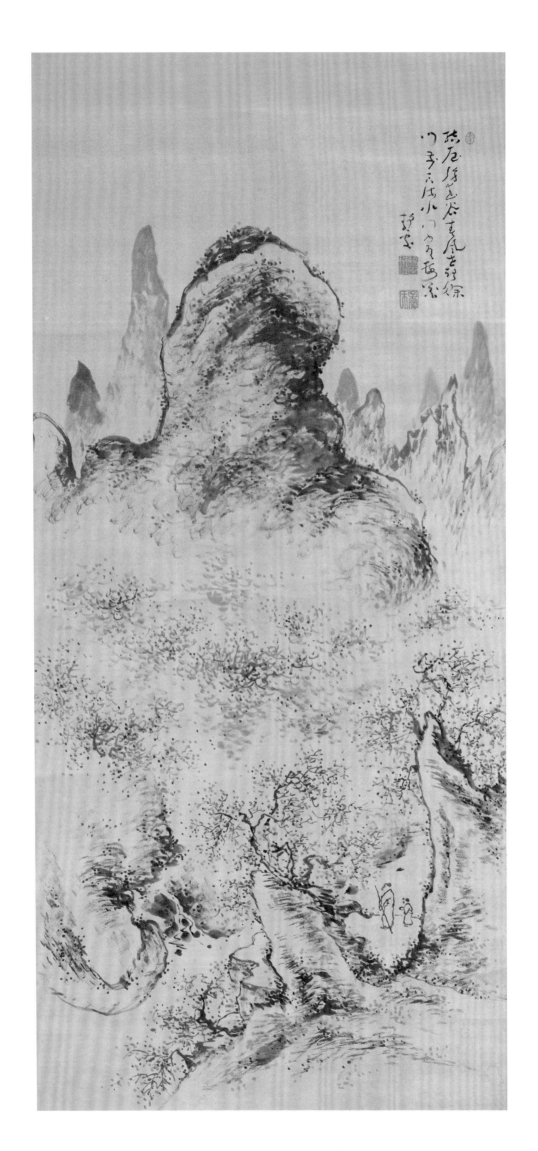

結屋於虛谷
春風亦紆徐
門前咽流水
門內有梅疏

I have built my hut in a deserted valley;
The spring breeze blowing, I slowly wander about.
In front of my gate gurgles a flowing stream;
Within my gate, there's sparseness of plum blossoms.

NO. 3

*PLUM FOREST*

c. 1901–2

Bachmann Eckenstein Japanese Art,
Switzerland

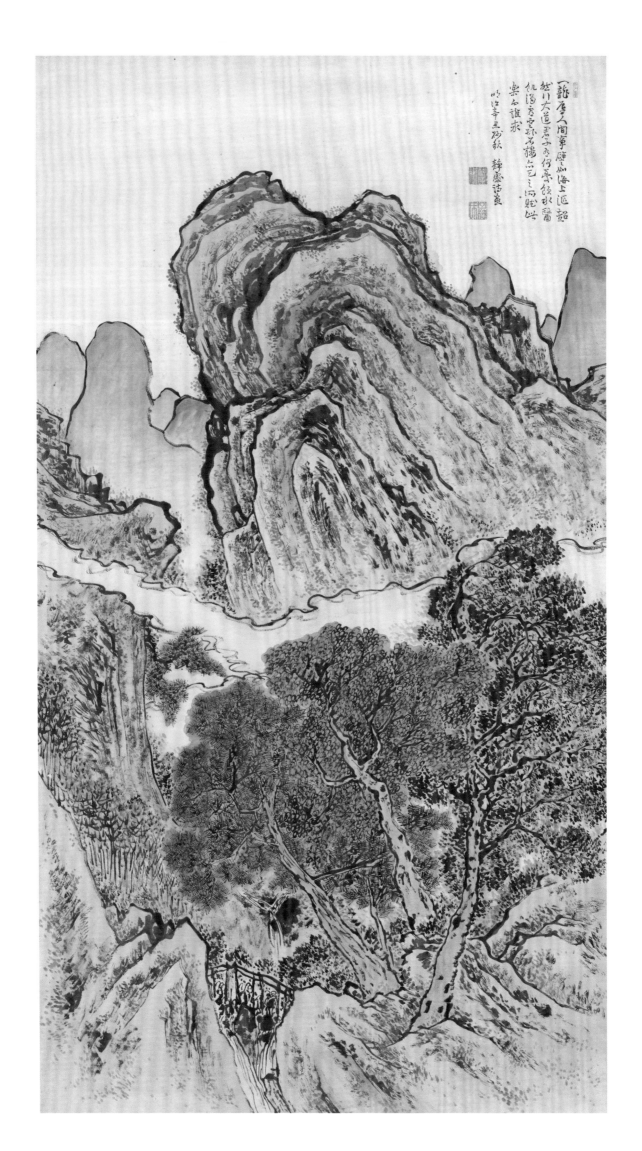

寵辱人間事
譬如海上漚
超然行大道
君子有何憂
飲水醫飢渴
看雲臥石樓
亦天之河賦
此樂向誰求

Favor? Shame? Routine human affairs;
Compare them to the bubbles on the sea.
Transcendently enact the Great Way;
A gentleman, what worries will you have?
Drink water to doctor thirst and hunger;
Watch the clouds, lying in a tower of stone:
They are indeed Heaven's poem about rivers;
From whom can you request such joy as this?

NO. 2

*BLUE-GREEN LANDSCAPE*

September 1901

Private collection, USA

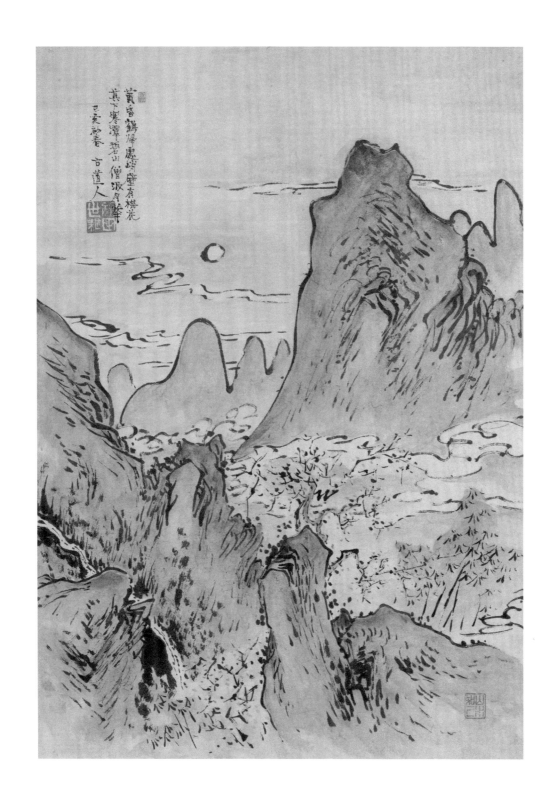

27

黄昏鶴歸處
峭壁有梅花
其下寒潭碧
山僧汲月華

Here at dusk, where cranes return,
The sheer cliffs show plum blossoms.
Beneath them the azure of a cold pond,
Where a mountain monk draws water, moon-adorned.

NO. 1

*MOON OVER AZURE MOUNTAINS*

January 1899

Bachmann Eckenstein Japanese Art,
Switzerland

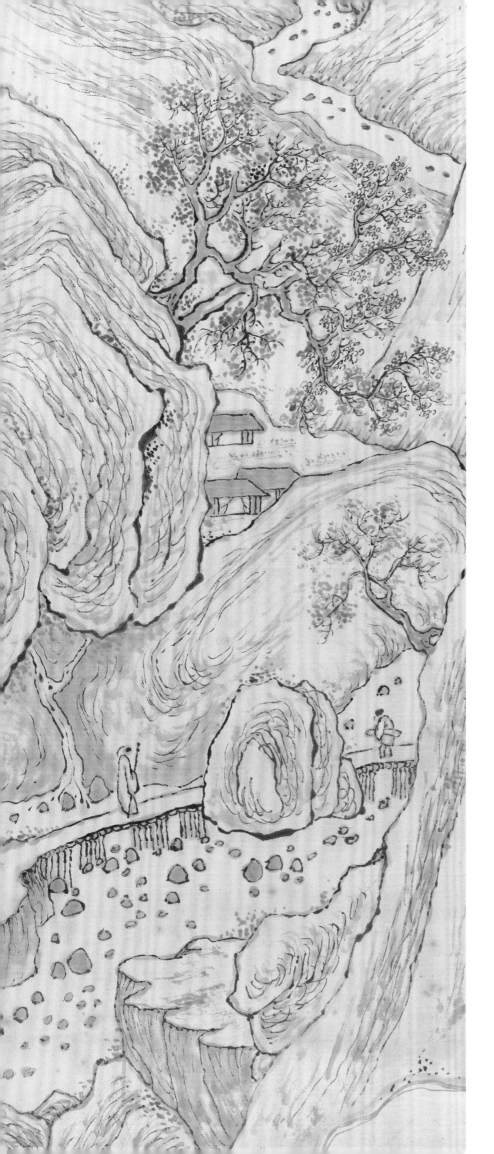

two men would remain close friends for the next forty years. Taiji came from a family of whalers, and his ancestors had developed a method of whale hunting with nets instead of harpoons, which brought the family financial success and recognition by the regional feudal lord. Taiji also assisted Kodōjin financially by acquiring some of his paintings. This visit to Shingū is further corroborated in his paintings since two exist in which he inscribed different locations in Shingū. The first, dated to February 1906, notes that it was painted at the "Temporary Abode West of Shingū Castle" (*Tankakujō sai gūkyo*). The second, dated 1906 (no month), was painted at the "Abode of Essence at Shōgan" (*Shōgan seikyo*). The latter most likely refers to Shōgan'in, a temple in Shingū that is around ten minutes by foot from the castle. In June and July, Kodōjin stayed for a month in Okazaki, Aichi Prefecture, following an invitation by the editors of the local haiku periodical *Haya*, who intended to run a special issue on his poetry (it is not known if this was ever realized). His youngest son, Minoru, was born in February 1907.

(DETAIL) NO. 4 *Quiet Setting of a Mountain Creek*

a companion in the mountains to play music, meditate, drink, or simply enjoy the scenery —is a common subject in Chinese literati painting. The scholar is generally rendered as a minuscule figure seen from behind. In *Plum Forest* this takes the form of a man holding a staff in the bottom right corner who is followed by a young attendant carrying an unidentified object.

*Plum Forest* is a fairly straightforward painting executed with only a few brushstrokes. Compare this with *Quiet Setting of a Mountain Creek* from July 1902 (no. 4), which is much more detailed and would have taken considerably more time to finish. The composition deviates from Kodōjin's previous works in its increased complexity seen, for example, in the rock arch in the bottom right or the narrow path between the steep cliffs and river in the bottom left. The recluse and his attendant are no longer the sole beings in a commanding natural setting—five huts in the middle ground point to a larger human presence. Another aspect that distinguishes this painting is the fact that it is the earliest painting in which Kodōjin notes his location. In this case, it might have been entirely symbolic since he writes "Temporary Abode on Mount Heng" (*Kōzan gūkyo*), a reference to one of the five sacred mountains in China. This muchrevered mountain is located in China's north-central Shanxi Province, and Kodōjin would not have seen it firsthand. The locations he mentions on subsequent paintings, however, relate to the actual places where he painted.

In Kyoto, in the early 1900s, Kodōjin established a friendship with fellow poet Amada Guan (1854–1904), who had been adopted in 1878 by Shimizu Jirochō (1820–93), a powerful organized crime (*yakuza*) boss also in service to the Meiji court. Guan left Jirochō in 1888, became a Buddhist monk, and concentrated on the composition

of poetry. He passed away in January 1904, and many years later, in 1927, Kodōjin selected one of Guan's handwritten texts as a frontispiece for his book *Withered Trees and an Abundance of Spring* (see pp. 166–67).

Through Guan, Kodōjin met Guan's neighbor Nakagawa Kojūrō. Nakagawa was a close friend of Prince Saionji Kinmochi (1849–1940), and he rose rapidly through the ranks of the Ministry of Education in Tokyo when Kinmochi served as minister. Both men left the ministry in 1898, and Nakagawa went to Kyoto where in 1900 he established the Kyoto Hōsei School, later renamed Ritsumeikan University and today one of Japan's leading private universities. In 1903, Nakagawa returned to government service and became the executive director of Kyoto Imperial University (present-day Kyoto University). In August 1903, Nakagawa and Kodōjin traveled together to Kitakuwada in the mountains north of Kyoto, and in the same year Nakagawa asked Kodōjin to pick the winner of a haiku contest issued in the bulletin of the Kyoto Hōsei School.

There are around forty paintings dating to the 1900s, and there are no documented paintings dated by Kodōjin from 1904 and 1905. It is only known that the poet Takahama Kyoshi (1874–1959), a fellow student under Shiki and editor of the *Hototogisu* journal that published several of Kodōjin's haiku, visited him in the autumn of 1904. Kyoshi stayed overnight and the next day Kodōjin showed him around Saga where he now lived near Tenryūji, a major Rinzai Zen temple complex established in 1339 and today a UNESCO World Heritage Site. Other friends called in on Kodōjin in April 1905 to enjoy the area's scenery, famous for its cherry blossoms.

According to Kodōjin's student Ryōun, the elder artist went to his hometown Shingū in the spring of 1906 for a gathering of haiku poets. There he met Taiji Gorōsaku and the

on the journey, and she stayed with her parents while Kodōjin returned to Tokyo in late September or early October. *Blue-Green Landscape* was discovered in a collection in Ehime Prefecture, the prefecture adjacent to Yamaguchi. It is quite possible that Kodōjin painted it when the couple were at Misu's parents and before his trip back to Tokyo.

*Blue-Green Landscape* is a formative work in Kodōjin's oeuvre for two reasons: its size and palette. Although in height it is only slightly taller than his average landscapes after this time, it is approximately double in width, making it the largest of Kodōjin's documented hanging scrolls. This work is particular noteworthy because it figures so early in his painting career. Given the absence of other such monumentally sized works, we might assume that this painting posed a technical challenge to Kodōjin and that he decided against working in this scale in the future. Moreover, this is the earliest known example of Kodōjin's use of a blue-green color palette for a landscape. (Twenty years later he would begin to produce several blue-green landscapes, but these were more intense in color than this piece.) The connection to *Moon over Azure Mountains* is apparent, most notably in the unassuming, light-blue mountains in the background of both works but also in the overall composition of a tall, majestic mountain at the top right and a cloud band below that serves to separate the peak from the different types of trees on the right and the flowing water on the left. The inscribed poem is original and not published in any of his anthologies.

Kodōjin most likely had Misu stay with her parents because of their imminent move to Kyoto, which is situated almost half-way between Yamaguchi and Tokyo. As Misu was six months pregnant, it could have been that Kodōjin wanted to find a new home first to avoid any unnecessary stress to his wife. This might explain why he returned to Tokyo alone, packed up their belongings, and attended a farewell party organized by his friend Shiki at his home on October 12, 1901. Kodōjin's and Misu's decision to go to Kyoto may have been due to the artist's acceptance of an invitation by Kondō Ryōgen (1852–1920), the seventy-sixth abbot of the Eikandō (Zenrinji), the head temple of the Seizan branch of Jōdo (Pure Land) Buddhism. Founded in 853, the Eikandō houses a rich collection of important Japanese sculptures and paintings. Ryōgen was part of a group of people in Kyoto who, impressed with Kodōjin's Chinese-style poetry, engaged him as their teacher.

While the thirty-six-year-old Kodōjin was setting up the family's new home in Kyoto, Misu gave birth to their son Yutaka on December 16. We do not know where they first resided in Kyoto, but it was probably in Ichijōji in the northeast of the city. In late September 1902, Kodōjin traveled to Matsue in Shimane Prefecture, some 190 miles (300 km) west of Kyoto, to attend the memorial service of his friend Shiki, who had died of tuberculosis, aged only thirty-four.

The seals on the landscape *Plum Forest* (no. 3) suggest that it was created in 1901 or 1902, thereby making it one of Kodōjin's earliest datable monochrome landscapes. As with *Blue-Green Landscape* from 1901, he also includes a poem on *Plum Forest* that is not published in any of his poetry anthologies. (The title *Plum Forest*, written on the back of the painting, may not have been added by Kodōjin.) The compositional structure of this work resembles *Moon over Azure Mountains* and *Blue-Green Landscape*, but here he adds figures to the vast landscape, drawing on the theme of the "recluse" that would become an essential element in many of his subsequent landscapes. The image of a recluse—a scholar wandering alone or with

# Painting Beginnings, 1899–1906

In the spring or summer of 1899, Kodōjin began to work as proofreader for the *Nippon* newspaper where his poetry confrere Masaoka Shiki had worked since 1892. This new position provided him a secure income. In July 1899, he was living in Yotsuya in Tokyo's Shinjuku ward but by March 1900 had moved to Kōjimachi in the neighboring Chiyoda ward. Kodōjin had begun to paint before his employment at *Nippon*, as is attested by his earliest documented work inscribed with the date January 1899: *Moon over Azure Mountains* (no. 1). A landscape rendered in blue wash with just a few red accents, it is modest in scale and lacks the inscribed wooden storage box that would normally provide the title of the work assigned by the artist. Its composition and execution already hint at the path that Kodōjin would embark on over the next forty years in an unconventional and unrestricted style in the placement and drawing of mountains, rocks, clouds, waterfalls, and trees. Devoid of any human activity, the lofty view depicts an evening scene with a gnarled

plum tree in the center foreground and a moon in the distance. His poem, composed specifically for this painting, conveys the sentiment evoked by the image. It was later included in his 1912 anthology *Seisho's Mountain Studio Collection* (*Seisho sanbōshū*).

In his publication on Kodōjin, Stephen Addiss dated a small, simple drawing of bamboo and plum to 1897–1901, believing it to be Kodōjin's earliest painting (Addiss 2000, p. 5). Addiss had not seen the work, which is stored in a signed box with the date 1907 and in the collection of the Matsuyama City Shiki Memorial Museum. Although this dating seems plausible given that Kodōjin left Tokyo in 1901 and that the painting has a poem by his friend Shiki, who died in 1902, the exact date is still unclear. It cannot be determined with certainty whether this was created before 1899 when Kodōjin painted *Moon over Azure Mountains*.

This author's survey of over 660 paintings and 150 calligraphies has yet to unearth any work that can be definitively dated to 1900. After *Moon over Azure Mountains*, the second earliest painting by the artist is *Blue-Green Landscape* from September 1901 (no. 2). Almost a year previously, in December 1900, Kodōjin married Misu (1875–?), the eldest daughter of Yoshiyama Sakuzō (dates unknown), a former samurai affiliated with the Chōshū clan that once governed what is today Yamaguchi Prefecture in southwestern Japan (fig. 2). Why Misu lived in Tokyo, over 620 miles (1,000 km) away from her home, and how the couple met remains a conundrum. The lack of paintings and calligraphies from this period might be attributed to the fact that Kodōjin was preoccupied with his position at *Nippon* and his relationship with Misu. He and Misu left Tokyo in mid-1901 to visit his hometown Shingū and her home in Yamaguchi. Misu was already pregnant with their son Yutaka when they embarked

FIG. 2 Wedding photo of Kodōjin and Misu, 1900

and that his poems began to be published in the *Nippon* newspaper and in the literary magazine *Hototogisu*. Founded in 1897 and still in circulation today, *Hototogisu* played an essential role in popularizing traditional and modern haiku. Kodōjin's haiku and then his Chinese poems were sought after, laying the groundwork for his reputation as a poet. His success as a poet and his profound knowledge of Chinese literature led Stephen Addis to claim that the composition of poetry accounted for his primary source of income. It was clearly Kodōjin's literati paintings, however, that eventually maintained him and his family.

It was common for Japanese artists to change their art names or make use of different art names for specific purposes. Kodōjin was no exception. He employed the name Haritsu, which almost always appears written in *hiragana* (はりつ), exclusively for his haiku published in magazines, books, or inscribed on paintings. He sometimes utilized Kodōjin (or the abbreviated version Kojin) for haiku, but not exclusively since it is also found on paintings and calligraphy with other forms of classical Japanese poetry, such as *tanka* or *waka*. There are equally paintings and calligraphy with his Chinese-style poetry signed *Kodōjin*. The name Seisho was exclusively reserved for his Chinese-style poetry (*kanshi*), which is by far the most frequently encountered poetic type on his paintings and calligraphy (table 1a–c):

TABLE 1A–C. KODŌJIN'S ARTIST NAMES AND SEALS ON PAINTINGS AND CALLIGRAPHY WITH CHINESE-STYLE POETRY

A. ART NAMES

| Kodōjin | 古道人 | Old Daoist | 1899–1944 (as seals 1902–42) |
|---|---|---|---|
| Kojin | 古人 | Old Man | 1901–43 |
| Seisho | 靜處 | Quiet Place | 1901–36 (as seals 1901–44) |
| Seisho sanjin | 靜處山人 | Mountain Man at a Quiet Place | 1901–6 |
| Hekiō | 碧翁 | Azure Old Man | 1910–42 (as seals 1915) |
| Dokugenshi | 讀玄子 | The One who Reads the Mysterious | 1918 |
| Seizan shoin | 西山小隱 | Lesser Recluse of the Western Mountains | 1918 |
| Hekiō koji | 碧翁居士 | Layman Azure Old Man | 1937 |

B. SELECT ART NAMES ONLY APPEARING ON KODŌJIN'S SEALS

| Seikō | 世耕 | Tiller of the Generations | 1899–1944 |
|---|---|---|---|
| Kō | 耕 | Tiller | 1901 |
| Shitoku | 子徳 | Virtuous Child | 1901–40 |

C. ARTISTIC NAMES (*GŌ*) KODŌJIN USED AS A PREFIX OR SUFFIX TO THE ART NAMES LISTED IN (A)

| Nankai-ichi hōi | 南海一布衣 | One-of-the-Southern-Sea in Simple Clothes | 1902–36 |
|---|---|---|---|
| Denkō | 田耕 | Tiller of the Fields | 1907–38 |
| Nanajūni-hō shōsha | 七十二峰樵者 | Woodcutter of the Seventy-Two Peaks | June–Aug. 1918 |
| Tōsan inshi | 東山隱士 | Recluse of the Eastern Mountains | 1923–33 |
| Rokkoku inshi | 鹿谷隱士 | Recluse of Shishigatani | 1932–36 |
| Rokumon inshi | 鹿門隱士 | Recluse of Deer Gate | 1933–34 |

During his time in Kyoto, Kodōjin also studied poetry with Hayashi Sōkyō (1828–96), who is included in the section on Chinese studies (*kangaku*) in the 1880 *Guide to Current Honorary Experts in Japan* (*Dai Nihon genzai meiyo sho ōya hitori annai*) of scholars in Tokyo, Osaka, and Kyoto. There are no details about Kodōjin's training with Sōkyō, but it is known that Sōkyō had opened the private poetry school, Eishō-juku, in 1875 and that he accepted some twenty-five students each year. Himself an authority on Chinese literature, Sōkyō composed Chinese-style poems and created paintings in the *nanga* mode. These factors may have kindled Kodōjin's own interests, motivating him to pursue a similar career path. Kodōjin

clearly had a deep fondness and respect for Sōkyō, and he eventually became one of Sōkyō's stellar students. After Kodōjin left Kyoto, presumably in 1880, he may have continued to receive instruction from Sōkyō. Kodōjin would later compose two poems lamenting his teacher's passing in 1896 that appeared the same year in the *Nippon* newspaper.

It is equally unclear what Kodōjin did in Shingū after his return from Kyoto, but in 1897 he published a poem that he claims to have written on March 14, 1885, while sightseeing in the Nishitama district in western Tokyo. This suggests that he had resettled in Tokyo by late 1884 or early 1885 when he was nineteen. He opened a private evening school for Chinese studies while working at the post or ward office. No further information exists regarding this period: there are no records or anecdotal evidence about Kodōjin's activities over the next decade. Whether Kodōjin returned to Shingū for the funerals of his mother Ishii and father Jun'ichi in 1887 and 1893, respectively, cannot be confirmed, but in a later letter to his friend Taiji Gorōsaku (1875–1957) Kodōjin mentions that he was in the city of Sendai, some 217 miles (350 km) north of Tokyo, in 1894.

In the 1890s, Kodōjin began to sign his haiku poetry with the name Haritsu. On June 25, 1894, the *Shō Nippon* newspaper issued a list of remarkable haiku poets that includes the name of one Haritsu living in Sendai. (The newspaper's editor-in-chief Masaoka Shiki, 1867–1902, was a central figure in the development of modern haiku poetry.) Although the name Haritsu 破笠 ("Torn Bamboo Hat") in this list was written with different characters than the Haritsu 把栗 ("Bundled Chestnuts") later used by Kodōjin, it is possible that he changed the characters and that the two Haritsu are in fact the artist. What is certain is that Kodōjin joined Shiki's poetry circle in 1896

THE ARTIST FUKUDA KODŌJIN was born Nakamura Isajirō on the twenty-seventh day
of the fifth month (June 20 in the Western calendar), 1865, in Shingū, a small city located
in Wakayama Prefecture on the southeastern tip of the Kii Peninsula that looks out to the
Pacific Ocean. His father, Nakamura Jun'ichi (died 1893), was a former samurai retainer of
the feudal lord of Shingū; nothing is known about his mother Ishi (died 1887). Jun'ichi and
Ishi had four children: Kodōjin's older brother Kōzō (died 1943), his older and younger sisters
Hana and Kō, who both passed away in their eighties.

As the second son it would not have been unusual for Kodōjin to be given up for adop-
tion to a family without a male heir, in his case to Fukuda Tokuzō (dates unknown), who was
most probably a former samurai like Kodōjin's biological father Jun'ichi. There are no docu-
ments that record Kodōjin's age at the time of the adoption, and it might be conjectured that
his adoptive father died prematurely, after which time Kodōjin would have returned to his
birth family.

It was also customary that a son would give up his childhood name during the coming-
of-age ceremony that occurred between the ages of fifteen and seventeen. When Kodōjin
stopped using Isajirō and which of his several names he first used is not known. What is
certain is that in 1879, aged fifteen, Kodōjin left his hometown for Kyoto, a cultural mecca
situated some 124 miles (200 km) from Shingū, to study painting with Suzuki Hyakunen
(1825–91). In 1880, Hyakunen succeeded in establishing the largest painting school in Kyoto.
Among his students were individuals who would become celebrated artists in their own right,
including Imao Keinen (1845–1924), Suzuki Shōnen (1848–1918), and Kubota Beisen (1852–
1906). Hyakunen's painting style was a marriage of various schools (fig. 1), and it was only
late in life that he turned to literati or scholar-poet painting (*nanga* or *bunjinga*).

Much of what we understand about Kodōjin's life is from the biography written by his
principal student Watase Ryōun (1904–80), whose admiration for his teacher may have
colored the information most likely received firsthand. Ryōun recounts that Kodōjin studied
under Hyakunen for several years, but a surviving letter written by Hyakunen to Kodōjin's
father Jun'ichi expresses sadness about Kodōjin ending his training and returning to Shingū.
Unfortunately, the letter lists just the day and month (October 20); however, it can be
deduced that Hyakunen wrote it in 1880 based on the founding of his school that year. This
indicates that Kodōjin trained with Hyakunen for about a year, and not several as maintained
by Ryōun.

In his letter, Hyakunen conveyed his belief that Kodōjin had the potential to become a
gifted painter but to achieve that goal would require a further three years of study. Hyakunen
further noted that Kodōjin ended his training because he contracted beriberi, a disease
caused by a vitamin B1 deficiency and often the result of alcoholism, although Hyakunen
dismissed the latter as a contributing factor. Nonetheless, Kodōjin did not return to Kyoto
following his illness, perhaps offering him, it might be concluded, an excuse to abandon his
tutelage under Hyakunen due to a dissatisfaction with the direction of his training. Another
possibility is that Hyakunen's mention of three additional years of study was related to
the opening in 1880 of the Kyoto Prefectural School of Painting (present-day Kyoto City
University of Arts). Hyakunen was one of the founding members of this now oldest art
university in Japan, and a three-year course was the recommended enrollment period. It
could be that Hyakunen's statement about Kodōjin's abilities might have been self-serving
in an attempt to have him enter the school. But ultimately Kodōjin's family may have been
unwilling to finance his further art education.

FACING PAGE: (DETAIL)
NO. 14 *Landscape after Mi Fu*

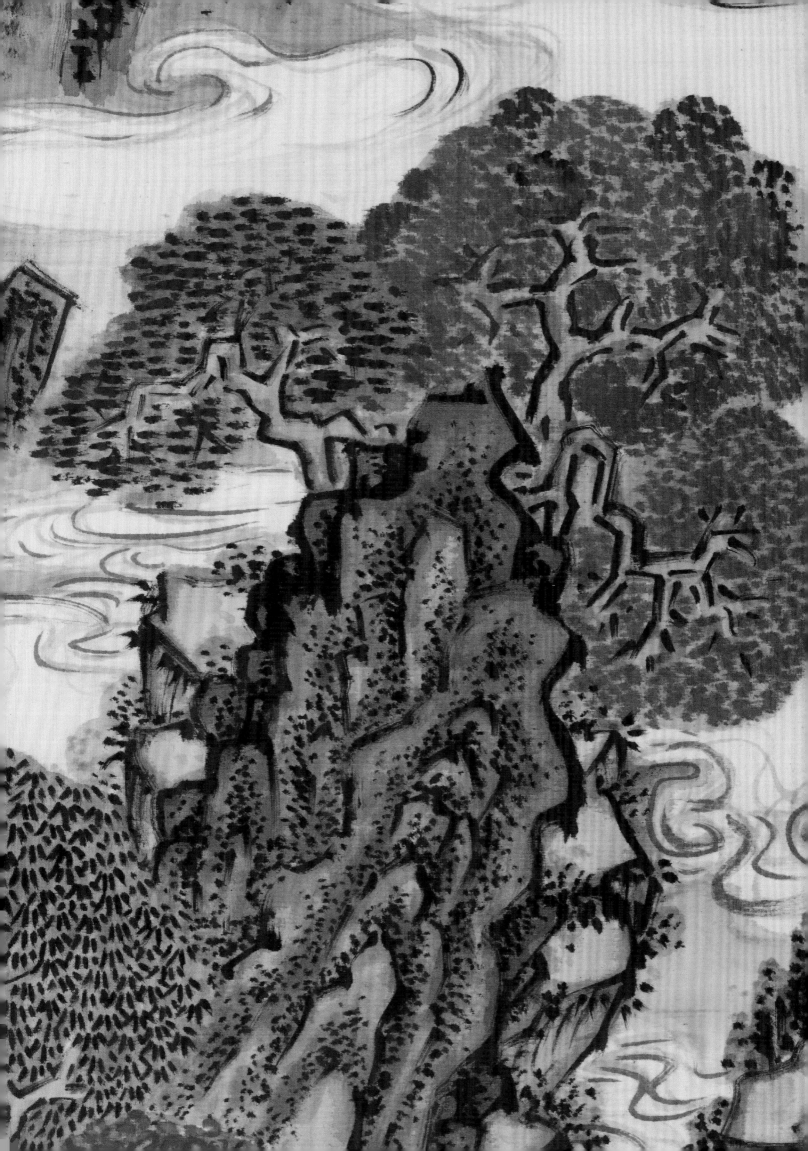

Museums (Rachel Saunders, Matthew Rogan), Indianapolis Museum of Art, Johnson Museum of Art, Kumanokodo Nakahechi Museum of Art, Matsuyama City Shiki Memorial Museum (Hiraoka Eiji), Metropolitan Museum of Art (Aaron Rio), The Museum of Fine Arts, Houston (Bradley Bailey), National Museum of Asian Art (Kit Brooks, Jennifer Berry), Portland Art Museum, Seattle Art Museum (Xiaojin Wu), Shingū City Museum of History and Folklore (Minami Yuki), Worcester Art Museum, Thomas Bachmann and Gabriel Eckenstein, Gordon Brodfuehrer, John Copoulos, Mary and Cheney Cowles, Patricia Criticos, Matthew Edlund, Matthew Fraleigh, David T. Frank and Kazukuni Sugiyama, Ed Freis, Furusawa Kōtarō, Kurt A. Gitter and Alice Yelen Gitter, Hashimoto Tadayoshi, Stuart Katz, Alexey Kononenko, Matsumoto Shōeidō, Josh Michaell, Mizutani Michikazu, Michiyo Morioka, Nakazawa Noriko, Rhiannon Paget, SHINYA Japanese Art & Design (Okunishi Shinya), Sakuma Toshirō, John Walker, Terry Welch, and Yamazaki Yasushi.

I am grateful for the widespread support at the Minneapolis Institute of Art (Mia) in helping to realize the exhibition and this publication, and I would like to single out Katherine C. Luber, Nivin and Duncan MacMillan Director & President; Matthew Welch, Mary Ingebrand-Pohlad Deputy Director and Chief Curator; Jennifer Komar Olivarez, head of exhibition planning and strategy; Yuko Ralston, curatorial department assistant for Japanese and Korean art; Megan Dischinger, assistant registrar for extended loans and exhibitions; Dan Dennehy, head of visual resources; Charles Walbridge, lead collections photographer; and Joshua Lynn, digital media specialist. I am delighted that John Hubbard accepted the task of designing yet again another stunning publication and that Amy Reigle Newland expertly and patiently guided us through the editing process. As always, the production of this publication proceeded seamlessly under the careful supervision of Jim Bindas at Books & Projects.

This publication is dedicated to Willard "Bill" Clark (1930–2015) and David T. Frank and Kazukuni Sugiyama, enthusiastic collectors of Fukuda Kodōjin, who for decades supported the idea of a Kodōjin exhibition in the United States, and Stephen Addiss, whose book *Old Taoist* was a pioneering effort in introducing Kodōjin to the general public.

ANDREAS MARKS
Mary Griggs Burke Curator
of Japanese and Korean Art,
Director of the Clark Center
for Japanese Art
Minneapolis Institute of Art

Japan at that time. Prices ranged between ¥5,000 for a pair of two-panel folding screens to only ¥50 for a horizontal sheet of paper with just two calligraphed characters.

Living a relatively uncomplicated life, Kodōjin was idealized as a recluse and a true literatus, his fans captivated by his poetry and his paintings. "I have named myself for poetry, calligraphy, and painting—my 'Three Clumsinesses!'" (no. 82), he admits modestly in the postscript of the *Album of Untrammeled Living* of March 1933. But following Kodōjin's death in 1944 and the end of the Asia-Pacific War in 1945, Japan averted further from traditional values and interests to a highly modernized country wherein Chinese studies no longer held the societal significance it once had. Apart from one exhibition in 1960, organized by an admirer from Kodōjin's home prefecture of Wakayama, he fell into obscurity in his native Japan. Outside Japan, the late Japanese painting scholar Stephen Addiss (1935–2022) collaborated with Jonathan Chaves and J. Thomas Rimer on the 2000 publication, *Old Taoist: The Life, Art, and Poetry of Kodōjin (1865–1944)*, the only monograph in a Western language on the artist. *Old Taoist* provides an insightful view into Kodōjin's poetry, offering a cursory introduction to his life and work as a painter-calligrapher.

It was not until the 1990s that three Japanese scholars undertook a rigorous study of specific aspects of Kodōjin's life. Yamamoto Shirō, a professor in the Faculty of Literature at Kobe Women's University, wrote a biography of Kodōjin in 1993 that laid the groundwork for Matsumoto Akira's extensive investigation of the artist, which was first issued in 2004 and then revised in 2005. From 2007 to 2009, Matsumoto, deputy director of the Division of Academic Affairs at Ritsumeikan University in Kyoto, published annotations of three volumes of

Kodōjin's haiku. Chiba Kōtarō, a teacher at Tanabe High School in Wakayama Prefecture, undertook the ambitious task of annotating the five surviving manuscripts of Kodōjin's Chinese-style poetry in three separate publications (2010–2011). While drawing on the earlier work by the above scholars, the present publication also includes new primary written source materials and is the result of a survey of hundreds of hitherto unknown artworks. It seeks to expand on our knowledge of Kodōjin—the man and the artist—as well as correct a number of inaccuracies about him encountered in the aforementioned publication, *Old Taoist*.

I am indebted to Jonathan Chaves, professor of Chinese Language and Literature at George Washington University in Washington DC, for his enthusiasm and his devotion to the study of Kodōjin for more than two decades. His contribution as the translator of the artist's Chinese-style poetry has been invaluable. I am also extremely grateful to Paul Berry, professor of art history at Kansai Gaidai University, himself a passionate art collector and one of the foremost authorities on Japanese literati painting, for the essay on Kodōjin that examines the world of the literati painting tradition and touches on the patronage of his oeuvre. Readings and translations are provided for all of Kodōjin's poems appearing on the paintings illustrated in this publication. Many of these are original and were composed for specific paintings. They are not included in Kodōjin's poetry anthologies, making the contributions in reading the texts by Joseph Chang for the Chinese and Kawasaki Hiroshi for the Japanese haiku instrumental to the project.

My sincerest thanks are extended to the numerous institutions and individuals who shared their collections and valuable expertise: Honolulu Museum of Art (Stephen Salel, Kyle Swartzlender), Harvard Art

IN RECENT DECADES, art historians in the West have made attempts to reevaluate the understanding of when the tradition of literati or scholar-poet painter (*nanga* or *bunjinga*) ended in Japan. It was initially held that this tradition disappeared with the end of the Edo period (1603–1868) and the beginning of the Meiji era in 1868, and that Tomioka Tessai (1837–1924), an artist who worked into the 1920s, was acknowledged as the last Japanese *nanga* artist. But there were several others after Tessai who kept this art form alive. Irie Shikai (1862–after 1938) and Fukuda Kodōjin (1865–1944) both had "fan clubs" of influential admirers from elite society. Komuro Suiun (1874–1945), founder of the Nanga Appreciation Society (Nanga Kanshōkai) in 1932, was honored with the title of Imperial Household Artist in 1944. Shirakura Jihō (1898–1970) and Yano Tetsuzan (1894–1975) were driving forces in the continuation of the *nanga* style following the Asia-Pacific War (1941–45).

Kodōjin can perhaps be seen as a more ambivalent figure than any of his twentieth-century peers due to his extraordinary prolificacy as both poet and painter. Except for the three publications released during Kodōjin's lifetime that illustrate his paintings—*Poems and Paintings by Kodōjin* (*Kodōjin shiga*, 1919), *Withered Trees and an Abundance of Spring* (*Koboku yoshun*, 1927), and *Rock Slivers and Lonely Clouds* (*Koun henseki*, 1929)—he left no lists or records of his paintings. In the research for this publication and exhibition, I unearthed more than 660 paintings and over 150 calligraphies, and their numbers are certain to increase with the discovery of undocumented paintings in the future. Such a body of work attests to Kodōjin's immense output but conceals the vast differences regarding dimensions and detailed execution. His calligraphy ranges from simple oblong poetry sheets (*tanzaku*), with a verse of just a few characters and roughly one-third the size of a sheet of paper that could be produced in a moment's time, to large more involved hanging scrolls with up to seven lines of text comprising more than one hundred characters.

Equally, his paintings consist of compositions that range from a modest hut and trees rendered with the minimum of brushstrokes and a brief inscription to painstakingly detailed polychrome landscapes that would have taken several weeks to complete. The considerable number of the artist's simple, and often staid, works that are today circulating in the art market have tainted his image in Japan as a painter in an already competitive field given the countless talented artists in the country's long art history. These "minor" works should not be underestimated, however, as they targeted less affluent patrons whose priority was his poetry and who viewed his accompanying paintings as secondary. Kodōjin and his fellow artists would have clearly understood the different levels of their art practice and set the prices for their work accordingly.

At the height of Kodōjin's career in 1928 to 1929, the incumbent prime minister Tanaka Giichi and other high-ranking politicians and industrialists joined forces to found the Kodōjin Society (Kodōjinkai), a testament to the appreciation of his art. The Mitsukoshi department store mounted a sales exhibition of eighty-six works by him, and the pricelist of this event has survived, providing a rare insight into the economic reality of the art world in

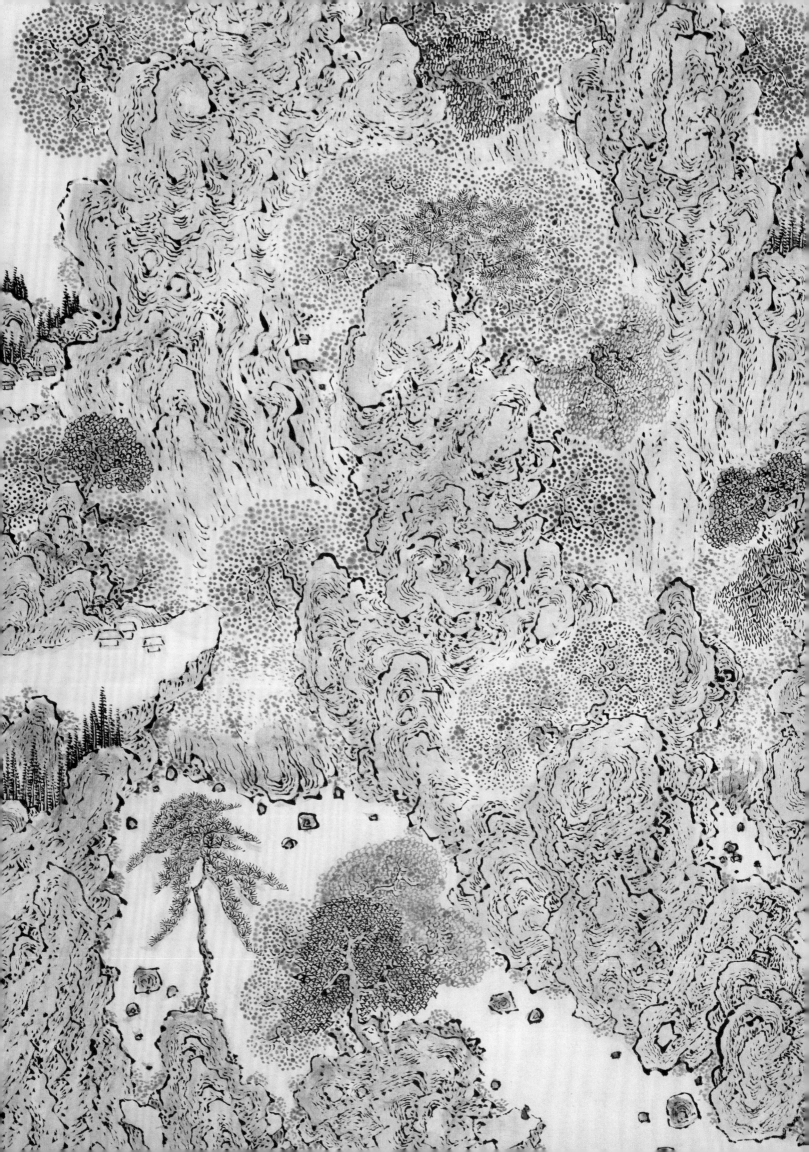

THE JAPANESE COLLECTION AT THE MINNEAPOLIS INSTITUTE OF ART (MIA) has grown to become one of the largest and most important in the United States. Through donations and purchases, it has almost doubled over the last decade and now comprises close to 9,500 works of art, selections of which are displayed in sixteen permanent galleries devoted to Japanese art.

Mia is also today home to the most comprehensive collection of artworks by Fukuda Kodōjin (1865–1944) worldwide, with sixty-three paintings and eleven calligraphies that include folding screens, hanging scrolls, and albums. Kodōjin was never a mainstream artist but made a name for himself first as a poet of haiku and then of Chinese-style poems (*kanshi*). His love of Chinese literature and art made him famous among aficionados of Chinese culture in Japan in the late nineteenth and early twentieth centuries. His appeal outside Japan only began in the late twentieth century, decades after his death, and he is now known more abroad than in his home country.

The majority of the works by Kodōjin at Mia were donated by two avid collector couples: Willard "Bill" and Elizabeth "Libby" Clark and David T. Frank and Kazukuni Sugiyama. For a few years, they even collected together and split the findings up between them. Eventually, both collections were united at Mia.

Over the last fifteen years, Dr. Andreas Marks, Mary Griggs Burke Curator of Japanese and Korean Art and Director of the Clark Center for Japanese Art at Mia, conducted extensive research into the life and work of Fukuda Kodōjin, including visits to his descendants in Japan. More than just a record of an exhibition, this stunning publication reflects Dr. Marks' meticulous scholarship. I am proud that Mia is host to the first Kodōjin retrospective, which features our own extensive holdings as well as loans from generous collectors from around the globe.

KATHERINE CRAWFORD LUBER
Nivin and Duncan MacMillan Director & President
Minneapolis Institute of Art

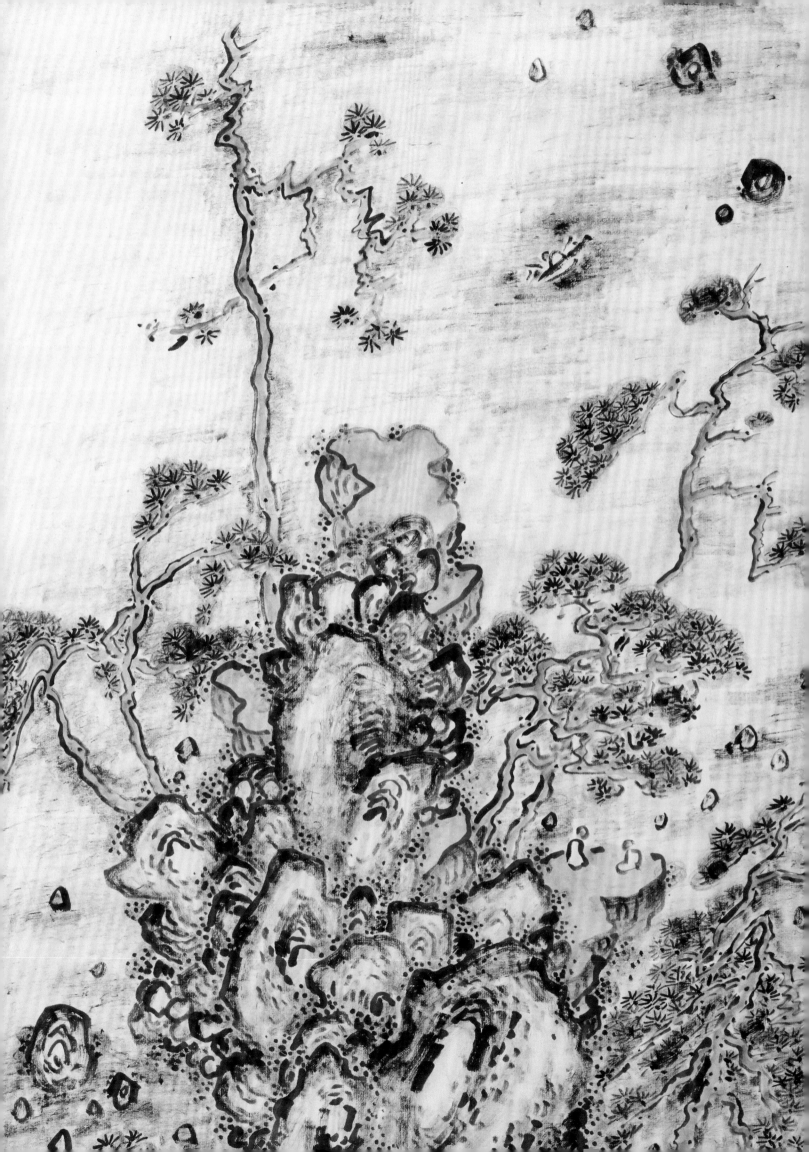

# CONTENTS

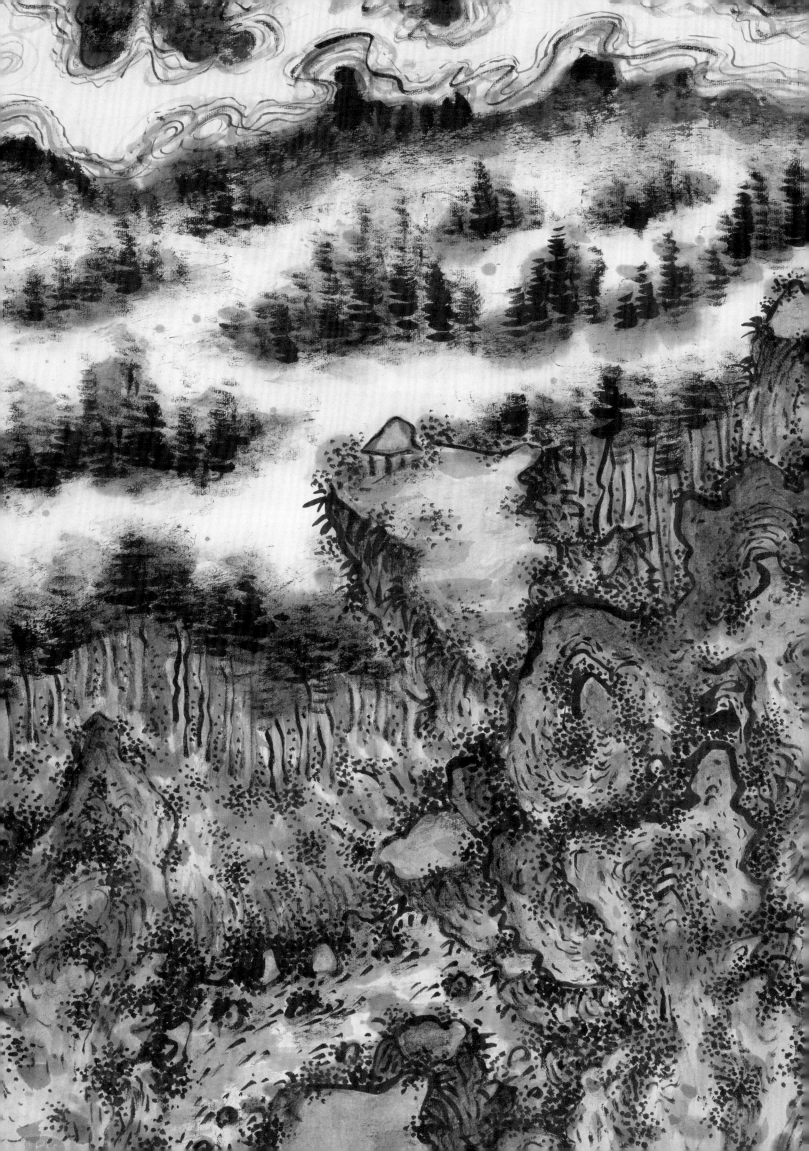

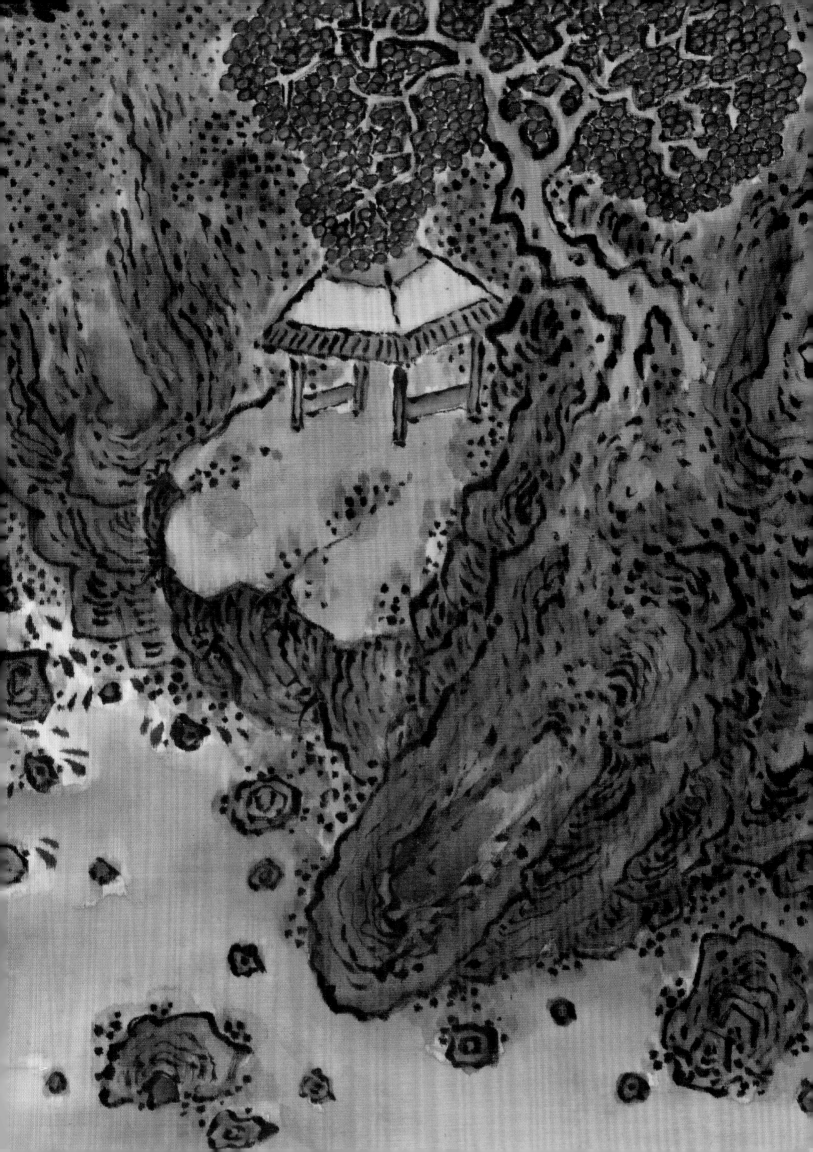

角巾而野服
吟詠步斜曛
澹泊即離俗
寂寥唯所欣
雖無蓮社侶
自有虎溪雲
日夕從來去
松風一逕分

With horned hermit's cap and rustic clothes,

Chanting poems I walk in the glow of the setting sun.

Serene and calm, thus parting from the vulgar world,

In isolation doing what I please.

Though I have no Lotus Society companions,

There are still the clouds over Tiger Stream.

Each evening I go and come,

The single path dividing in the pine winds.

NO. 6

*SECLUSION AT A STREAM*

April 1907

Oni Zazen collection

角巾而野服吟詠步斜嶼澹泊即
離俗寂寥唯所欣雖無蓮社侶自
有虎溪雲日夕従來去松風一逕
分丁未猶清和月 靜廬詩畫

興到忘吾我
出門隨意行
水邊林下路
自有好詩成

Inspiration comes, forgetting "self,"
I issue forth and go wherever I want.
The path beside the stream, beneath the grove:
Here naturally the finest poems will come.

NO. 7
*RETIRING FROM THE WORLD AT A MOUNTAIN CREEK*
Summer 1907
The Kura Art Gallery, Kyoto

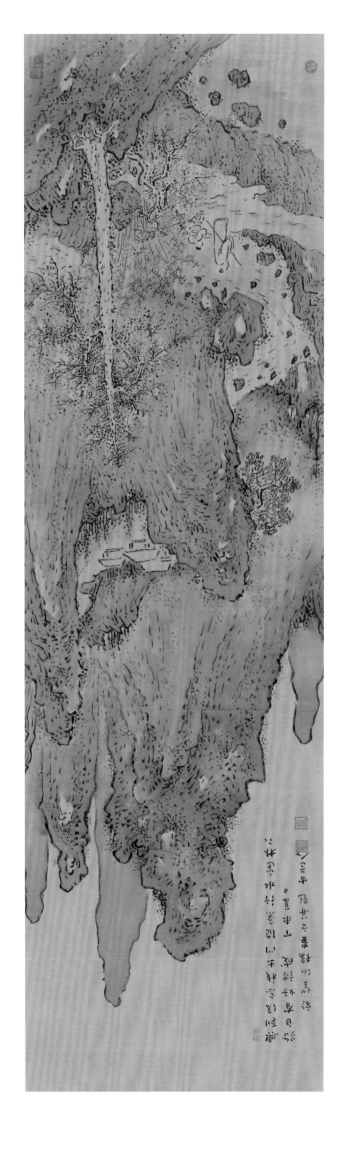

一竿風月足
我意自然如
側有神龍蟄
深潭獨釣魚

One fishing rod, the windswept moon—enough!
My contentment comes naturally like this.
Beside me a divine dragon hibernates:
In his deep tarn alone I will try for fish.

NO. 8

*EVENING FISHING IN AN AUTUMN BAY*

c. 1907–9

Oni Zazen collection

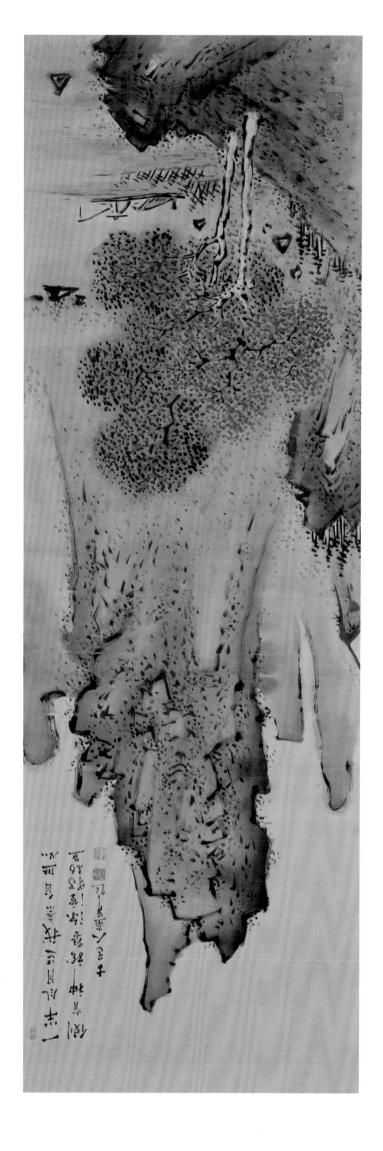

NO. 9

*BLUE-GREEN LANDSCAPE*

April 1907

Mary and Cheney Cowles collection

日之將出眾禽飛
遙望南山無色佀
小焉天地一時明
萬物濛濛含光煇
幽人早起未看書
汲泉掃逕且焚香
澹然自怡心自樂
只之羨慕是所算
甲光萬瑬忘是非
詩成長詠聊自解
陽春白雪和者稀

Before the sun's first appearance, birds begin to fly;

Look at that Southern Mountain: how faint its pulse and shape!

Still few birds between Heaven and Earth, a season of brightness;

The ten thousand beings, veiled in mist, contain beams of light.

The recluse, up early, has read no books as yet;

He draws pure stream water, and sweeps clean the pathway to his gate.

Burning incense, alone he sits in his thatched hut;

At peace, contented, mind free of machination.

The ancient sages and worthies are those whom I admire;

From then to now exists their true realm, forgetful of right and wrong.

This poem is now done—I chant it out loud in self-consolation;

In white snow this early spring, there are few to sing along.

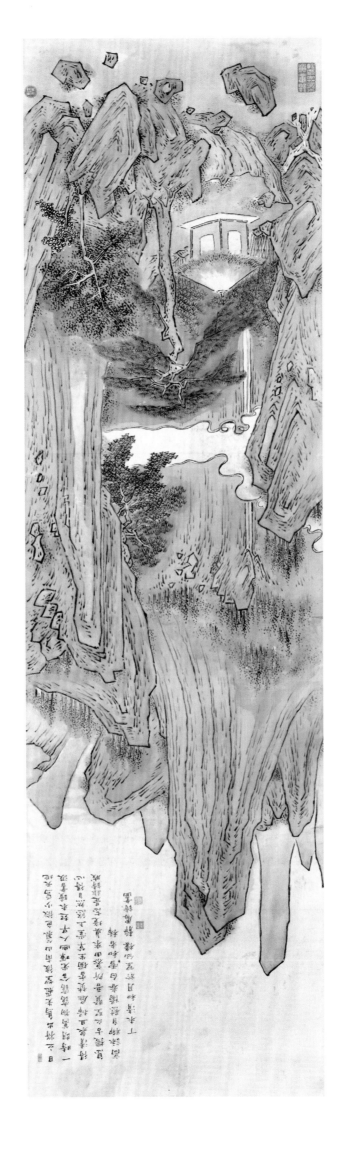

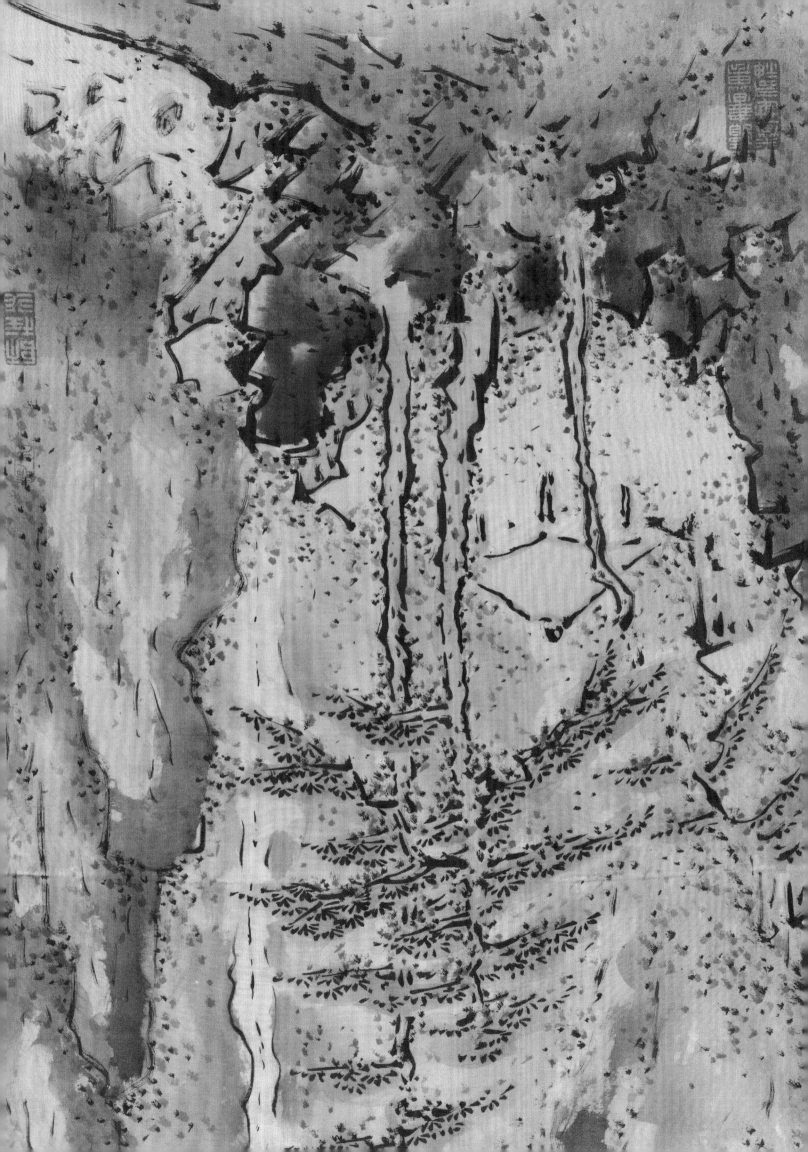

独坐青山老
無愁白髮生
衡門日之夕
延詠愜吾情
幽菊充餐者
自知詩句清
悠悠千歲下
慕古酒杯傾

I sit alone, aging among green mountains;

I have no grief, yet hair keeps turning white.

Slanting across my gate, the sun moves toward evening;

I sing at length, pleasing my inner feelings.

The mysterious chrysanthemum suffices for this diner;

I know the purity of those verses of Tao Yuanming!

Far, far beyond a thousand years,

Admiring antiquity, I will pour a glass for him.

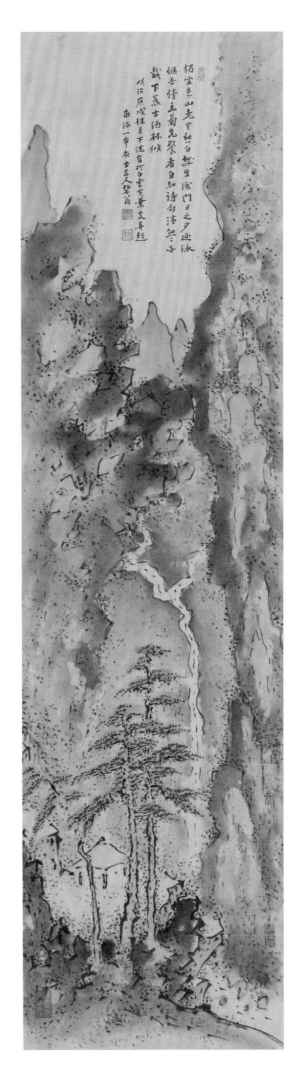

NO. 10

*PINE TREES BETWEEN CLIFFS*

August 1910

Robert Mangold collection

靄々古松色
雲霞流水閑
老鶴引雛歩
和唱天地間

Rich and full, colors of ancient pines,

Cloudy mists and flowing water, serene.

An elderly crane leads her chicks in a walk;

All sing in harmony between Heaven and Earth.

NO. 11

*EXCURSION UNDER PINE TREES*

C. 1907–12

Gitter-Yelen collection

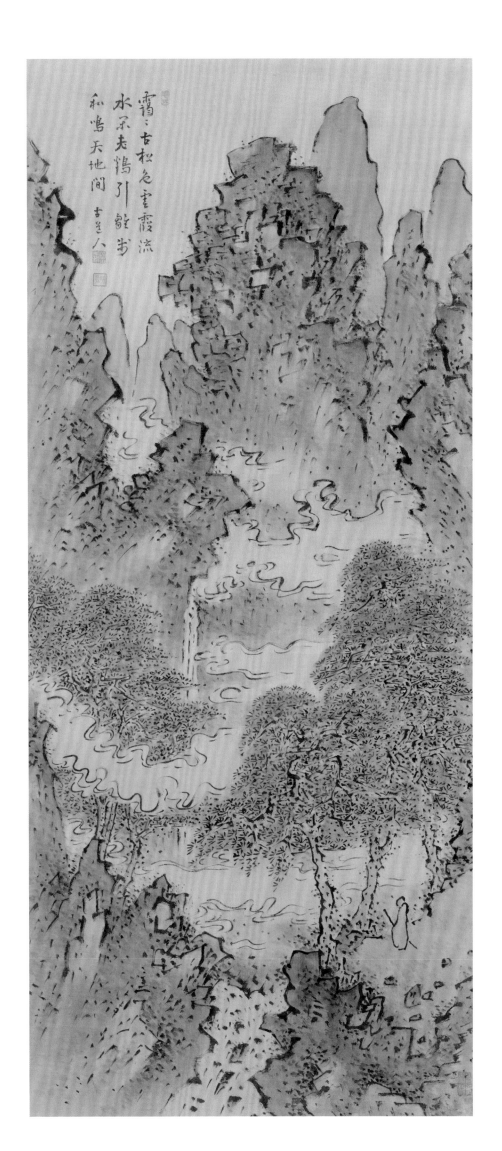

性本拙衣食

棲遁慕昔賢

自耕幽谷底

或嘯白雲巔

采藥隋麋鹿

煎茶汲石泉

逍遥吾願足

時復仰蒼天

By nature clumsy about clothing, food,

I perch in reclusion, admiring ancient sages.

I plow myself bottoms of hidden valleys,

Or whistle on peaks above white clouds.

Gathering herbs, I follow the deer;

Brewing tea draw water from rocky streams.

Wandering at leisure, fully content,

Often gazing up again at blue sky.

NO. 12

*LANDSCAPE IN PALE RED*

April 1912

Minneapolis Institute of Art, Gift of the Clark Center
for Japanese Art & Culture, formerly given to the Center
by David Frank and Kazukuni Sugiyama (2013.29.341)

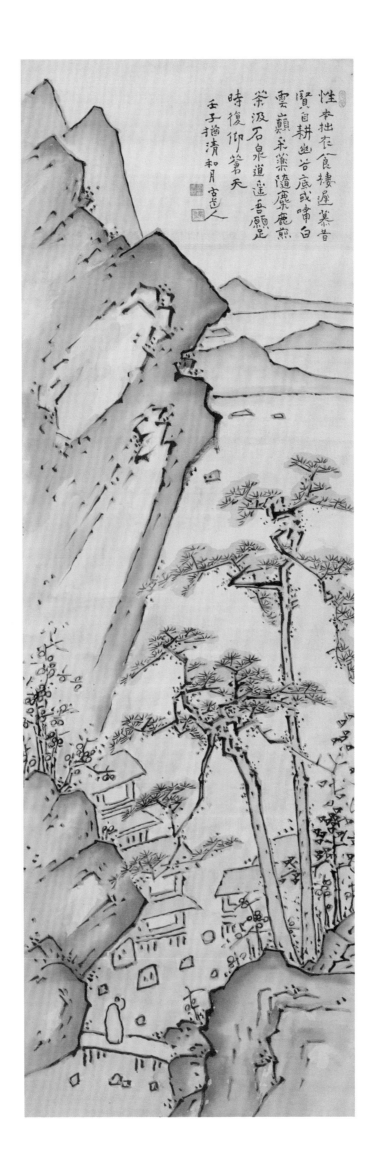

性本拙在食棲遲慕昔
賢自耕幽谷底或嘯白
雲巔禾藥隨麋鹿煎
茶汲石泉道遙吾願足
時復御筆天
壬子播清和月古道人

# DISCOVERING A MI FU STYLE

TO DATE THERE ARE NO known paintings by Kodōjin from 1911. In December, after four years in the Higashiyama area, he moved back to the western side of Kyoto, this time to Matsuomura. This change marked a new chapter in his life, as the forty-six-year-old artist was now in the financial position to purchase his own home. In May 1912, his first daughter, Yoshiko, was born.

Yamamoto Shirō and Matsumoto Akira have attempted to reconstruct where Kodōjin lived and traveled through an analysis of his poetry and the letters he exchanged with other poets. But they failed to consider the important information embedded in his paintings and on their storage boxes. For example, Kodōjin noted on *Landscape after Mi Fu* from the spring of 1912 (no. 13) that he painted it at a "Lodging in Koza" (*Koza*

*kyakusha*), which must refer to the town of Koza in Wakayama Prefecture. From this we can extrapolate that Kodōjin went there to visit his younger sister Kō.

This landscape is not only remarkable because of the location where Kodōjin painted it but also for the style, which was unusual for Kodōjin's paintings at this stage in his career. As noted above, in his youth, Kodōjin received only brief painting instruction from the professional painter Suzuki Hyakunen and the amateur painter Hayashi Sōkyō. This contrasts his study of poetry, which was much more comprehensive, and his Chinese-style poems frequently have allusions to ancient Chinese texts. As a painter he was largely self-taught, and his style is as idiosyncratic as his cursive calligraphy style. Kodōjin refrained from copying or alluding to revered painters as was commonly taught in Chinese painting. Some scholars (see the essay by Paul Berry in this publication) assert that certain traits in the work of influential Chinese painters, such as Ni Zan (1301–74), Hong Ren (1610–64), Gong Xian (c. 1618–89), and Mei Qing (1623–97), can be detected in Kodōjin's landscapes. But it could be argued that this point has been somewhat oversimplified and overinterpreted. Artists often drew on stylistic elements from others but it does not necessarily mean that they were deliberatively attempting to emulate older masters. In Kodōjin's case, we might question the view that he deliberately appropriated various modes because he neither had the opportunity to study Chinese masters in any depth nor had an interest in

FIG. 3  Attributed to Mi Fu (1051–1107),
*Auspicious Pines and Spring Mountains*,
c. 1100, album leaf, ink and color on
silk, 13¾ × 17⅜ in. (35 × 44.1 cm),
©National Palace Museum

following earlier painting traditions. Rather, we might better understand his art as a pursuit of his own unconventional, unrestricted freedom. One exception is the Chinese painter-calligrapher Mi Fu (Mi Fei, 1051–1107; fig. 3).

Mi Fu is acknowledged as one of the four greatest calligraphers of the Song dynasty (960–1279). No definitely authenticated works by Mi Fu exist; however, his distinctive style of rendering mountains without outlines through the use of wet dots of ink (so-called "Mi dots") had become popular during the Yuan dynasty (1271–1368). Kodōjin discovered his own affection for these misty scenes and included a Mi Fu-style mountain range in the c. 1907 *Album of What Exists* (no. 5). The aforementioned *Landscape after Mi Fu* is currently the earliest identified hanging scroll in which he adopted a Mi Fu style. A single isolated hut is nestled amid tall, narrow peaks, a perfect spot for a hermit. In the accompanying poem, Kodōjin does not signal the link to Mi Fu, and there is no signed storage box with a title. We can assume nonetheless that the title of this painting might have been *Landscape after Mi Fu* since several similar later paintings have the same title, as seen in a work from October 1914 (no. 14). This piece belongs to a set of at least two hanging scrolls that are exceptional because they are the tallest of the artist's landscapes, and they are painted on satin instead of on silk or paper. Satin was frequently employed by the painter and calligrapher Zhang Ruitu (1570–1641), but only around 4 percent of Kodōjin's works are

on this material. This landscape and its counterpart *Quiet Mountains on a Slow Day* (no. 18) could indeed have belonged a set of four. Each portrays a season, yet only two are currently documented.

Mi Fu's dark, bold scenes are brought to a new level of abstraction, as seen in another work, also entitled *Landscape after Mi Fu* (no. 15). The shapes of the mountains are almost imperceptible behind scattered tufts of fluffy clouds. The accompanying poem alludes to the celebrated Chinese calligrapher Wang Xizhi (303–61), who lived in Shanyin and was known for raising geese to study their movements, as he believed this would inform his calligraphy. The title of Kodōjin's *Beyond Mi Family Style* (no. 16) from 1927 signals his wish to go a step further, which he did through the use of red, not black, ink. Kodōjin adopted a Mi Fu style in more than twenty hanging scrolls and in several album pages. In his sets illustrating landscapes of the four seasons, the Mi Fu-style landscape always represents summer.

深山晴有雨
黑染匀洽衣
川斜白雲表
無人幽鳥飛

Deep in the mountains, clear skies yet there is rain;
Blackness dyes my robe from head to toe.
A stream slants off beyond the edge of cloud,
There is no one here, but hidden birds on the wing.

NO. 13

*LANDSCAPE AFTER MI FU*

Spring 1912

Oni Zazen collection

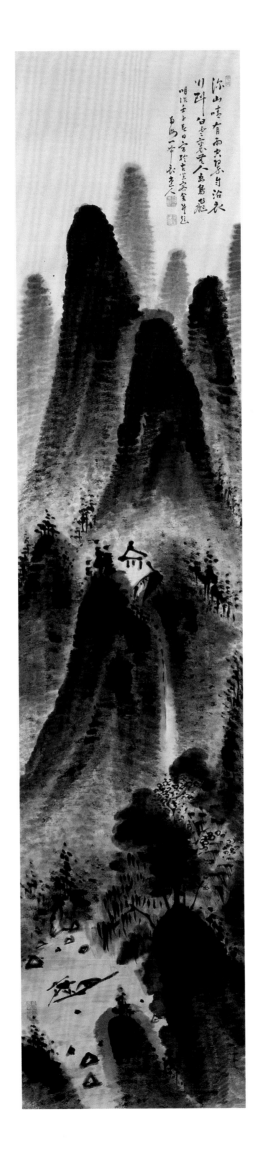

雲起山皆動
泉流石亦鳴
年來仙窟裏
自覺道心生

Clouds arise, the mountains now all move!
Streams are flowing, the very stones sing out.
For years, here in this grotto of the Immortals,
Feeling the mind of the Way arise in me.

NO. 14

*LANDSCAPE AFTER MI FU*

October 1914

Minneapolis Institute of Art,
Gift of the Clark Center for Japanese Art & Culture
(2013.29.1041)

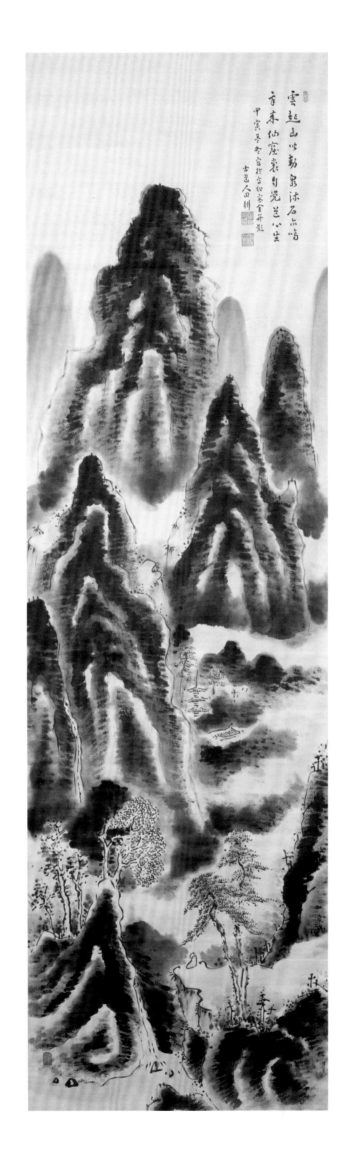

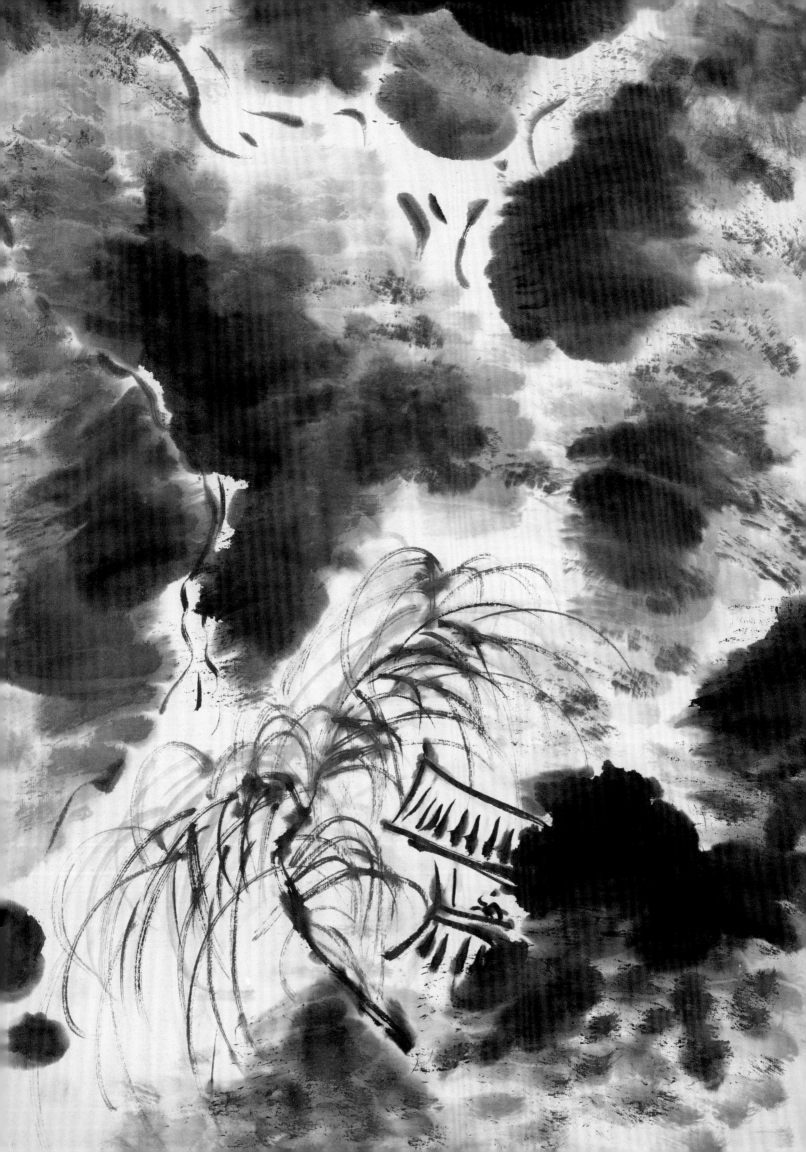

山陰有道士
蘆荻養群鵝
安得籠之去
慚吾一字無

At Shanyin there is a Daoist
Who raises flocks of geese among the reeds.
But how can I get to carry some off in cages?
I am ashamed to have not even one written word!

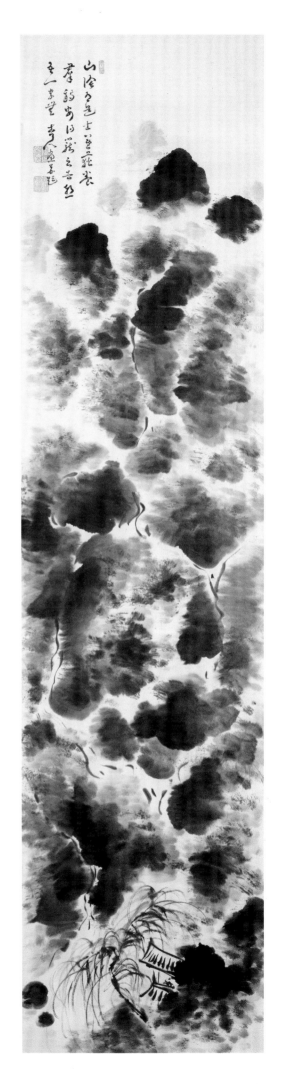

NO. 15

*LANDSCAPE AFTER MI FU*

c. 1921–40

Minneapolis Institute of Art,
Gift of David Tausig Frank and Kazukuni Sugiyama
(2015.111.19)

米家以外
別開一法
箇中天地
獨住者誰

Beyond the Mi family style
I have created a style quite different.
The world shown in this picture:
Who is the one living alone?

NO. 16

*BEYOND MI FAMILY STYLE*

Spring 1927

Private collection

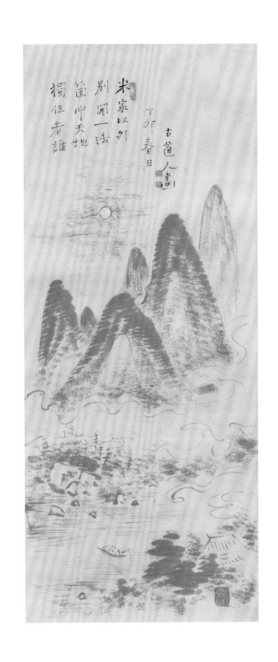

KODŌJIN'S FIRST POETRY ANTHOLOGY, *Cultivating Clumsiness, Preserving the Truth* (*Yōsetsu hōshin*), was issued in April 1912. This short publication contains twenty-five of his Chinese-style poems: twenty five-character, eight-line verses (C: *lüshi*, J: *risshi*) and five five-character, four-line verses (C: *jueju*, J: *zekku*). The more ambitious *Seisho's Mountain Studio Collection* (*Seisho sanbōshū*) with 254 poems, followed in October that year and in around August 1913 the *Collection of Poems by Haritsu* (*Haritsu kushū*). Although the latter was a pamphlet, it nonetheless contained 263 haiku. An entry on him (with photo) in the 1913 multivolume set *Who's Who in Japan* (fig. 4) is testimony to his rising fame.

In the 1910s, Kodōjin produced another style of landscape that is characterized by monochromatic sparsity: withered trees with trunks rendered with dark lines, emaciated

FACING PAGE: (DETAIL)
NO. 18 *Quiet Mountains on a Slow Day*

mountains, and a generous use of blank space are the main elements of these works (no. 17–18). Their simpler execution meant that they could be produced comparatively swiftly, and it is no surprise that he created a considerable number of these landscapes.

In a letter to his friend Taiji Gorōsaku from August 1914 Kodōjin laments his financial situation and declares that he might be forced to sell his house and land if the family's dire situation continued. We do not know if Taiji helped Kodōjin or if the artist's circumstances improved but judging from four paintings dated to October and December (no. 14, 18) with the geographic notations, "Guestroom in Takamatsu" (*Takamatsu kyakuji*) and "Lodging in Takamatsu" (*Takamatsu kyakusha*; on the storage boxes, *Takamatsu jūkyo*, or "House in Takamatsu"), he must have spent the winter of 1914 in Takamatsu (Kagawa Prefecture) on the Seto Inland Sea. Although there are no other records to substantiate this, it is quite possible that he traveled there in response to invitations by fans of his poetry or to undertake painting engagements. According to a letter in the collection of Fukuda family, he returned from Echigo in Niigata Prefecture on May 22, 1915, and in mid-autumn he spent time in the city of Ōshū in Iwate Prefecture. In each instance, he would have traveled several hundred miles / kilometers north of Kyoto. Only two paintings from May 1916 have been uncovered and not a single work from 1917—there is hiatus of two years for which there are no paintings or letters by the artist.

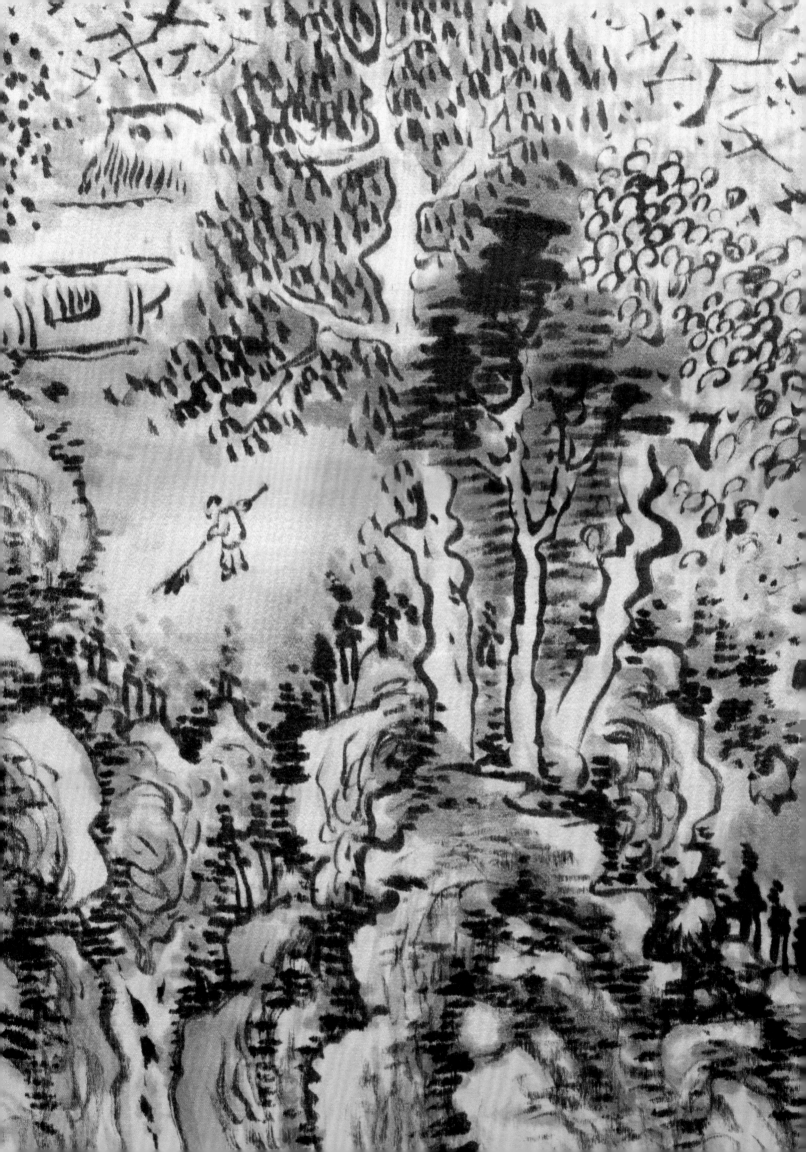

落日蒼天色
寒山啼鳥聲
蕭蕭紅葉下
冉冉白雲生
獨往情無極
高秋老益清
因看明月出
偶訪道人行

Setting sunlight darkens Heaven's color;
Cold mountains, sounds of singing birds.
Sighing, soughing, red leaves tumble;
Curling, rising, white clouds emerge.
Alone I go forth, feelings without limit:
Autumns seem still purer as I grow old.
And now I see the bright moon rising—
This is the time to visit a man of the Way.

NO. 17

*EXCURSION INTO THE MOUNTAINS*

September 1914

The Kura Art Gallery, Kyoto

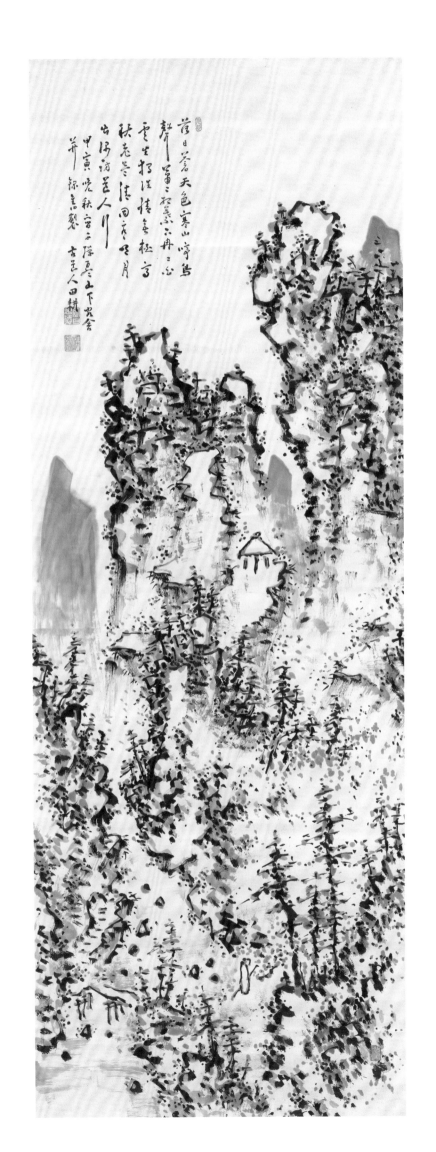

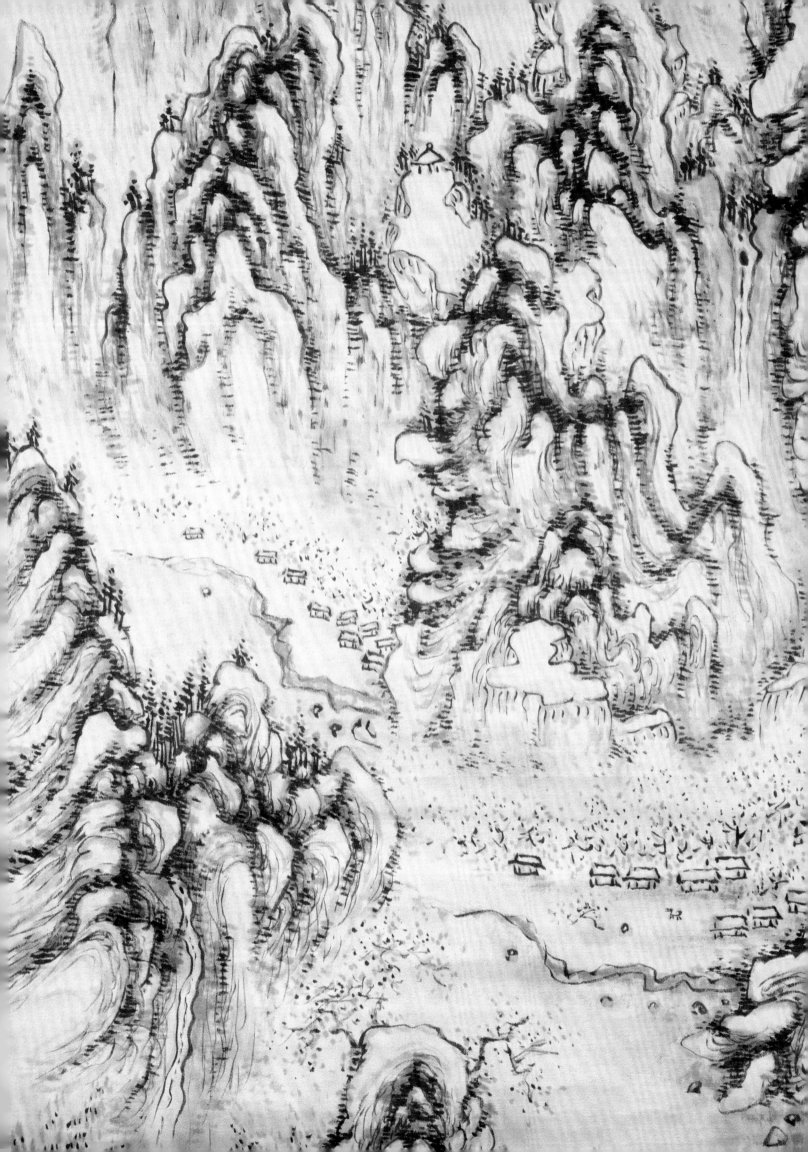

日高門尚掩

樹暖雨初晴

独坐幽花落

間庭春艸生

讀書頗樂道

省事豈無情

性本憐微物

相馴鳥雀鳴

Sun risen high, door still shut tight,

Trees all warm, rain just clearing up,

Alone I sit where mysterious flowers fall

In the quiet courtyard where spring plants grow.

Reading books, greatly enjoying the Way,

Reducing chores—doesn't that help the feelings?

By basic nature, fond of tiny things,

As if tamed, little sparrows chirp.

NO. 18

*QUIET MOUNTAINS ON A SLOW DAY*

October 1914

Minneapolis Institute of Art, Gift of the Clark Center
for Japanese Art & Culture (2013.29.1040)

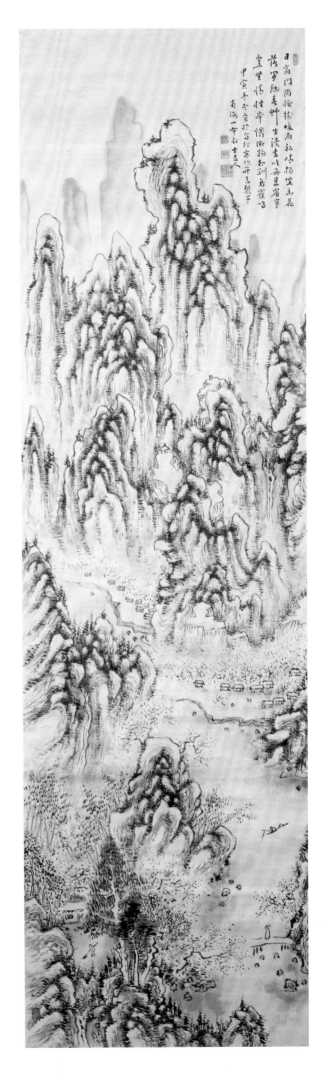

# The Exhibition at Heian Gabō, 1919

THE FIRST COMMERCIAL ART galleries opened in Japan in 1910, first in Tokyo and a few months later in Kyoto. On November 17, 1914, while Kodōjin was in Takamatsu, the poet Oka Tōri (1879–1916) opened the gallery Heian Gabō on Shijō Street in the Gion district. The ground floor was built in a Western style (visitors could keep their shoes on); the upper floor was in a traditional Japanese style with tatami mats. Following Tōri's early death, Ezaki Ken'ichi took over the gallery. It was a hobby for him, as his main business was in *sake* and lumber; he was also mayor of Fushimi (1911–15). Ezaki Ken'ichi was fond of Amada Guan's poetry, and it is possible that Ken'ichi and Kodōjin met through Guan.

Records of the initial sales exhibitions at the Heian Gabō no longer exist, making it difficult to determine if these early shows included Kodōjin's work. One Kodōjin exhibition at the gallery can be confirmed, however, as it was accompanied by a catalogue issued in July 1919 entitled *Poems and Paintings by Kodōjin* (*Kodōjin shiga*). It would be fair to assume that an eponymously named exhibition was held in the same month. The publication begins with twenty-six Chinese poems, followed by the illustration of eight painting hanging scrolls, eleven calligraphy hanging scrolls, eight album leaves of paintings, and seven album leaves of calligraphy. Four of the paintings form a landscape set depicting the four seasons, and the fifteen album leaves were from a set of two albums that together numbered twenty-eight leaves. Titles, dates, and dimensions were not provided for any of the works, but the reproductions are clear enough to facilitate a reading of the inscriptions. There were five paintings dated to either April or September 1918. It is plausible that Kodōjin created the other works in 1918 and certainly no later than the spring of 1919.

The painting set of four seasons (no. 19a–d) and the two albums (no. 20–21) can be counted among Kodōjin's best works. The four landscapes from April 1918 have the same signature form and seals. The titles are written by Kodōjin on the individual storage boxes: *Landscape with Spring Scenery* (*Shunkei sansui*), *Landscape after Mi Fu* (*Bei Futsu sansui*), *Landscape with Autumn Scenery* (*Shūkei sansui*), and *Landscape with Snow Scenery* (*Sekkei sansui*). Each work was meticulously executed. Color is applied for the blossoms in the spring view and for the foliage in the autumn scene. In contrast, the summer composition in the style of Mi Fu and that for winter are both monochrome.

The album leaves in the publication belong to two albums, arguably the most impressive by Kodōjin recorded to date. Each of the two albums has fourteen leaves, consisting of a frontispiece, six alternating calligraphies and landscapes, and a postscript. The albums are undated, but the seals point to their creation in 1918. The *Album of White Clouds* (no. 20) illustrates landscapes in monochrome, while the scenes in the *Album of Colored Clouds* (no. 21) are in color. The twelve landscapes in both are little jewels, offering lovingly rendered and innovative scenes. The ink compositions in subtle gray shading offer a striking contrast to the color landscapes in deep green and blue tones. It seems that this album pair was the only work by Kodōjin to be sold at auction during his lifetime, at the prestigious Kyoto Art Club (Kyōto Bijutsu Kurabu) on December 4, 1933 (lot 137). The sale was from the collection of a certain family, although their identity was not disclosed. It is not known how much they sold for or where they were housed before the current owners acquired them from a Kyoto-based art gallery in 1997.

FACING PAGE: (DETAIL)

NO. 21 *Album of Colored Clouds*, leaf 10

花宿幽鳥
石潭遊美魚
出門行樂久
入室復繙書

Amid flowering trees are perched hidden birds;
In stony tarn are swimming lovely fish.
I sally forth, enjoying myself for hours,
Return back home, again flip through my books.

一旦謝名利
林下忘世囂
請看自然理
春筍入夏高

One day I said goodbye to fame and fortune,
Beneath the forest, forgot all worldly noise.
Please take a look at the Principles of Nature:
Spring bamboo shoots with summer surge up high.

NO. 19A

*LANDSCAPE WITH SPRING SCENERY*

April 1918

Minneapolis Institute of Art,
The Suzanne S. Roberts Fund for Asian Art
(2012.71.4)

NO. 19B

*LANDSCAPE AFTER MI FU*

April 1918

Minneapolis Institute of Art,
The Suzanne S. Roberts Fund for Asian Art
(2012.71.3)

落日幽巖下
寒泉木葉沈
澄然明似鑑
照見古人心

Setting sun beneath a hidden cliff;

Cold spring, where leaves are sinking.

Crystalline, as clear as a mirror;

Here are reflected the hearts of the ancients.

衣食非不拙
憂道臥衡門
金錢非不貴
積善遺兒孫

Clothing, food? It is not that I am not clumsy,

But grieved at the world's ways, I rest behind my gate.

As for money, it is not that I am not rich,

But to accumulate goodness, I will leave it to my children.

NO. 19C

*LANDSCAPE WITH AUTUMN SCENERY*

April 1918

Minneapolis Institute of Art,
The Suzanne S. Roberts Fund for Asian Art
(2012.71.2)

NO. 19D

*LANDSCAPE WITH SNOW SCENERY*

April 1918

Minneapolis Institute of Art,
The Suzanne S. Roberts Fund for Asian Art
(2012.71.1)

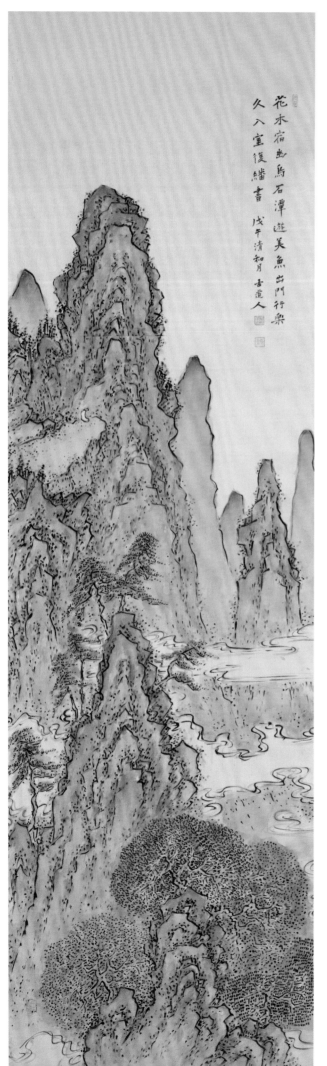

花木宿幽鳥石潭遊美魚出門行樂
久入室復緘書
戊午清和月 古道人

A

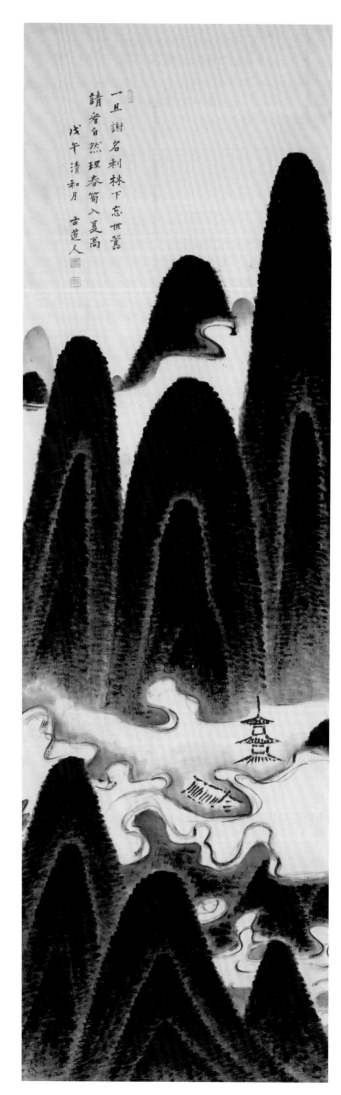

一旦謝名利林下忘世囂
請看自然理春筍入夏高
戊午清和月 古道人

B

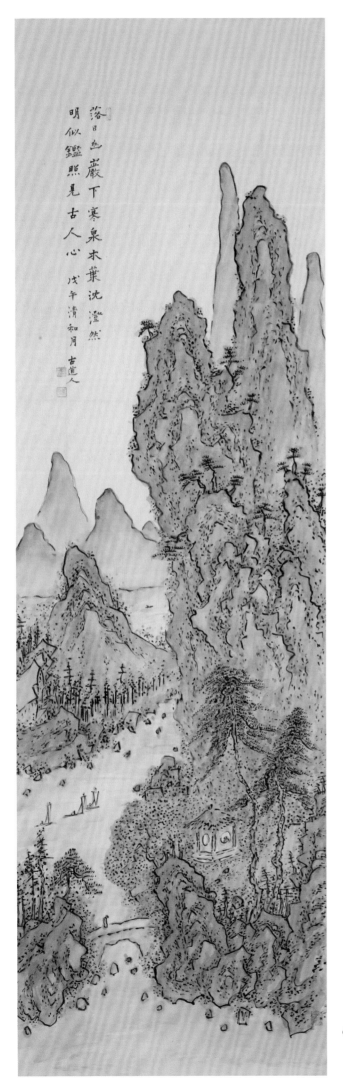

落日血巖下寒泉木葉沈澄然
明似鑑照見古人心 戊午清和月 古道人

C

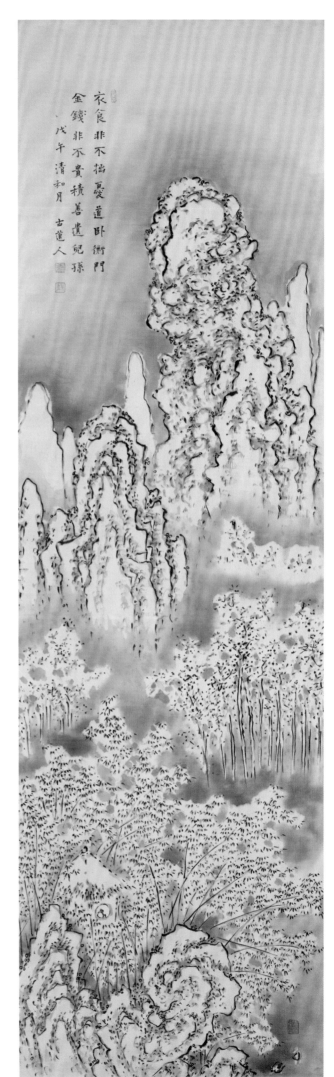

衣食非不捎憂道卧衡門
金錢非不貴積善遺兒孫 戊午清和月 古道人

D

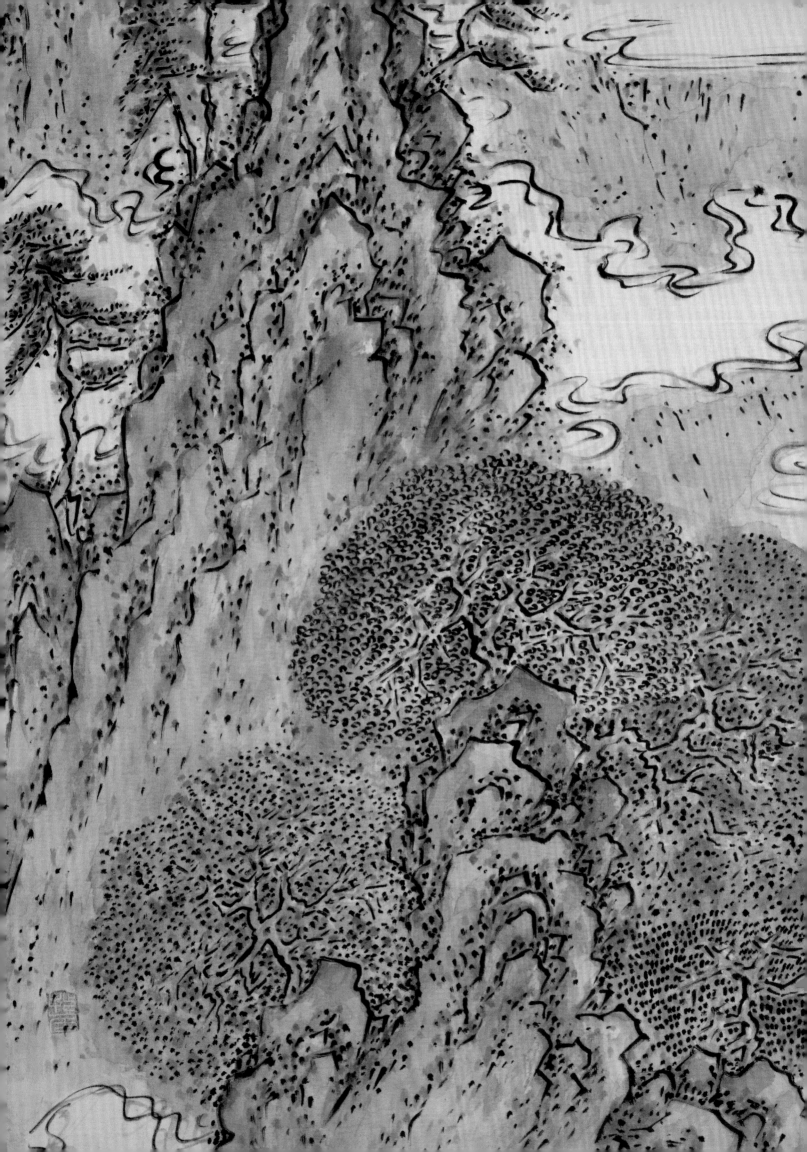

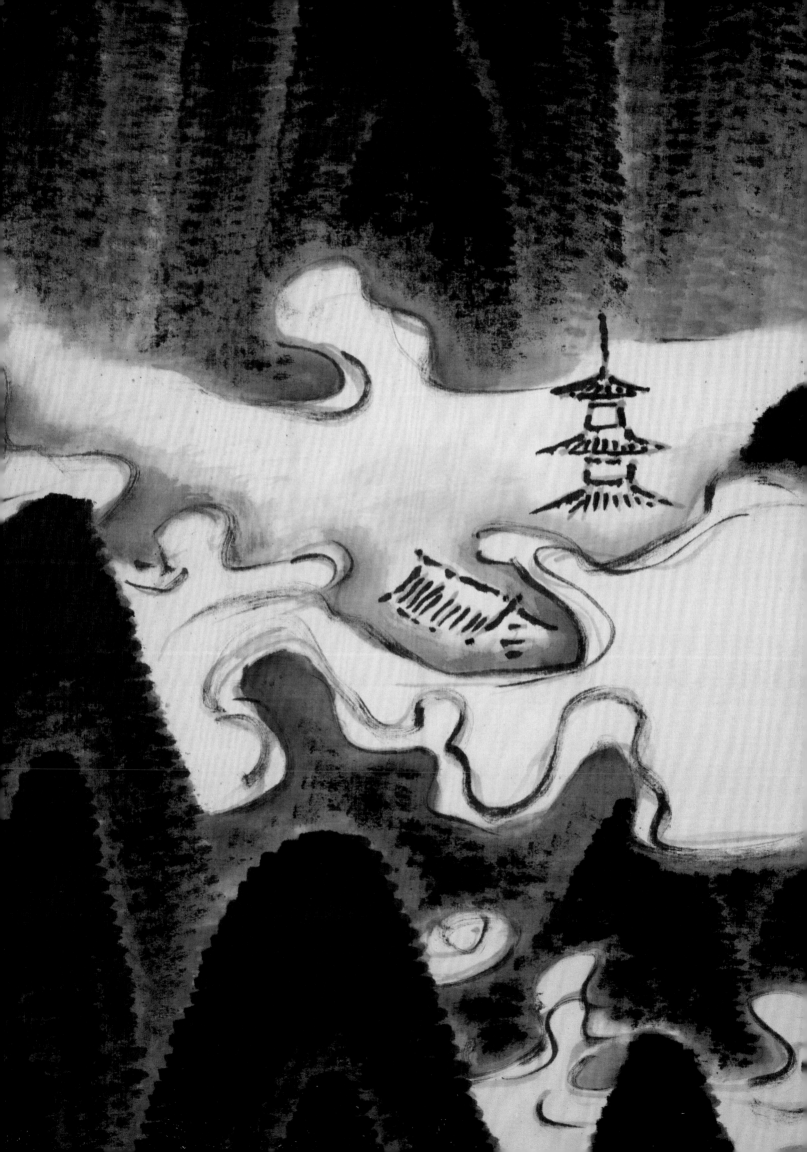

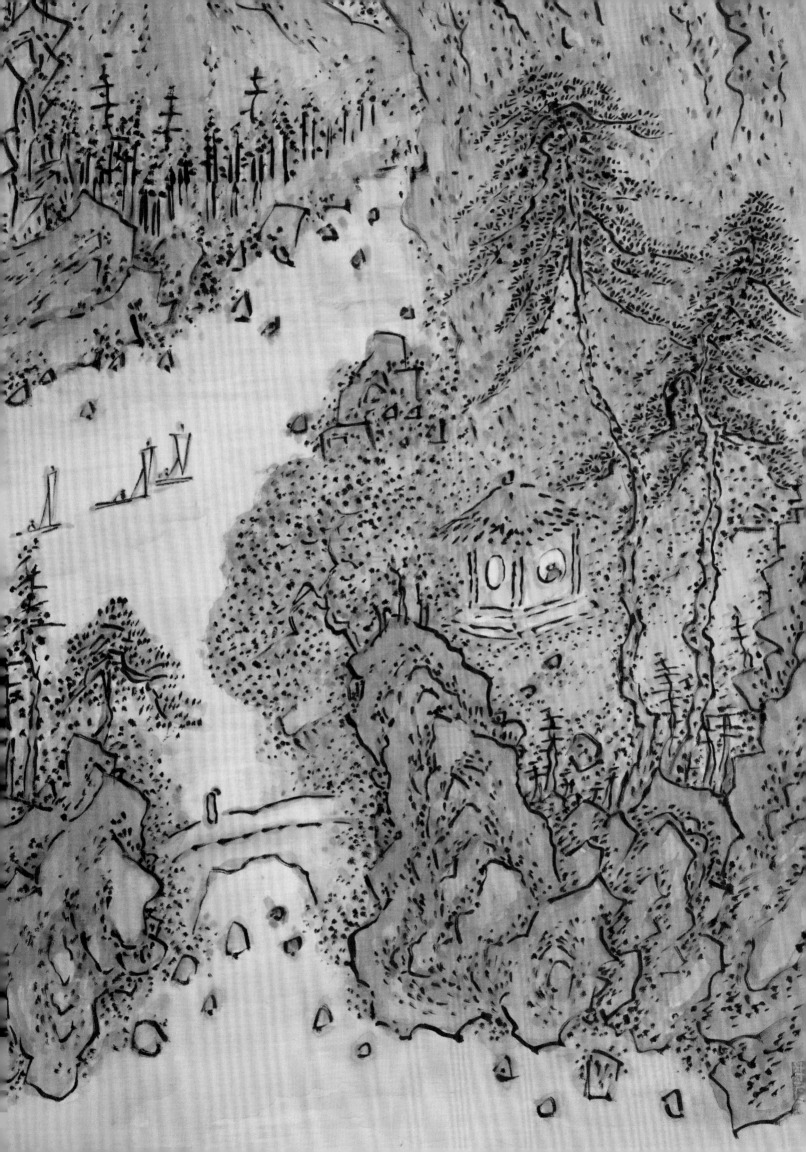

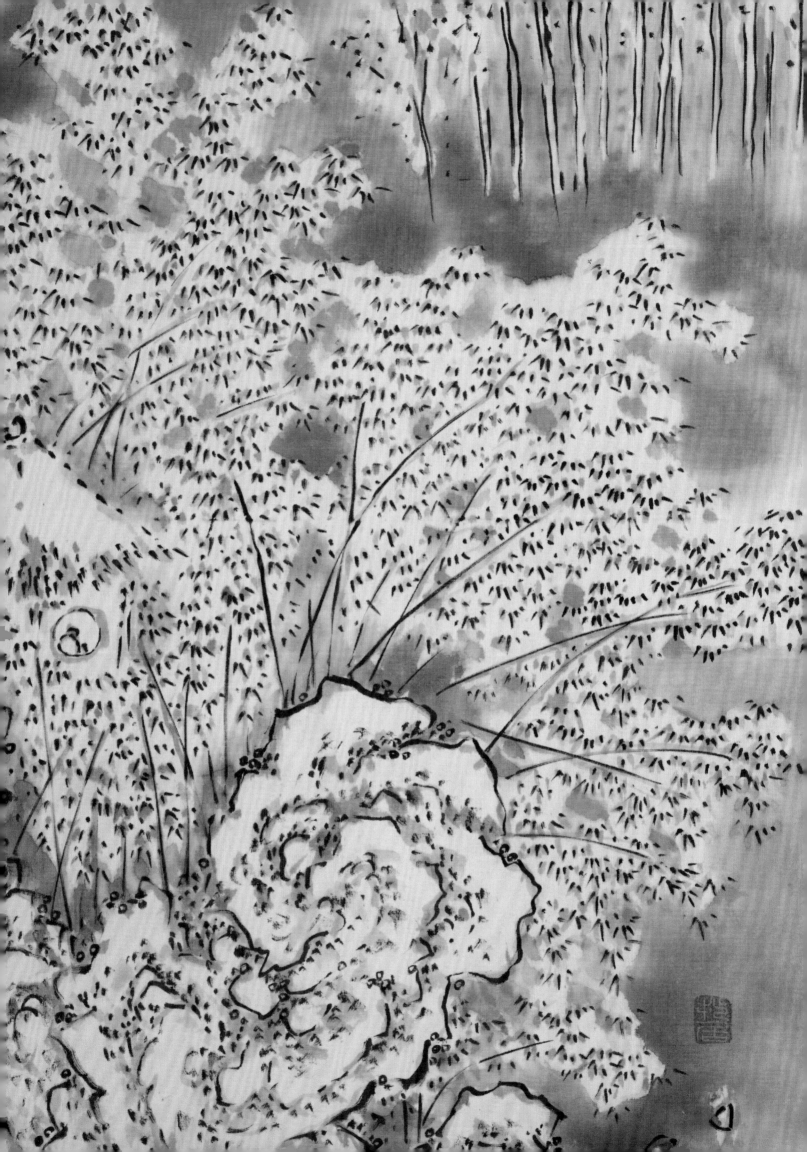

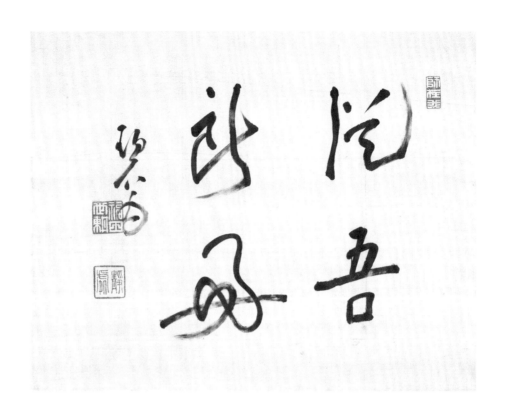

(FRONTISPIECE)

從吾所好            I pursue the ways I love.

NO. 20

*ALBUM OF WHITE CLOUDS*

1918

Gitter-Yelen collection

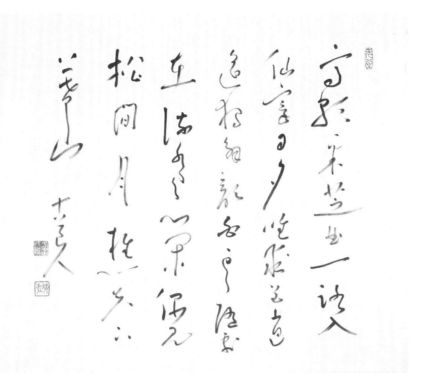

(2)

| 高歌采芝曲 | I sing out loud a song of gathering magic fungi, |
| 一路入仙寰 | My route bringing me into the realm of the Immortals. |
| 日夕唯求道 | At sunset, I seek only the Way, |
| 逍遥獨解顔 | Freely wandering along, my smile relaxed. |
| 白雲随處在 | White clouds here are everywhere, |
| 流水与心間 | Flowing streams serene as is my mind. |
| 偶見松間月 | I happen to catch sight of the moon among the pines, |
| 樵夫下暮山 | And woodcutters, descending the evening mountain. |

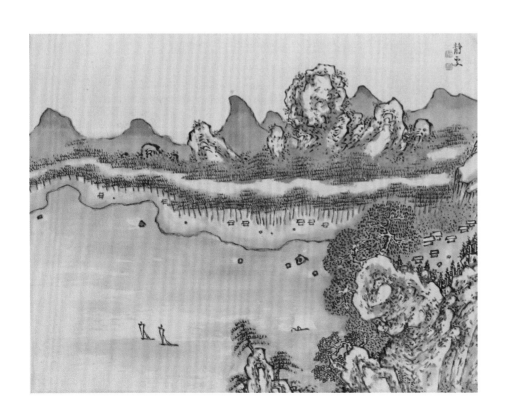

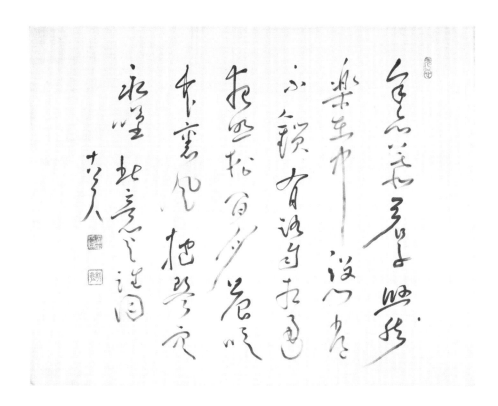

(4)

| 余亦慕君子 | I too admire the true gentleman, |
|---|---|
| 悠然樂在中 | All at peace, joy within his soul. |
| 設門常不鎖 | He has set up his gate, it is never locked; |
| 有路自相通 | There is road which naturally leads to it. |
| 夜照松間月 | At night is shining the moon among the pines; |
| 晨吹竹裏風 | Dawns there blows a wind through the bamboo. |
| 抱琴空永嘆 | Embracing his lute, he signs long, without reason: |
| 此意与誰同 | Such feeling: with whom can he now share it? |

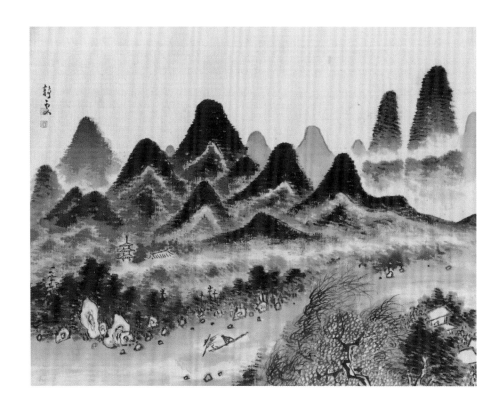

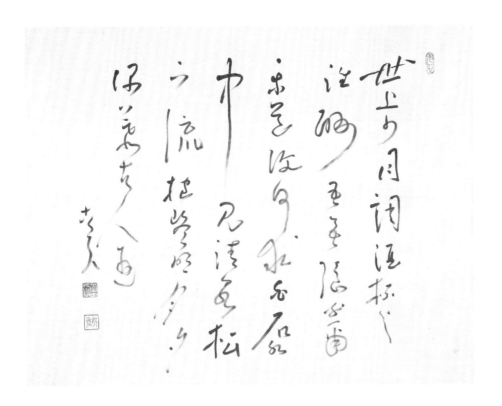

(6)

| 世上少同調 | Few are the soulmates in this world— |
| 酒杯誰共酬 | With whom am I to share cups of wine? |
| 我無隱乎爾 | It is not that I am withdrawing from others: |
| 樂道復何求 | I take joy in the Way, so what more need I seek. |
| 白石水中見 | White rocks appear in the stream; |
| 清泉松下流 | Pure waterfalls flow beneath the pines. |
| 抱琴明月夕 | Clutching my lute this night of bright moonlight, |
| 偶慕古人遊 | I admire the wanderings of the ancients. |

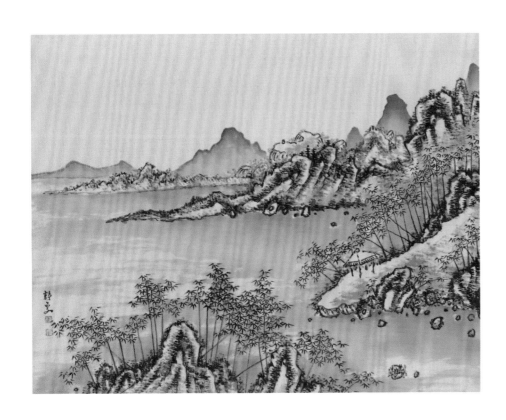

(8)

余亦有仙骨 I too have the bones of an Immortal,

飲水且讀書 Drinking from streams, reading my books.

誰能解真味 Who can comprehend this true flavor,

同此林下居 Reside with me here beneath forest trees?

故人期不至 A friend had a date, but did not come;

去者日何疎 Daily we seem more distanced from each other.

鼓琴歌一曲 I pluck my lute and sing a song,

永嘆良有余 My long sigh leaving an aftermath.

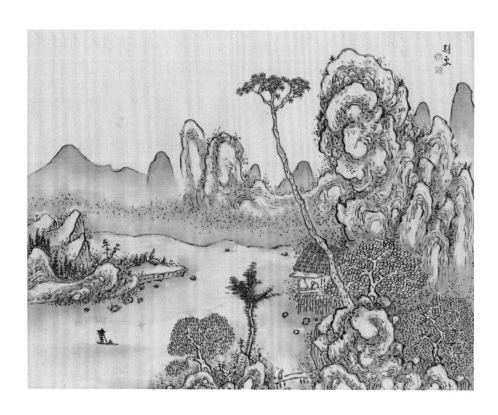

(10)

| | |
|---|---|
| 日出知天曙 | The sun comes up, we know the warmth of Heaven; |
| 雲歸任道存 | Clouds return, allowed by the Way to survive. |
| 山中樂如許 | With such joy here in the mountains, |
| 林下吾獨尊 | Beneath the forest, I alone find honor. |
| 對酒有真味 | Facing wine, which has the taste of truth, |
| 皷琴歌五言 | I play my lute and sing my five-word verse, |
| 善哉古君子 | Ah, how wonderful the gentlemen of old, |
| 守拙臥衛門 | Preserving their simplicity even in vulgar garrisons. |

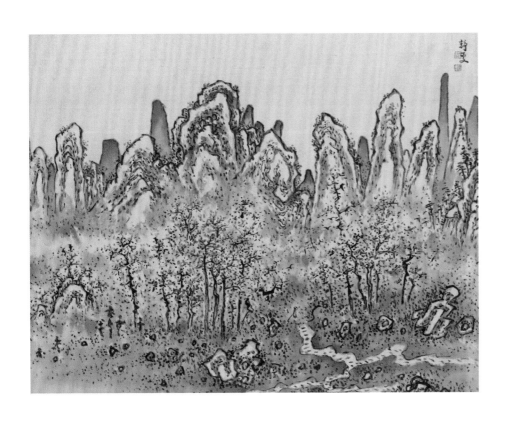

(12)

| | |
|---|---|
| 偶作采薇客 | All at once, I am an herb-gathering wanderer, |
| 西山慕昔賢 | At the Western Mountains yearning for ancient worthies. |
| 白雲如有約 | These white clouds seem to have an appointment with me; |
| 相得共悠然 | We get each other, together in a serene daze. |
| 豈謂非聖代 | Why would one say this is no sagely dynasty? |
| 憂道聊樂天 | Grieving for the Way, I take pleasure in Heaven. |
| 此意人若問 | Should anyone be asking the meaning of this, |
| 永嘆独撫絃 | I just sigh long, alone strumming the strings. |

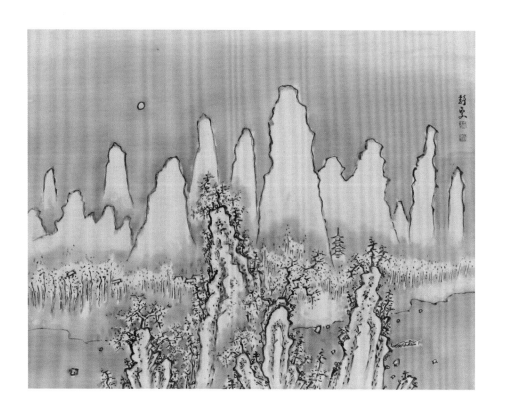

(POSTSCRIPT)
讀書餘事偶畫山水世
論工拙抑似畫奧不

Things done after studying; I just happen to paint a landscape:

The world will debate whether it is skillful or clumsy.

Or might it not be something like the mystery of painting?

FOLLOWING PAGES:
(DETAIL) NO. 20  *Album of White Clouds*, leaf 4
(DETAIL) NO. 21  *Album of Colored Clouds*, leaf 2

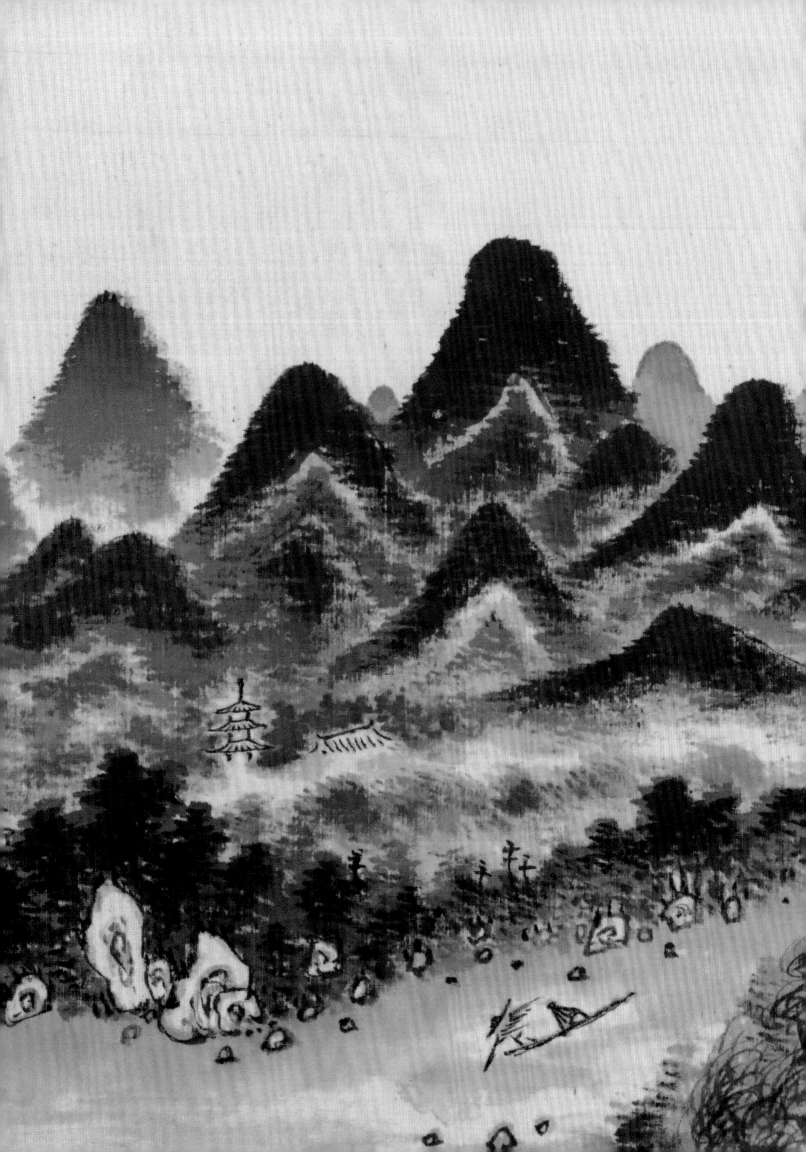

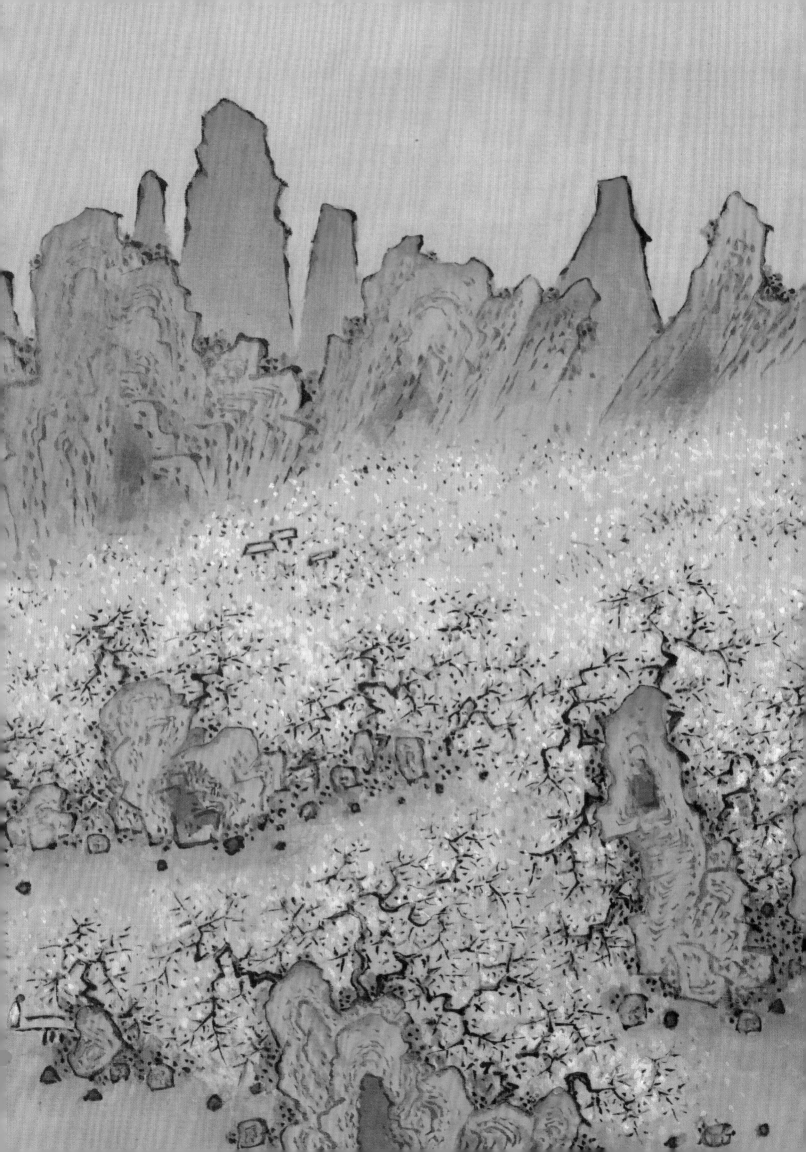

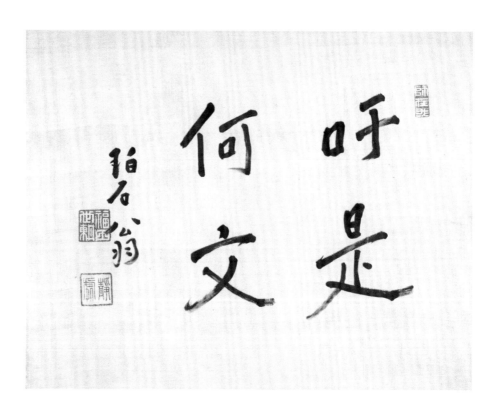

(FRONTISPIECE)

吁是何文                    Ah! What sort of text is this?

NO. 21

*ALBUM OF COLORED CLOUDS*

1918

Gitter-Yelen collection

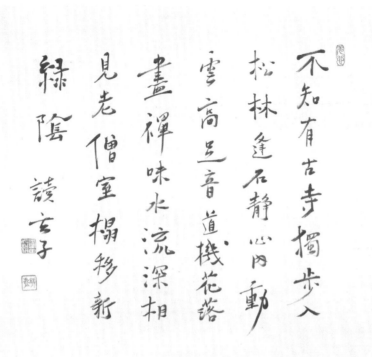

(2)

| | |
|---|---|
| 不知有古寺 | Not knowing there was an ancient temple |
| 獨步入松林 | Alone I stepped into the pine forest. |
| 逢石靜心內 | Encountering rocks, they calm my mind; |
| 動雲高足音 | Pushing through clouds, my footsteps get louder. |
| 道機花落盡 | Workings of the Way: flowers completely fallen; |
| 禪味水流深 | Flavor of Zen: streams flow with deep waters. |
| 相見老僧室 | In the old monk's cell we look at each other: |
| 榻移新綠陰 | Move the bench out to the shade of new green. |

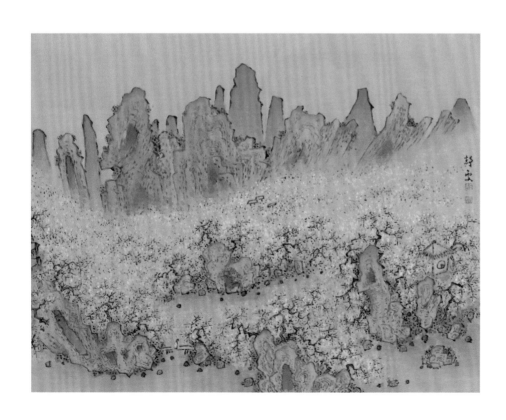

(4)

| 澄潭深萬仞 | Clear pool, ten thousand fathoms deep; |
| 清音不可聽 | Pure sounds, almost beyond hearing's range. |
| 映者絕塵滓 | All mutually reflecting, free of dust or mud; |
| 浮者現神形 | All that floats revealing body and soul. |
| 日月星辰照 | Sun and moon and constellations glitter; |
| 嵋巖草木青 | Rocky precipices show trees and flora, green. |
| 蟄龍若一起 | Should the hibernating dragon once awaken, |
| 天地忽冥冥 | Heaven and Earth would suddenly turn all dark. |

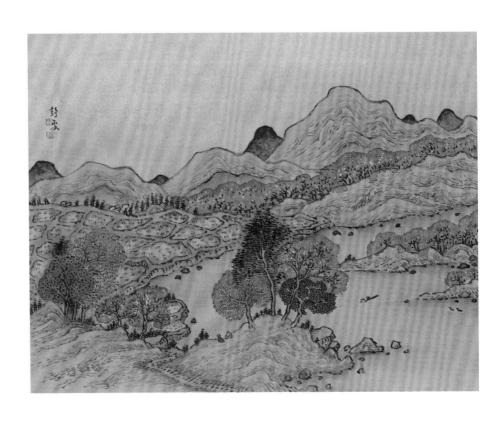

(6)

| 觀樹知異心 | Viewing trees, I grasp their different minds; |
| 聽鳥知殊音 | Listening to birds, I grasp their differing calls. |
| 日出見山高 | Sun rises, and I see the mountains are tall; |
| 月來見水深 | Moon appears, and I see the waters are deep. |
| 風行花自動 | Wind moves, the flowers wave by themselves; |
| 天寒魚自沈 | Sky turns cold, fish dive by themselves. |
| 靜者無雜念 | In such serenity, no conflicting thoughts: |
| 忘跡理可尋 | I have forgotten all traces, True Principle can be sought. |

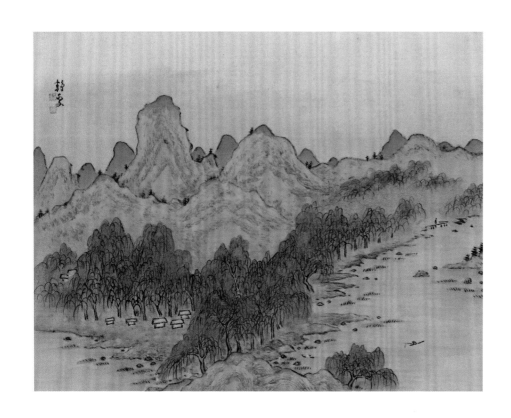

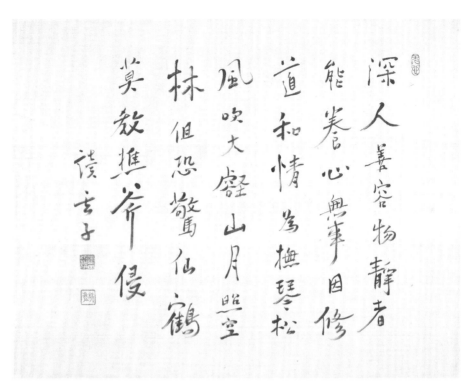

(8)

| | |
|---|---|
| 深人善容物 | The deep thinker is good at comprehending things; |
| 靜者能養心 | The serene one is able to nurture his mind. |
| 無事因修道 | With no pressing matters, I can cultivate the Way; |
| 和情為撫琴 | With harmonious feelings, I start to play the lute. |
| 松風吹大壑 | Wind in the pines blows through the great valley; |
| 山月照空林 | The mountain moon shines on the deserted wood. |
| 但恐驚仙鶴 | Only immortal cranes might be startled: |
| 莫教樵斧侵 | Please do not let the woodman's axe invade. |

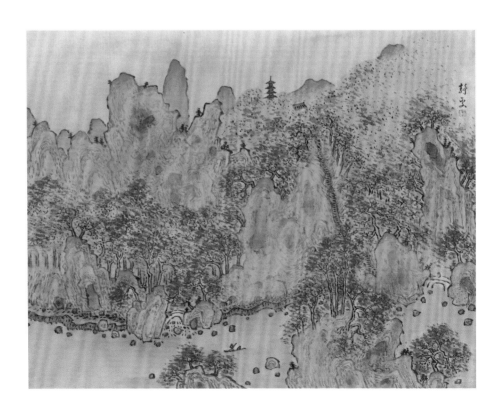

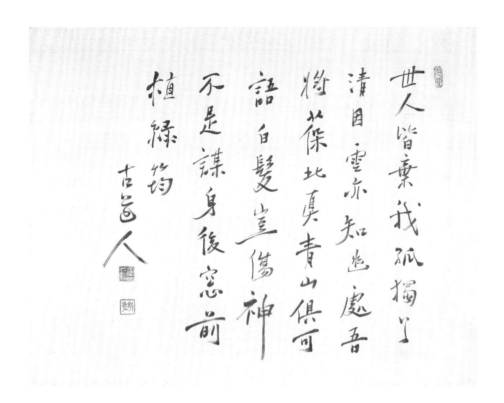

(10)

| | |
|---|---|
| 世人皆棄我 | The men of this world all reject me; |
| 孤獨了清因 | Solitary, alone, I grasp pure karmic causes. |
| 雲亦知幽處 | The clouds too know this hidden spot: |
| 吾將葆此真 | I aim to hold on to this Truth. |
| 青山俱可語 | Green mountains here all are able to speak; |
| 白髮豈傷神 | White hairs? How could they wound my soul? |
| 不是謀身後 | I have no plans for an afterlife; |
| 窗前植綠筠 | Outside my window I plant green bamboos. |

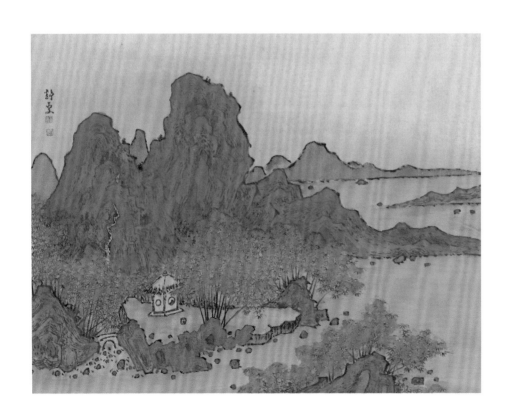

(12)

| | |
|---|---|
| 遂作山中士 | And so I became a scholar in the mountains, |
| 因知道味真 | Hence came to know the truth of the flavor of the Way. |
| 水流隨我意 | The waters flow, following my own intentions; |
| 雲在自成隣 | The clouds are here, and naturally become my neighbors. |
| 獨往松間月 | I set out beneath the moon in the pines, |
| 更無衣上塵 | No speck of dust any longer taints my robe. |
| 興來尋靜者 | When inspiration strikes, I seek a serene one, |
| 時復問深人 | And also at times, inquire about deep men. |

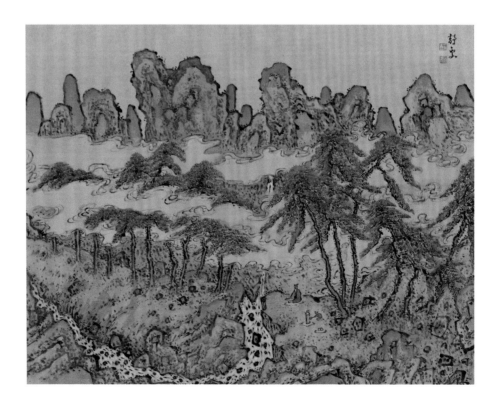

(POSTSCRIPT)

若問箇中意味焚香冏靜
尚讀書深人但能識之耳

If you ask the meaning in all this, taste returning peace by
burning incense. Only the deep man who reveres reading
books will ever be able to understand it.

# Innovative Experiments, 1919–20

Kodōjin's second daughter Hideko was born on February 4, 1918. In the autumn (August), he painted *One Thousand Mountains and Ten Thousand Streams* (no. 22), a popular subject of literati painters. Its title adequately relates to the myriad rock formations conceived in shades of light orange separated by negative space filled with different expanses of water. Kodōjin further enhanced the remarkable scenery by using gray dots to convey the sense of dense foliage growing on the rocks, in places even upside down. He also included an unusually large number of poems. Generally, his paintings have one poem and any additional text is prose. Here, however, Kodōjin inscribed eleven poems, by far the most compared with any of his other paintings. He likely opted for eleven in order to have one poem represent each group of the one thousand mountains and streams mentioned in the title. This is the only painting known in which he notes the location as being "Residing in Clumsiness" (*Sekkyo*), an expression found on one of his most frequently used seals and appearing on many of his paintings. On *One Thousand Mountains* it is seen in the bottom right corner.

Although this painting is dated to the autumn of 1918, it is stored in a wooden box that Kodōjin inscribed in December 1935. It is plausible that he had kept the painting and only signed the box seventeen years later, perhaps for a new owner, perhaps because the initial owner had not acquired the scroll with a box and wished to have one signed, or perhaps the original box had been damaged. This is an extreme example of the possible discrepancy between the date a painting was created and the date written on its storage box. Several other works exist in which the time difference is only a few months. It is important to remember that an artist's painting could be much older than its box, and that the seals on a painting need to

be considered in narrowing down the time frame when the piece was made.

In March 1919, the fifty-three-year-old Kodōjin and his family moved once again, and as in 1907, from the west to the east of Kyoto. The new home was at Shishigatani Teranomaechō, no. 27, which is significant since his last residence was nearby at no. 65. The move here might have been due to a fire in August at the house in Matsuomura, which Kodōjin refers to in *Landscape with Autumn Scenery* (no. 23):

> On this day there was an autumn fire that destroyed my reading books. After dousing the fire for a short time, with a great burst of energy I painted this landscape, not necessarily in the manner of the old masters.
>
> (translation by Jonathan Chaves)

Two contrasting events occurred in July 1919: the first was the tragic death of his eldest daughter, the seven-year-old Yoshiko, and the second was the celebration of Kodōjin's first painting exhibition and catalogue at the gallery Heian Gabō. There are no records about how Kodōjin coped with the loss of a child or how the exhibition was received, but this period witnessed an outburst of fresh ideas for paintings in the winter of 1919 and the spring of 1920. *Returning Sails in Colorful Trees* (no. 25), for instance, was made to paste onto a wooden lattice for use as a fan. The pristine (uncut) condition of this fan painting signals that it was never actually employed on a fan substrate. It is impossible to estimate how many fans Kodōjin painted in his career as they rarely survive. Of the six presently identified, this is the only example in which he first applied gold paint to the silk and then painted two boats amid a scene of colorful rocks and trees.

Kodōjin regularly painted orchids, sometimes in black or red ink, sometimes on

their own but frequently in combination with a distinctive vertical rock form as in *Solitary Orchid with Bizarre Stone* (no. 26). This hanging scroll from December 1919 is rendered in greater detail and would have taken considerably more time than any of the other four orchid paintings currently known. He occasionally added a third element—plum blossoms. Missing from this configuration were the bamboo and the pine, which together would have constituted the Five Purities (*gosei*), a favorite subject of the natural world for literati painters.

Another example representing this very experimental period in Kodōjin's art practice is *Green Bamboo and White Clouds* (no. 27), which depicts, as the title indicates, bamboo and white clouds, here framed by blue, orange, and red rocks. The color palette is exceptional, as is the rendition of the fluffy clouds. As an interesting side note, this hanging scroll was featured in 2015 on the popular antiques TV program *Kaiun! Nandemo kanteidan*, the Japanese version of *Antiques Roadshow*.

In *Pure Elegance of a Mountain Wellspring* (no. 28) Kodōjin revisits the light orange shading for his mountains seen in *One Thousand Mountains and Ten Thousand Streams* from 1918, however here there is no compositional balance. The scenery is dominated by a striking mountain at top right that looks like a massive egg-shaped boulder with small protrusions. To the left, perched high up in the mountains is a pagoda, the only sign of human life in the upper half of the work. This contrasts the bottom, which features three sailboats with two men fishing, one from a rock, the other from a boat, and two men admiring nature from a lofty viewing platform.

The unique composition of *Peach-Blossom Spring of Wuling* (no. 29), in which a large white cloud constrains the scenery at the top, is not seen in any of his other paintings.

The title refers to the district of the Peach-Blossom Spring (C: Taoyuan) east of Wuling in China's Hunan Province, which is mentioned in a preface of an eponymously named poem by the celebrated Chinese poet Tao Yuanming (Tao Qian, 365–427). It describes how a fisherman found himself on an unfamiliar river lined on both banks with blossoming peach trees; upstream he encountered an enchanted valley. Yuanming was Kodōjin's favorite Chinese poet, and the artist included several allusions to his poetry and prose in his poems. On *Peach-Blossom Spring of Wuling*, for example, he has the inscription "Temporary Abode in Shishigatani" (*Rokkoku gūkyo*), a location indicator that he used between March 1919 and autumn 1924 on at least fourteen paintings. His allusion to this place as "temporary" suggests that he knew that his stay at this new home would not be long term.

Kodōjin demonstrated his versatility and innovativeness in working in a smaller scale in the set *Pictures of Four Gentlemen* (no. 30a–d). It does not depict the plum blossom, orchid, bamboo, and chrysanthemum as was customarily the case when referencing the Four Gentlemen (C: *junzi*, J: *shikunshi*) in Chinese or Japanese art, but rather landscapes in the four seasons. Each rectangular sheet (8¼ × 7⅛ in.; 21 × 18 cm) has a unique color palette and composition. The illustration for spring revisits the palette of *Green Bamboo and White Clouds*, with green bamboo adjacent to blue and orange rocks. The image for summer is a Mi Fu-style scenery and for autumn the richly colored foliage beneath a waterfall. Winter concludes with a sparse scenery of mountains blanketed in snow.

1
林晴啼鳥響
早起出門行
欲汲清溪水
前山受日明

2
唯有白雲動
我心歸一聞
超然窮達外
獨坐見空山

3
忽有清機發
吟詩上翠微
夕陽明古逕
松色照寒衣

4
獨徃空山夕
相隨一古琴
水中天上月
雨雨照吾心

5
初日照門戶
一花高立霜
起來汲寒水
山色遠蒼蒼

6
我心清不寐
明月在天間
寂寂虛窓外
秋聲夜動山

7
曲逕通深竹
故人有幽墅
思詩坐雨前
可與青山語

8
颯颯空林葉
荒村燈火青
行人不見影
一犬吠寒星

9
古寺寒燈照
幽人獨坐長
夜深如有鬼
風葉走虛廊

10
山靜雲猶宿
日高門未開
落花幽意動
啼鳥故人來

11
客去柴門寂
秋心弄物萃
幽禽啄枯葉
寒日照孤花

NO. 22

*ONE THOUSAND MOUNTAINS AND TEN THOUSAND STREAMS*

Autumn 1918

Minneapolis Institute of Art,
Gift of David Tausig Frank and Kazukuni Sugiyama
(2015.111.27)

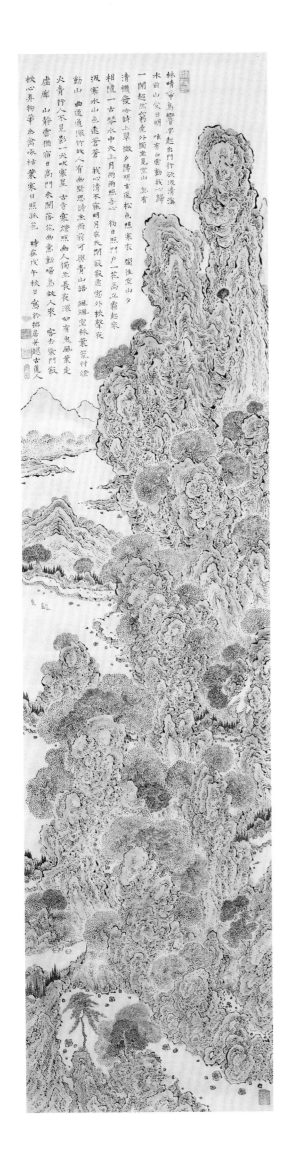

1 Sky over forest clears, singing birds echo,

   Up early I am out the door to walk.

   I want to draw water from the clear stream

   As the mountains ahead receive the sun's light.

2 Only the white clouds are moving—

   My heart returns to primal peace.

   Transcendentally, beyond success and failure,

   I sit alone to watch deserted hills.

3 Suddenly pure inspiration strikes—

   Chanting poems I climb the blue-green slopes.

   Evening sun glows down the ancient path;

   Pine tree colors illumine my cold robe.

4 Alone I go up the empty mountain—evening,

   And all I bring is my ancient lute.

   In stream water, in the sky—two moons,

   And this pair now glows within my heart.

5 The new sun shines on my gate;

   One flower grows there, upright through the frost.

   I rise to draw some cold well water;

   Mountain colors stretch far away.

6 My mind too clarified for sleep,

   The moon appears in Heaven.

   In the silence outside my empty window

   Autumn sounds are shaking the mountain tonight.

7 A winding path leads deep into bamboo

   Where a friend has a hidden retreat.

   Meditating poems we sit as rain comes down;

   We can discuss them with these mountains of green.

8 Soughing, soughing, leaves in the empty wood;

   From the deserted village, one lamplight, dim.

   The traveler sees not a single shadow;

   Somewhere a dog barks at the cold stars.

9 In the ancient temple, one cold lamp glows;

   The hidden one sits alone for hours.

   Deep in the night, there seem to be ghosts:

   Windblown leaves twirling down empty cloisters.

10 The mountain, calm, last night's clouds still here;

   The sun is high, the gate remains unopened.

   Flowers falling—movement of mysterious meaning;

   To songs of birds, an old friend now appears.

11 My guest has left, the bramble gate is silent.

   My autumn heart touches season's colors.

   A hidden bird pecks at withered leaves;

   Cold sunlight illuminates a solitary flower.

巨石頑然立
其高過丈餘
上生無菓樹
下有碩人居
飲水忘飢渴
看雲任卷舒
道心深不測
白日讀仙書

A vast rock boldly stands,

Its height much greater than 10 feet.

On it grow trees that bear no fruit;

Below resides a man of character.

Drinking from the stream,

He forgets hunger and thirst,

He watches the clouds,

Just lets them curl and unfold.

The Mind of the Way is deep and hard to fathom:

In broad daylight he reads books of the Immortals.

NO. 23

*LANDSCAPE WITH AUTUMN SCENERY*

August 1918

Seattle Art Museum, Gift of Griffith and Patricia Way,
in honor of the 75th Anniversary of the Seattle Art Museum
(2010.41.50)

雲本無心舒
花絶無草過
小人求諸奴
非是佛經法

Clouds, lacking any mind, unfold;
Flowers—utterly nonexistent!—fade.
The petty man seeks truth from slaves:
This is not the dharma of Buddha's sutras.

NO. 24

*RUNNING WATER AND PLUM BLOSSOMS*

C. 1913–21

Minneapolis Institute of Art,
Gift of David Tausig Frank and Kazukuni Sugiyama
(2015.111.8)

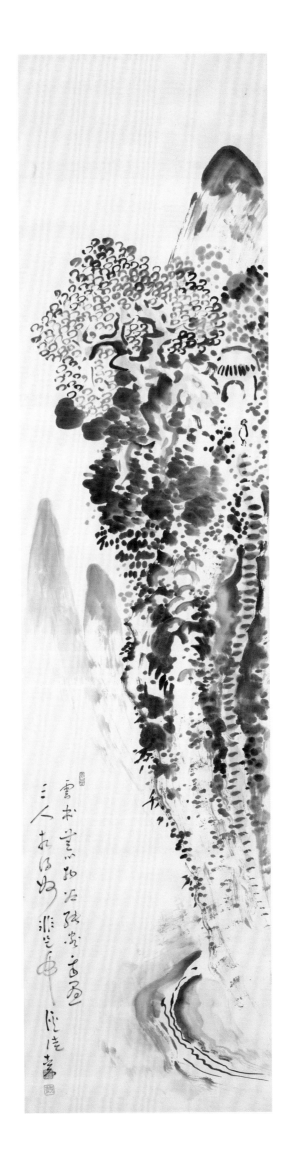

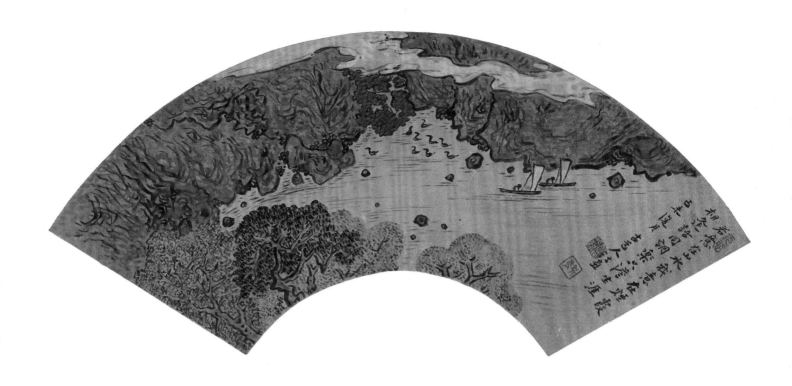

若意在山水
我意在煙霞
相逢話同調
樂只澹生涯

Your mind is on mountains and streams;

My mind is on mist and haze:

We meet and talk the same tune—

Our joy lies simply in making life serene.

NO. 25

*RETURNING SAILS IN COLORFUL TREES*

November 1919

Fukuda Kiyoko collection

衣食非不拙
憂道臥衡門
金錢非不貴
積善遺兒孫

Clothing, food? It is not that I am not clumsy,

But grieved at the world's ways, I rest behind my gate.

As for money, it is not that I am not rich,

But to accumulate goodness, I will leave it to my children.

NO. 26

*SOLITARY ORCHID WITH BIZARRE STONE*

December 1919

Patricia S. Criticos collection

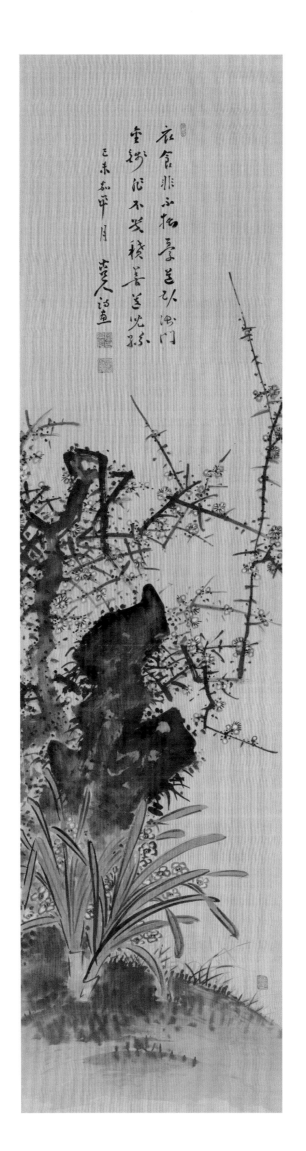

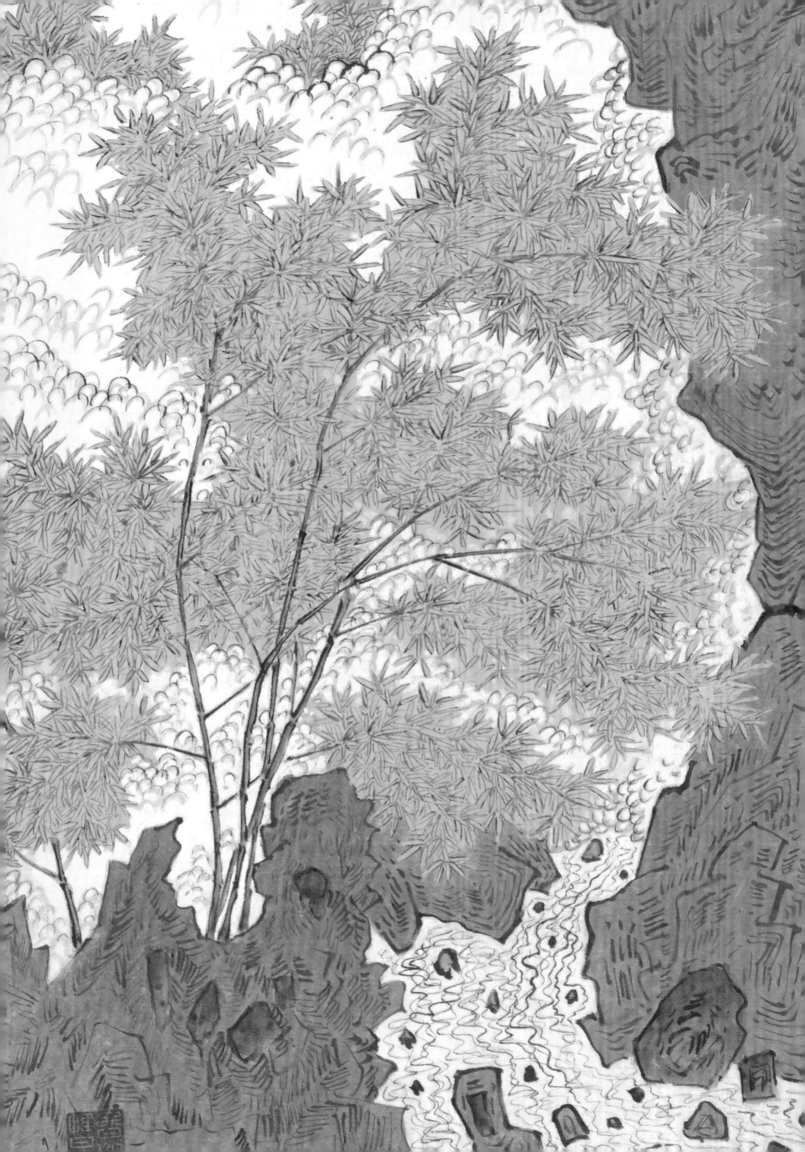

南山種綠竹

猗々見古心

日出鳳來舞

君子云皷琴

延詠如有得

何必待知音

At Southern Mountain I have planted green bamboo,

Elegantly displaying the heart of antiquity.

The sun rises—the phoenix comes to dance;

The gentleman will now play his lute.

He extends his chanting, as if quite content:

What need to find one who "knows his music"?

NO. 27

*GREEN BAMBOO AND WHITE CLOUDS*

Spring 1920

Sakuma Toshirō collection

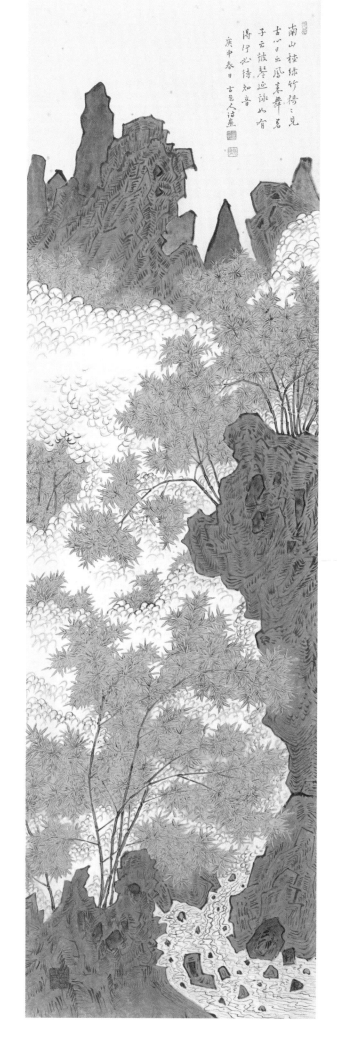

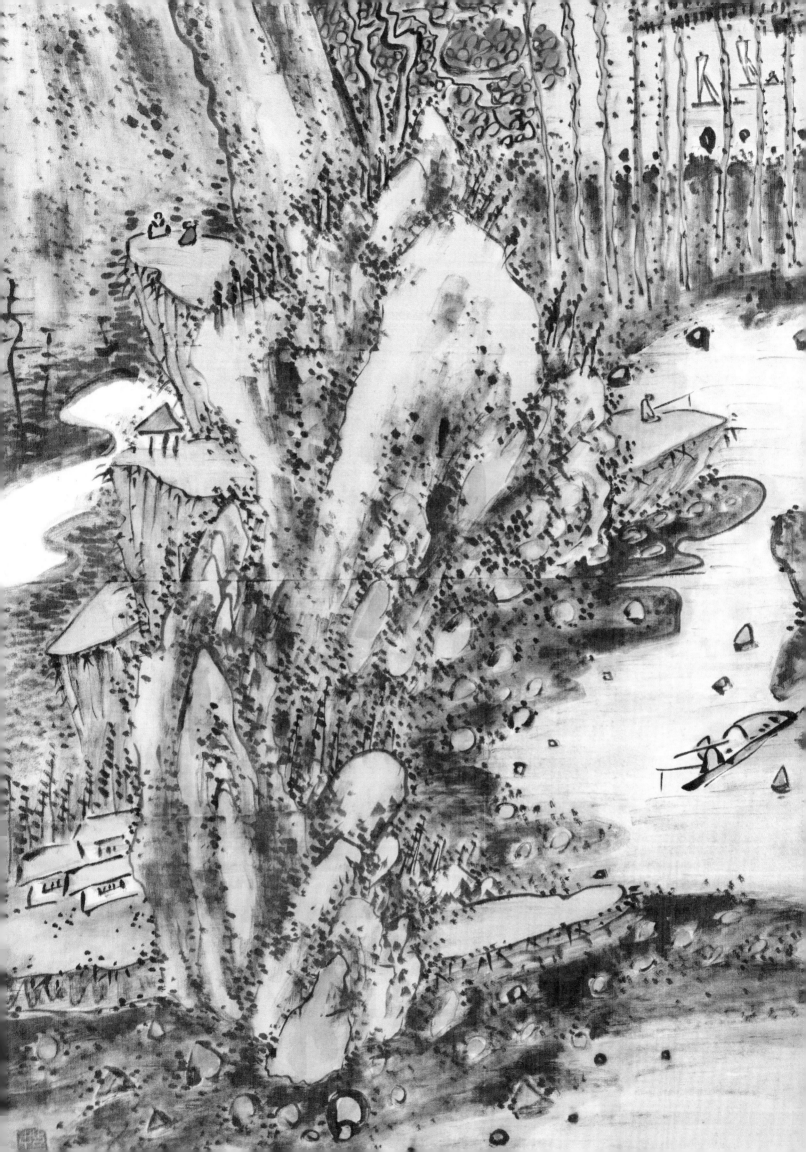

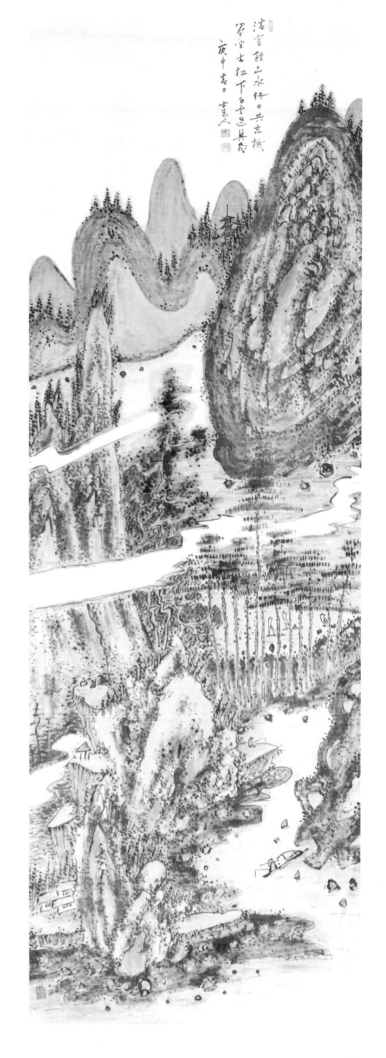

清言牲山水
終日共忘機
獨坐古松下
白雲幽奧飛

Pure words I sacrifice to mountains, streams,
All day both they and I forget all scheming.
I sit alone beneath an ancient pine,
White clouds scudding through all this mystery.

NO. 28

*Pure Elegance of a Mountain Wellspring*

Spring 1920

SHINYA Japanese Art & Design

捨舟從口入
洞裏有冲虛
仙境當桃林
漁郎來在初
飛雲映清水
鷄犬啼茅屋
天地文章在
依然秦火餘

Abandoning his boat he enters the tunnel mouth,
And in the cave meets purified atmosphere.
The realm of the Immortals is in a peach tree grove,
The fisherman the first to visit there.
Scudding clouds reflect in crystal waters,
Chickens and dogs cry out from huts with thatch.
Between Heaven and Earth emerges a great writing,
Which will stay whole after the fires of Qin die out.

NO. 29

*PEACH-BLOSSOM SPRING OF WULING*

Spring 1920

SHINYA Japanese Art & Design

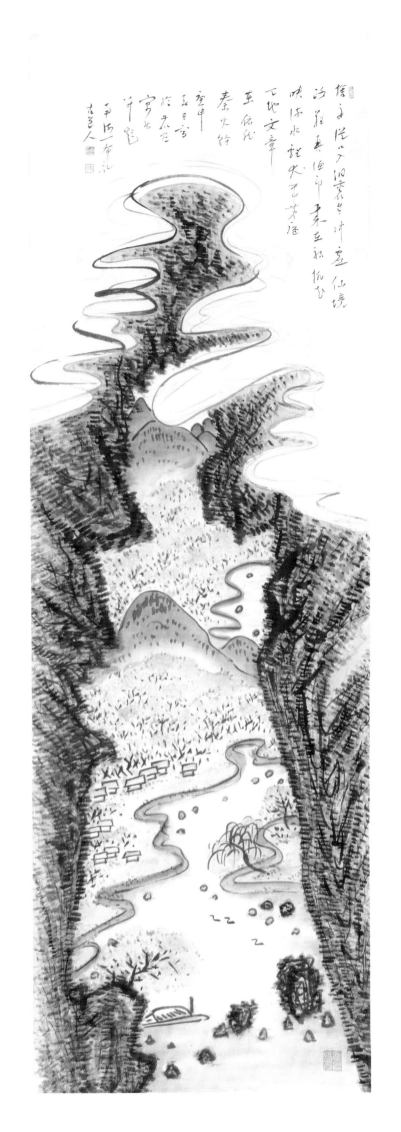

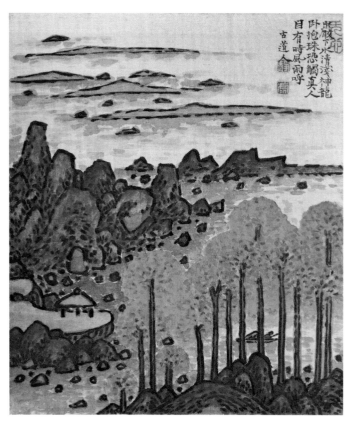 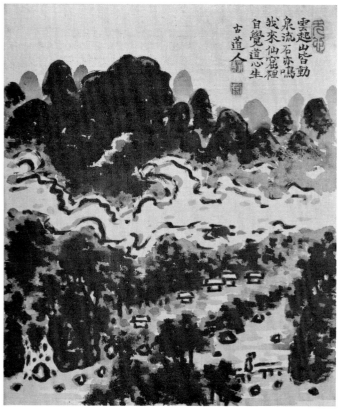

(A)

嚴下水清淺
神龍臥抱珠
恐觸眞人目
有時風雨呼

Beneath the cliffs, waters clear and shallow;
Here a divine dragon rests, clutching his pearl.
Afraid he might be spied by a True Man's eye,
At times he cries out for wind and rain.

(B)

雲起山皆動
泉流石亦鳴
我來仙窟裡
自覺道心生

Clouds arise, the mountains now all move!
Streams are flowing, the very stones sing out.
I have come to this grotto of the Immortals,
Feeling the mind of the Way arise in me.

NO. 30A–D

*PICTURES OF FOUR GENTLEMEN*

April 1920

Oni Zazen collection

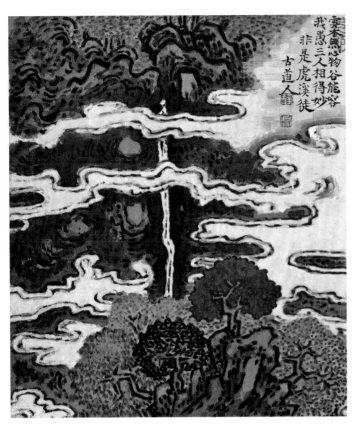 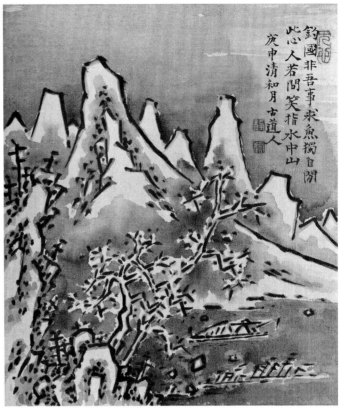

(C)

雲本無心物
谷能容我愚
三人相得妙
非是虎溪徒

Clouds are basically without a mind;

Valleys can accommodate my foolishness.

Should three men find these wonders together,

They are no true disciples of the men of Tiger Stream.

(D)

釣國非吾事
求魚独自閒
此心人若問
笑指水中山

To fish for a kingdom is not my affair;

Seeking fish I just relax alone.

If someone should inquire about this concept,

I will smile and point to mountain reflections in the stream.

# Branching Out, Growing Success, the 1920s

In January 1921, the second of Kodōjin's haiku anthologies, *Draft Poems by Kodōjin* (*Kodōjin eisō*), was published and in the following month the third anthology of Chinese poems, *Free and Easy Wandering Collection* (*Shōyōshū*). In addition to his poetry and painting, and at least from 1923 onward, Kodōjin joined with various craftspeople in composing poems and designs for their artworks. Such collaborations were firmly grounded in the literati tradition. They attest to Kodōjin's versatility and allowed him to expand his art practice and attract clients who would not necessarily be interested in acquiring a painting, a calligraphy, or even to add to their existing painting collections. An inscribed leaf-shaped bamboo tray for use in *sencha*, for example, pictures a snail by Kodōjin (fig. 5). It was produced in the autumn of 1924 by the Yamada Heiandō, a workshop that was established in Tokyo in 1919 and still in operation today. A set of two wooden tea caddies made a year earlier may also have been made by Yamada Heiandō (fig. 6).

Unfortunately, signed storage boxes have not survived for any of these objects, making it difficult to identify the craftspeople with whom Kodōjin worked. This is likewise the case for several porcelain *sake* cups, a stoneware teapot, a bamboo wrist rest, five small bamboo plates, and a stoneware inkstone, all today in private collections. We do know that the inkstone was made in 1935, evidence that Kodōjin continued these collaborations for more than a decade.

It was perhaps in August 1925 that Kodōjin moved again to a location in Shimokawarachō, some twelve minutes by foot from his former residence. In his paintings, he referred to it as the "Temporary Abode at the Eastern Mountains" (*Tōsan gūkyo*), a description that seems to have first appeared in late October and that he used at least thirteen times until June 1929. In early October, he traveled to Shingū for two weeks to pay his respects at the family graves and to enjoy the nearby Nachi Falls, which even today is one of the most popular scenic spots in Japan. While in Shingū he met the twenty-one-year-old Watase Ryōun (1904–80) and agreed to take him on as a painting student. Ryōun followed Kodōjin to Kyoto and initially lived with his teacher and his family. He would become an important source of information about Kodōjin's personal life. In the spring of 1926, Kodōjin returned to Wakayama Prefecture and visited his close friend Taiji Gorōsaku in Shintori in Wakayama city.

The vast majority of Kodōjin's paintings are oriented vertically (i.e., hanging scrolls), but on rare occasions he worked in horizontal formats, including wide compositions that would have been framed. This format was inspired by the horizontal handscroll, and Kodōjin mostly employed it for calligraphy works that were the names of rooms or buildings and mounted over doorways or under eaves. If these were hung outdoors, he painted directly on a wooden substrate. Landscape paintings in this format are unusual, with only two examples documented: *Solitary Journey of a Recluse* (1925; no. 36) and one with Mi Fu-style mountains (1926).

FIG. 5 *One-of-a-Kind Bamboo Root* (*Nedake itten*), autumn 1924, bamboo, 1⅛ × 10¾ × 7⅛ in. (2.9 × 27.3 × 18.1 cm), The Kura Art Gallery, Kyoto

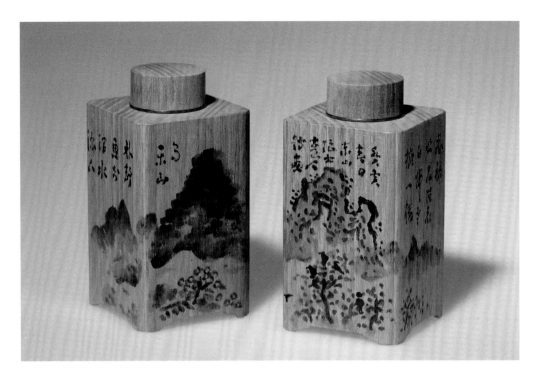

FIG. 6  Set of two tea caddies, summer 1923, wood and ink, 3¾ × 2 × 2 in. (9.5 × 5.1 × 5.1 cm), The Kura Art Gallery, Kyoto

*Solitary Journey of a Recluse* is the largest known horizontal landscape painting by Kodōjin.

In East Asia, there are several mountains and rock formations referred as the Bamboo Shoot Peaks (J: *Gyokujunpō*) because their cone-shaped peaks are likened to young bamboo shoots. The most famous is possibly Oksunbong in Jecheon city in present-day South Korea, but Kodōjin's *Picture of Gyokujunpō* (*Gyokujunpō zu*; no. 37) resembles Meshimori-iwa, a lesser-known Japanese Bamboo Shoot Peaks site in Kozagawa. The Meshimori-iwa was near the house of Kodōjin's younger sister Kō in Wakayama Prefecture. The seals on this undated painting point to a date between 1922 and 1932. He spent several weeks in this region in 1925–26, so it is likely that he visited Kozagawa and made this painting around that time.

*Picture of Gyokujunpō* is inscribed with a long text in standard script (J: *kaisho*), in which Kodōjin recalls reading the book *Jade Dew in the Crane Forest* (C: *Helin yulu*) written by the Southern Song scholar Luo Dajing (1196–after 1252). Dajing recounts a conversation with Zhao Jiren (dates unknown) about the significance of enjoying beautiful scenery as set out by the Southern Song

Neo-Confucian scholar Zhu Wengong (1130–1200). Kodōjin concurs in this text that it is equally important for him to indulge in nature, therefore fitting, he felt, that he should inscribe this passage on one of his landscape paintings.

Kodōjin had a deep admiration for several great Chinese poets who are celebrated even today. References are repeatedly found in his poetry, sometimes rephrasing well-known verses without mentioning a poet's name, as these would have been understood by the cognoscenti of Chinese art and culture drawn to Kodōjin's work. Perhaps an exception is seen in the landscape *Returning Sails and Colorful Tree* (no. 43) from the spring of 1926, on which he included a lengthy personal reflection of Tao Yuanming, Du Fu (712–70), and Li Bai (Li Bo/Li Taibai, 701–62). The motivation behind this annotation is unclear.

Plum blossoms are the theme of two of Kodōjin's landscapes from 1926 and 1927: *Landscape with Plum Forest* (no. 45) and *Boating on a Creek amid Plum Trees* (no. 46). *Landscape with Plum Forest* is an exceptional composition. In it, an impressive central mountain dominates the scene, with a rugged rock formation supporting countless plum trees—characteristically Kodōjin—pushing in

all directions, even upside down. Although undated, this work has a prose inscription that is almost identical to the hanging scroll *Plum-Blossom Library* (*Baika shōku*) in the collection of the Minneapolis Institute of Art (acc. no. 2013.29.382). The Minneapolis painting is dated to February 1926, and so it can be assumed that Kodōjin's *Landscape with Plum Forest* is roughly contemporary. The poem inscribed on *Boating on a Creek amid Plum Trees* makes note of "wandering free and easy," an allusion to the first chapter (C: *Xiaoyaoyou*) in the Daoist classic *Zhuangzi*. The last line in Kodōjin's work is a take on a section from the poem "Riverside Pavilion" (C: *Jiangting*) by Du Fu:

水流心不競
雲在意俱遲

*The water flows on,*
*The heart does not contend;*
*The clouds still here,*
*My thoughts just as slow.*

(translation by Stephen Owen)

衣食非不拙
憂道臥衡門
金錢非不貴
積善遺兒孫

Clothing, food? It is not that I am not clumsy,
But grieved at the world's ways, I rest behind my gate.
As for money, it is not that I am not rich,
But to accumulate goodness, I will leave it to my children.

NO. 31

*QUIET SETTING OF A MOUNTAIN CREEK*

c. 1921

Hakutakuan collection

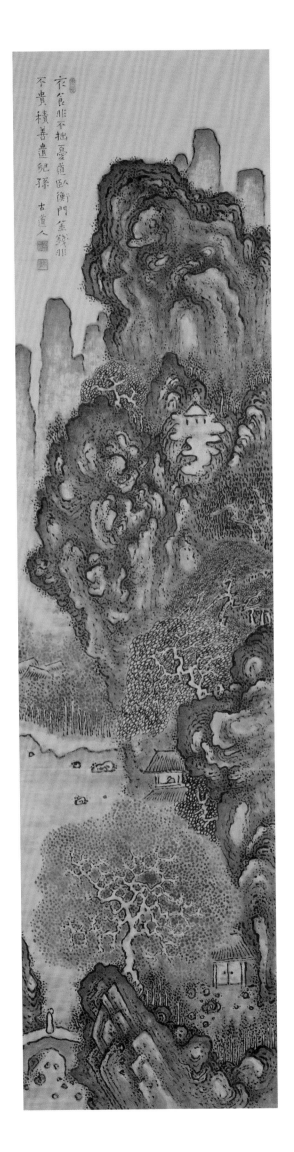

吾今老矣

何樂何憂

雖曰未死

人事☒休

采藥飲水

慕彼丹丘

俯仰永嘆

欲去旦留

河嶽流峙

日月懸頭

茫茫宇宙

獨與化遊

Now I have grown old;

What joy have I, what grief?

Though you say, "You are not yet dead!"

I am done with human affairs.

Gathering herbs, drinking from streams,

I admire cinnabar hills of Immortals.

Look down, look up—sighing long,

I want to leave, but yet I linger.

Rivers and Fuji—they flow, it surges,

While sun and moon hang up above.

Vast, so vast the universe!

Alone I move with Transformation.

NO. 32

*CLIFFS AND BIZARRE ROCKS*

April 1922

The Metropolitan Museum of Art,
Gift of Gitter-Yelen collection, 2009
(2009.510)

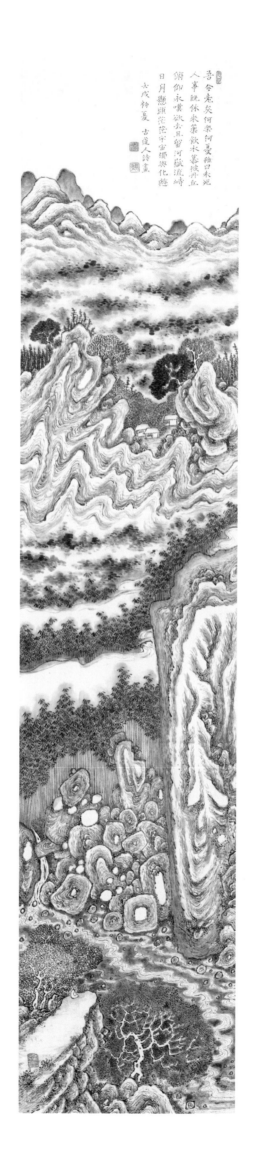

吾今老矣何樂何憂何憂雄日未延
人事既休來業欲水慕被丹丘
俯伽永嘆欲去且留河嶽流峙
日月懸頭茫茫宇宙舆化遊
壬戌初夏 古道人詩畫

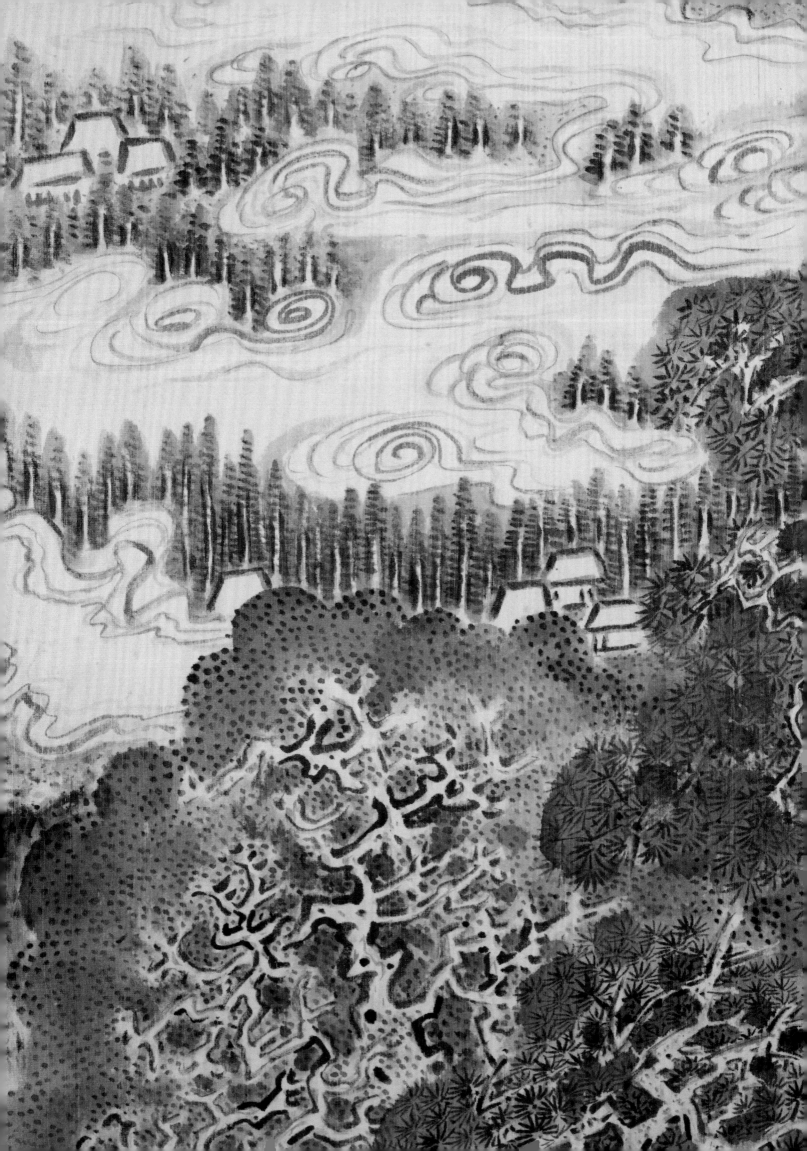

人皆曰吾老

我豈徒守愚

讀書不甚解

求道與誰俱

自古天下士

却作布衣徒

悠然獨養志

寄跡泉石區

People all say I must be getting old,

But maybe I have been cultivating this stupidity!

I read books, but do not know how to interpret them;

I seek the Way, but have one to share with.

From ancient times, truly world-class scholars

Have been followers of the Way of Simple Clothes.

Trancelike, alone I nurture my intentions;

Visitors, please note this "region of streams and rocks."

NO. 33

*FISHING ALONE IN A PURE CREEK*

Spring 1924

Minneapolis Institute of Art,
Gift of the Clark Center for Japanese Art & Culture
(2013.29.840)

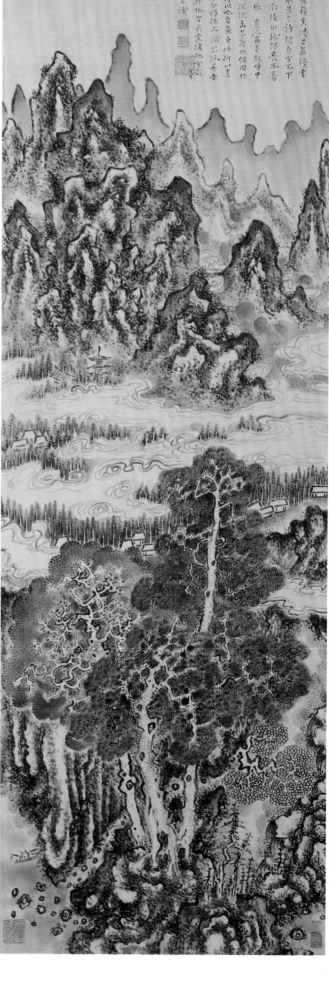

南山春有瑞
秀色照人顔
日出蒼松上
雲興白石間
無疆同聖壽
獨立護仙關
萬古塞天地
高高不可攀

On the Southern Mountains, spring shows many omens:

Rich verdancy illuminates men's faces.

The sun now rises over gray-green pines,

And clouds emerge from among white rocks.

Illimitable, sharing longevity with our emperor;

Standing alone, protecting the gates of the Immortals.

For ten thousand eras, defending Heaven and Earth,

High, so high, you cannot climb up there!

NO. 34

*SECLUSION DEEP IN THE MOUNTAINS*

c. 1922–37

Oni Zazen collection

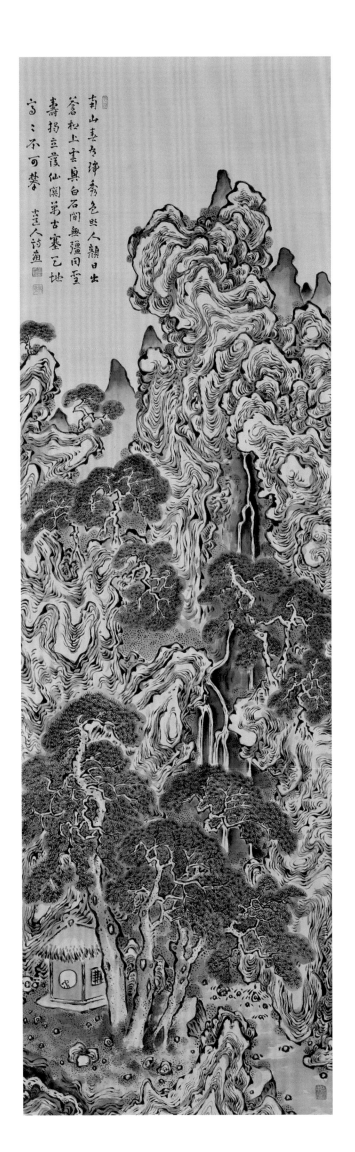

維嶽三州青未了
陰晴屢變走雷霆
雲煙決渳壓平麓
日月動揺離大溟
半夜高寒明帝座
千年獨立表神靈
温容如玉使人敬
君子國中留典型

Sacred peak—three provinces—
The green goes on forever;
Dark or clear, through several changes
Roll the thunder bolts.
Clouds and mist so vast and wide,
Press on the foothill plains,
Sun and moon move on and on,
Departing from the great expanse.
At midnight, high and cold,
Our brilliant Monarch's throne;
For thousands of years, standing alone,
Manifesting divine intelligence.
His glowing face like jade
Causes men to feel reverence:
True gentlemen bequeath to their land
Model works as classics.

NO. 35

*FUJI ABOVE THE CLOUDS*

October 1925

The Kura Art Gallery, Kyoto

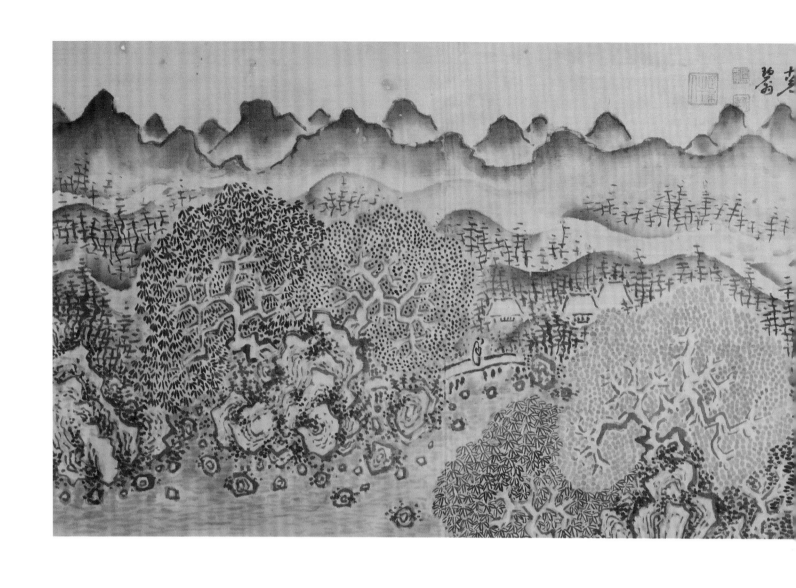

NO. 36

*SOLITARY JOURNEY OF A RECLUSE*

October 1925

Minneapolis Institute of Art,
Anonymous gift in honor of Gordon Brodfuehrer
(2017.144.3)

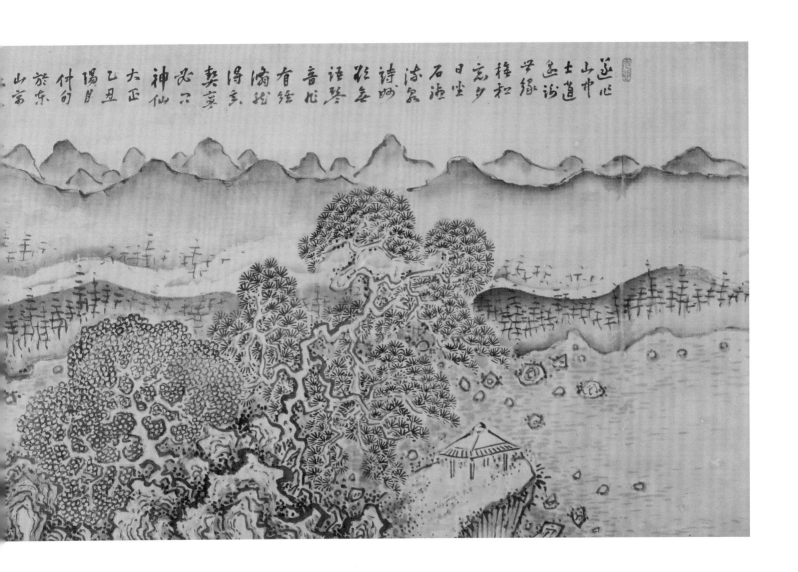

遂作山中士　　And so I have become a mountain-dwelling scholar,

道遙謝世緣　　Wandering freely, having renounced worldly karma.

撫松忘夕日　　Caressing a pine tree, I forget the westering sun,

坐石聽清泉　　Sitting on a rock, listen to the pure stream.

詩妙欲無語　　I want my poems so subtle that they lack words,

琴音非有絃　　My lute playing so fine it is as if I used no strings.

脩然得真契　　Joyfully I have grasped true integration:

寧必問神仙　　What need to query the Spirits and Immortals?

偶閱鶴林玉露,觀山水條曰 "趙季仁謂余曰 '某平生有三願;一願識盡世間好人;二願讀盡世間好書;三願看盡世間好山水.' 余曰 '盡則安能? 但力到處莫放過耳.' 季仁因言 '朱文公每經行處聞有佳山水雖迂塗數十里必徃遊焉.携樽酒一古銀盃大幾容半外,時引一盃登覽,竟日未嘗厭倦.又嘗欲以木作華夷圖,刻山水凹凸之勢;合木八片爲之,以雌雄筍相入,可以折度一人之力足以負之.每出則以自隨,後竟未能成.余因言 '夫子亦嗜山水如智者樂水仁者樂山.固自可見如子在川上與夫登東山而小魯,登泰山而小天下,尤可見大抵登山臨水足以觸發道機,開豁心志,爲益不少.' 季仁曰 '觀山水亦如讀書,隨其見趣之高下.'"此篇頗得吾意,書以題自畫,不亦可乎!

NO. 37

*PICTURE OF GYOKUJUNPŌ*

c. 1925–26

Oni Zazen collection

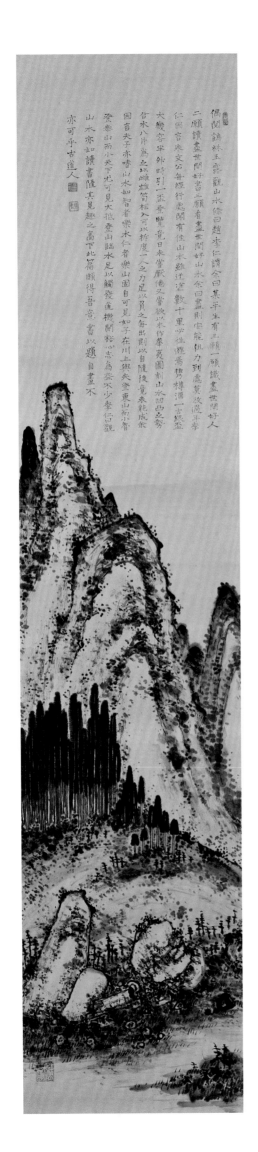

偶閱鶴林玉露觀山水儵曰趙李仁讀余曰某平生有三願一願識盡世閒好人
二願讀盡世閒好書三願看盡世閒好山水余曰盡則宏儘力到處莫放過半季
仁因言朱文公每經行處閒有住山水雖迂逵數十里必往歟携樽酒一古銀盃
大畧奇半外時引一盃者縱飲厭倦又嘗彼以米作奉英圖割山水凹凸之勢
皆水八片萬之以峯筒相入可折度一人之力足以舉之每此則以自隨後覺束能成余
因言夫子亦嗜山水如智者樂水仁者樂山圈自可見如子在川上與夫登束山祈小魯
登泰山而小天下尤可見大抵登山臨水足以觸發道機閒豁志意為益不少拳伯觀
山水亦如讀書隨其見趣之高下此篇頗得吾意書以題自畫畫不
亦可乎古道人

筆端存造化

一幅直千金

自濕雲煙氣

若聽山水音

未成歸隱計

聊寫臥遊心

是我幽居趣

應從畫裏尋

The tip of my brush has Creator's Power,

So a single scroll is worth a thousand pieces of gold!

When moistened with vapors of cloud and mist,

It is like hearing the sounds of stream and mountain.

Since I have not carried out my plan of hermitage,

I just use this to show my "armchair wanderer's" heart.

And thus my joy of living in retirement

Must be sought here, inside this painting.

NO. 38

*EXCURSION IN CLOUDY MOUNTAINS*

C. 1922–32

Minneapolis Institute of Art,
Gift of David Tausig Frank and Kazukuni Sugiyama
(2015.111.1)

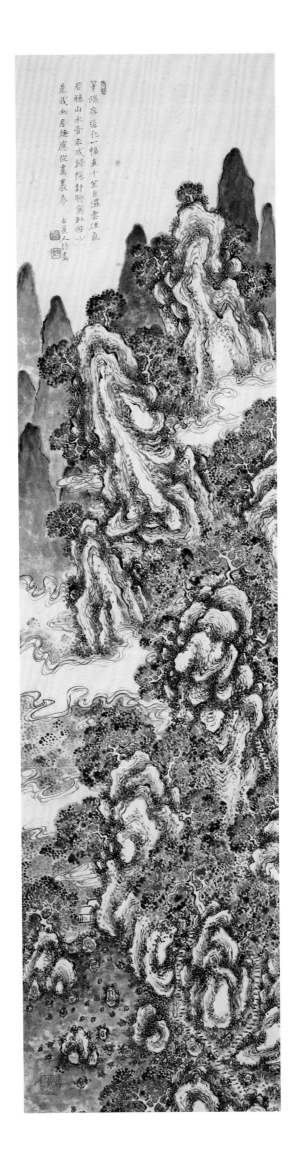

真人本無位
樂道不求名
白日逍遥足
天地一心清
常服煙霞気
浩然仙骨輕
苟能得乘化
可以悟無生
神龍洞中老
時復卷雲行

The "True Man" basically has no fixed place;

He joys in the Way and does not seek for fame.

In broad daylight, he wanders free and easy,

Unified mind all pure between Heaven and Earth.

Regularly he imbibes the ether of the mists,

Transcendently his immortal bones turn light.

And if he can ride on Transformation,

He may gain enlightenment about the Unborn.

A divine dragon, aging in his cave,

From time to time twirling up among the clouds.

NO. 39

*ONE THOUSAND MOUNTAINS AND TEN THOUSAND RAVINES*

c. 1922–32

Minneapolis Institute of Art,
Gift of Willard G. Clark
(2017.145.6)

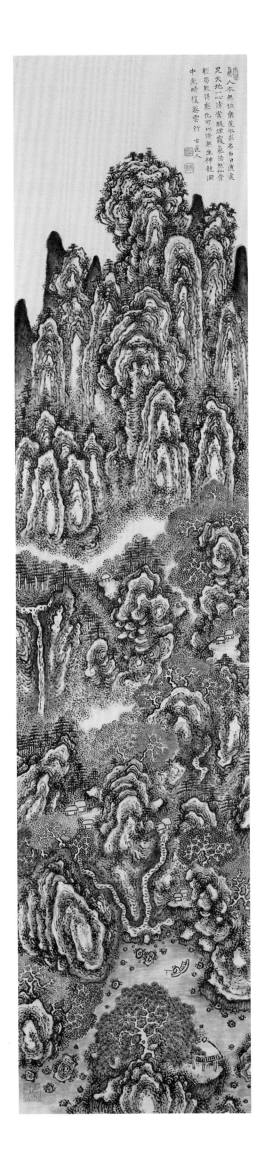

我老猶頑健

山中獨客身

貧居唯有隱

古道余自虛

月落帰何處

花開不侍人

靜觀玄妙理

聊此樂天空

I am aging, but still strong,

A dweller in the mountains, all alone.

Living poor: for me, there's just seclusion;

I have emptied myself through the ancient Way.

The moon sets—where does it go to?

Flowers open, but not to please us people.

Serene, I contemplate the wondrous Principle;

And just this way, take joy in Heaven's void.

NO. 40

*LANDSCAPE WITH LAYERED PEAKS*

c. 1925–29

Hakutakuan collection

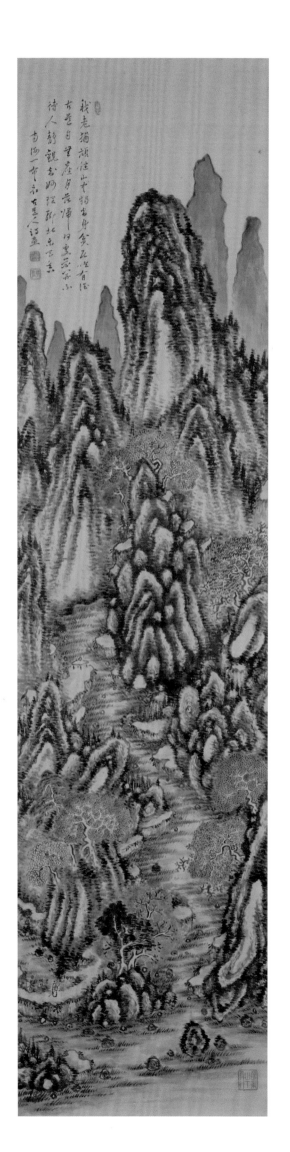

145

南山種緑竹
猗々見古心
日出鳳來舞
君子云皷琴
延詠如有得
何必待知音

At Southern Mountain I have planted green bamboo,
Elegantly displaying the heart of antiquity.
The sun rises—the phoenix comes to dance;
The gentleman will now play his lute.
He extends his chanting, as if quite content:
What need to find one who "knows his music"?

NO. 41

*BAMBOO FOREST LANDSCAPE*

c. 1925–29

Oni Zazen collection

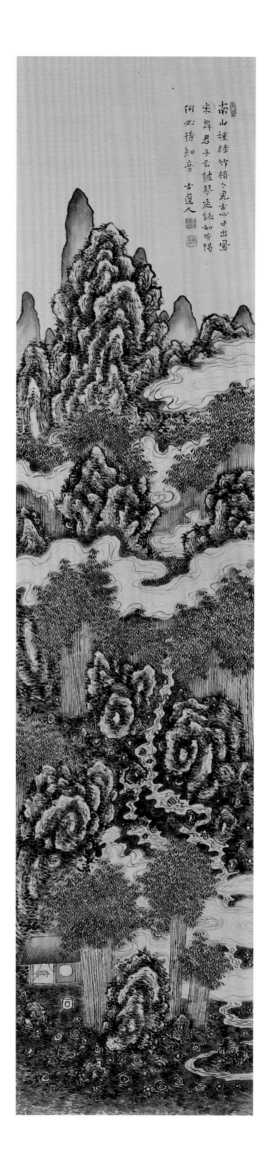

147

風月誰為主
河濱独結廬
任他生計拙
舜亦学陶漁

Wind and moon—who is their master?
By riverside alone I have built my hut.
So what if my plan for life is clumsy?
Even Shun made pottery and fished.

NO. 42

*WIND AND MOON BY THE RIVERSIDE*

c. 1922–24

Minneapolis Institute of Art,
Gift of the Clark Center for Japanese Art & Culture
(2013.29.968)

自古、士之閒居野處者必有同道同志之士相與往還、故有以自樂。陶淵明移居詩云"昔欲居南村　非爲卜其宅。聞多素心人　樂與數晨夕。"又云"隣曲時時來　抗言談在昔。奇文共欣賞　疑義相與折。"則南村之隣豈庸々之士哉！杜少陵在錦里亦與南隣朱山人往還、其詩云"錦里先生烏角巾　園收芋栗不全貧。慣看賓客兒童喜　得食階除鳥雀馴。秋水纔深四五尺　野航恰受兩三人。白沙翠竹江村暮　相送柴門月色新。"又云"相近竹參差　相過人不知。幽花欹滿樹　小水細通池。歸客村非遠　殘尊席更移。看君多道氣　從此數追隨。"所謂朱山人者固亦非常流矣。李太白尋魯城北范居士誤落蒼耳中、詩云"忽憶范野人　閒園養幽婆。"又云"還傾四五酌　自詠猛虎詞。近作十日歡　遠為千歲期。風流自簸蕩　詭浪偏相宜。"想范野人者固亦可人之流也。

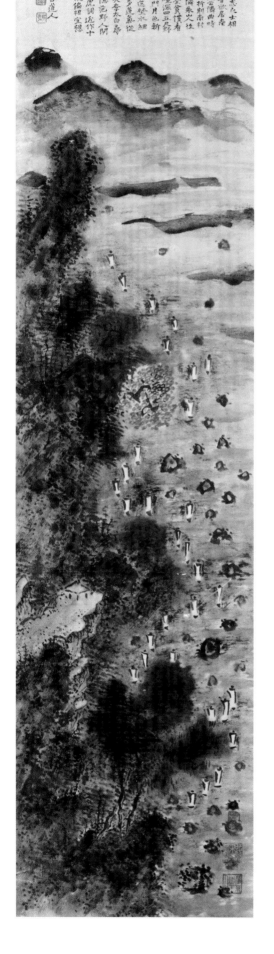

NO. 43

*RETURNING SAILS AND COLORFUL TREE*

Spring 1926

Seattle Art Museum, Gift of Griffith and Patricia Way,
in honor of the 75th Anniversary of the Seattle Art Museum
(2010.41.47)

From ancient times, those scholars residing at leisure in rustic spots would have friends sharing their Way and their will with whom they could associate, thus gaining in their happiness. Tao Yuanming, in his "Poems on Moving my Residence," says,

"In the past, wishing to live in the southern village, I did not bother to 'divine' the place. Instead, I inquired about men of pure heart, and then enjoyed spending many days and nights with them."

And again, "Hidden neighbors would regularly come around, And in frank words we would discuss the past. Remarkable writings together we would enjoy, together cracking the toughest passages."

Thus, how could his neighbors at the southern village have been commonplace men?

Du Fu, when at Jinli, also visited back and forth with his southern neighbor, Mountain Man Zhu. In his poems on this, he writes:

"This gentleman of Jinli with his bird's-beak cap, Garden provided with yams and chestnuts—not completely poor! Accustomed to see this visitors, his sons greet me with joy, and the sparrows, able to eat beneath the porch steps, are fully tamed. The autumn waters are just 4 or 5 feet deep, The rustic skiff accommodates just two people, or three. White sand, blue-green bamboo, at evening from this river-village He sees me off at his bramble gate as moon colors return."

And again, "Still together, bamboo makes zigzag patterns; now passed far off, beyond each other's ken. Hidden flowers lean down, filling the trees; A little creek so fine leads to a pool. This home-bound visitor's village is not far; leftover wine cups he must be removing once again. I see you, sir, are full of the spirit of the Way: from now on, I will often pursue your company. The so-called Mountain Man Zhu for certain was no ordinary fellow! Li Bai, when seeking out Layman Fan to the north of Lu City by mistake got lost in a patch of xanthium. His poem says: 'Suddenly I forgot all about Rustic Dweller Fan, In his leisure garden caring for his hermit wife.'"

And again, "Again we pour out four or five rounds, And sing together the 'Poem on the Fierce Tiger.' For now, we enjoy ten days of happiness; In the distant future, we have a date for a thousand years ahead. Romantic spirit, ebullient by nature, fantastic waves suit you to a tee."

We can imagine that Rustic Man Fan also was clearly a member of the cohort of men you can get along with!

巨石頑然立
其高過丈餘
上生無菓樹
下有碩人居
飲水忘飢渴
看雲任卷舒
道心深不測
白日讀仙書

A vast rock boldly stands,

Its height much greater than 10 feet.

On it grow trees that bear no fruit;

Below resides a man of character.

Drinking from the stream,

He forgets hunger and thirst,

He watches the clouds,

Just lets them curl and unfold.

The Mind of the Way is deep and hard to fathom:

In broad daylight he reads books of the Immortals.

NO. 44

*WHITE CLOUDS EMERGING FROM THE MOUNTAINS*

c. 1921–30

Private collection

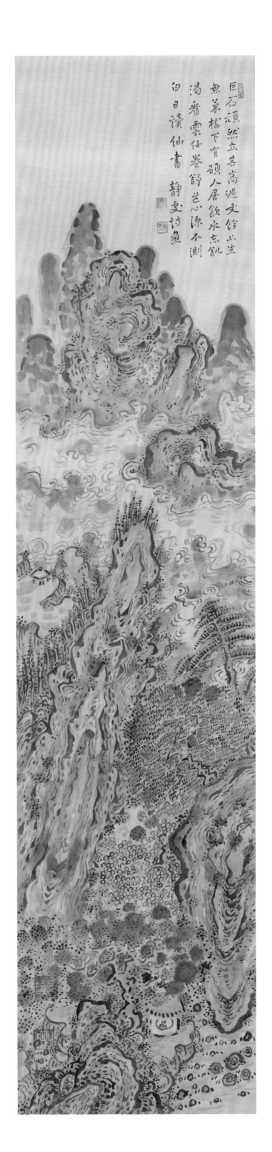

巨石頑然立其高過丈餘山生
無苔橋下有頑人居飲水忘飢
渴看雲任卷舒芭心源不測
白日讀仙書　靜雯詩畫

153

繞屋吹梅花
春風興有餘
古香流几席
春意滿琴書
樂道耽山水
忘機友鳥魚
此中聊自得
終日無塵語

All round my house, blowing plum petals,

The spring winds are so full of spirit!

Ancient fragrance wafts over desk and mat,

Springtime feeling overflows lute and books.

Enjoying the Way, I relax with mountains, rivers;

Forgetting machination, befriend the birds and fish.

In all of this for now I find my true self:

All day long, not one word of dusty speech.

NO. 45

*LANDSCAPE WITH PLUM FOREST*

c. 1926

Stuart Katz collection

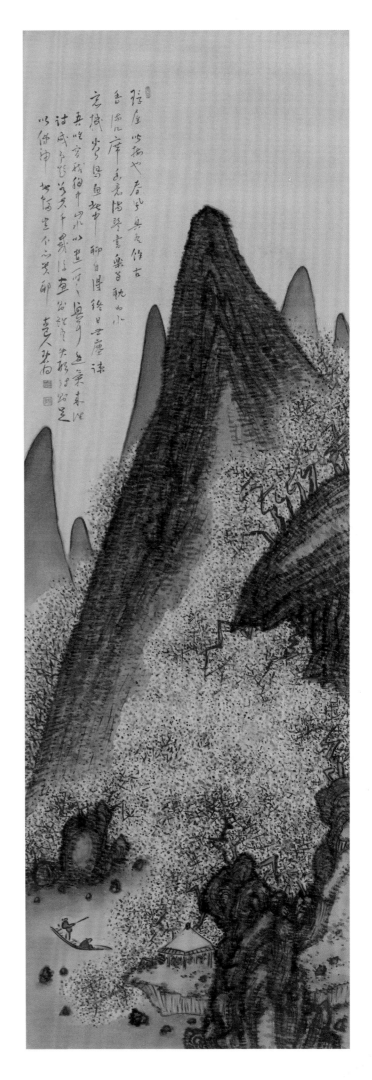

獨賦詩兮独皷琴
高風千載少知音
是吾平日逍遥處
雲在水流無競心

Alone, I write poems, Ah! Alone I play the *qin*;
This noble tune, a thousand years old,
But few have known the music!
This is the place on ordinary days I wander free and easy:
Clouds above, the water flowing, no contentious heart.

NO. 46

*BOATING ON A CREEK AMID PLUM TREES*

June 1927

Harvard Art Museum,
Promised gift of Robert S. and Betsy G. Feinberg
(FEIN.168)

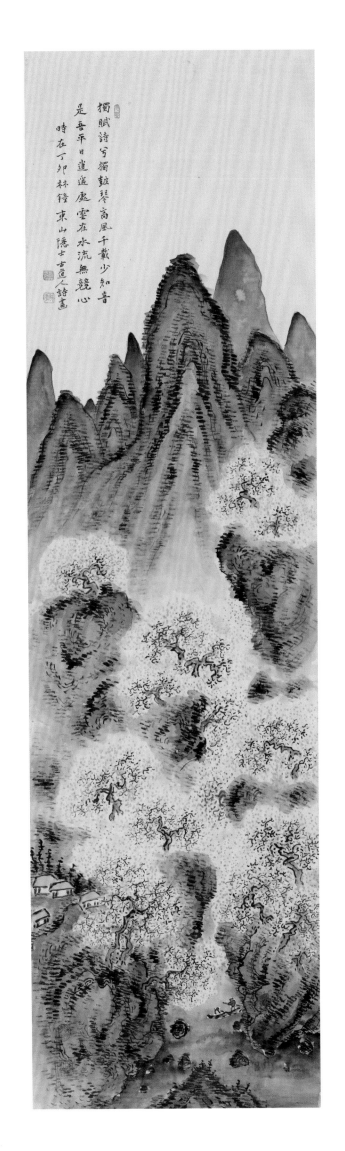

獨賦詩寫獨鼓琴高風千載少知音
是吾平日道道處雲在水流無競心
時在丁卯林鐘東山隱士古道人詩畫

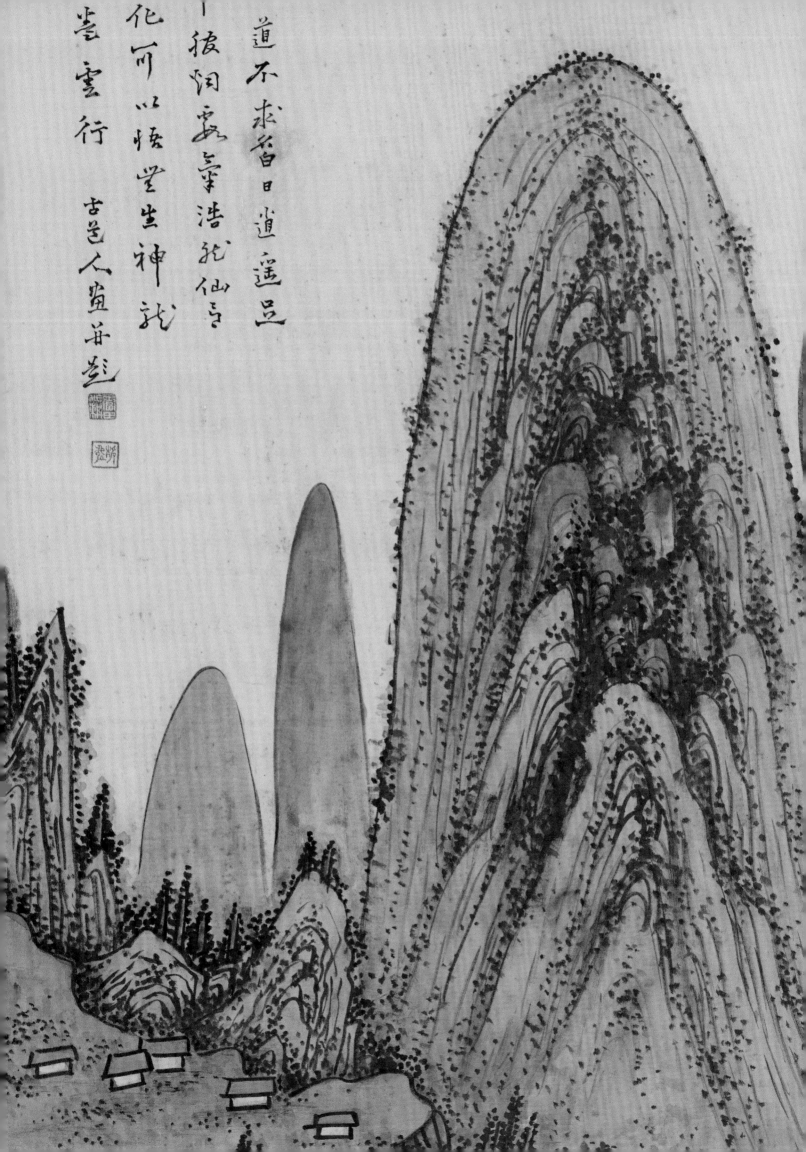

真人本無位

樂道不求名

白日逍遥足

天地一心清

常服煙霞気

浩然仙骨輕

苟能得乘化

可以悟無生

神龍洞中老

時復卷雲行

The "True Man" basically has no fixed place;

He joys in the Way and does not seek for fame.

In broad daylight, he wanders free and easy,

Unified mind all pure between Heaven and Earth.

Regularly he imbibes the ether of the mists,

Transcendently his immortal bones turn light.

And if he can ride on Transformation,

He may gain enlightenment about the Unborn.

A divine dragon, aging in his cave,

From time to time twirling up among the clouds.

NO. 47

*RED TREE IN VERDANT MOUNTAINS*

c. 1921–30

Freer Gallery of Art, Smithsonian Institution, Washington DC:
The Mary and Cheney Cowles collection,
Gift of Mary and Cheney Cowles (F2019.3.4a-d)

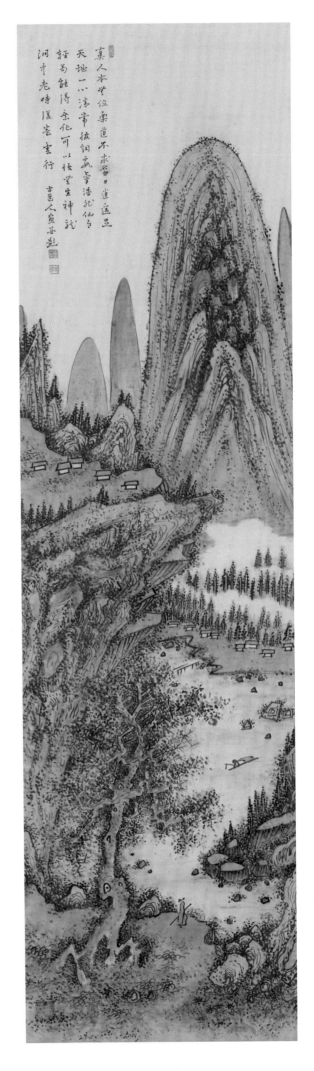

野外逢晴日
人生樂出遊
欣欣草木秀
涓涓春水流
山色自蒼翠
細雨潤平疇
農家將有事
處處雞犬幽
良辰本如此
携酒復何求

Out in the wilds I meet the clear day—
In human life, all take joy in wandering!
Full of happiness, trees and flora flourish;
Gurgling along, springtime waters flow.
Mountain colors, naturally bluish-green;
Fine rains moisten the level farms.
The farmers soon will have work to do:
Everywhere, chickens and dogs seem hidden.
Fine times basically are like this:
Jug of wine in hand, what more would you seek?

No. 48

*LANDSCAPE WITH RICE FIELDS*

Spring 1923

Private collection

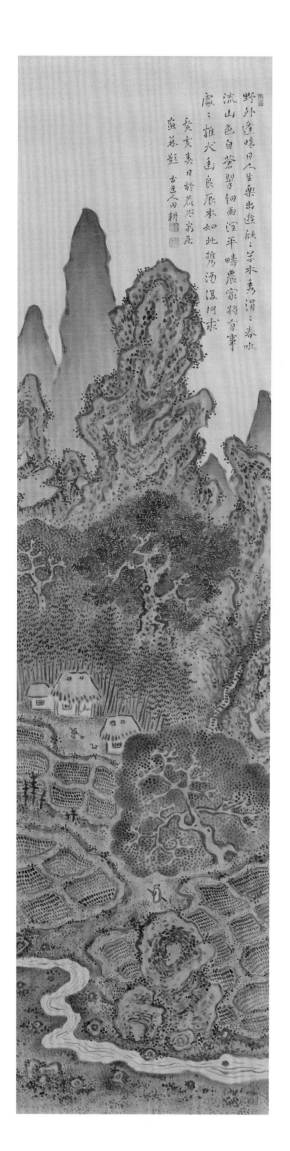

嚴宇非工匠
雲構慕神仙
登臨復長嘯
霊籟出蒼煙
鬱々松柏色
気象令人遷
良禽集其下
自得樂天然
我亦欲嘉遯
但恐塵緑牽
皎日照衣装
行々見寒泉

This realm of cliffs was never carved,
This structure of clouds—admire the gods!
I climb and look and whistle out loud;
Magical echoes emerge from green mist!
Thick, thick the colors of pine and cypress:
The air here entices men to move!
Fine birds too are flocking down below,
Finding a natural enjoyment for themselves.
I also wish to find serene seclusion,
But I am afraid the dust will pull me back!
The brilliant sun shining on my shirt and robe—
On and on, I seek the crystal spring.

NO. 49

*EXCURSION UNDER PINE TREES*

Summer 1927

Oni Zazen collection

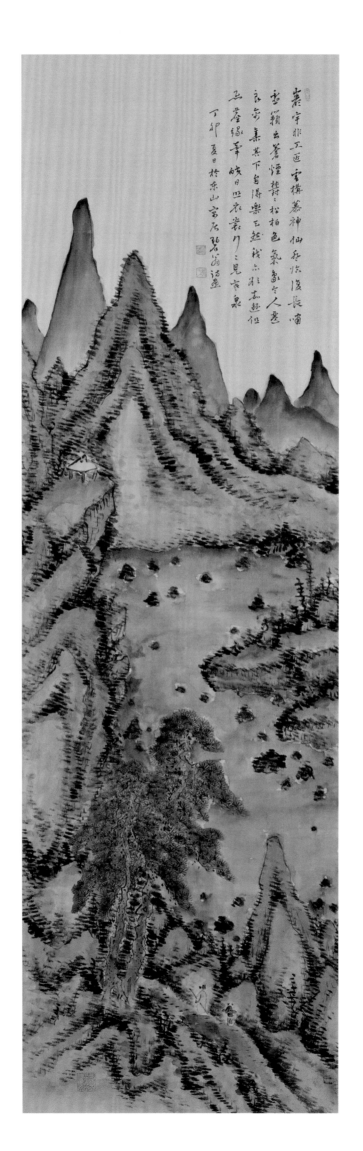

我來先撫掌
客至亦怡顔
此地頗幽邃
白雲隔世寰
遂為林下士
悠然獨見山
問余笑不答
天地与心閑

I have come here, first to caress pines with my hands;
Guests arrive and that too brings joy to my face.
This place is mysterious, remote,
White clouds cutting off the worldly realm.
And so I have become a scholar beneath the trees,
In a daze, alone, gazing at mountains.
You ask me, Why? I smile and do not answer:
With Heaven and Earth my mind too is at peace.

NO. 50

*RETIRING FROM THE WORLD AT A MOUNTAIN CREEK*

c. 1922–40

Oni Zazen collection

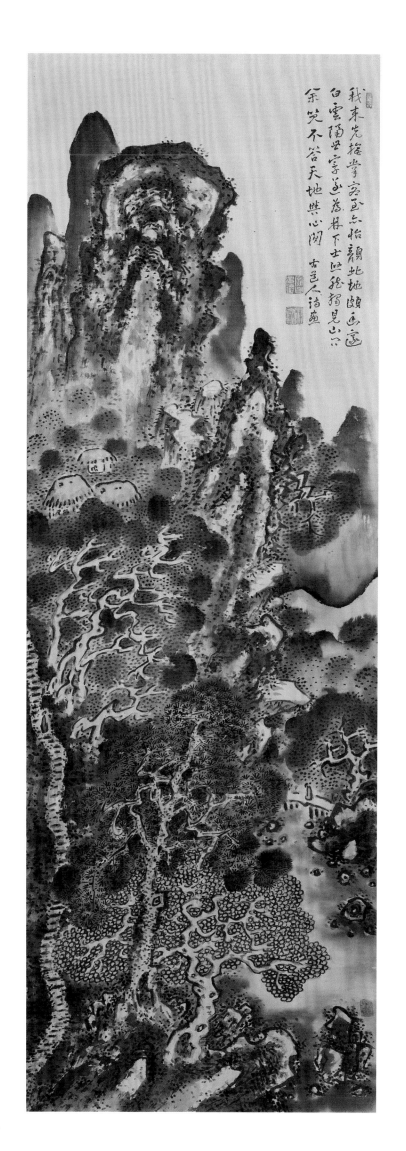

WITHERED
TREES
AND AN
ABUNDANCE
OF
SPRING,
1927

FUSEHARA TOSHIZŌ, the owner of the scroll mounting shop Shunpōdō (est. 1856) in Kyoto's Nakagyō ward, together with his son Keiichirō, issued Kodōjin's painting catalogue *Withered Trees and an Abundance of Spring* (*Koboku yoshun*) on March 8, 1927. It accompanied an exhibition held at the Kyoto Art Club (Kyōto Bijutsu Kurabu) on March 9–10. There are no records to suggest that Kodōjin had an exhibition of his paintings during the eight years following the 1919 show at Heian Gabō. *Withered Trees and an Abundance of Spring* therefore marked a pivotal moment in his painting career.

The exhibition prospectus hailed Kodōjin as one of the great masters of *nanga* painting, an individual who relishes his life of poverty (*seihin*) and as a hermit (*sennin*). For that reason, it claimed, few would know about his recent artworks (Matsumoto 2004, p. 94). The introduction to the 1919 exhibition catalogue already described him as such, but instead used *hinkyū* for "poverty" and *senkotsu* for "hermit." In his monograph on Kodōjin, Stephen Addiss repeatedly (and perhaps misleadingly) portrayed Kodōjin as an impoverished figure and an aloof scholar leading a subsistence existence devoted to poetry and painting.

*Seihin*, however, connotes a sense of "voluntary and honorable poverty," a philosophical tenet that in actual fact has no connection to real life. It conveys the notion of a simple and frugal life, one not desirous of worldly wealth and materialism. Kodōjin revered the Zen monk Ryōkan (1785–1831), who embodied the notion of *seihin* by living a solitary life in a small hut on Mount Kugami in Niigata Prefecture.

Living in such voluntary poverty was considered virtuous, and Kodōjin's striving for this goal profoundly impressed his admirers. Although we might interpret this kind of idealism as principled, we should perhaps step back and reappraise it within the context of the artist's life. Kodōjin earned his living from selling his poetry and paintings, and it would have been beneficial for him to fashion an image of an artist seeking higher values associated with celebrated masters of the past. Like most, if not all professional artists, Kodōjin consciously crafted a public persona that served his own ends. In reality, he had a family with four children, traveled constantly through Japan, and enjoyed drinking. He was very prolific, selling hundreds of paintings and calligraphies over the more than forty years of his career.

*Withered Trees and an Abundance of Spring* illustrates thirty-one paintings and four calligraphies, listing the title and medium of each work. All were sold with signed boxes by the artist. The oldest work is dated July 1926. Some paintings, such as *Withered Trees and Winter Crows* (no. 51), are dated to the spring of 1927. In that spring in Japan traditionally runs from January to March, he must have painted them sometime during these months. This suggests that Kodōjin finished these pieces shortly before the deadline set to send the manuscript to the printer. Given that half of the publication's title—*Withered Trees*—is the same as the title of this painting, it is quite possible that a strong correlation exists between the two and that Kodōjin assigned this painting a special significance. The subject of *Withered*

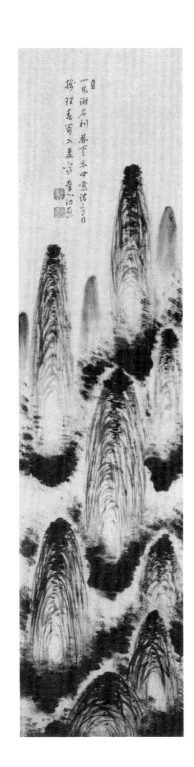

*Trees and Winter Crows* (C: *han ya kumu*, J: *kan'a koboku*) was already known in Chinese painting during the Yuan dynasty (1271–1368), but it never became as popular there as in Japan.

A noteworthy and unusual piece in *Withered Trees* and indeed in Kodōjin's entire corpus of work is *Bamboo in Snow* (no. 52), in which the bamboo is painted in red ink and set against a background that is inconsistently washed with black ink and inscribed with a brief four-character verse. Bamboo was a frequent motif in Kodōjin's oeuvre. There are at least six other paintings of bamboo depicted with red ink, but this is the only example with a black background, hinting at a nocturnal scene.

Of the thirty-five works recorded in *Withered Trees and an Abundance of Spring*, only six have been located. The whereabouts are unknown, for example, of *Bamboo Shoot Peaks* (*Gyokujunpō*), an innovative fantasy landscape executed without outlines in what is described as the "boneless" technique (C: *mogu*, J: *mokkō*; fig. 7). Heian Gabō's pamphlet *Poems and Paintings by Kodōjin* did not list any of his *haiga* (paintings with haiku), but pieces such as *Sponge Gourds* (no. 53) are included in *Withered Trees*.

FIG. 7  *Bamboo Shoot Peaks*
(*Gyokujunpō*), c. 1927, hanging
scroll, whereabouts unknown

人皆曰吾老
我豈徒守愚
讀書不甚解
求道與誰俱
自古天下士
却作布衣徒
悠然獨養志
寄跡泉石區

People all say I must be getting old,

But maybe I have been cultivating this stupidity!

I read books, but do not know how to interpret them;

I seek the Way, but have one to share with.

From ancient times, truly world-class scholars

Have been followers of the Way of Simple Clothes.

Trancelike, alone I nurture my intentions;

Visitors, please note this "region of streams and rocks."

NO. 51

*WITHERED TREES AND WINTER CROWS*

Spring 1927

Harvard Art Museum,
Promised gift of Robert S. and Betsy G. Feinberg
(FEIN.169)

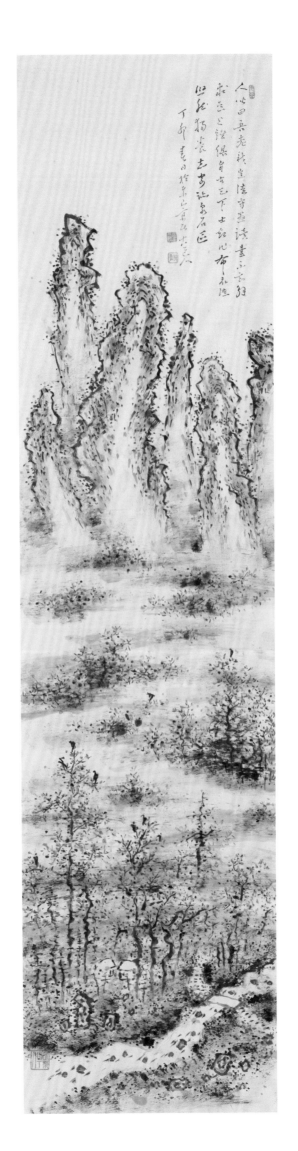

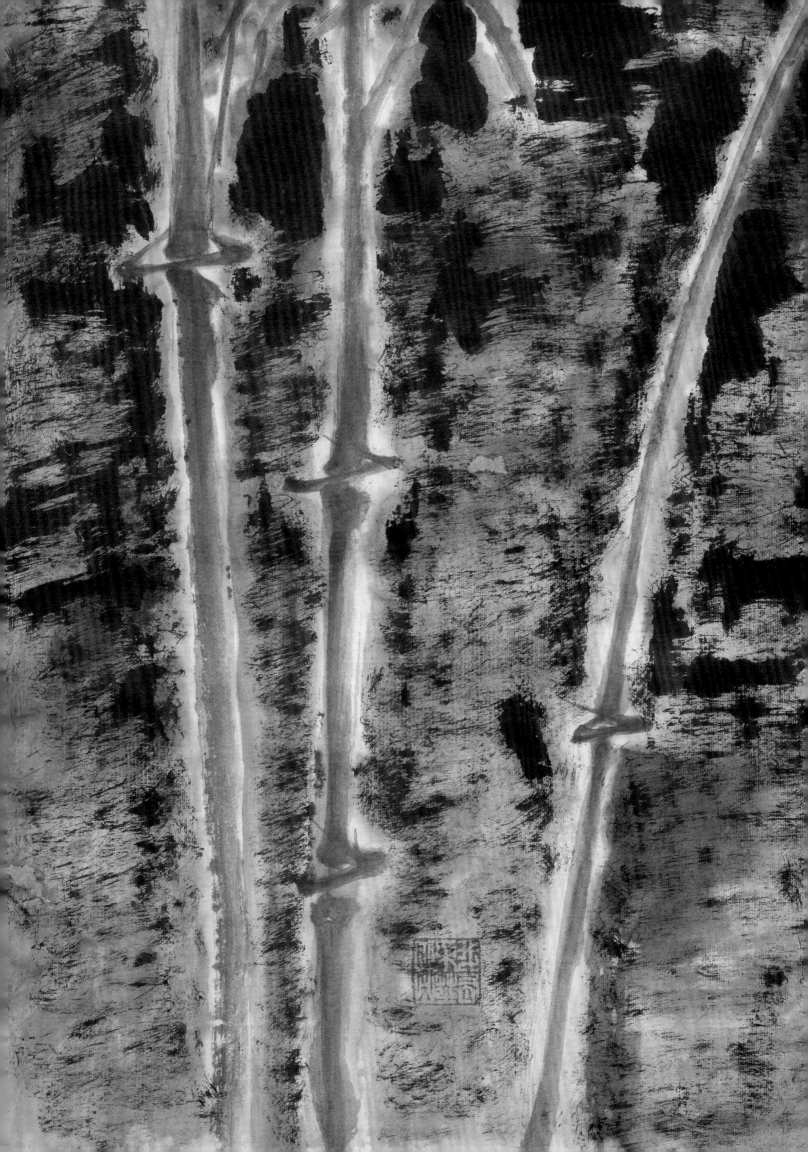

衣錦尚絅

Wearing silk, yet displaying plain cloth.

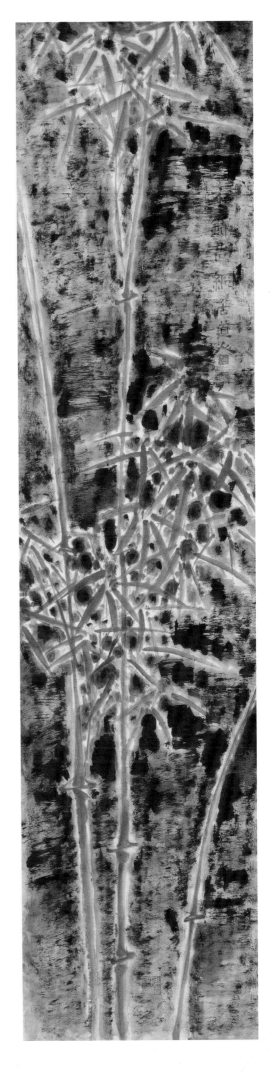

NO. 52

*BAMBOO IN SNOW*

c. 1927

Minneapolis Institute of Art,
Gift of David Tausig Frank and Kazukuni Sugiyama
(2015.111.24)

世の中を
愚にしてか〃る
絲瓜哉

In this world
Hanging foolishly,
Gourds.

NO. 53

*SPONGE GOURDS*

c. 1927

Bachmann Eckenstein Japanese Art,
Switzerland

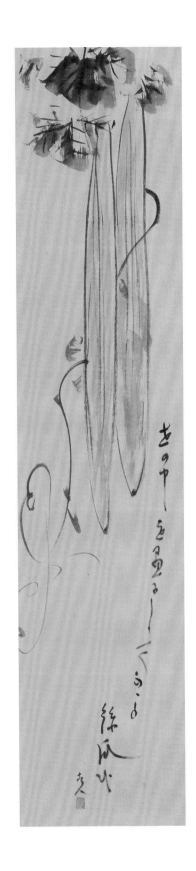

# LUXURY

# IN

# BLUE-GREEN

LANDSCAPES RENDERED in blue-green are Kodōjin's most detailed and most sumptuous paintings. During his lifetime, and even today, they attract the highest prices and are greatly sought after. This can be explained by the fact that these painstakingly executed works took longer to produce and were done with expensive natural pigments: ground malachite (*rokushō*) for the green and azurite (*gunjō*) for the blue. These rich colors intensify the tonalities to create a lush appearance and a shimmering surface effect. They also account for the steep prices of these works, particularly when compared with his regular color landscapes, as Kodōjin needed to recuperate his investment costs of the materials.

In China, the tradition of blue-green (C: *qinglu*) landscape painting was well established by the Tang dynasty (618–907), and it underwent a revival in the late Ming dynasty (1368–1644) by painters such as Qiu Ying (c. 1494–1552; fig. 8). More than just distinctly colored representations of the natural world, these blue-green paintings were associated

with magical properties because malachite and azurite were additionally used in the alchemical search for the elixir of immortality. The employment of the pigments produced from them in Japan dates to the seventh century. Japan not only imported these stones from China but also sourced them locally (FitzHugh 2003, pp. 15, 18).

Apart from one leaf in his 1918 *Album of Colored Clouds*, Kodōjin produced at least five hanging scrolls between 1921 and 1932 that fall into this category of blue-green (J: *seiryoku*) works. Four are explicitly titled *Blue-Green Landscape* (*Seiryoku sansui*). Although these works are all bright blue-green landscapes, Kodōjin made use of this color palette in his landscapes as early as 1901 and 1907, albeit not as lavishly or vibrantly (no. 2, 9).

The *Blue-Green Landscape* from the spring of 1921 is Kodōjin's only horizontally oriented blue-green painting. It is stored in a box that Kodōjin inscribed and dated twenty-one years later. In the poem that he composed specifically for this work, Kodōjin adapted

FIG. 8 Traditionally attributed to Qiu Ying, detail of *Journey to Shu*, 16th–17th centuries, handscroll, ink and color on silk, 21⅝ × 72⅛ in. (54.9 × 183.2 cm), Freer Gallery of Art, Smithsonian Institution, Washington DC: Purchase—funds provided by the B. Y. Lam Foundation Fund (F1993.4)

phrases from the famous Chinese literati Su Shi (Dongpo, 1037–1101):

贈東林總長老
溪聲便是廣長舌
山色豈非清淨身
夜來八萬四千偈
他日如何舉似人

*Presented to Senior Monk Linzong:*
*Stream's sound must come from a broad,*
*long tongue;*
*How could mountain colors not be a pure,*
*cleansed body?*
*Eighty-four thousand gāthā in a single night!*
*What if I give them to people some day in*
*the future?*

(translation by Jonathan Chaves)

Two blue-green landscapes are also included in the book *Rock Slivers and Lonely Clouds*, which accompanied an exhibition of Kodōjin's paintings in 1929. The work generically titled *Blue-Green Landscape* (no. 58) has been located, but only a monochrome illustration of the other, *Cliffs and Lonely Pine Tree* (fig. 9), has survived. *Cliffs and Lonely Pine Tree* was almost half the size of *Blue-Green Landscape*, and this would explain the large discrepancy between the prices of *Cliffs* at ¥1,000 and *Blue-Green Landscape* at ¥2,500.

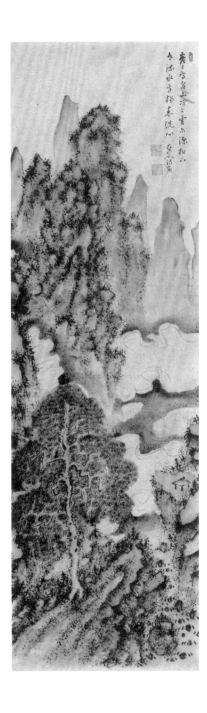

FIG. 9 *Cliffs and Lonely Pine Tree* (*Koshō zeppeki*), c. 1928, hanging scroll, whereabouts unknown

溪聲廣長舌
山色清净身
絶妙蘇公偈
古來嗎一人

"Stream's sound"—"from a broad, long tongue";
"Mountain colors"—"this pure, cleansed body."
Ah, how marvelous, Master Su's *gāthā*!
He was the one man from antiquity to now.

NO. 54

*BLUE-GREEN LANDSCAPE*

Spring 1921

David Tausig Frank and Kazukuni Sugiyama collection

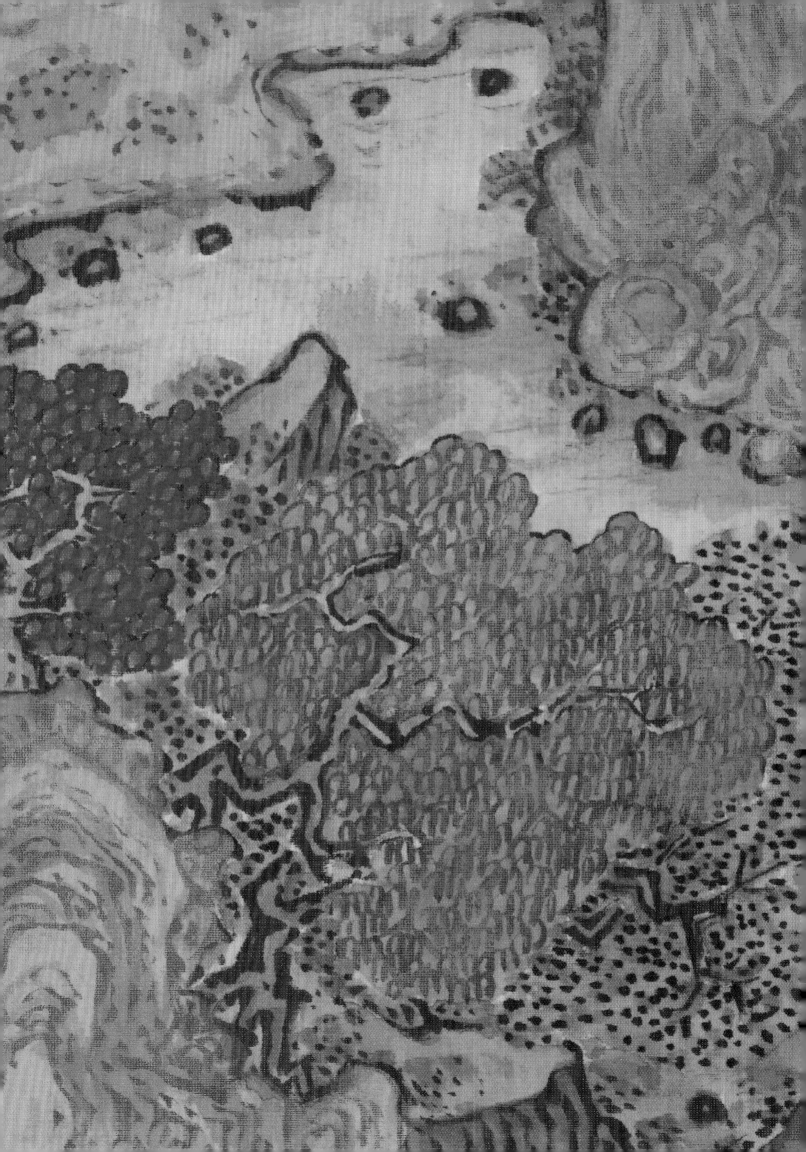

讀書天下樂
此外復何求
獨坐間思古
幽人最愛秋
孤雲如有意
落日不知愁
借問誰同調
山高水自流

Reading books is the greatest pleasure on earth!
Aside from this, what more need you seek?
Alone I sit, calmly contemplating the past;
the hermit loves autumn the best!
That solitary cloud seems to have feeling;
The setting sun knows nothing of grief.
Let me inquire: who shares this melody,
"Mountains High," or "Water Simply Flowing"?

NO. 55

*BLUE-GREEN LANDSCAPE*

c. 1922–32

Private collection

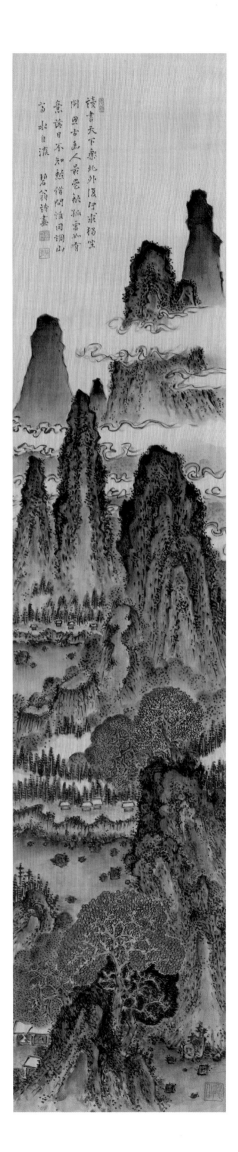

我日服元氣　　嶽嶽景雲起
四體自冲融　　杳杳朝日紅
颼颼乘獨鶴　　萬物生輝光
浩浩駕長風　　八極何玲瓏
一舉凌萬里　　達人應至變
飛騰排蒼穹　　妙機不可窮
抗志九天上　　一化神仙骨
游心四海中　　逍遙莫始終

One day I shall imbibe the Primal Ether,

And all four limbs will be in harmony.

Floating, floating, I will mount a solitary crane,

And vastly, vastly ride the long wind!

One leap up and I will pierce ten thousand miles,

Soaring on high, reaching the azure vault!

My powerful ambition set on the ninth heaven,

My journeying heart covering all the four seas!

Towering, mountainous, colored clouds will rise,

Scintillating, the morning sun rise red!

All ten thousand creatures will emit a brilliant radiance,

And the eight corners of the universe—how dazzling they will be!

The Achieved Man must engage in perfect transformation,

So wondrous junctures will never be exhausted.

Once metamorphosed into the bones of an immortal,

Free and easy wandering without beginning or end!

NO. 56

*BLUE-GREEN LANDSCAPE*

February 1926

Minneapolis Institute of Art,
Gift of the Clark Center for Japanese Art & Culture
(2013.29.902)

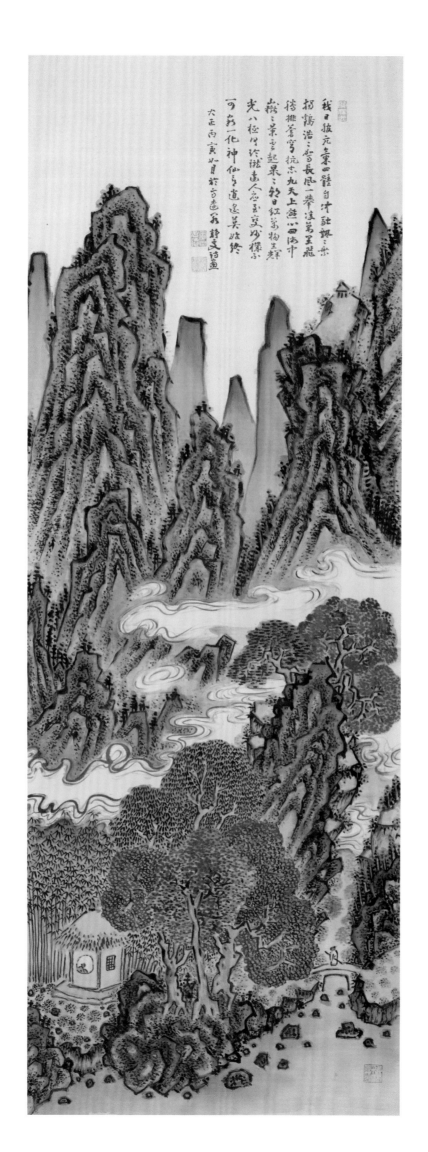

落日蒼天色
寒山啼鳥聲
蕭蕭紅葉下
冉冉白雲生
獨往情無極
高秋老益清
因看明月出
偶訪道人行

Setting sunlight darkens Heaven's color;
Cold mountains, sounds of singing birds.
Sighing, soughing, red leaves tumble;
Curling, rising, white clouds emerge.
Alone I go forth, feelings without limit:
Autumns seem still purer as I grow old.
And now I see the bright moon rising—
This is the time to visit a man of the Way.

NO. 57

*BLUE-GREEN LANDSCAPE*

Summer 1932

Minneapolis Institute of Art,
Gift of David Tausig Frank and Kazukuni Sugiyama
(2015.111.6)

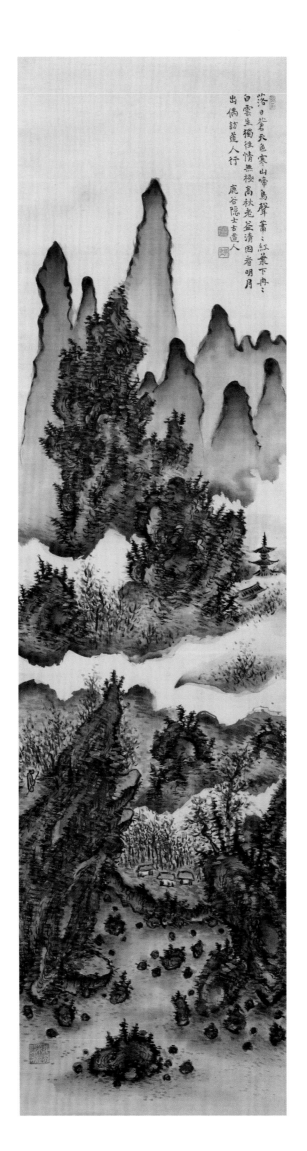

落日蒼茫天色寒　山啼鳥聲
蕭蕭　紅葉下冉冉　白雲生獨徃情無極
高秋老　益清因者明月　出偶訪蓮人行
鹿谷隠士古道人

# THE
# FOUNDATION
# OF THE
# KODŌJIN
# SOCIETY,
# DECEMBER
# 1928

FOLLOWING THE DEATH of his father, Emperor Taishō, on December 25, 1926, Prince Hirohito (1901–89) was officially enthroned as Emperor Shōwa on November 10, 1928, at the imperial palace in Kyoto. Kokubu Saitō (Tanenori) was in town for the occasion and met with his old friend Kodōjin, who he had not seen for thirty years. Saitō was a prolific poet and teacher of Chinese-style poetry with a number of publications. He was also a newspaper reporter, and in 1900 worked for six months in Taiwan, which had been under Japanese occupation since 1895. In 1908, he was asked to join the government and became an official in the Cabinet and Home Ministry. He was involved in formulating the Ceremony of the Imperial Funeral (*taisō no rei*) and the Ceremonies of the Accession to the Throne (*sokui no rei*). When Emperor Meiji died in 1912 and a new era name for his oldest son Yoshihito was discussed, it was Saitō who proposed "Taishō" (Great Righteousness). Three years later, his suggestion for the childhood name Takahito for Prince Mikasa (1915–2016), the youngest son of Emperor Taishō, was accepted. The Ministry of the Imperial Household sent Saitō to England and France in 1920, and to Taiwan in 1923.

Saitō was extremely well connected within the top ranks of Japanese society. Impressed by Kodōjin's life as a literati and his corpus of excellent paintings and calligraphy, Saitō spoke with his circle of friends and initiated the Kodōjin Society (Kodōjinkai) at some point in November 1928. The pamphlet announcing the foundation of the Kodōjin Society in December 1928 begins with a glowing description of Kodōjin by Saitō, who declared the sixty-three-year-old to be "a phoenix of painting and a *kirin* of calligraphy" (a *kirin* is a legendary creature without horns). Saitō compared his poetry with the Chinese monk Hanshan (J: Kanzan, dates unknown) and his calligraphy with Ryōkan (1785–1831), Ike Taiga (1723–76), and Tanomura Chikuden (1777–1835). For Saitō, the artist's *haiga* surpassed Yosa Buson (1716–84), his haiku equaled Masaoka Shiki (1867–1902) and Naitō Meisetsu (1847–1926). Moreover, it states that Kodōjin reportedly admired the monk Gasan Jōseki (1275–1366), that he enjoyed drinking like Tō Enmei

(365–427), and that he would not pick up his brush without being entertained. And it concludes that not many people know about Kodōjin but those who do compete to acquire his works.

The impressive list of fifty-three founding and supporting members of the Society reads like a who's who of Japan in 1928. It includes politicians and the business elite: a prime minister, a former prime minister, four active ministers, members of the House of Lords and House of Representatives, high-ranking managers from the *zaibatsu* conglomerates Sumitomo, Mitsubishi, and Mitsui, directors of railways and utilities, and others. Also on the list are the names of scholars and educators, such as the fifth principal of the Tokyo School of Fine Arts (present-day Tokyo University of the Arts), Masaki Naohiko, and Naitō Konan, the most influential figure in Chinese historiography whose periodization shaped the Western view of China in the twentieth century. One founding member was Kodōjin's old friend Nakagawa Kojūrō, who by this time had become a member of the House of Lords and in September was appointed director of the Tokyo Yamanote Express Electric Railway (present-day Odakyū Electric Railway). Information is provided about the positions or occupations of the majority of individuals. Sakamoto Takako, the owner of a business in Kyoto called Tan'ei, is the only woman on the list.

At this juncture, it would be instructive to comment on Kodōjin and his supporters' stance regarding the nationalistic developments in Japan during the 1930s. Most members of the Society held high political office or were wealthy industrialists, but they were not affiliated with the faction of ultranationalists led by Tōjō Hideki (1884–1948) who eventually took over control of Japan and pushed it toward war in the Asia-Pacific. The sole objective of the Society was the promotion of Kodōjin and his art with no political agenda. How that was negotiated and whether the members met in person is not known. It is also not understood how new members joined or whether there was a membership fee that assisted in maintaining the Society and directly benefited Kodōjin.

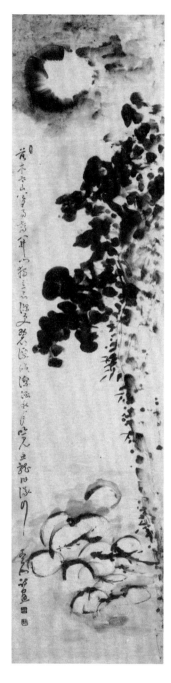

FIG. 10 *Fish Playing with the Moon Reflected in the Water* (*Suigetsu yūgyo*), c. 1928, hanging scroll, whereabouts unknown

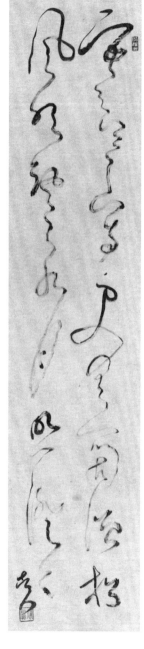

FIG. 11 *Cold Mountain, Five-Character Verse* (*Kanzan gozetsu*), c. 1928, hanging scroll, whereabouts unknown

IN DECEMBER 1928, the Society released a one-page broadside that outlined its plans to organize the *Painting and Calligraphy Exhibition of the Venerable Kodōjin Fukuda Seisho* (*Kodōjin Fukuda Seisho-ō shoga tenrankai*). The broadside provided neither date nor venue name. It listed the seventeen exhibition patrons recruited by Kokubu Saitō from the Society's founding members. This included Minister of Communications Kuhara Fusanosuke, a major player in mining before turning to politics; Kamata Eikichi, the president of Keio University before becoming a member of the emperor's Privy Council; and Ogura Masatsune, a high-ranking manager of the Sumitomo *zaibatsu* who would be the sixth director-general of the Sumitomo Group in 1929.

Kurachi Masao, the managing director and in 1929 the chairman of Tokyo's Mitsukoshi department store, was also one of the patrons. It is therefore not surprising that the exhibition was held at Mitsukoshi in Nihonbashi. Even today, large Japanese department stores have art gallery spaces where they mount commercial exhibitions of artworks. The planning of the exhibition proceeded quickly. In February 1929, the Kyoto-based art publisher Unsōdō printed the pamphlet, *Painting and Calligraphy Exhibition of the Venerable Kodōjin Seisho* (*Kodōjin Seisho-ō shoga tenrankai*; omitting *Fukuda* from the original broad-side), which announced that the exhibition would be on the seventh floor of Mitsukoshi on February 22–26. The pamphlet illustrated three of the artist's paintings: *Blue-Green Landscape* (no. 58), *Silhouettes of Sails and Glowing Pine Trees* (no. 60), and *Fish Playing with the Moon Reflected in the Water* (fig. 10), and the calligraphy on satin, *Cold Mountain, Five-Character Verse* (fig. 11). It is noteworthy that an undated broadside with the titles, mediums, sizes, and prices for eighty-six

artworks was also printed. The exhibition title on this similarly omits the name Fukuda, leading to the conclusion that it was printed after the December statement of intent.

The pamphlet additionally gives Saitō's private address as the Society's headquarters in Tokyo, with the Kyōkadō the location of the Osaka branch. The Kyōkadō, owned by Shin Denta, was most probably a scroll mounting shop like the Shunpōdō or another type of art business. The Shunpōdō was the editor and publisher of the next (and last) book of Kodōjin's artworks created during his lifetime, *Rock Slivers and Lonely Clouds*, which was printed in Kyoto by Unsōdō on February 15. It was released five days later on February 20, two days before the opening of the Mitsukoshi exhibition. Intriguingly, *Rock Slivers and Lonely Clouds* makes no mention of the upcoming exhibition. The book was not for sale, rather distributed for free to interested parties. The frontispiece comprises a four-character calligraphy by the incumbent prime minister Tanaka Giichi reading "Hermit's Brush, Extraordinary" (仙筆超凡). This is followed by a second four-character calligraphy written by Tanaka's predecessor, Wakatsuki Reijirō, and a longer prose text authored by Naitō Konan in praise of Kodōjin.

*Rock Slivers and Lonely Clouds* lists eighty-seven works by Kodōjin (eighty-six from the Mitsukoshi list plus one), including the title and the type of work, as well as the names of the owners of twenty pieces. All but five of the listed owners were founders of the Kodōjin Society. In a practice that continues today, sales galleries sent out mailings beforehand so that customers could purchase works as soon as the exhibition opened. This must also have been the case here, as the book was printed one week before the exhibition was launched.

The eighty-seven works range in date from the spring of 1921 to December 1928, indicating that some predated the publication of the previous catalogue *Withered Trees and an Abundance of Spring* on March 8, 1927. There are sixty-eight hanging scrolls and thirteen calligraphies, and surprisingly, for the first time, folding screens: one six-panel screen pair, three two-panel screen pairs, and one two-panel screen. Up to this point in his career, Kodōjin seems to have painted only hanging scrolls and albums. None of the artist's other eight documented six-panel screen pairs, one single six-panel screen, and one single-panel screen can be firmly dated to before 1929. Either his clientele was not keen to accommodate the larger format of the folding screen in their domestic settings or Kodōjin himself was unenthusiastic about painting these bigger works. The latter seems a more plausible explanation given that his screens are generally comprised of only calligraphy or images of single pine trees, bamboos, reeds, or Mount Fuji. There are no meticulously executed landscapes among Kodōjin's known screens; instead, they are comparatively simple in compositional terms.

The majority of the hanging scrolls included in *Rock Slivers and Lonely Clouds* ranged between ¥100 and ¥500. *Blue-Green Landscape* (no. 58), the second painting in the book, was listed at the hefty price of ¥2,500. This work was by far the most expensive hanging scroll in the sale because of the materials used for it. At that time, ¥1 equaled around 45 US cents, meaning that the scroll would have cost $1,125, at that time close to the average annual income of $1,368 in the United States and approximating the price of two new cars. Today, this would be roughly equivalent to $18,000 to $19,000. The next most expensive hanging scroll was *Excursion of a Recluse* (no. 59) for ¥1,500, again so

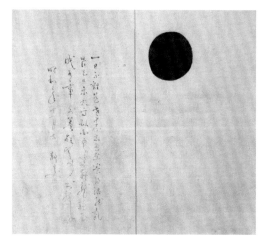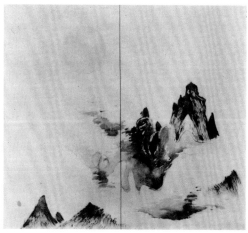

FIG. 12  *Colorful Clouds and Rising Sun* (*Kyokujitsu saiun*), November 1928, pair of two-panel folding screens, whereabouts unknown

FIG. 13  *Morning Sun over Mount Fuji* (*Fugaku chōyō*), December 1928, pair of two-panel folding screens, whereabouts unknown

priced due to the costly materials used. Kodōjin painted *Excursion of a Recluse* on silk but with a layer of gold leaf underneath. This is the only such scroll identified to date.

It is not known who acquired these two hanging scrolls or who purchased the remarkable landscape, *Withered Tree and Winter Crow* (no. 62), that exemplifies Kodōjin's command of abstraction. Although abstraction in Western painting does not become a movement until the late nineteenth and early twentieth centuries, in China abstract painting was recognized from at least the Tang dynasty (618–907). One technique, called "splashed ink" (C: *pomo*, J: *hatsuboku*), freely applies swathes of wet ink; it is tied to the "boneless" technique but is more defined. In *Withered Tree and Winter Crow* Kodōjin leaves considerable negative space and places only five tall, vertical peaks in the background, each painted with a wet brush in a different color: red, black, yellow, green, and blue. The withered tree mentioned in the title is positioned at the bottom edge of the painting, rendered in black with red spots atop of which sits the almost indiscernible crow. In this work, Kodōjin pushes the illustration of a popular subject to a new level, and it represents a stylistic break with an earlier identically titled work (no. 51).

The first painting in the book and the most expensive overall was *Colorful Clouds and Rising Sun* (fig. 12), a pair of two-panel folding screens acquired by Saitō for ¥5,000 (today roughly equivalent to $36,000–$38,000). The second most expensive work at ¥3,000, *Morning Sun over Mount Fuji* (fig. 13), was also a pair of two-panel folding screens. One of the patrons of the exhibition, the aforementioned Minister of Communications Kuhara Fusanosuke, purchased this work. Yamamoto Washichi, executive director of Kyoto Electric Light,

bought another pair of six-panel folding screens, titled simply *Landscape* (*Sansui*) for ¥2,000. The whereabouts of these three pieces are unknown. Yamamoto's colleague, managing director Ishikawa Yoshijirō, acquired *Crabs Walking Sideways* (no. 63) for only ¥120, the same price paid by Izumi Kichijirō, a lead pipe manufacturer and a founding member of the Kodōjin Society, for *Moon and Pine Tree* (no. 64).

On March 5, the Kodōjin Society released an invitation to another two-day event in Tokyo on March 9–10 to view some seventy of Kodōjin's paintings and calligraphies. The venue was the third floor of the prestigious Peers' Assembly Hall (Kazoku Kaikan) in Nagatachō, Chiyoda ward, the head office of the association of Japanese nobility (the Kasumi Kaikan). Such an extraordinary location for Kodōjin's exhibition was only possible due to the intervention of the aristocratic members in the Kodōjin Society, and the invitation lists the four patrons, beginning with Count Tokugawa Satotaka, who was Emperor Taishō's chamberlain from 1922 to 1927. Satotaka was not a founding member of the Society, but the other three were: the army infantry colonel and member of the House of Lords, Viscount Yagyū Toshinaka; vice director of Shimizu Corporation, Shimizu Yōnosuke; and Kokubu Saitō.

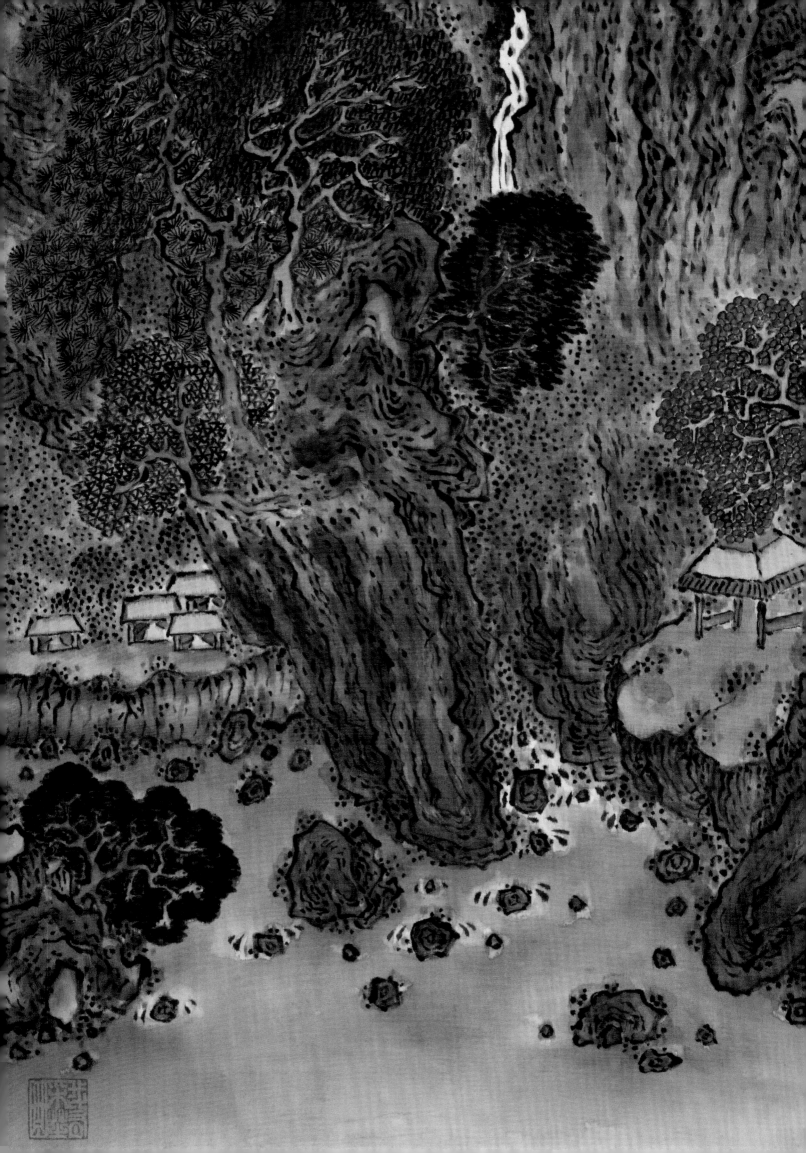

一日不讀書
三月減其樂
何如富貴人
束之委高閣
吾抱躬行志
至老猶力作
偶為識字農
賦性奈劣弱
聊云樂天命
守分伍燕雀
營巢茅屋足
豈羨乘軒鶴

If I do not read books for a single day,

For three months my pleasure is reduced.

How about those wealthy, high-placed folks

Who pack them away in high towers?

I embrace the ambition of "carrying it out in my conduct,"

Until old age, still working hard at it!

I happen to have become a literate peasant:

Alas, that my nature is so weak!

For now, I will just enjoy Heaven's Mandate,

Accepting my lot like the swallows or sparrows.

They are content building nests in thatched roofs;

Would they envy that crane who rode in a carriage?

NO. 58

*BLUE-GREEN LANDSCAPE*

April 1928

Minneapolis Institute of Art,
Gift of David Tausig Frank and Kazukuni Sugiyama
(2015.111.21)

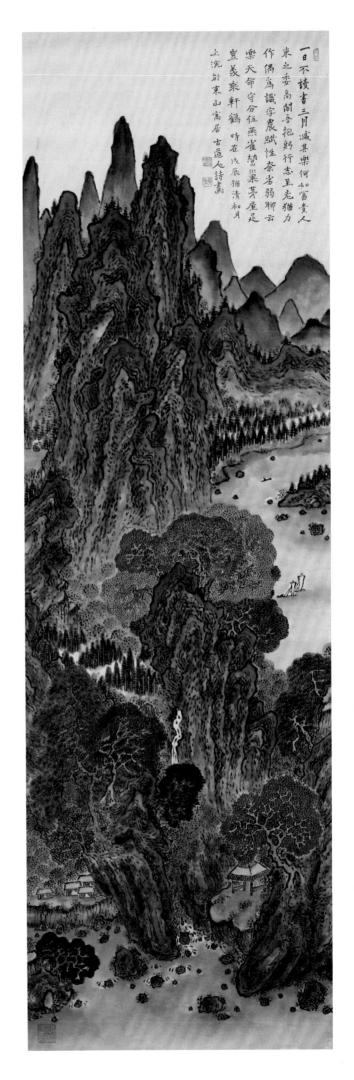

樹根能裂石
雲氣亦吞山
青巖為神助
詩成物怡顔

These tree roots can split rock;

The clouds' energy can also swallow mountains.

Green cliffsides are aided by the spirits;

My poem is done—I lift my joyful face.

NO. 59

*Excursion of a Recluse*

c. 1928

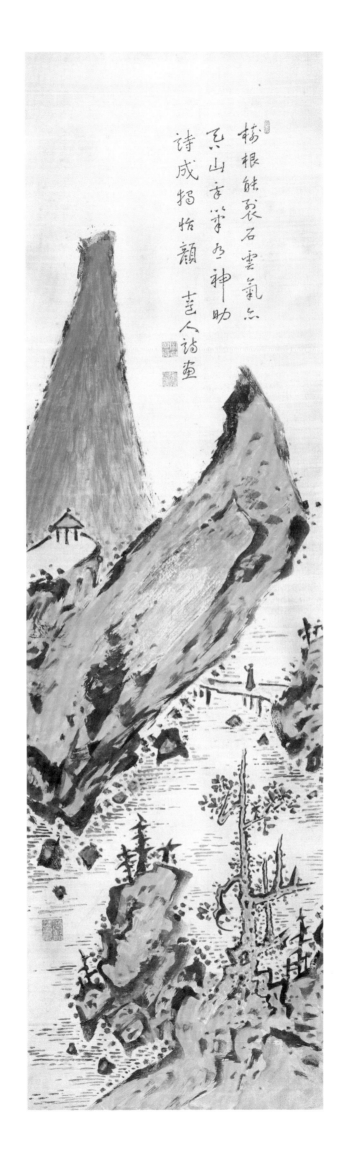

緣石求魚水清淺隔雲聽鳥
樹扶疎出門行樂復還室斜日
在窗重讀書　時在昭和戊辰仲
夏於東山草堂　古道人詩畫

緑石求魚
水清淺隔
雲聴鳥樹
扶疎出門
行樂復還
室斜日在
窓重讀書

Along the rocks I search for fish
Where the water is clear and shallow;
Beyond the clouds I hear the birds
Where trees spread in profusion.
I go out my gate to enjoy myself,
Then return back home;
As setting sunlight shines through the window
Again I read my books.

NO. 60

*SILHOUETTES OF SAILS AND GLOWING PINE TREES*

May 1928

Minneapolis Institute of Art,
Gift of the Clark Center for Japanese Art & Culture
(2013.29.1004)

好是米家山水緣
讀書餘事弄雲煙
吾能養我浩然氣
直自筆端流到天

Happily I share the karma of a Mi family landscape!

As a sideline after reading, I play with clouds and mist.

I am able to nurture my Overflowing Energy,

And send it flowing, straight from my brush tip, all the way to Heaven!

NO. 61

*HIGH WATERFALL AND ROLLING PEAKS*

Summer 1928

Minneapolis Institute of Art,
Gift of David Tausig Frank and Kazukuni Sugiyama
(2015.111.26)

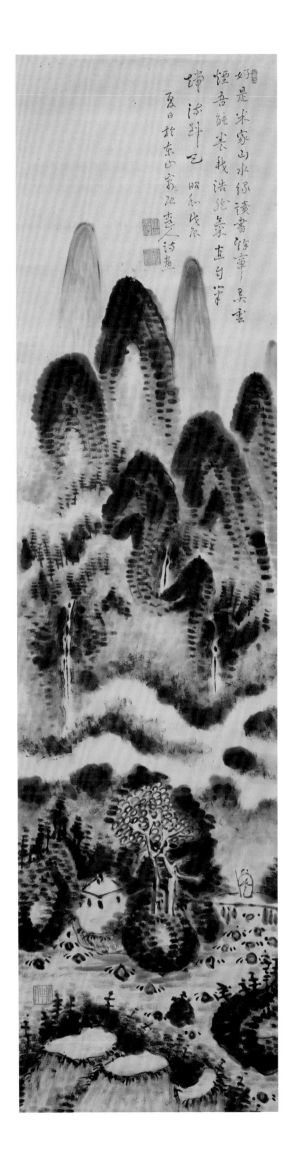

青山日相對
白雲日往來
青山與白雲
悠悠有樂哉

Green mountains face me every day,
Clouds daily come and go.
Green mountains and white clouds:
Ah! Reverie! Here is joy!

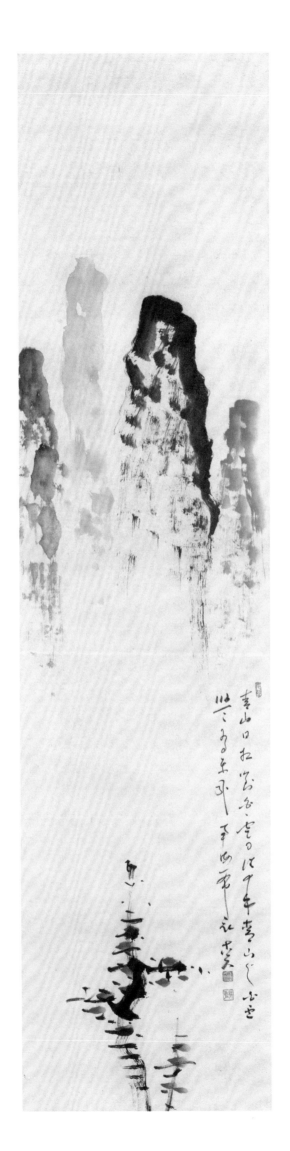

遠流波如層
終日釣舟横
但有蠢翁動
魚今不求名

In this far-flowing stream, waves like layered peaks!
All day, beached fishing boats lie on their sides.
There are only these foolish fellows abroad:
Today, no fish are out seeking fame!

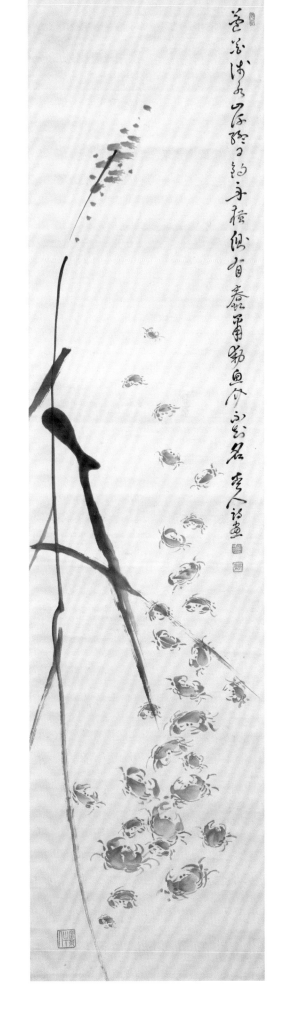

NO. 63

*CRABS WALKING SIDEWAYS*

c. 1928

Minneapolis Institute of Art,
Gift of David Tausig Frank and Kazukuni Sugiyama
(2015.111.23)

松子南望照飲泉
山中高臥豈將仙
此來當笑皆依舊
何獨文章不流連

Gazing south through pine cones,
There shines my drinking brook:
Here in the mountains, calmly reclining,
Could I almost be an Immortal?
Coming here again, I must laugh—
Everything just the same,
So why is my writing—that alone!—
Not flowing effortlessly?

NO. 64

*MOON AND PINE TREE*

c. 1928

Minneapolis Institute of Art,
Gift of David Tausig Frank and Kazukuni Sugiyama
(2015.111.7)

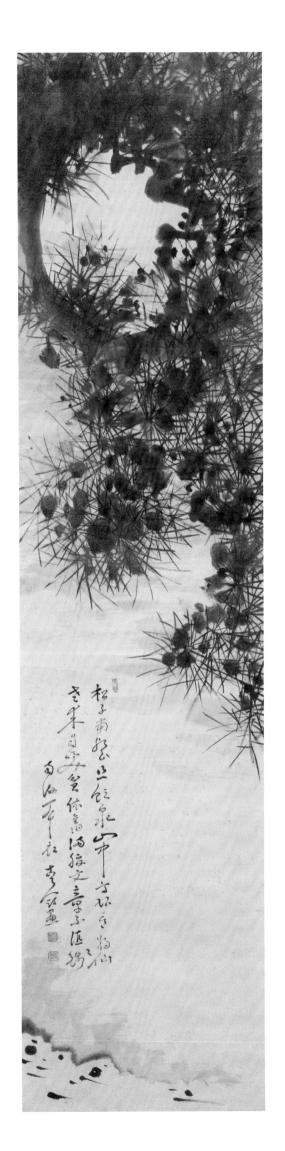

# A Decade of Perseverance, the 1930s

FIG. 14 Kodōjin in the garden of
Furusawa Tokuji, May 1935,
private collection

FIG. 15 Kodōjin being entertained
at the residence of Furusawa
Tokuji, May 1935, private
collection

BY THE SUMMER OF 1929, the sixty-four-year-old Kodōjin had reached the pinnacle of his career. For a number of years he had been well known among aficionados of Chinese culture, literature, and art. For example, on the tenth death anniversary of Kurata Isao (1827–1919), a scholar of Chinese learning (*kangaku*) from Ise who had lived in Kodōjin's home prefecture of Wakayama, Kodōjin, as a sign of respect, inscribed the box for a pair of hanging scrolls. One scroll had calligraphy, the other depicted bamboo, both done by Isao in 1916. Kodōjin was effectively a household name in Japanese high society, but relatively unfamiliar to the general public.

In late 1929, Kodōjin moved again, this time to Shishigatani Teranomaechō no. 65, adjacent to the house he lived in from 1919—this was his last move. Only a few details are understood about Kodōjin's life in the 1930s, even though he continued to be a prolific painter. This period was again marked by tragic personal loss with the death from illness of his eldest, twenty-nine-year-old son Yutaka in April 1931. The exact circumstances surrounding Yutaka's death are not known, but losing a second child must have been a devastating blow to Kodōjin and Misu.

The Kodōjin Society disappeared almost as quickly as it had appeared. Following the exhibition at the Peers' Assembly Hall in March 1929 there are no traces of the Society's activity until April 1933 with the release of a single-sheet broadside containing some general information about Kodōjin. It stated that he would be staying at the Kinmata Inn in Nakatsugawa (then called Nakatsuchō) in Gifu Prefecture during the first ten days of May. This trip was organized (or sponsored) by the Kodōjin Society at the

Buddhist temple Nanrinji in Nakatsugawa. It is unclear if one of the founding members had ties to Nanrinji or even how the Society was connected with the visit. In any case, this is the last time that the name of the Society appeared—was it dissolved officially or did it simply cease operations? Intriguingly, there are no names of Society members on the photograph of the memorial held on October 15, 1944, one month after Kodōjin's death.

Kodōjin continued to travel throughout Japan in response to invitations from friends and admirers. Known for his fondness of *sake*, it is not surprising that a number of his hosts were *sake* brewers, a group that was generally interested in upholding tradition and was quite likely to be supporters of the arts. In July 1934, Kodōjin went to Shingū to see Ozaki Sakujirō (dates unknown), whose father had begun brewing *sake* in the early Meiji era and who subsequently moved the brewery, Ozakishuzo, in 1880 to the location where it still operates today under the sixth-generation head.

In the following year (1935), Furusawa Tokuji (dates unknown) invited Kodōjin to his brewery in Sagae in Yamagata Prefecture. The last time Kodōjin had visited northern Japan was probably on a trip to Iwate and Niigata two decades earlier. This extended trip was likely more arduous for the now seventy-year-old artist. Although no records survive to say how long he stayed, photographs from the trip show him in a garden (fig. 14) and being entertained by a young woman who offers him *sake* as he paints a pair of six-panel folding screens portraying bamboo and a pine tree (fig. 15). The screens are dated to May, and Kodōjin might have sojourned in the region until August when he went the Ōnuma no Ukishima, a Shinto

shrine in southern Yamagata Prefecture, because a stone stele with one of his haiku was erected there (fig. 16).

Bamboo and pines were the principal subjects in Kodōjin's screens from the 1930s. In October 1932, he painted a pair of *Old Pines* that illustrates two gnarled trees bent toward each other (no. 74). It is quite possible that this was a commission, but unfortunately no records have survived. Believed to be from around this time (1925–1935) are the three pairs of screens created in white ink on brown persimmon-dyed paper. Each pair is divided, with a painting on the right and a calligraphy on the left. One of the paintings depicts reeds under the moon paired with haiku, while the other two have Chinese-style poems and portray Mount Fuji or bamboo in snow. The execution is minimalistic, the visual effect striking. *Bamboo in Snow* (no. 75) was originally owned by a popular inn in Wakayama Prefecture.

The records of the Fukuda family in Kyoto have photographs of four sets of

FIG. 16 Celebration of the construction of Kodōjin's stele at Ōnuma no Ukishima, Yamagata, August 1935, private collection

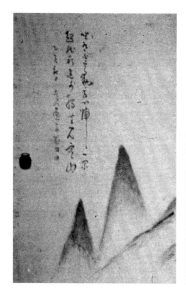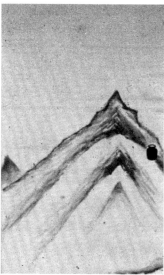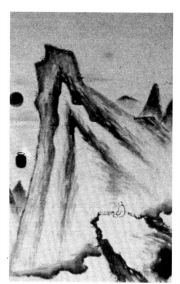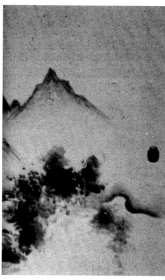

FIG. 17 *Mountains and Rising Sun*,
autumn 1935, four sliding doors,
whereabouts unknown

sliding doors by Kodōjin. Where they were
painted or where they are presently housed
is not known, but they were most likely
private commissions. Each set differs in size,
one just two doors, the other three are four
doors (these, too, vary in height and width).
Two are dated: 1922 for an old pine tree, and
autumn 1935 for *Mountains and Rising Sun*
(fig. 17). Presumably the largest of the four
sets, *Mountains and Rising Sun*, portrays a
scholar sitting on a rock as he admires the
sunrise.

The poem inscribed on *Old Plum* (no. 69)
from the spring of 1936 offers a succinct
reflection on plum blossoms. Kodōjin
included the expressions "secret fragrance"
and "sparse reflections" (J: *ankō soei*), taken
from the most renowned Chinese poem on
plum blossoms, *Little Plum Blossom of Hill
Garden* (C: *Shanyuan xiaomei*), by Lin Bu
(967–1028). Kodōjin often incorporated
plum trees into his landscapes, but he rarely
painted such magnified views of branches
as seen here. This approach is commonly
encountered in his representations of pine
trees (see no. 64, 95).

*One Thousand Mountains and Ten Thousand
Ravines* (no. 71) is a meticulously conceived
panorama in ink with layer upon layer of
interlaced rocks and mountains. This
undated landscape was kept with a letter
from July 1937, which accompanied the
painting sent from the Kyoto mounting shop
Yamakawa Shōbidō to Taiji Gorōsaku in

Wakayama. The Shōbidō, located in central
Kyoto directly south of the imperial palace at
the intersection of the streets Oshikōjidori
and Fuyachōdori, fulfilled six purchase orders
to Taiji from 1930 to 1938. This confirms that
Taiji regularly bought Kodōjin's work and had
the Shōbidō mount them before he took
delivery. One such piece dating to November
1937 is inscribed with the geographic location
"Temporary Abode Beneath Wakayama
Castle" (*Gakojō-ka gū*), an indication that
Kodōjin must have visited Taiji.

Kodōjin also created at least seven
painted albums between 1932 and 1937, five
with monochrome landscapes and calligra-
phy and two with polychrome landscapes
and calligraphy. The last, the *Album of Joy in
Heaven* (no. 83) of April 1937, is once again
testimony to the artist's kaleidoscopic
versatility in intimate ink landscapes.

FACING PAGE: (DETAIL)

NO. 71 *One Thousand Mountains
and Ten Thousand Ravines*

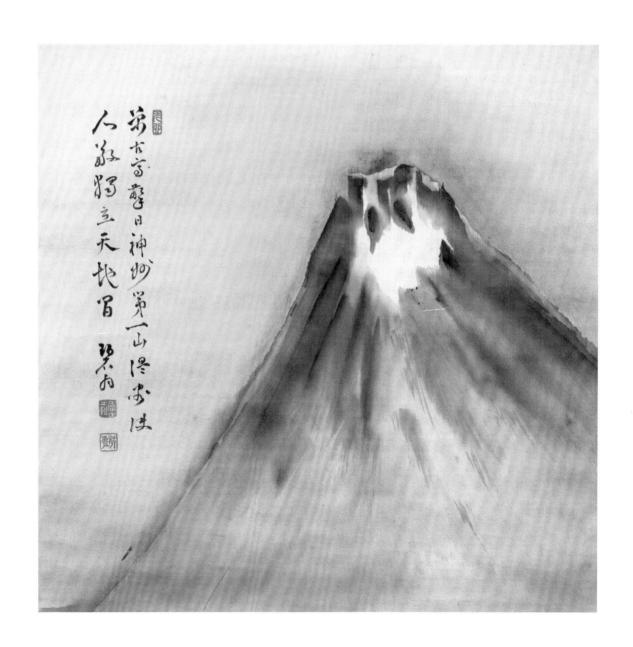

209

白日雲煙氣
深山瀑布聲
結廬其下住
洗盡世間情

Broad daylight, vapor of cloudy mist—
Deep mountain, roar of waterfall:
I have built my hut right here to live,
Washing away the feelings of the world.

NO. 66

*HIGH WATERFALL IN CLOUDY MOUNTAINS*

June 1929

Oni Zazen collection

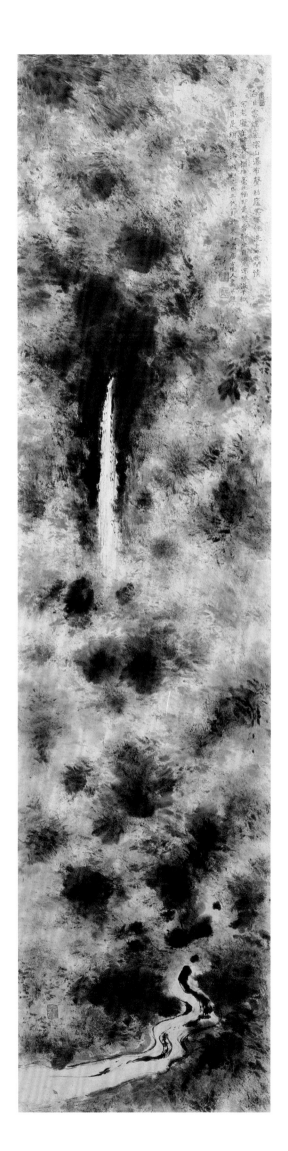

飛流直下動乾坤

山谷鳴兮草木翻

萬古以前蒼茫往

千年之後復歸元

天河忽現神通力

巉石無非鬼造痕

若使詩仙來到此

慨應擬關定驚魂

The flying torrent flows straight down, shaking Heaven and Earth;

In the mountain valley, birds sing, Ah! Plants and trees are swayed.

Ten thousand eras ago, from great vastness it issued forth,

Thousands of years later, again it returns to the Primal Origin.

The Heavenly Milky Way suddenly manifests its spiritual power of penetration,

The sheer stone cliffs are nothing less than signs of the labors of spirits.

If Li Po, Immortal of Poetry, could come to visit this place,

Appalled, he would plan to stop it up to calm all troubled souls.

NO. 67

*A MAN OF NOBLE CHARACTER VIEWING A WATERFALL*

Spring 1930

Minneapolis Institute of Art,
Gift of David Tausig Frank and Kazukuni Sugiyama
(2015.111.15)

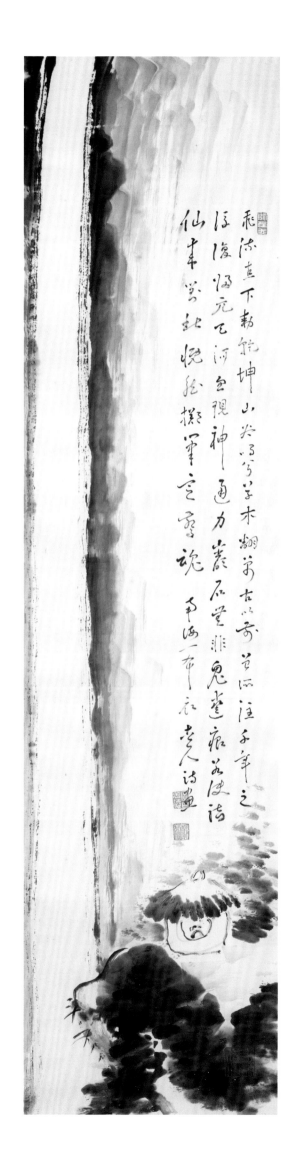

飛流直下勒船坤山尖弱弩末翻莫古以奇苦以注于年之注後悔亢飛河堂現神通力巖石豈非鬼逢痕苗便涉仙羊尝虯悅狂撑筆云雲詭甲酒一布花黃詩畫

退步瀑布聲

I step back at the sound of a waterfall.

NO. 68

*WANDERER UNDER THE MOON*

c. 1913–37

Minneapolis Institute of Art,
Gift of David Tausig Frank and Kazukuni Sugiyama
(2015.111.22)

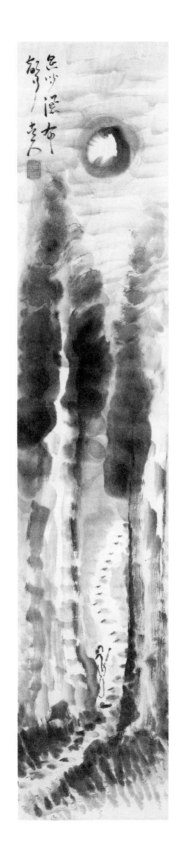

梅花皎然白
其上明月閑
春色滿千里
一枝天地間
暗香入流水
疎影動空山
冷々無相見
高々不可攀

Plum blossoms white in white moonlight,
Above them the moon itself, calm.
Spring colors extending a thousand miles,
This single branch between Heaven and Earth.
Their "secret fragrance" falls on flowing waters,
"Sparse reflections" moving the deserted mountain.
Cold, so cold, the moon's beyond our meeting,
High, so high, we cannot climb up there.

NO. 69

*OLD PLUM*

Spring 1936

Minneapolis Institute of Art,
Gift of David Tausig Frank and Kazukuni Sugiyama
(2015.111.25)

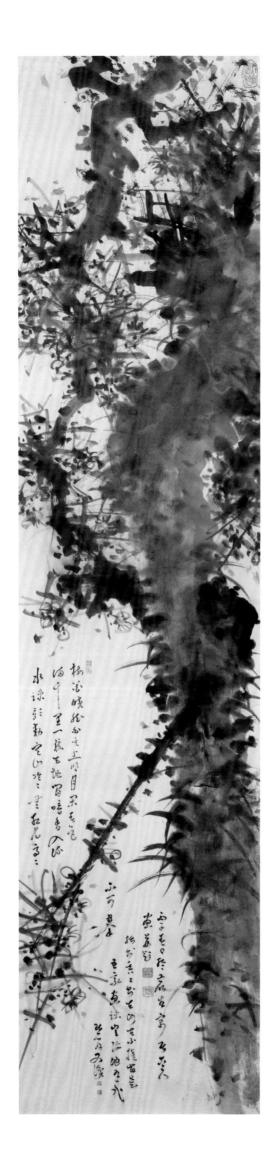

一幅雲煙

奪化工閒

來逸奧與

誰同吾家

畫訣如拜

問坐在圖

書萬卷中

A hanging scroll of cloud and mist,

Snatching the Creator's work!

Serene, I come here: transcendent mystery—

With whom may I share it?

If someone should inquire about the secrets

Of my "school of painting":

Just sit here, in the middle of

Ten thousand volumes of books!

NO. 70

*PEACEFUL GARDEN AND OLD TREE*

January 1930

Minneapolis Institute of Art,
Gift of David Tausig Frank and Kazukuni Sugiyama
(2015.111.12)

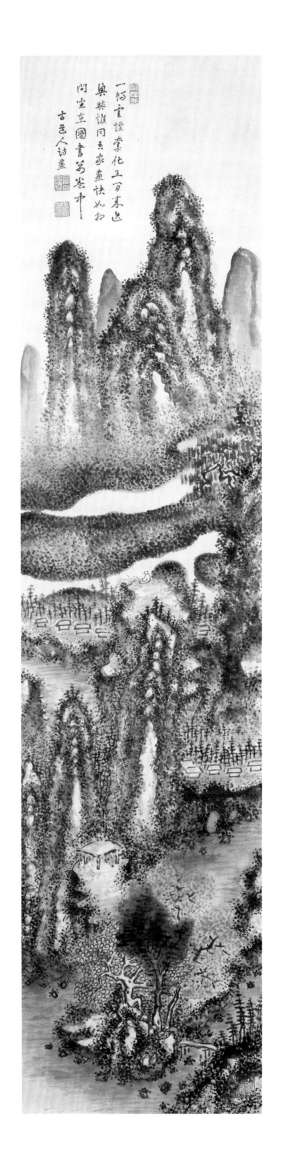

219

石洞白雲起
松風天地閑
行歌日之夕
幽意滿空山

From the stone cave, white clouds rise;
Pine winds—Heaven and Earth are calm.
I walk along, singing, the evening of the day,
Mysterious feeling fills the deserted mountain.

NO. 71

*ONE THOUSAND MOUNTAINS AND TEN THOUSAND RAVINES*

c. 1937

Private collection

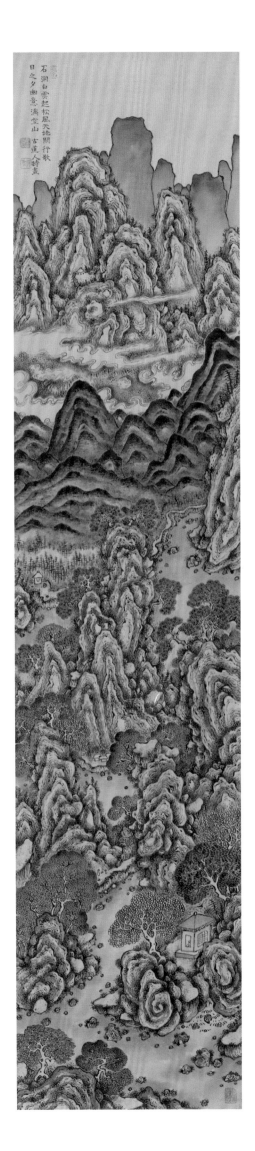

唯有白雲動
我心歸一閑
超然窮達外
獨坐見空山

Only white clouds are moving,
My spirit returns to a point of ease,
Transcendent—beyond failure or success,
Sitting alone viewing the empty mountains.

NO. 72

*HIGH WATERFALL IN CLOUDY MOUNTAINS*

Winter 1931

Oni Zazen collection

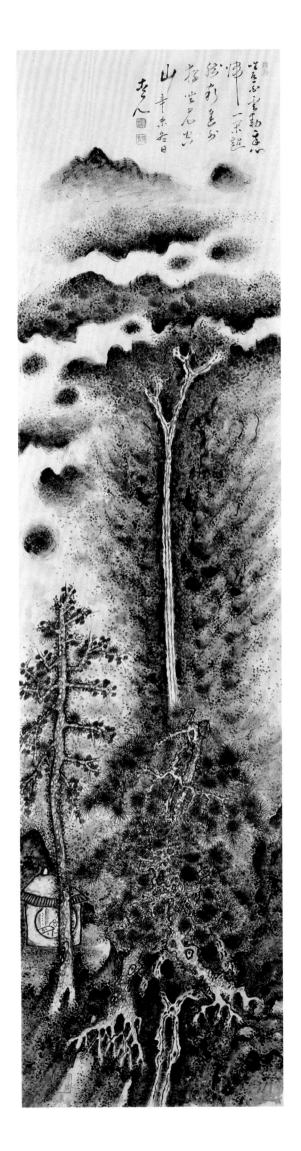

昔賢能守節
千古感吾情
昨日入山去
未首薇蕨生

The sages of the past were able to hold onto virtue,
Moving me from thousands of years in the past!
Yesterday I went into the mountains
But could not find any ferns growing there.

NO. 73

*PINE TREE AND RISING SUN BETWEEN CLIFFS*

c. 1931–33

Minneapolis Institute of Art,
Gift of the Clark Center for Japanese Art & Culture
(2013.29.1254)

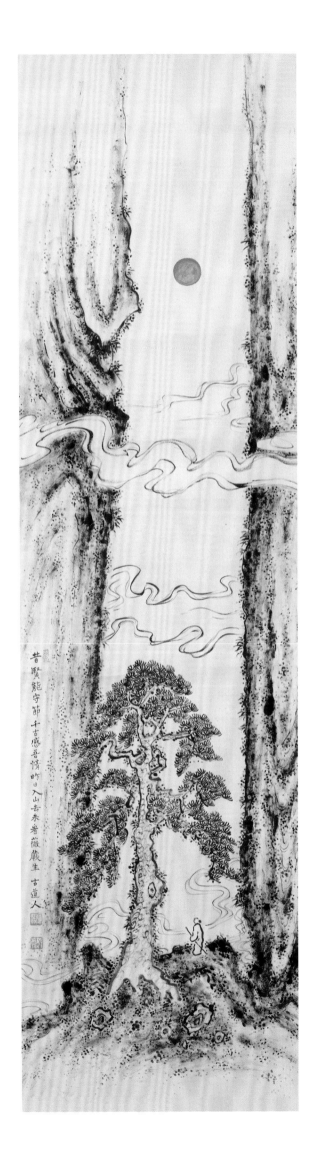

昔賢能守節
千古感吾情
昨日入山去
來看薇蕨生
古道人

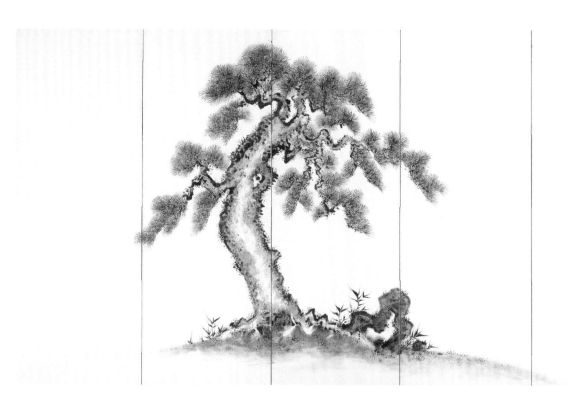

| 愛此老松樹 | I just love this old tree! |
| 自存君子姿 | How it preserves the demeanor of a gentleman! |
| 有時明月夜 | At times, on moonlit nights, |
| 仙鶴來宿枝 | Immortal cranes come to spend the night on its branches. |

NO. 74

*OLD PINES*

Autumn 1932 (RIGHT)

October 1932 (LEFT)

Minneapolis Institute of Art, Gift of the Clark Center
for Japanese Art & Culture, formerly given to the Center
by Elizabeth and Willard Clark (2013.29.842.1-2)

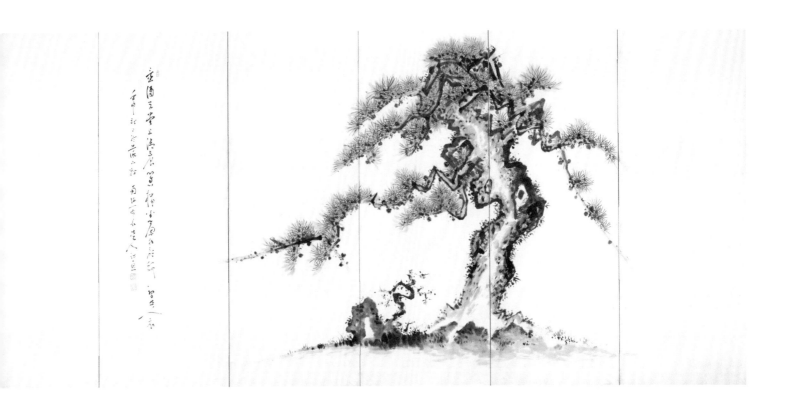

置酒高堂且論文
梅花爲我吐清芬

We set out wine in the high hall and then converse of letters;
Plum blossoms for us spit forth their pure blossoms.

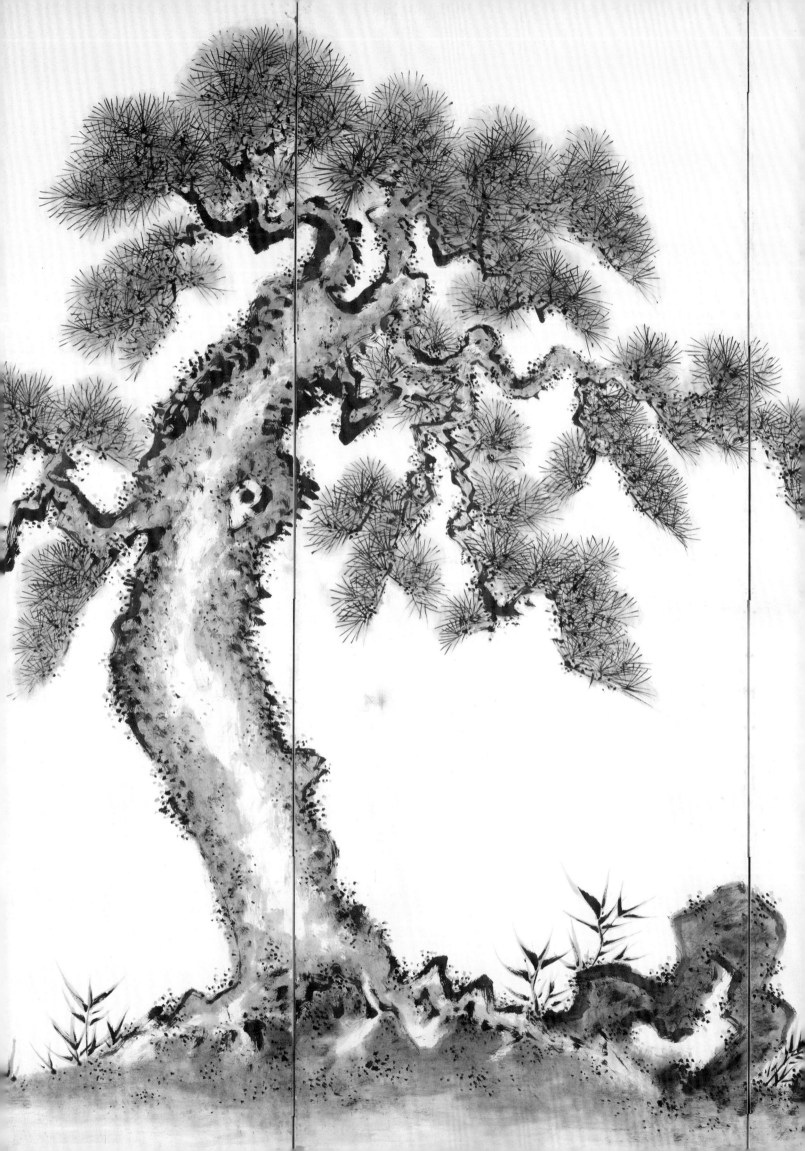

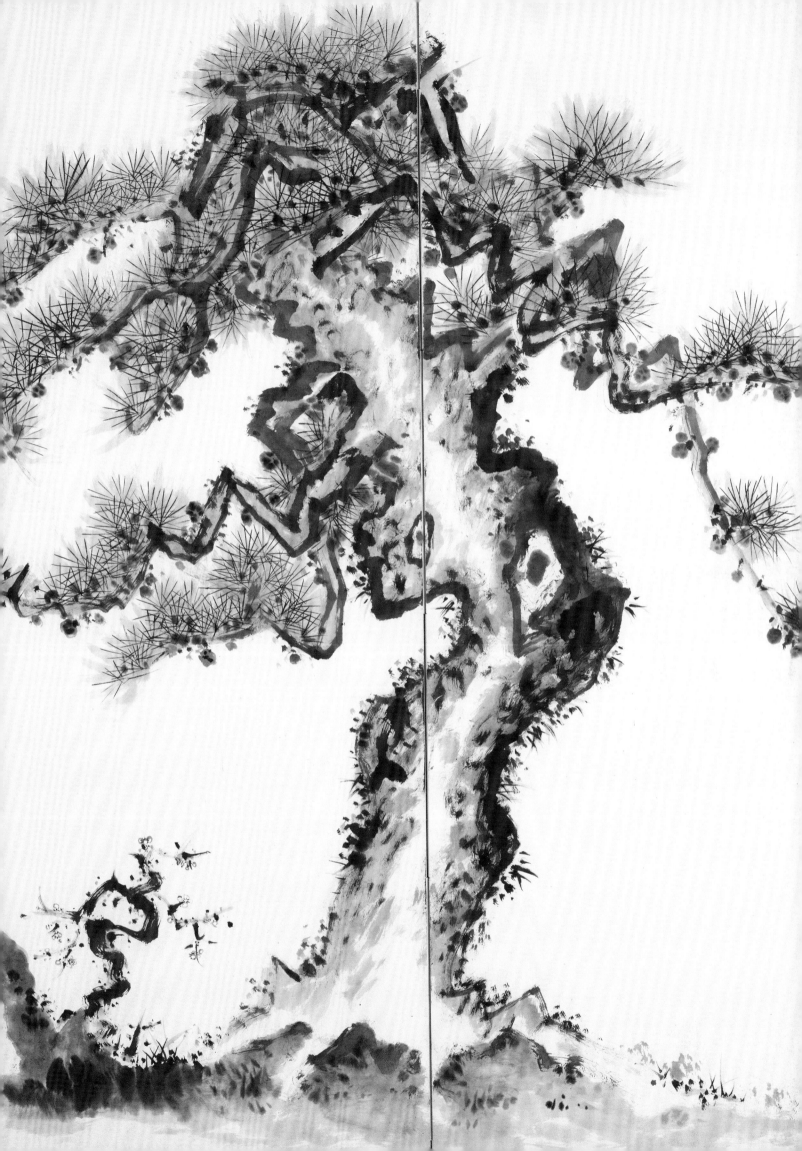

君自故山到　　白首有何思　　You have come from hometown mountains,
遙過洛北居　　昔日俱歡樂　　To live far off, beyond northern Kyoto.
相遇忘久闊　　出遊郭門頭　　Meeting, we forget our long parting,
對酒意相舒　　滿天風雪暮　　Bring out wine, our feelings comfortable.
醉來聯榻臥　　驅馬上高邱　　Getting drunk, we lie on the bench:
交道貧未疎　　飛騰功名念　　When the Way is shared, poverty is no barrier.
明朝又千里　　砲磚隘九州　　Tomorrow, another one thousand *li*:
莫惜數行書　　而今守吾拙　　Please do not spare a few lines in a letter.
歲月水東流　　林下臥柴門　　Years and months, the waters flowing east;
天地如寓寄　　借問江南路　　Heaven and Earth are like a traveler's inn.
安心得其所　　來往幾人存　　The peaceful mind will find its rightful place;

Even with white hairs, what is there to worry about?

In former days we shared happiness together,

Leaving city gates to go out for a stroll.

On evenings when windblown snow filled the sky,

We galloped on horseback up the steep slopes.

Flying, leaping, beyond thoughts of fame and fortune,

Full of energy, constrained by the Nine Continents!

And so today, I hold on to my clumsiness;

Beneath forest trees, lying behind my bramble gate.

Let me ask: along the road south of the river,

How many of those who came and went still live?

NO. 75

*BAMBOO IN SNOW*

c. 1925–35

The Kura Art Gallery, Kyoto

日出往南潤　　The sun rises above the southern moisture;

猗々緑竹陰　　Rich and full, shade from green bamboo.

清風多古意　　A pure wind full of feelings of antiquity

吹我塵外襟　　Wafts them toward my dust-free lapels!

一日不離道
老來志愈堅
養得浩然氣
畏天旦樂天
高臥白雲裹
猶龍抱玉眠
有事則英碓
無事則神仙

I do not leave the Way for a single day;
The older I get, the firmer my will.
I have nurtured the Overflowing Energy,
In awe of Heaven, yet joying in Heaven.
I rest high among the white clouds,
Like a dragon who sleeps, clutching his jade.
If you have affairs, then be a hero;
If without affairs, then be an Immortal.

NO. 76

*LANDSCAPE IN PALE RED*

Spring 1929

Private collection

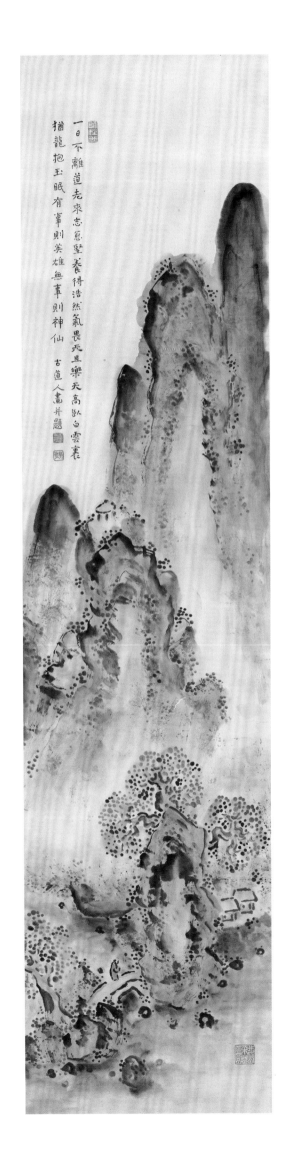

一日不離道走來志愜墅養得浩然氣晨兆且樂天高臥白雲裏擒龍抱玉眠有事則英雄無事則神仙 古道人畫并題

233

求食無餘粒
著衣無一絲
是吾衣食道
獨樂與誰期

Seeking food? No extra seed of grain.
Wearing clothes? Not a single stitch.
This is my clothes-and-food technique!
I enjoy it alone—with whom would I share it?

NO. 77

*BOATING ON A PURE CREEK*

January 1930

Minneapolis Institute of Art,
Gift of the Clark Center for Japanese Art & Culture
(2013.29.146)

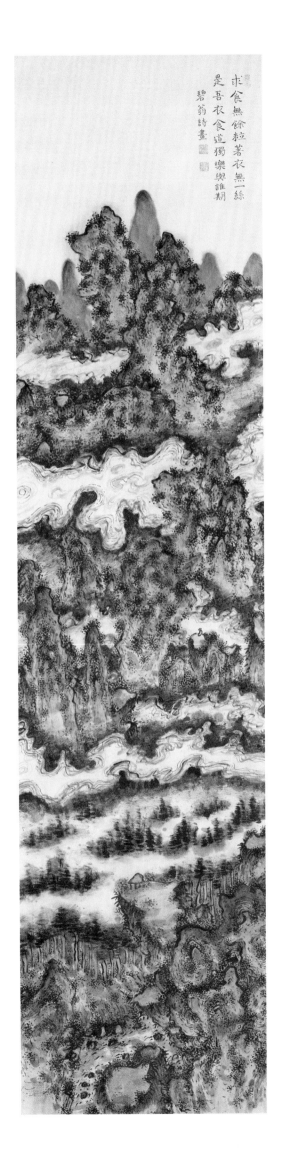

求食無餘粒著衣無一絲
是吾衣食道獨樂與誰期
碧筍詩畫

誰結茅屋
山水絶俗
修竹梅花
主人如玉

Who has built his thatched hut here,
Mountains and streams cut off from the vulgar world,
Tall bamboo and plum-tree blossoms,
The master himself as pure as jade?

NO. 78

*PLUM-BLOSSOM LIBRARY*

c. 1922–37

Gordon Brodfuehrer collection

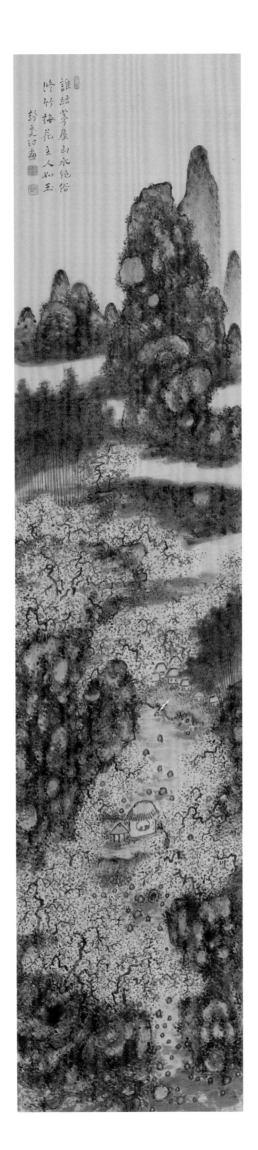

自古高臥士
志與世相違
不許題鳳字
載酒叩巖扉
童子護猿鶴
見余語依依
先生偶有事
朝出向帝畿
政局昨來變
無論問是非
誰使蟄龍起
谷口斷雲飛

From ancient times, scholars of high reclusion
Have had a purpose at odds with the world outside.
No one allowed to inscribe Phoenix here!
Just bring some wine, knock at my bramble gate.
A boy servant cares for my gibbons and cranes;
When they see me, we chat intimately.
And when this gentleman happens to have business,
He embarks at dawn for the emperor's realm
The administration recently has been changed:
It matters not to me if this be good or bad.
Who might awaken this hibernating dragon?
Only cloud fragments, scudding past the valley mouth.

NO. 79

*RED LEAVES AND WHITE CLOUDS*

April 1934

Stuart Katz collection

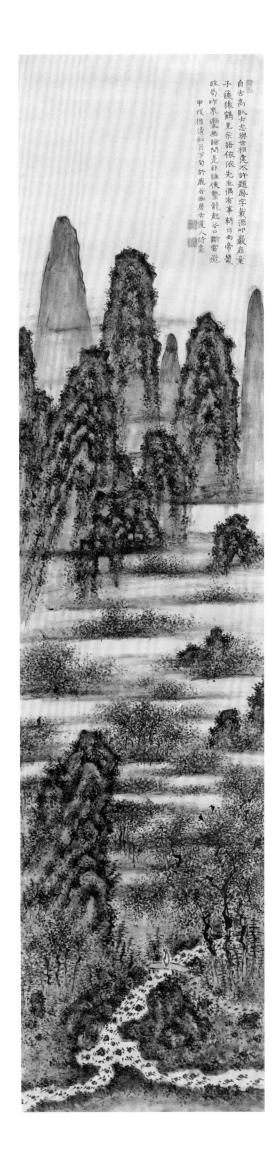

自古高卧士志與世相違意不許題鳳字戴酒卯巖扉童
子謁猿鶴見余語依依先生偶有事朝出南帝畿
欧局昨來變無端閒是非誰使蟄龍起谷口斷雲飛
甲戌德清初月下旬於鹿谷幽居古蓮人詩畫

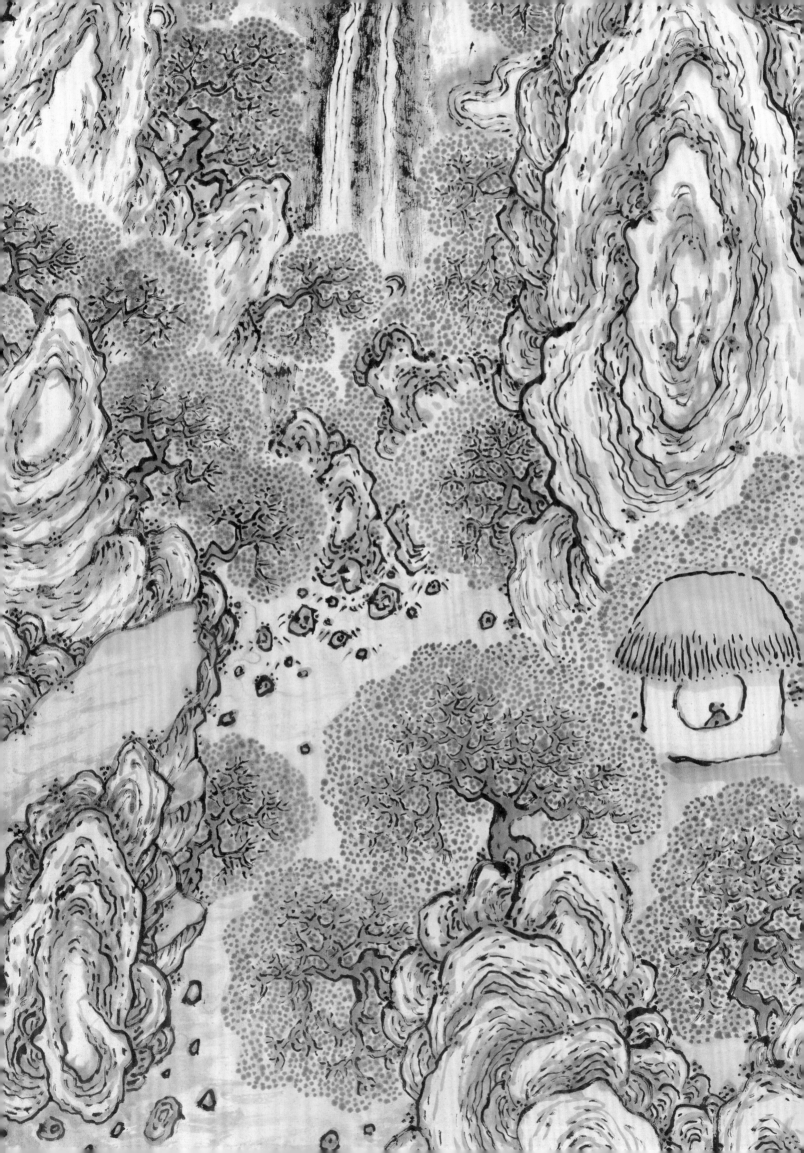

深人善容物
靜者能養心
無事因修道
和情為撫琴
松風吹大壑
山月照空林
但恐驚仙鶴
莫教樵斧侵

The deep thinker is good at comprehending things;
The serene one is able to nurture his mind.
With no pressing matters, I can cultivate the Way;
With harmonious feelings, I start to play the lute.
Wind in the pines blows through the great valley;
The mountain moon shines on the deserted wood.
Only immortal cranes might be startled:
Please do not let the woodman's axe invade.

NO. 80

*LANDSCAPE IN PALE RED*

c. 1930–35

Private collection

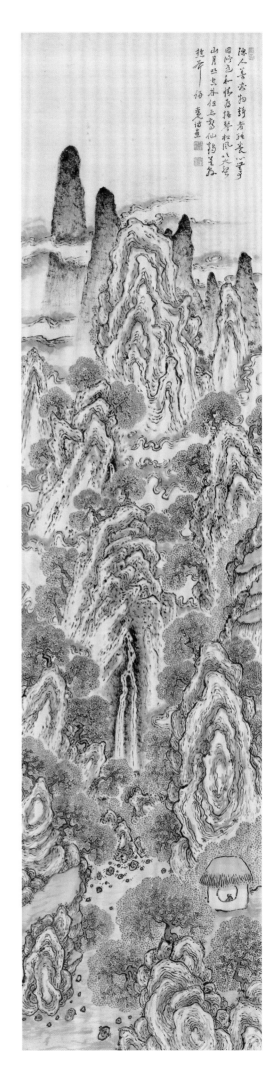

日出往南潤
猗猗綠竹陰
清風多古意
吹我塵外襟

The sun rises above the southern moisture;
Rich and full, shade from green bamboo.
A pure wind full of feelings of antiquity
Wafts them toward my dust-free lapels!

NO. 81

*SECLUSION AT A STREAM AND BAMBOO*

c. 1933

Private collection

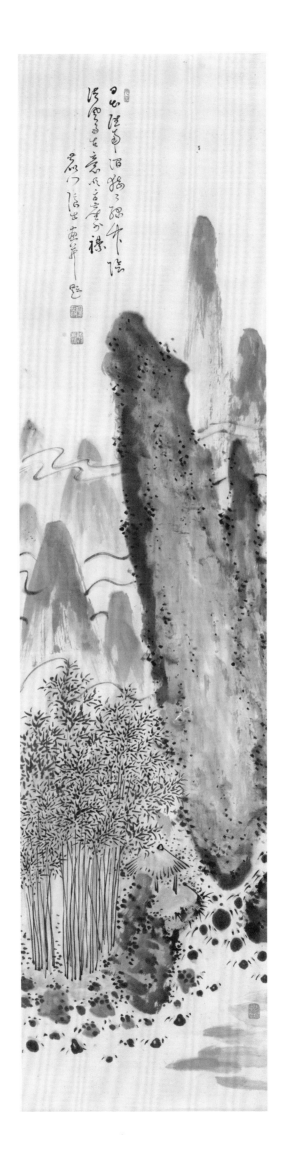

243

(FRONTISPIECE)

讀書餘事                  Things done after studying.

NO. 82

*ALBUM OF UNTRAMMELED LIVING*

March 1933

Minneapolis Institute of Art,
Gift of the Clark Center for Japanese Art & Culture
(2013.29.935)

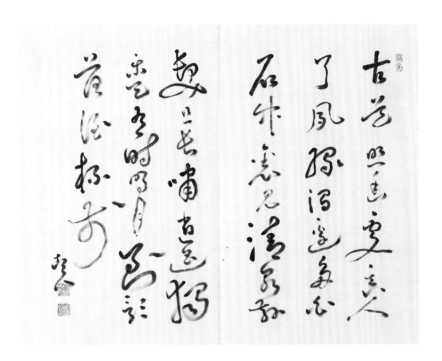

(2)

| 古道照幽処 | The ancient Way illumines hidden places; |
|---|---|
| 真人了夙緣 | The True Man lives out residual karma. |
| 澗邊多白石 | Along the stream banks, many whitish rocks, |
| 竹裏見清泉 | Through the bamboo one glimpses the crystalline stream. |
| 散髮且長嘯 | Hair hanging loose, and whistling out loud, |
| 逍遙独樂天 | I wander freely, alone loving Heaven. |
| 有時明月到 | And then at times the bright moon joins me, |
| 影落酒杯前 | Its shadows falling right near my wine cup. |

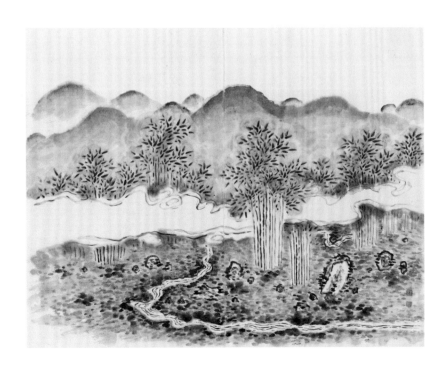

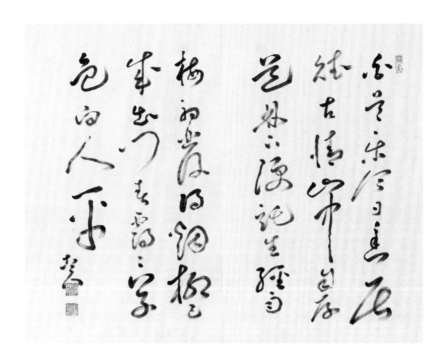

(4)

| | |
|---|---|
| 白首樂今日 | White-headed, I take joy in today, |
| 幽居賦古情 | Residing in seclusion, writing old-style poems. |
| 山中自存道 | Here in the mountains, I preserve the Way, |
| 林下便託生 | Entrusting my life to the woods. |
| 經雨梅初發 | The rains done, plum blossoms start to bloom; |
| 得煙柳已成 | With their misty look, the willows are at their peak. |
| 出門春靄々 | I go out the gate—spring haze covers all, |
| 草色向人平 | And plant hues face me with peace. |

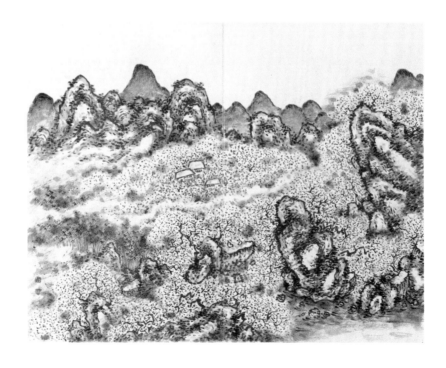

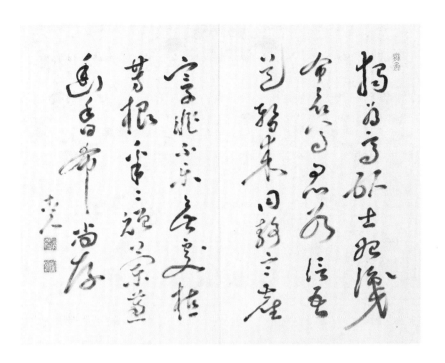

(6)

| | |
|---|---|
| 獨為高臥士 | Alone, I have become a scholar of noble reclusion, |
| 始識布衣尊 | Starting to sense how venerable is this life in plain clothes. |
| 君若信吾道 | Should you suddenly come to believe in my Way, |
| 暫來同靜言 | Please come visit, and we will share our tranquil words. |
| 塵寰非不樂 | It is not that the dusty realm is utterly without pleasures, |
| 無処植芳根 | But it lacks any ground to plant the Fragrant Root. |
| 采々贈蘭蕙 | Year after year I send out these "elegant orchids" |
| 幽香希尚存 | Hoping the subtle perfume may be preserved. |

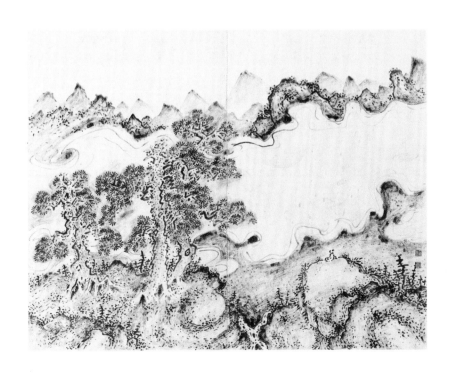

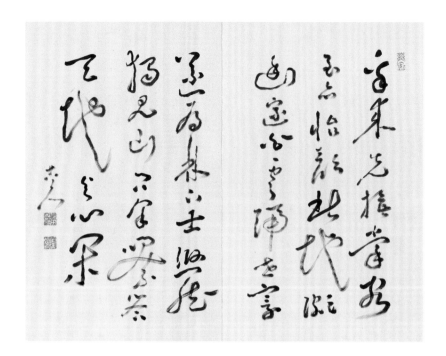

(8)

| | |
|---|---|
| 我來先撫掌 | I have come here, first to caress pines with my hands; |
| 客至亦怡顏 | Guests arrive and that too brings joy to my face. |
| 此地頗幽邃 | This place is mysterious, remote, |
| 白雲隔世寰 | White clouds cutting off the worldly realm. |
| 遂為林下士 | And so I have become a scholar beneath the trees, |
| 悠然獨見山 | In a daze, alone, gazing at mountains. |
| 問余笑不答 | You ask me, Why? I smile and do not answer: |
| 天地与心閑 | With Heaven and Earth my mind too is at peace. |

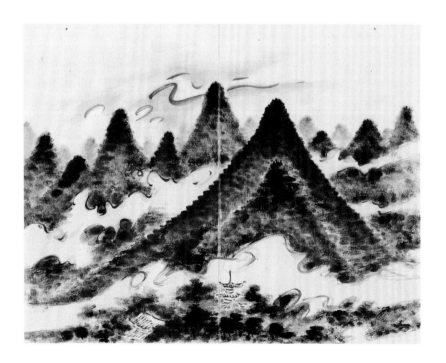

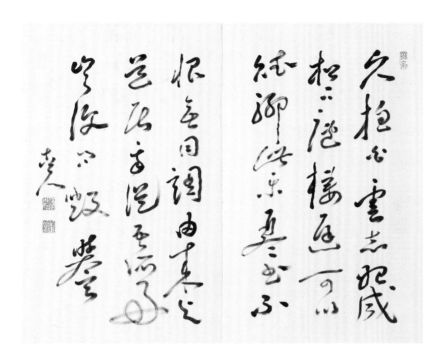

(10)

| 久抱白雲志 | For long I have harbored a desire for the white clouds, |
| 始成松下廬 | Now finally beneath the pines I have built my hut. |
| 棲遲可以賦 | My lingering reclusion is worthy of poetic expression, |
| 聊此樂琴書 | As here I enjoy my lute and books. |
| 不恨無同調 | I do not regret that I have no soulmate here; |
| 由來與道居 | Always I have resided with the Way. |
| 我從吾所好 | I simply follow what I most enjoy; |
| 豈復問毀譽 | What need to worry about praise or calumny? |

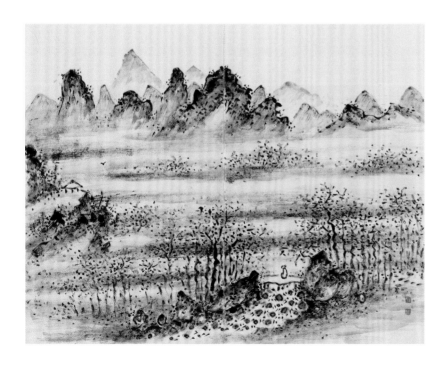

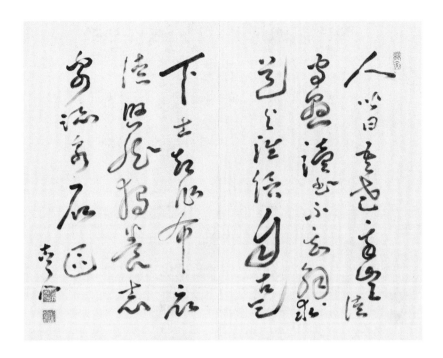

(12)

| | |
|---|---|
| 人皆曰我老 | People all say I must be getting old, |
| 我豈徒守愚 | But maybe I have been cultivating this stupidity! |
| 讀書不甚解 | I read books, but do not know how to interpret them; |
| 求道與誰俱 | I seek the Way, but have one to share with. |
| 自古天下士 | From ancient times, truly world-class scholars |
| 却作布衣徒 | Have been followers of the Way of Simple Clothes. |
| 悠然獨養志 | Trancelike, alone I nurture my intentions; |
| 寄跡泉石區 | Visitors, please note this "region of streams and rocks." |

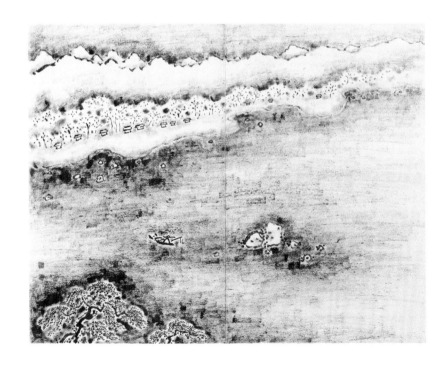

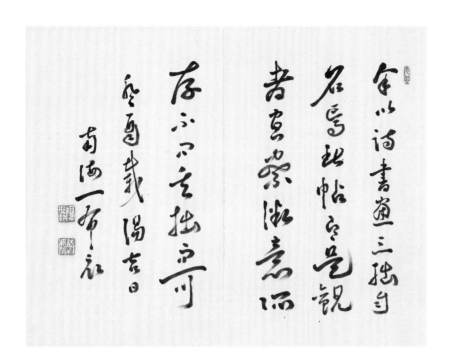

(POSTSCRIPT)

余以詩書画三拙自名焉
此帖即是観者宜察微意
所存不問其拙而可

I have named myself for poetry, calligraphy, and painting,
my "Three Clumsinesses!" This album is a perfect example.
The viewer would do well to discern wherein my subtle
meaning lies, without questioning the clumsiness.

FOLLOWING SPREAD: (DETAILS)
NO. 82 *Album of Untrammeled
Living*, leaves 4 and 6

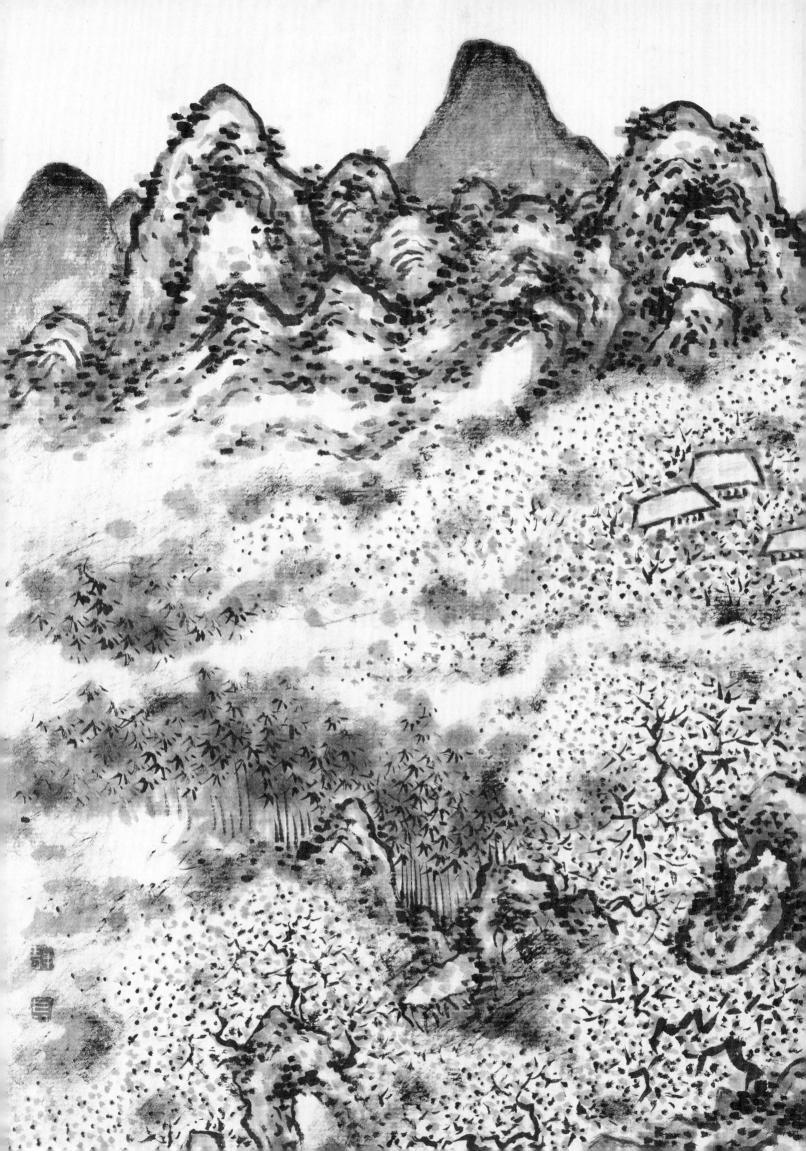

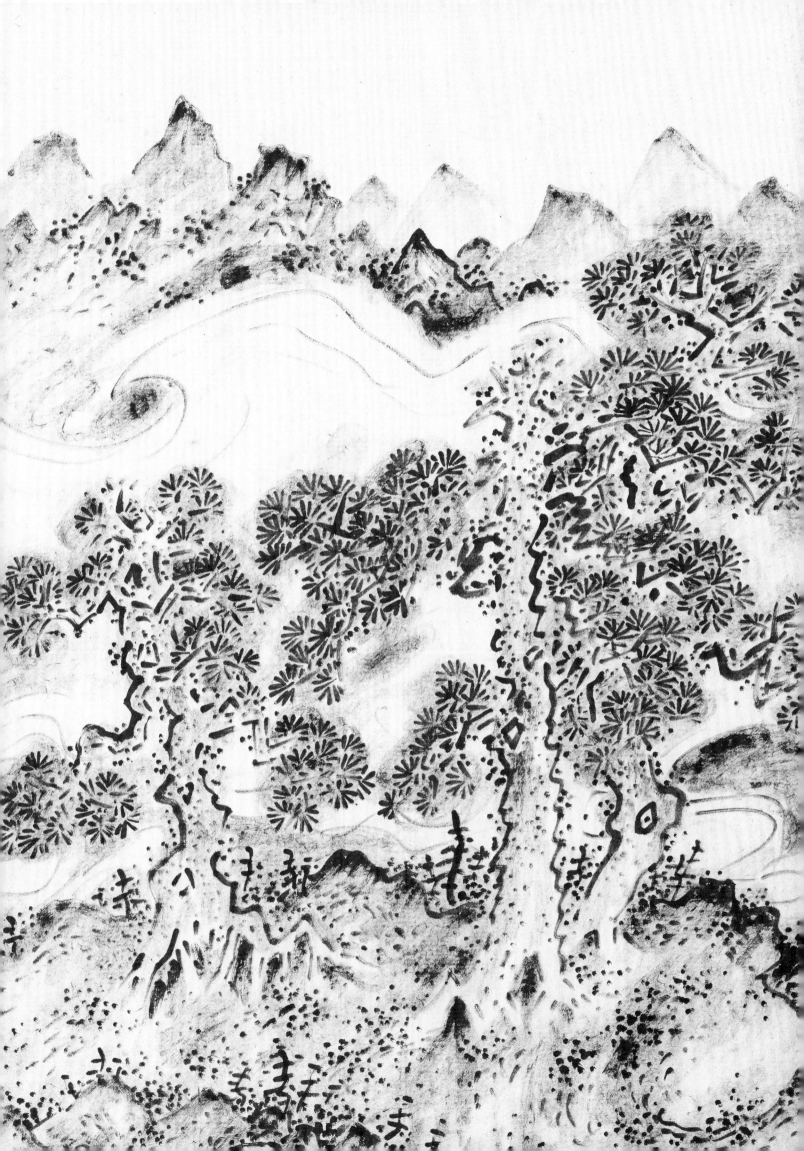

(FRONTISPIECE)

樂天者往 The nature of one who takes joy in Heaven.

NO. 83

*ALBUM OF JOY IN HEAVEN*

April 1937

Shingū City Museum of History and Folklore

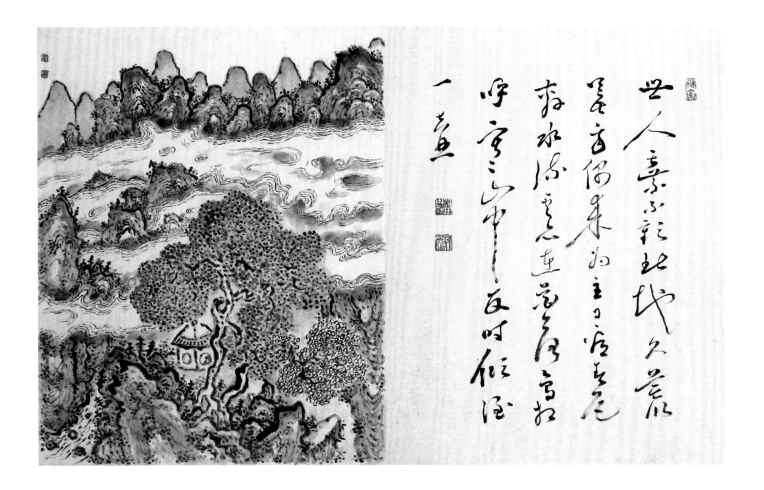

(2)

| | |
|---|---|
| 世人棄不顧 | Worldly men have left this place unheeded; |
| 此地久荒蕪 | The ground has lain all overgrown for long. |
| 我偶來為主 | I happened to have come to be its master, |
| 日看春色敷 | Daily watching spring colors spread around. |
| 水流雲亦在 | Streams are flowing, clouds are also present; |
| 花落鳥相呼 | Flowers fall, the birds call to each other. |
| 寂々山中友 | Amid the loneliness are mountain friends; |
| 時傾酒一壺 | From time to time we share a jug of wine. |

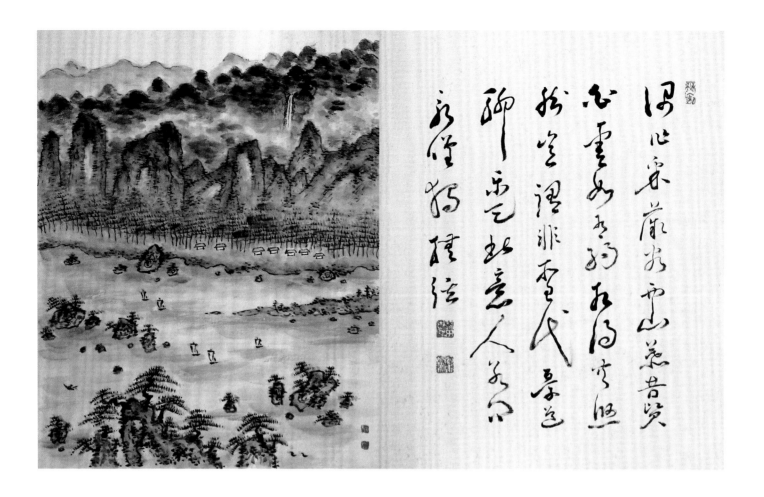

(4)

| 偶作采薇客 | Happening to be a wanderer gathering herbs, |
| 西山慕昔賢 | On the Western Mountain I admire ancient sages. |
| 白雲如有約 | The white clouds seem to have expected me: |
| 相得共悠然 | We get along, together in a dream. |
| 豈謂非聖代 | Who would say this is no sagely era? |
| 憂道聊樂天 | Joying in the Way, at ease, I love Heaven. |
| 此意人若問 | Should anyone ask me my meaning, |
| 永嘆独撫絃 | I would sigh for long, and play my lute alone. |

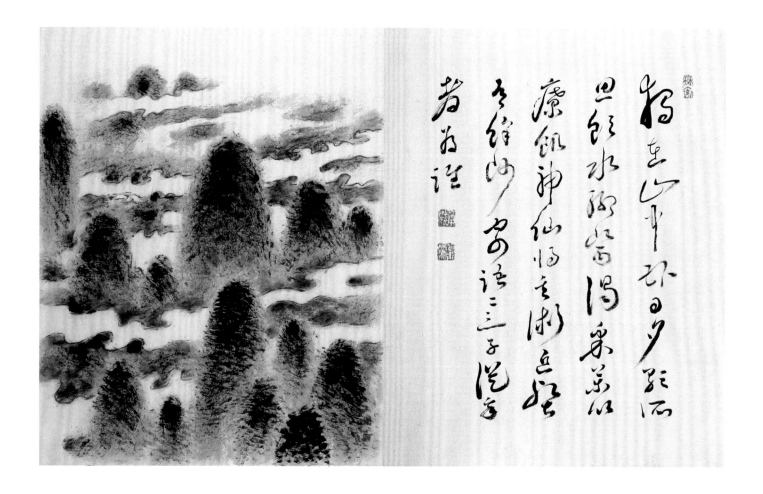

(6)

| | |
|---|---|
| 獨在山中臥 | Alone I repose up in the mountains, |
| 日夕歌所思 | At evening singing of the one I long for. |
| 飲水聊医渴 | I drink water to doctor my thirst, |
| 采藥以療飢 | Gather herbs to cure my hunger. |
| 神仙得其術 | Spirits, Immortals: I have mastered their techniques, |
| 丘壑有余師 | The hills and valleys have become my teachers. |
| | I send word to you two or three friends: |
| | Who among you will follow me? |

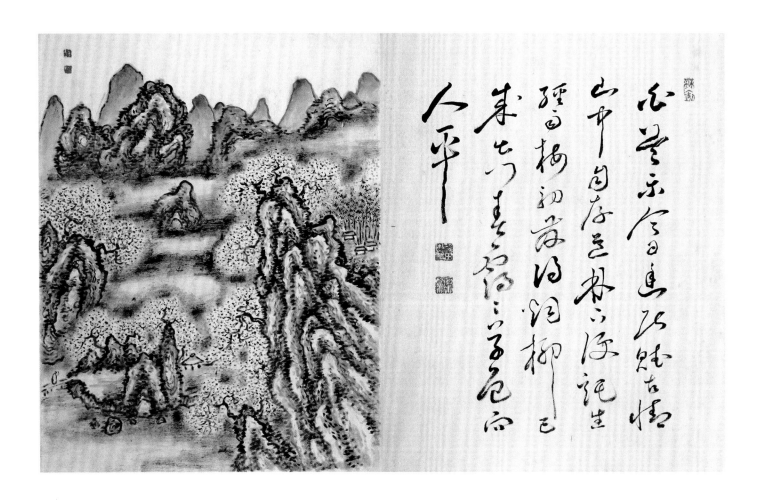

(8)

| | |
|---|---|
| 白首樂今日 | White-headed, I take joy in today, |
| 幽居賦古情 | Residing in seclusion, writing old-style poems. |
| 山中自存道 | Here in the mountains, I preserve the Way, |
| 林下便託生 | Entrusting my life to the woods. |
| 經雨梅初發 | The rains done, plum blossoms start to bloom; |
| 得煙柳已成 | With their misty look, the willows are at their peak. |
| 出門春靄々 | I go out the gate—spring haze covers all, |
| 草色向人平 | And plant hues face me with peace. |

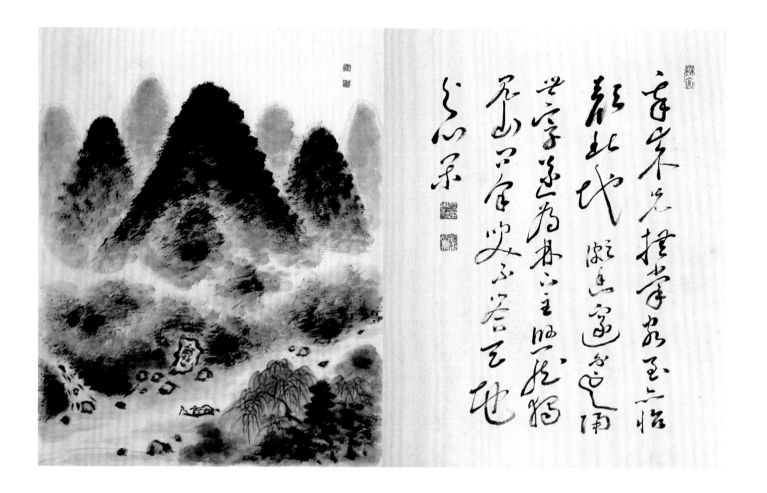

(10)

| | |
|---|---|
| 我來先撫掌 | I have come here, first to caress pines with my hands; |
| 客至亦怡顏 | Guests arrive and that too brings joy to my face. |
| 此地頗幽邃 | This place is mysterious, remote, |
| 白雲隔世寰 | White clouds cutting off the worldly realm. |
| 遂為林下士 | And so I have become a scholar beneath the trees, |
| 悠然獨見山 | In a daze, alone, gazing at mountains. |
| 問余笑不答 | You ask me, Why? I smile and do not answer: |
| 天地与心閑 | With Heaven and Earth my mind too is at peace. |

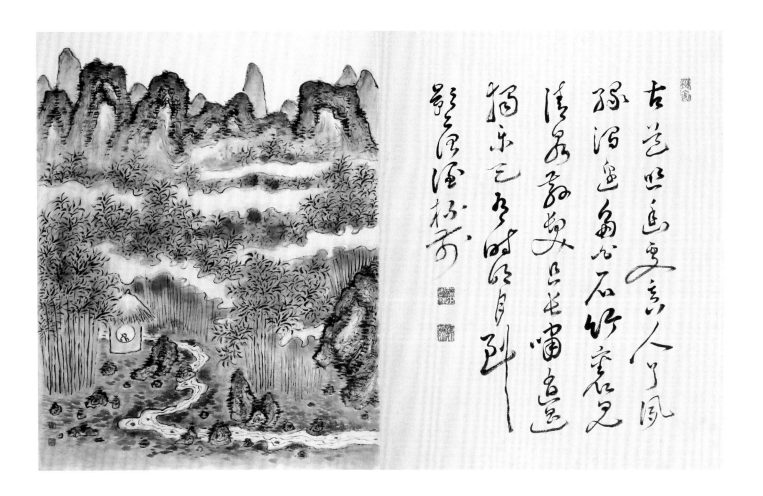

(12)

| 古道照幽處 | The ancient Way illumines hidden places; |
| 真人了夙緣 | The True Man lives out residual karma. |
| 澗邊多白石 | Along the stream banks, many whitish rocks, |
| 竹裏見清泉 | Through the bamboo one glimpses the crystalline stream. |
| 散髮且長嘯 | Hair hanging loose, and whistling out loud, |
| 逍遙獨樂天 | I wander freely, alone loving Heaven. |
| 有時明月到 | And then at times the bright moon joins me, |
| 影落酒杯前 | Its shadows falling right near my wine cup. |

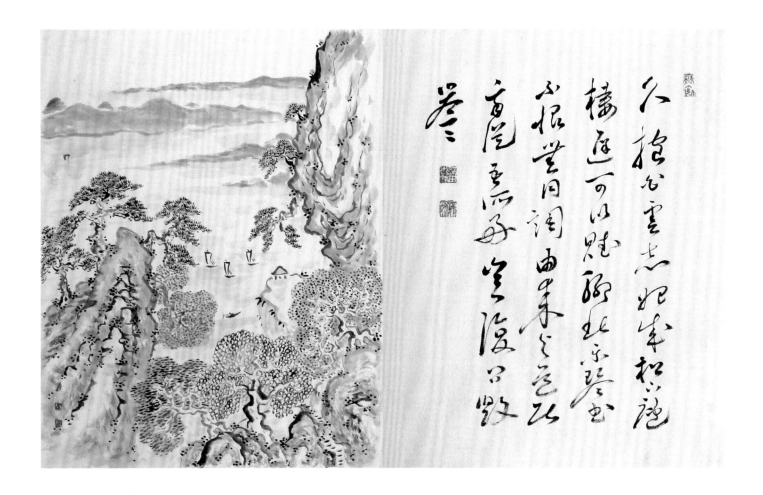

(14)

| | |
|---|---|
| 久抱白雲志 | For long I have harbored a desire for the white clouds, |
| 始成松下廬 | Now finally beneath the pines I have built my hut. |
| 棲遲可以賦 | My lingering reclusion is worthy of poetic expression, |
| 聊此樂琴書 | As here I enjoy my lute and books. |
| 不恨無同調 | I do not regret that I have no soulmate here; |
| 由來与道居 | Always I have resided with the Way. |
| 我從吾所好 | I simply follow what I most enjoy; |
| 豈復問毀譽 | What need to worry about praise or calumny? |

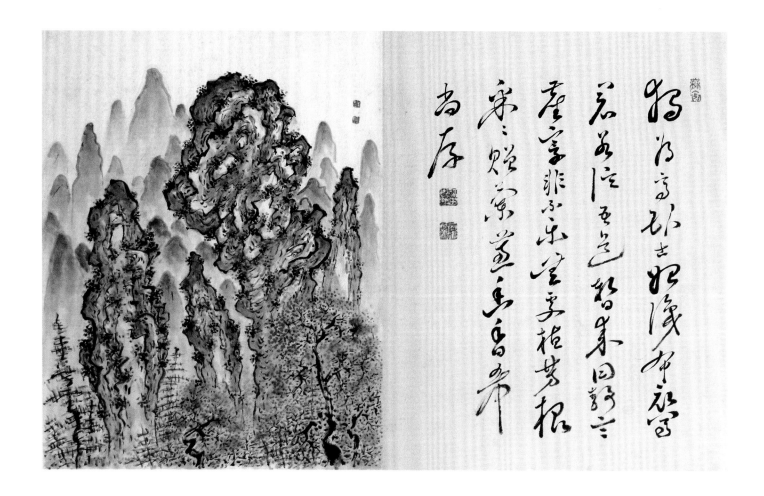

(16)

| | |
|---|---|
| 獨為高臥士 | Alone I am a scholar in high reclusion, |
| 始識布衣尊 | Starting to get the honor of wearing simple clothes. |
| 君若信吾道 | If you, sir, believe in this my Way, |
| 暫來同靜言 | Please come stay a while and share serene conversation. |
| 塵寰非不樂 | It is not that the dusty realm is lacking pleasures, |
| 無處植芳根 | But nowhere there can you plant the Fragrant Root. |
| 采々贈蘭蕙 | I gather and gather orchids to give you, |
| 幽香希尚存 | As I hope their secret fragrance can be preserved. |

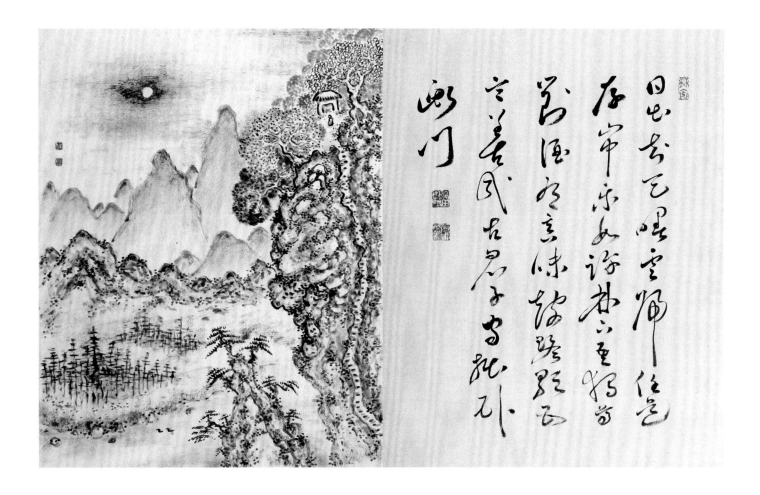

(18)

| | |
|---|---|
| 日出知天曙 | The sun comes up, we know the warmth of Heaven; |
| 雲歸任道存 | Clouds return, allowed by the Way to survive. |
| 山中樂如許 | With such joy here in the mountains, |
| 林下吾獨尊 | Beneath the forest, I alone find honor. |
| 對酒有真味 | Facing wine, which has the taste of truth, |
| 皷琴歌五言 | I play my lute and sing my five-word verse, |
| 善哉古君子 | Ah, how wonderful the gentlemen of old, |
| 守拙臥衛門 | Preserving their simplicity even in vulgar garrisons. |

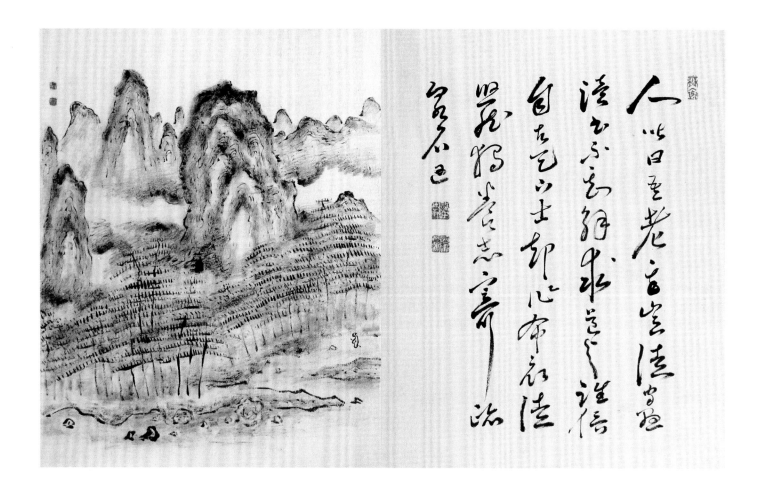

(20)

| | |
|---|---|
| 人皆曰我老 | People all say I must be getting old, |
| 我豈徒守愚 | But maybe I have been cultivating this stupidity! |
| 讀書不甚解 | I read books, but do not know how to interpret them; |
| 求道與誰俱 | I seek the Way, but have one to share with. |
| 自古天下士 | From ancient times, truly world-class scholars |
| 却作布衣徒 | Have been followers of the Way of Simple Clothes. |
| 悠然獨養志 | Trancelike, alone I nurture my intentions; |
| 寄跡泉石區 | Visitors, please note this "region of streams and rocks." |

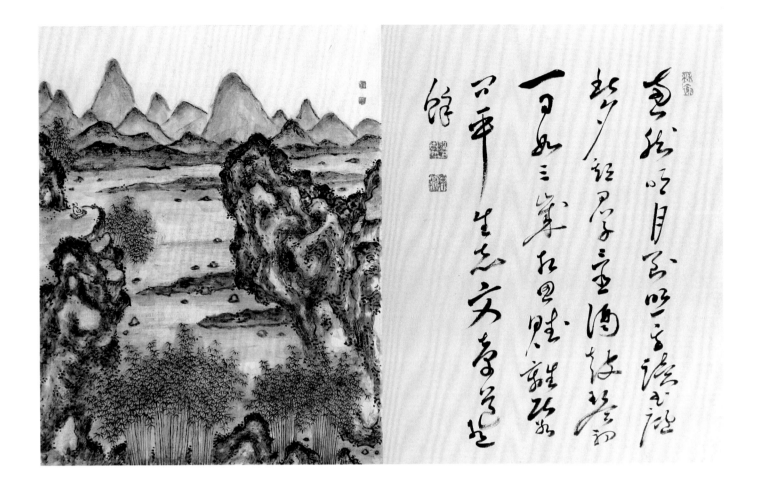

(22)

| 惠然明月至 | Kindly, the bright moon appears, |
| 照我讀書廬 | Illuminating my hut for reading books. |
| 此夕期君子 | This evening I await a gentleman, |
| 置酒皷琴初 | Setting out wine, starting to play my lute. |
| 一日如三歲 | One day can seem like three years: |
| 相思賦離居 | Thinking of him, I wrote poems about our separation. |
| 若問平生志 | Should he ask the goal of my whole life: |
| 文章道有餘 | In letters lies more than enough of the Way. |

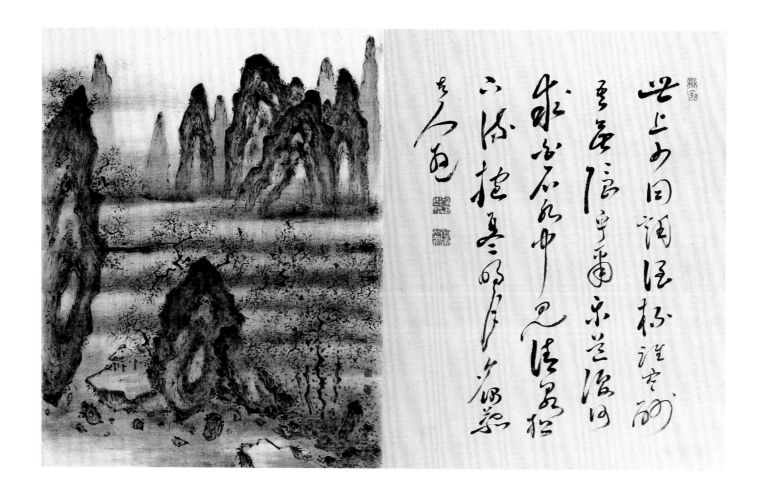

(24)

| | |
|---|---|
| 世上少同調 | Few are the soulmates in this world— |
| 酒杯誰共酬 | With whom am I to share cups of wine? |
| 我無隱乎爾 | It is not that I am withdrawing from others: |
| 樂道復何求 | I take joy in the Way, so what more need I seek. |
| 白石水中見 | White rocks appear in the stream; |
| 清泉松下流 | Pure waterfalls flow beneath the pines. |
| 抱琴明月夕 | Clutching my lute this night of bright moonlight, |
| 偶慕古人遊 | I admire the wanderings of the ancients. |

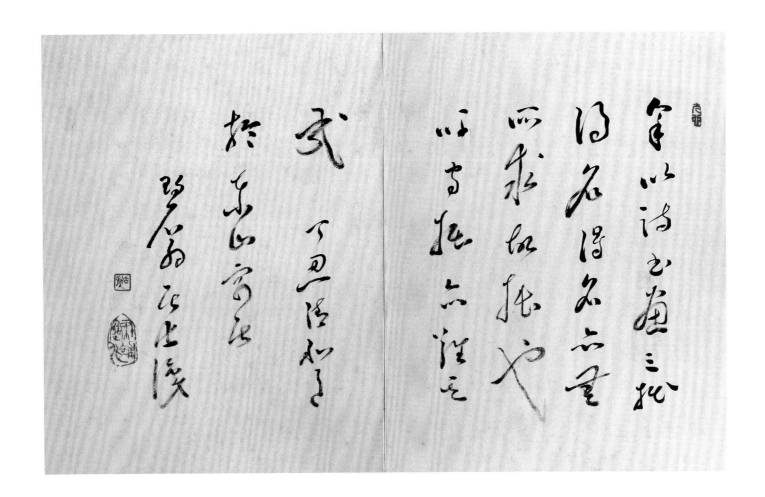

(POSTSCRIPT)

余以詩書畫三拙自名
得名亦無所求此拙也
呼豈拙亦難究哉

I have named myself for poetry, calligraphy, and painting,
my "Three Clumsinesses!" Having achieved this name,
I have nothing further to seek. This "clumsiness" is simply
so called. But is it not possible that clumsiness is indeed
difficult to penetrate?

FOLLOWING SPREAD: (DETAILS)
NO. 83 *Album of Joy in Heaven,*
leaves 6 and 16

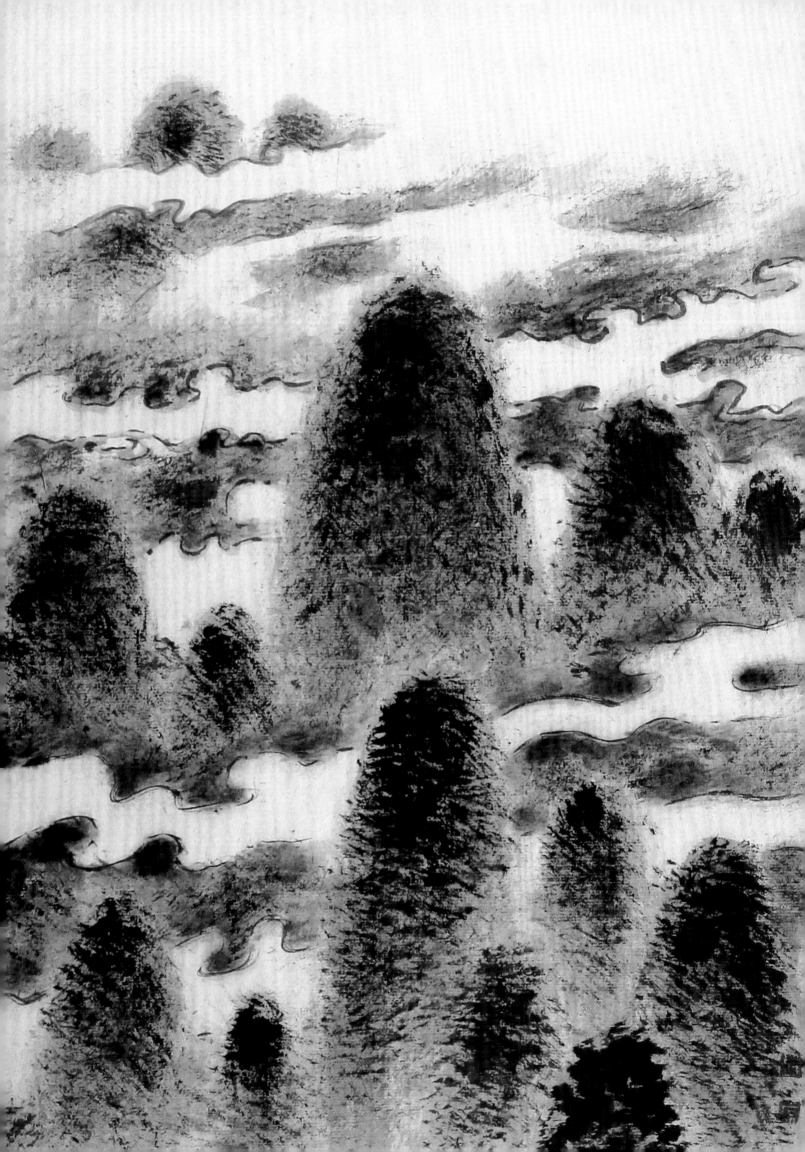

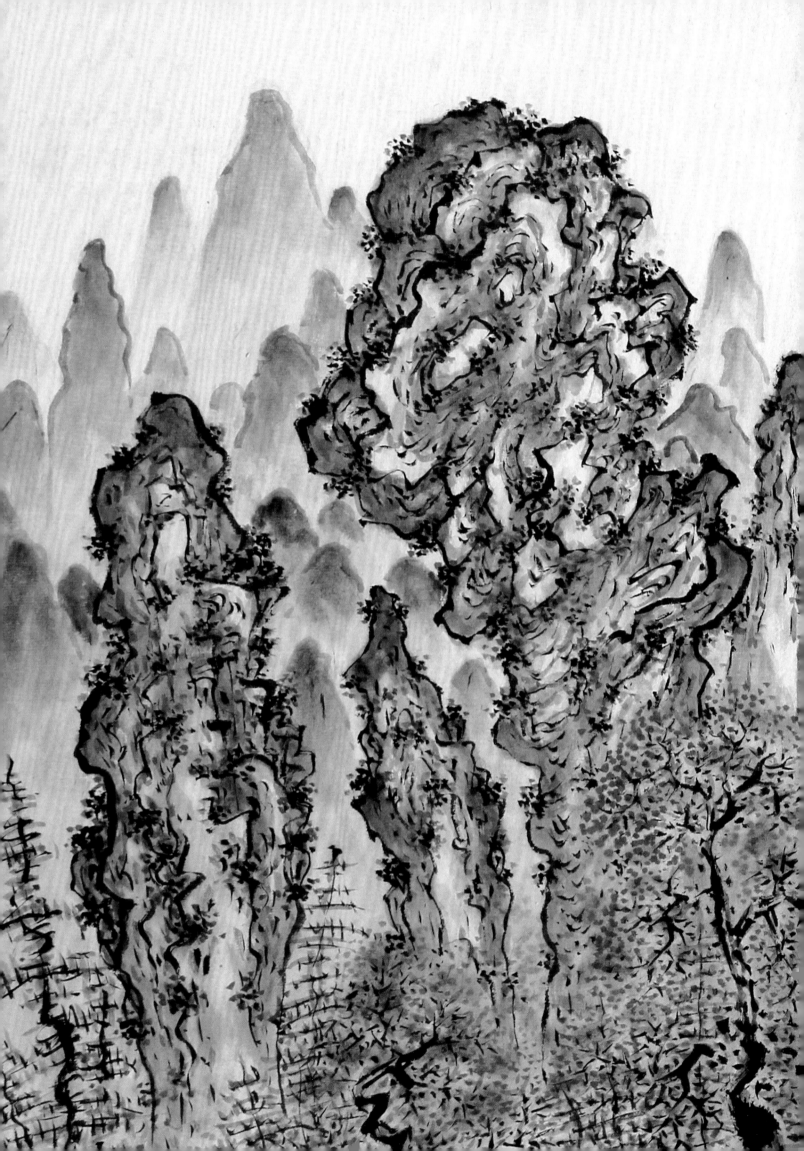

# HAIGA

*HAIGA* UNITE A HAIKU POEM with a simple painting, which might depict a man in a boat or objects such as hats, *sake* cups, teapots, animals, flowers, and vegetables as in *Sponge Gourds* (no. 53). Although Kodōjin composed hundreds of haiku, he did not regularly use them on his paintings, and therefore the number of his *haiga* is comparatively small. He created them from the beginning of his painting career, although they do not commonly appear as hanging scrolls until the 1920s. In *Sharing One Mind* (no. 84), executed in an ink wash, a tiny mouse sits on a large daikon radish. The combination of a mouse and a daikon (*nezumi daikon*) is a representative winter motif in Japanese art that was popular in the nineteenth and early twentieth centuries. It is mentioned in volume 4 of *Blownfur Grass* (*Kefukigusa*), a guide to haikai poetry compiled in 1638 by Matsue Shigeyori (1602–80). Judging from the seals and Kodōjin's inscription on the box recording that it was painted two decades previously, *Sharing One Mind* most probably dates to around 1922–24. There is at least one other painting by Kodōjin with this theme, a smaller work dating to the 1930s and composed in a horizontal format with the poem on the right.

Kodōjin clearly favored floral subjects, such as nandina, over fauna. Nandina is an evergreen shrub native to East Asia with red flowers in late autumn and winter. A tall plant that can reach over 7 feet (2 m), the nandina was cherished by literati for its appearance, even though the plant's poisonous berries contain cyanide. *Nandina Tree* (no. 85) is the largest and most elaborate to date of the artist's four nandina paintings. Another of the nandina paintings (its whereabouts unknown) reproduces the same poem as on *Nandina Tree*.

Lotus flowers were a relatively common theme in Kodōjin's oeuvre, and there are at least seven such paintings documented. On occasion, he combined lotus with other motifs, most notably kingfisher but also dragonflies, as seen in *Crimson Lotus Flower* (no. 86) from April 1931. The poems inscribed on his lotus paintings could be Chinese or Japanese. Here, it is a *tanka*, a genre of classical Japanese poetry that is fourteen syllables longer than a haiku.

FACING PAGE: (DETAIL)

NO. 88 *Smoking Out Insects*

270

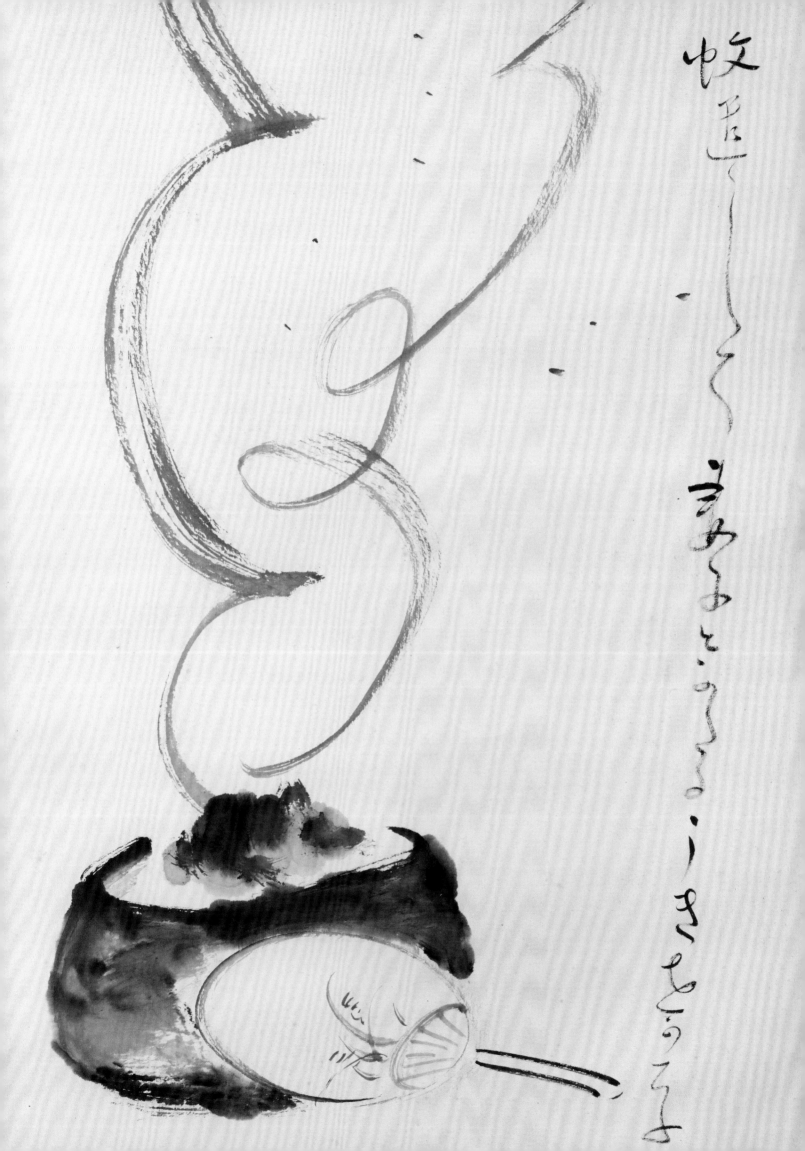

灯ともして
大根洗ふ
野川かな

Lighting a lamp
They wash a daikon,
In a river through a field.

NO. 84

*SHARING ONE MIND*

c. 1922–24

Private collection, USA

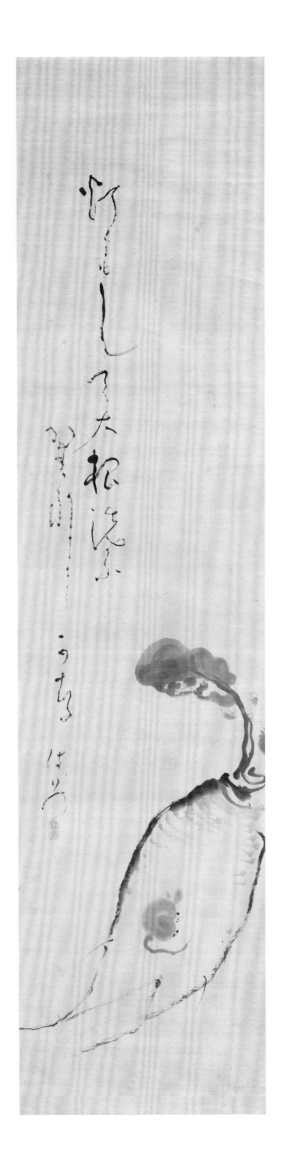

涼しさや大根洗ふ
瀬川にうつるはり

南天の
雪ふみ落す
小鳥か那

Snow knocked off
Nandina tree,
Little birds.

NO. 85

*NANDINA TREE*

c. 1929–32

Minneapolis Institute of Art, Gift of the Clark Center
for Japanese Art & Culture, formerly given to the Center
by Elizabeth and Willard Clark (2013.29.837)

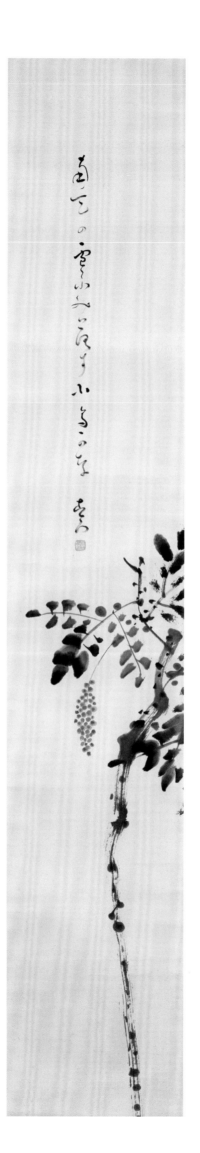

ふとむすひ
ふと砕けて
蓮葉の
露ころ／＼と
風ふきわたる

Suddenly forming,
Suddenly collapsing,
Dewdrops on lotus leaves
Are rolled around
By the blowing wind.

NO. 86

*CRIMSON LOTUS FLOWER*

April 1931

Minneapolis Institute of Art,
Gift of David Tausig Frank and Kazukuni Sugiyama
(2015.111.16)

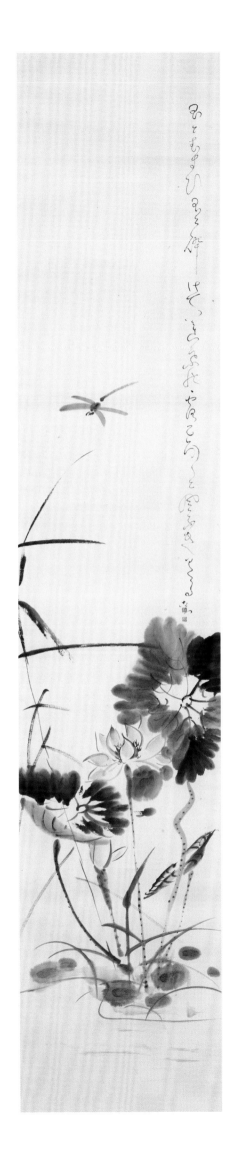

雪達磨
已に寂滅
為樂かな

Snow Daruma
Already vanished to nirvana,
Real joy.

NO. 87

*SNOW DARUMA*

c. 1943

Private collection

蚊遣して
妻子とかたる
うきよかな

Smoking out insects,
Chatting with wife and children,
The floating world.

NO. 88

*SMOKING OUT INSECTS*

c. 1927–41

Minneapolis Institute of Art,
Gift of the Clark Center for Japanese Art & Culture
(2013.29.967)

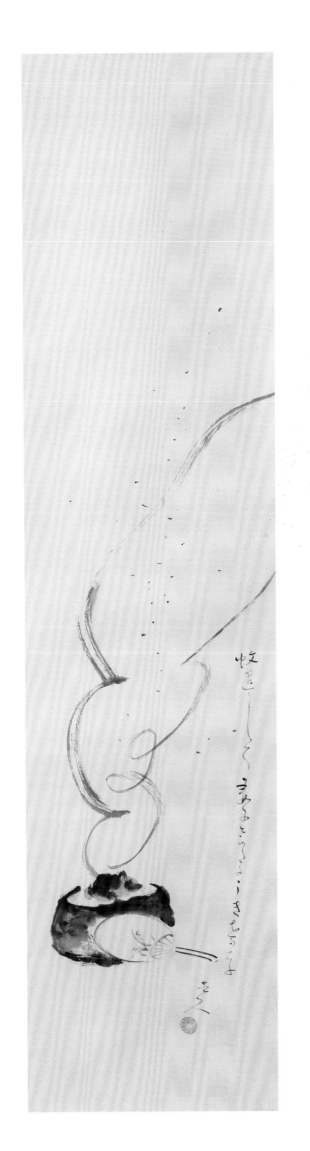

# CALLIGRAPHY

THE JAPANESE WRITING SYSTEM was adopted from Chinese characters and can be written in five different script types: seal (J: *tensho*), clerical (J: *reisho*), standard (J: *kaisho*), running (J: *gyōsho*), and cursive (J: *sōsho*). Kodōjin did not create calligraphies in the seal or clerical script, but he employed almost one hundred different seals, the majority of them in seal script. The considerable number of his seals and the fact that he only used some sporadically suggests that he cut his own seals. He would consequently have had knowledge of seal script, although in his calligraphy he chose between the standard, running, or cursive types. Each script form has its own rhythm, movement, and timing from the more exact strokes of the lexical standard *kaisho*, to the fluid running *gyōsho*, to the wild dancing of the cursive *sōsho*. Nonetheless, Kodōjin's cursive style was extremely free. It might even be placed in its own "ultra-cursive" category since at times his writing was so idiosyncratic that only the very skilled could read it.

Among Kodōjin's largest calligraphies is *Clearing after Snow, Five-Character Verse* (no. 89), which he wrote in five vertical lines in an unfettered style that unleashed his creative energy and power. Some single characters take up the space for what would normally be allocated to two, such as 帯 (J: *tai*) at the end of the first line. The poem ends with the character 中 (J: *chū*), which energetically cascades over the length of six characters. The painting *Fisherman, Five-Character Verse* (no. 90) is on satin, giving it a brighter sheen than a work on silk. This is the only calligraphy scroll with this poem, but it was his favorite on landscapes featuring a lone fisherman in a boat. At least four such pieces have been identified.

FACING PAGE: (DETAIL)

NO. 91 *Mount Kamayama, Five-Character Verse*

雪晴天一碧

鶴唳帶春風

獨立世塵外

滿身清氣通

古潭寒月白

幽石冷雲空

深夜無人見

梅花映水中

Clearing after snow—the sky a single blue;

A crane's cry is carried by the spring wind.

Alone I stand beyond the world's dust,

My whole person permeated by fresh air.

In the ancient pond the cold moon shines white;

Over hidden rocks, chilly clouds hang empty.

Deep in the night, there is no one to see

The plum blossoms reflected in the water.

NO. 89

*CLEARING AFTER SNOW, FIVE-CHARACTER VERSE*

1910s

Minneapolis Institute of Art,
Gift of the Clark Center for Japanese Art & Culture
(2013.29.1015)

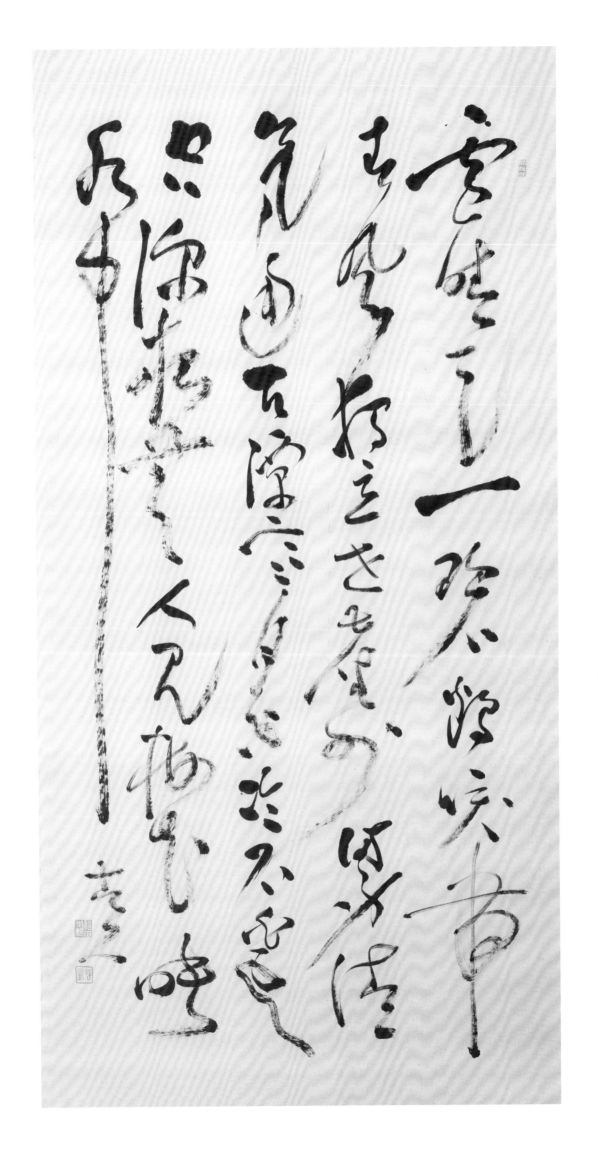

余亦学漁父

磻渓風月宜

蘆荻深蔵跡

文王未得知

I too will imitate the fisherman,

At River Pan, in wind and moonlight.

But I will hide my tracks deep among the reeds

So King Wen will never find me.

NO. 90

*FISHERMAN, FIVE-CHARACTER VERSE*

January 1922

Private collection, USA

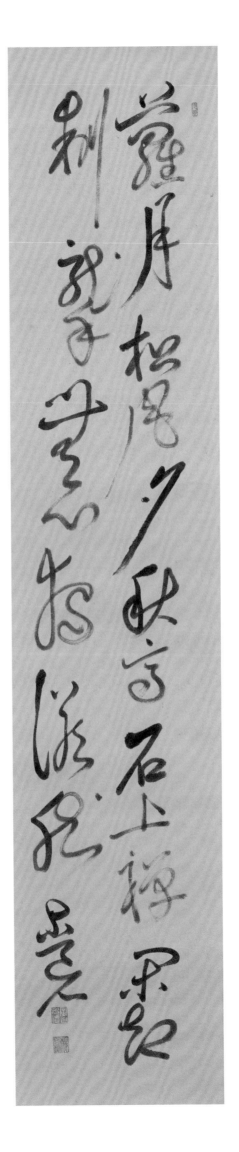

明月松间照，清泉石上流，竹喧归浣女，莲动下渔舟

竈山夜籟起
直到田水門
清石常滴海
終年惡浪翻

Mount Kamayama—nighttime sounds arise
And continue all the way to Tamizu Gate.
Over pure rocks, always dripping into the sea,
All year long, dangerous waves churning.

NO. 91

*MOUNT KAMAYAMA, FIVE-CHARACTER VERSE*

April 1940

Minneapolis Institute of Art,
Gift of David Tausig Frank and Kazukuni Sugiyama
(2015.111.9)

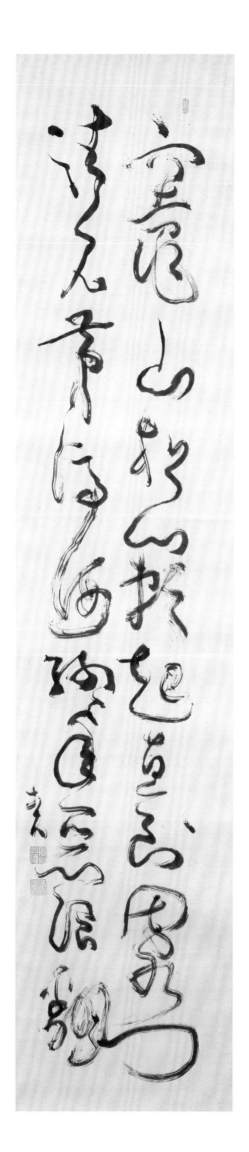

南無阿弥陀佛

I take refuge in Amida Buddha.

NO. 92

*I Take Refuge in Amida Buddha*

Winter 1942

Private collection

# Text and Image in Kodōjin's Paintings

THE VAST MAJORITY of Kodōjin's paintings have Chinese-style poems (*kanshi*), a literary genre in which he excelled. His first published poetry book, *Cultivating Clumsiness, Preserving the Truth* (*Yōsetsu hōshin*) of April 1912, has twenty-five *kanshi*. It was quickly followed in October by *Seisho's Mountain Studio Collection* (*Seisho sanbōshū*), an extensive anthology of 254 poems. Some seven years later, in July 1919, he released *Poems and Paintings by Kodōjin* (*Kodōjin shiga*) with forty-four poems. The *Free and Easy Wandering Collection* (*Shōyōshū*) with 132 poems appeared in February 1921. And finally, in 1928, he compiled a second volume of *Seisho's Mountain Studio Collection* with 140 poems, which was never issued. For reasons still unknown, thirty poems from *Poems and Paintings by Kodōjin* were republished in other anthologies. There seems to be only two publications of Kodōjin's haiku: the 1913 *Collection of Poems by Haritsu* (*Haritsu kushū*) with 263 haiku and the January 1921 *Draft Poems by Kodōjin* (*Kodōjin eisō*) with 113 poems of various forms.

Throughout most of Kodōjin's art practice, he maintained a degree of flexibility in his pairing of text and image, but why he selected one poem over another for a particular composition is not entirely clear. Most paintings from the first two decades of his career are inscribed with original poems that he composed specifically for an artwork. Subsequently, he mostly employed existing poetry from one of his anthologies. The majority of the poems on his early paintings were not included in future anthologies, with exceptions, for example, of the verse on *Moon over Azure Mountains* (no. 1), *Quiet Setting of a Mountain Creek* (no. 4), and *Pine Trees between Cliffs* (no. 10), which were later published in *Seisho's Mountain Studio Collection*. Kodōjin describes the practice of composing an original poem in two lengthy, almost identical, prose postscripts on landscapes from 1926 (e.g., no. 45):

> *I merely depict the mountains and rivers of my heart, painting the inspiration of a moment. Coming and going with liberated hiking staff, I may also come up with a poetic inscription. And then, a thousand years later, should the painting suffer damage or loss, this poem may serve to preserve its spirit, an equivalent to the actual painting! Would that not be worthy of just one laugh?*

(translation by Jonathan Chaves)

Kodōjin sometimes used the same poem on similarly themed paintings. No. 208 in *Seisho's Mountain Studio Collection* was his go-to poem for simple waterfalls, and no. 209 in that anthology for landscapes that illustrate a solitary fisherman in a boat (no. 90). The poem inscribed on *Morning Sun over Mount Fuji* (no. 65) appears on four Fuji paintings. But Kodōjin did not usually follow a particular pattern. There are many instances of one poem appearing on paintings seemingly unrelated to each other, except for the fact that they are by Kodōjin. Examples of paintings that share the same poem include:

1)  Ten instances of a poem in *Seisho's Mountain Studio Collection* (no. 50): no. 4 (1902, monochrome landscape), no. 22 (1918, polychrome landscape), no. 72 (1931, monochrome landscape), fig. 17 (1935, monochrome? landscape), and six further polychrome or monochrome landscapes (1900s–30s);

2)  Four instances of a poem in *Seisho's Mountain Studio Collection* (no. 37): no. 75 (c. 1925–35, bamboo in snow), no. 81 (c. 1933, polychrome landscape), a monochrome landscape from 1936 (not illustrated), and a polychrome landscape from c. 1930–38 (not illustrated);

3)  Three instances of a poem in *Cultivating Clumsiness, Preserving the Truth* (no. 8): no. 50 (c. 1922–40, polychrome landscape), no. 82, leaf 8 (1933, monochrome landscape), and no. 83, leaf 10 (1937, monochrome landscape);

4)  Two instances of a poem in *Seisho's Mountain Studio Collection* (no. 30): no. 17 (1914, monochrome landscape) and no. 57 (1932, blue-green landscape).

# FINAL YEARS, THE 1940s

VERY FEW OF KODŌJIN'S paintings and calligraphies can be firmly dated to the 1940s, and it is clear that the artist was no longer as prolific as he once was. *Quiet Setting of a Mountain Creek* (no. 93) from the spring of 1940 is the last detailed landscape by him. Following the traditional Japanese age system whereby a child is one year old at birth, Kodōjin turned seventy-seven in 1941, an auspicious birthday in East Asia. On this occasion, he painted a self-portrait that pictures him as a young man (no. 94), perhaps done when Kodōjin was in Kyoto or in Shingū for birthday celebrations, as attested by a photograph showing him together with ten friends, colleagues, and supporters outside a restaurant. This is the last recorded visit of Kodōjin to Wakayama. His health steadily in decline, the artist's frail appearance is apparent in another photograph from shortly before his death (fig. 18). In 1942, he produced a calligraphy invoking the Amida Buddha, the only scroll with Buddhist prayer known by his hand (no. 92).

Japan took control of Taiwan in 1895 and annexed Korea in 1910. In 1931, it invaded Manchuria where it established the puppet state of Manchukuo the following year. The Japanese invasion of China began in 1937, and the attack on Pearl Harbor in 1941 marked the beginning of the Asia-Pacific War. Quite a number of Kodōjin's paintings from the 1940s incorporate the red sun, a symbol of Japan, and the accompanying poems speak of a victorious country (no. 95). This does not necessarily imply that Kodōjin had become an ultranationalist and was ardently pro-war. In fact, he does not appear to have been politically active; it was more likely that he was following the general patriotic trend at this time in supporting Japan's wartime propaganda. In winter of 1943, he began to use new seals, one of a stylized Mount Fuji, the other resembling the Japanese national flag of a red sun on a white ground.

Kodōjin's second son Minoru was drafted and killed in battle in northern China on May 30, 1944, aged just thirty-seven. Kodōjin was grief stricken at losing his third child and second son. Two weeks later, on the evening of June 13, his old friend Taiji Gorōsaku came from Wakayama to visit him. Kodōjin gave him a painting of red bamboo that he had done the previous winter. Three months later, on September 10, the seventy-nine-year-old Kodōjin died in the early morning hours. The deprivations of wartime undoubtedly made life difficult, but the family was not impoverished, and Kodōjin did not die from starvation as asserted by Stephen Addiss (Addiss 2000, pp. 54, 161). Addiss interpreted the recollection by Kodōjin's student Watase Ryōun, who was with him during his final days, that at some point Kodōjin had refused to eat. But possessing neither the energy nor the willpower to continue, it is clear that Kodōjin passed away from natural causes.

Addiss also claimed that Kodōjin "destroyed a great deal of his collected writings before his death" (Addiss 2000, pp. 55, 161). This, too, cannot be substantiated. The manuscript for a second volume of the Chinese-style poetry anthology *Seisho's Mountain Studio Collection*, for example, survived in his family's possession (reprinted in Chiba 2011), as does his correspondence with many individuals over the decades (for their names, see Matsumoto 2005b, pp. 105–8).

Kodōjin was fond of the phrase "Things done after studying" (*Dokusho yoji*), which appears several times in his work, especially as a frontispiece or a postscript text in albums dating from 1918 to 1933. It encapsulated his belief that his paintings were spontaneous products of his leisure time, in contrast to more serious pastimes such as the study of books. "I just happen," he writes in the postscript to his 1918 *Album of White Clouds* (no. 20), "to paint a landscape: the world will debate whether it is skillful or clumsy." And for that, this publication seems a fitting tribute to this talented and humble artist.

FIG. 18 Kodōjin, c. 1944, Kumanokodo Nakahechi Museum of Art

観樹知異心
聴鳥知殊音
日出見山高
月來見水深
風行花自動
天寒魚自沈
靜者無雜念
忘跡理可尋

Contemplating, grasping the mind with thoughts of departure,

Alone I seek to know extraordinary music.

The sun emerges—one sees the height of the mountains;

The moon arrives—one sees the water's depth.

The wind blows—all the birds in motion;

The sky turns cold—fish naturally submerge.

In serenity, with no wild thoughts,

The forgotten path now can be found again.

NO. 93

*QUIET SETTING OF A MOUNTAIN CREEK*

Spring 1940

Minneapolis Institute of Art,
Gift of David Tausig Frank and Kazukuni Sugiyama
(2015.111.20)

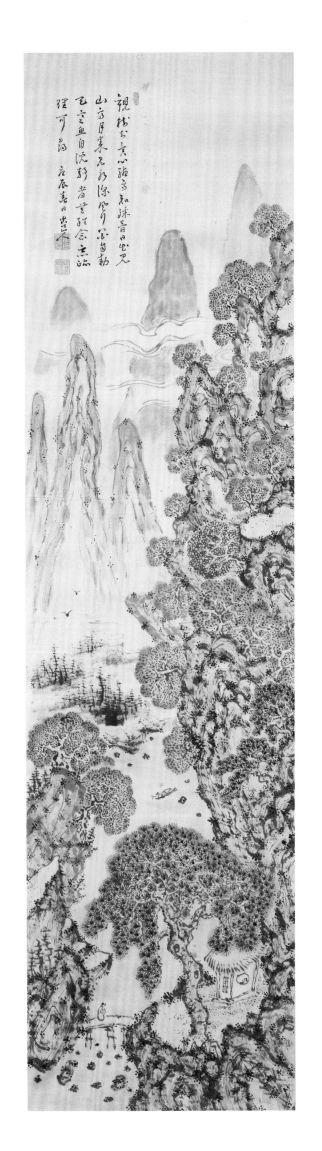

297

喜寿

Aged seventy-seven.

NO. 94

*SELF-PORTRAIT OF THE VENERABLE SEISHO*

1941

Minneapolis Institute of Art,
Gift of the Clark Center for Japanese Art & Culture
(2013.29.1005)

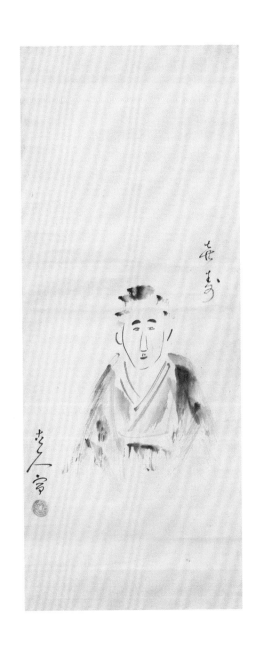

天半朱霞氣
雲中白鶴飛

Half the sky glows with red-haze energy;
Among the clouds white cranes are flying.

NO. 95

*PINE TREE AND RISING SUN*

c. 1942

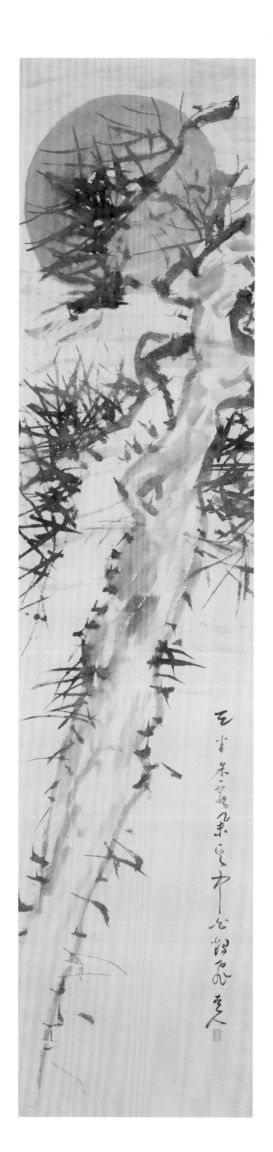

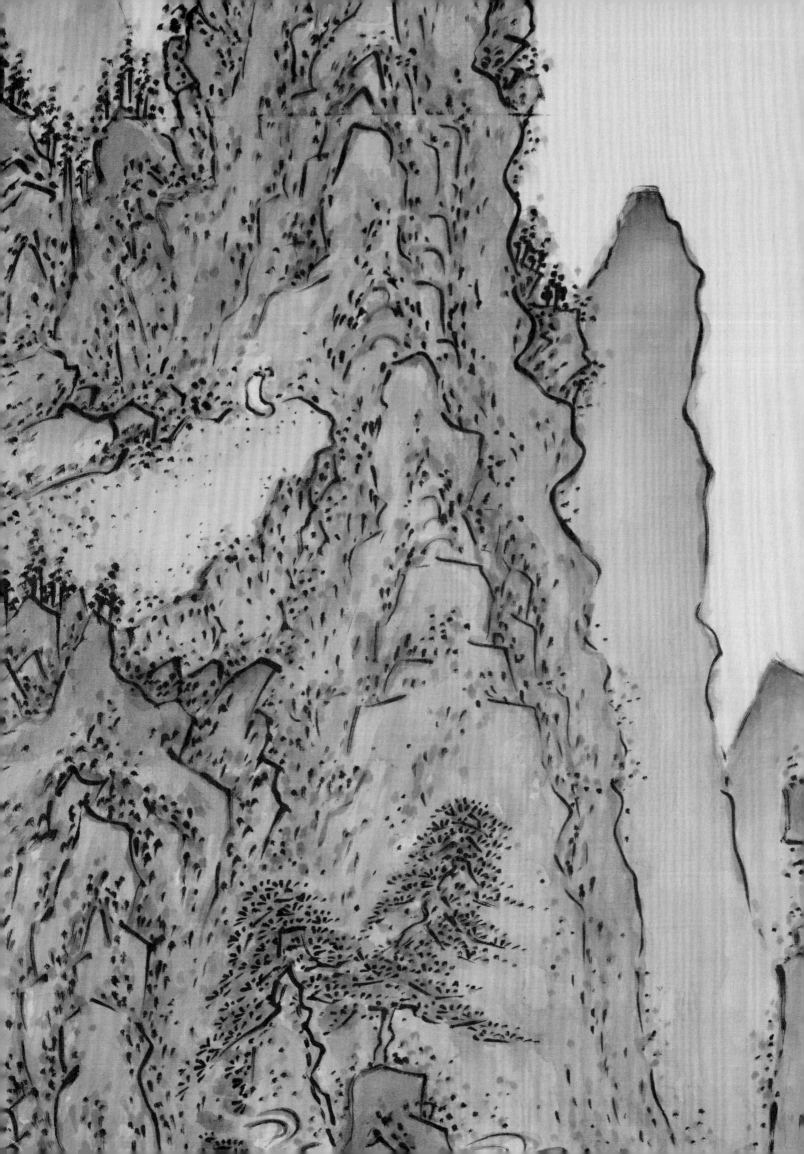

FUKUDA
KODŌJIN
IN THE REALM
OF THE
LITERATI
PAINTING
TRADITION

PAUL BERRY

THE CAREER OF THE ARTIST FUKUDA KODŌJIN is one of conundrums: how was it that his work was judged by his contemporaries to be both old and new, and how was it that this largely unknown and reclusive painter was supported by prestigious patrons that included politicians, scholars, collectors, dealers, and businessmen. Kodōjin, the painter, the poet, and the calligrapher, is perhaps best appreciated by situating him within the lineage of Chinese literati art—its history, its ideals, shifting societal circumstances, and patronage types. Such an approach also acknowledges the unique development of literati painting in Japan, which amid the limitations of access prompted a greater freedom of interpretation. Literati painting is most often formulated in connection with various theories of painting or as a complex diversity of styles, but social class and patronage as a lesser topic of discussion is usually framed in exclusion to artistic concerns. This essay brings together these different facets in order to explore some of the remarkable features of Kodōjin's oeuvre.

## LITERATI PAINTING IN CHINA

The origins of Chinese attitudes toward painting, long championed by literati painters, have been retrospectively understood in many ways, one of the earliest being the anecdote about the "true painter" in chapter 21 of the Daoist classic *Zhuangzi*.[1] Lord Yuan of Song called together the painters of his land to paint in his presence. As they eagerly prepared their brushes and materials, one person arrived late and quickly left the room once he received his materials. Intrigued by this odd behavior the ruler had the man followed to his home where he had taken off his robes and was sitting naked. "'Very good," said the ruler, "this is a true artist" (fig. 19). The anecdote suggests that more than two millennia ago a distinction had already been made between the role of painting based on how skillfully it represented an object and its deeper psychological expression of the state of mind of the creator. This distinction was to become one of the defining features of the later evolution of literati painting.

The term "literati painting," a translation of the Chinese *wenrenhua* (J: *bunjinga*), relates to painting done by writers, at first primarily poets. Later literati painters also included authors of philosophy, history, eventually fiction, and other topics. In the following centuries, references to the spiritual implications of painting and calligraphy steadily increased, yet among the many candidates for an "origin" point for literati painting, the famous Tang-dynasty poet Wang Wei (699–759) was often later described as the ideal personification of the fusion of poetry and painting. Although no actual paintings by Wang Wei are known, certain compositions are traditionally affiliated with his name. His poetry regularly involved metaphors of nature with Daoist and Buddhist overtones, a tendency that has remained popular with literati painters through the ages.

FACING PAGE: (DETAIL)
NO. 19a *Landscape with Spring Scenery*

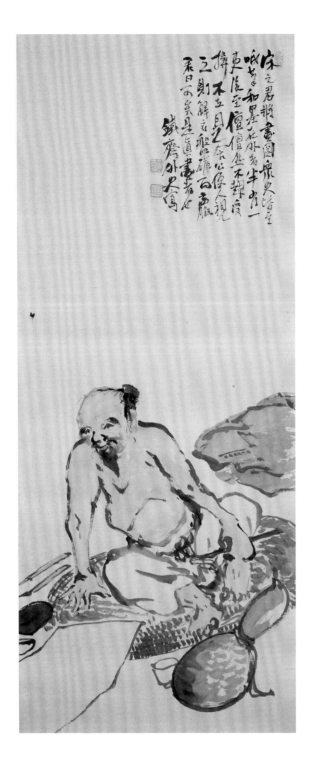

FIG. 19 Tomioka Tessai (1837–1924), *Zhuangzi on the True Painter*, c. 1890, hanging scroll, ink and light color on paper, 50⅛ × 20⅞ in. (127.3 × 53 cm), Hakutakuan Collection (HT1170)

The ancient Chinese interest in landscape painting greatly expanded with the various styles and schools emerging during the Northern and Southern Song dynasties (960–1276). The poetry and writings of the Northern Song poet-painter Su Shi (Dongpo, 1037–1101) became an idealized model of the poet-artist, and legends associate him with the creation of bamboo painting as an expressive theme.[2] His contemporary Mi Fu (Mi Fei, 1051–1107) was celebrated for his calligraphy and for his individual depiction of misty mountain forms using layers of horizontal dots, so-called "Mi dots," which became one of the foundational styles of *wenrenhua* landscapes. The collapse of imperial power in northern China led to the establishment of the Southern Song court in 1127 whose patronage of select painters and specific styles laid the basis for what was later regarded as the "professional painter" held in contrast to the ideal of amateur painting by literati. These distinctions were developed in subsequent centuries and applied retroactively to this period.

During the foreign Mongol rule of the following Yuan dynasty (1271–1368), disaffected literati painters and their associates became known as *yimin*, or "leftover subjects," of the previous dynasty. *Yimin* were mostly of the landed gentry or *shidafu* class of scholar-officials, some of whom resigned their positions to protest Mongol rule. Their status as *shidafu* is significant since literati paintings were chiefly made by and for members of this elevated, erudite class whose aesthetics revolved around philosophical approaches to the relation of humanity and nature as expressed in a fusion of painting and verse. That many also assumed the stance of passive resistance as *yimin* introduced a political element to their work that had hitherto been largely absent. Among the *wenrenhua* of the Yuan dynasty the styles of the following four artists would be continually cited in the work of later painters. Huang Gongwang (1269–1354) became famous for a landscape style that included abstractions of rock faces, cliff surfaces, and certain simplified forms of trees and plants placed on mountains with crumbly dry brushwork. Wang Meng (1308–85) was renowned for his dense, sometimes colorful, compositions of convoluted mountain valleys, using finely layered brushwork. Ni Zan (1301–74) achieved enormous popularity with an ascetic austerity of ink and brushwork in minimal compositions of foreground trees, and a single open pavilion with a few mountains in the background rising above water (fig. 20). Wu Zhen (1280–1354) was famed for his austere ink landscapes and bamboo paintings with heavily saturated ink. Collectively known as the Four Great Masters of the Yuan, references to their styles permeate later literati painting in China and Japan, even in select creations by Kodōjin.

The ensuing Ming dynasty (1368–1644) saw the flourishing of professional artists, often affiliated with the Zhe school of landscape and figure painting distantly derived from aspects of Southern Song court painting. In the mid-Ming, Shen Zhou (1427–1509) brought *wenrenhua* to the fore in his work based on diverse aspects of the Yuan masters characterized by distinctive calligraphy. Shen's foremost follower Wen Zhengming (1470–1559) formulated a more flamboyant, yet meticulous, style that served as inspiration for later painters. The

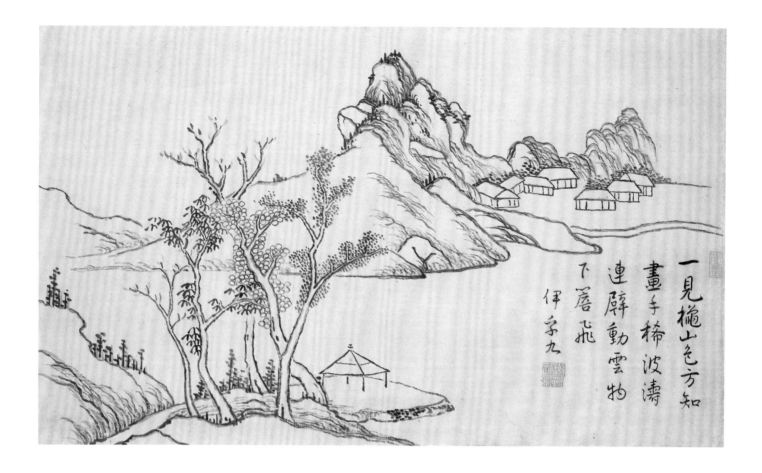

一見椎山色方知
畫手稀波濤
連璧動雲物
下層飛
伊孚九

FIG. 20 Kan Tenjū (1727–95),
*Landscape after Yi Fujiu following
Ni Zan*, ca 1780, hanging scroll,
ink on paper, 13 × 21¾ in.
(33 × 55.4 cm), Hakutakuan
Collection (HT800)

Ming painter, calligrapher, and theorist Dong Qichang (1555–1636) was responsible for popularizing a retrospective history of literati painting that contained the elements outlined above. Dong so emphasized the spiritual elements of his approach to painting that he called it *nansonghua* (Southern School Painting), modeled after the so-called Southern School lineage of Chan (J: Zen) Buddhism. This term later became popularized in an abbreviated form as "*nanga*" in Japan, yet despite being largely synonymous with *bunjinga* the focus on the interrelation of poetry and painting is more apparent in the later term.

The gradual collapse of the Ming dynasty and the advent of the Qing dynasty (1644–1911) produced a new generation of *yimin* painters loyal to Chinese Ming traditions that included several "eccentric" artists whose striking originality became major sources for innovation by literati artists in the late nineteenth and early twentieth centuries. One of the prominent theoreticians of painting, Shitao (1642–1707), developed types of compositions and brushwork that continue to inspire artists today. An even more eccentric painter, Zhu

Da (Bada Shanren, c. 1626–1705), evolved mordantly humorous depictions of fish and birds, and abstracted landscapes.

Although preserving their own language, the new Manchu imperial family of the Qing dynasty quickly sinified, bringing imperial imprimatur to the literati tradition as the most prestigious form of painting through the aggressive collecting habits of the Qianlong emperor (1711–95). Qianlong's art holdings—the largest in Chinese history—included literati paintings from ancient Wang Wei attributions, works by Yuan masters, as well as by Ming and then contemporary Qing artists such as Yun Shouping (1633–90) and Wang Yuanqi (1642–1715). This rise in prominence led to an increasing professionalism among some literati painters whose works and attitudes became more like those of professional painters. Going against that trend, painters in the Yangzhou area, patronized by merchants rather than elite officials, adopted fresh attitudes toward painting. These artists have been retrospectively called the Eight Eccentrics of Yangzhou, even though they numbered eleven or more. Among them, the bird-and-flower paintings of Li Shan

(c. 1686–1762), the figure paintings of Huang Shen (1687–1772), and the dramatic brushwork and original compositions of orchids and bamboo by Zheng Xie (1693–1765) became well known even in Japan. Inspired in part by these Yangzhou painters, artists in Shanghai active in the middle and later nineteenth century continued to create innovative approaches in the literati tradition.

Signal features of this highly compressed overview of Chinese literati painting history include the importance of poetry, amateurism, and philosophic implications. Social status certainly varied according to the period. Unlike the majority of other painting traditions that maintained a single approach through a lineage of professional painters, literati painting was characterized by stylistic eclecticism. Rather than a unified style, what bonded literati artists together was a shared idealism about the nature of their art and its meaning.

Literati paintings were therefore appreciated on several levels—the brushwork, the ink tonalities and use of color, and at times the subtle humor. For those steeped in the history of Chinese art, the paintings were, to borrow Bourdieu's remark, "a genre containing ever more references to the history of that genre call[ing] for a second-degree reading, reserved for the initiate, who can only grasp the work's nuances and subtleties by relating it back to previous works."[3] These paintings are full of visual references to the styles of earlier painters that are often amplified by specific references in the inscriptions on the works. In the simplest cases the referent may be only to a single style, such as a work fully employing "Mi dots" brushwork to create a landscape. Yet some inscriptions reveal more layers such as "following Shen Zhou's interpretation of Wu Zhen." Some paintings are compiled of two styles, such as those of Huang Gongwang and Ni Zan. Occasionally, a whole pedigree of sources is provided. Ancient poems were frequently quoted, yet rarely explicitly identified, since the viewer was expected to immediately recognize the verse. To the untutored these layered references may seem arcane and tedious, but to those well versed in Chinese art and literature it was a casual and enjoyable experience that could be witty and personally moving much like the "sampling" of songs in today's popular music. Many of Kodōjin's landscapes contain subtle, sometimes humorous, visual cues in brushwork and composition to older Chinese and Japanese literati styles.

## LITERATI PAINTING IN JAPAN

The start of literati painting in Japan is usually dated to the mid-seventeenth century, yet there were far older precursors.[4] The famous eleventh-century screen *Landscape Screen* (*Senzui byōbu*) was used at the Tōji temple in Kyoto as background decoration for esoteric Shingon Buddhist ordination ceremonies. It illustrates a Tang-style blue-green landscape focused on the disheveled figure of a man inside an open-air pavilion,[5] who is traditionally regarded as the famed Tang poet Bo Juyi (772–846). His poems are frequently found on later literati paintings, and in Japan this posture of a poet about to write became the standard iconography for the mythologized images of the poet Kakinomoto Hitomaro (c. 662–710). This honorific treatment of a literatus was representative of the high status accorded to poets and their calligraphy in later literati paintings. By the Muromachi period (1336–1573), textual references to noted literati painters in China were circulating in Japan, and their works and names are sometimes seen in Japanese paintings of the era that depict bamboos, plum flowers, and orchids.

The prime reason that the latter half of the seventeenth century is viewed as the origin of literati painting in Japan was the epochal arrival of the late Ming-dynasty version of Rinzai Zen Buddhism (C: Linji Chan) that became known in Japan as Ōbaku Zen.[6] Although the rising tide of Chinese monks coming to Japan at this time are often framed as *yimin*, a more prosaic but substantial motivation for the establishment of the first Ōbaku temples in Kyushu was the

desire for spiritual protection felt by the large number of merchant sea travelers.

The expanded significance of Ōbaku Zen became the conduit for the importation of many aspects of Chinese culture, including architecture, sculpture, novel styles of painting, calligraphy, and seal carving. Some of the monks were trained artists and were accompanied by Chinese artisans. These imported cultural activities caused a sensation among the scholarly class in Japan, and within decades aspects of literati painting and related activities, such as the steeped tea tradition now called *sencha*, became known and appreciated. By the eighteenth century, Manpukuji, the headquarters of the Ōbaku sect near Kyoto, became involved as a patron for emerging Japanese literati painters such as Ike Taiga (1723–76).

The early Japanese literati painters, Yanagisawa Kien (1703–58) and Sakaki Hyakusen (1697–1752), deepened their understanding of Chinese literati painting attitudes and styles and passed them on to a rising generation that included Taiga and the noted haiku poet Yosa Buson (1716–84). These artists not only studied imported woodblock-printed painting manuals, they also assiduously investigated all the recently imported Chinese paintings and calligraphy available to them. This somewhat haphazard introduction of the complexities of Chinese literati painting to Japan helped shape the future of the literati painting world there. It furthered the eclecticism that had been a part of the literati painting movement from its inception, as artists were encouraged to develop their own styles rather than maintain fidelity to a fixed approach that characterized the lineages of professional painters.

Japanese artists had long been aware from reading Chinese texts that amateurism was a key tenet of Chinese literati aesthetics. In actual practice, the "amateur" status of Chinese literati painters distinguished them from professionals who worked for commissions. While the Chinese *shidafu* class enjoyed hereditary wealth that allowed them to focus on self-expression largely free of marketplace constraints, in Japan the majority of literati painters, even though highly educated, were lower-level samurai, priests, doctors, and scholars who needed to sell their works to support their lifestyles.

Although more involved in selling their works, Japanese literati painters tended to take the "amateur" ideal quite literally in regards to technique. They were not as interested in the refinements of brushwork that had unfolded in China and cultivated a sense of freer, often playful, brushwork. This admiration for untutored expression was amplified by their appreciation of the works of the few Chinese painters they encountered in eighteenth-century Japan. Yi Fujiu (J: I Fukyū, 1698–c. 1747) became one of the much venerated Chinese painters in Japan for his simply sketched landscapes in the Ni Zan mode (see fig. 20). Yet Yi Fujiu and most of the other esteemed immigrant artist cohorts were primarily Chinese merchants who painted casually in their spare time— in that sense they were true amateurs in painting. The Japanese admiration for their work inspired literati painters to be less concerned about the general seriousness found in the works of famous Chinese literati, thus nurturing the casual mixing of styles, whether Chinese literati or professional, even with references to Japanese Tosa and Rinpa themes and brushwork.

At the opposite end of the aesthetic spectrum from these visiting merchant painters was Shen Nanping (J: Shin Nanpin, 1683–1760), the leading figure among the few professional Chinese painters to come to Japan in the Edo period (1603–1868). Shen produced numerous works while in Nagasaki and after returning to China, he and his studio continued to send their paintings to Nagasaki for sale. The popularity of his novel approach dominated Nagasaki painters of this genre and influenced artists throughout Japan, including some literati artists whose eclecticism embraced a diversity that would have been rejected in the literati world in China.

The generations that followed Taiga and Buson tended to explore Chinese painting even more deeply based on the increased flow of works arriving in Nagasaki. The combination of newly imported paintings

with the presence of Chinese painters and poets made study in Nagasaki a key ambition for literati painters in the late Edo period. Although the great majority of imported works were copies, fakes, or of low quality, they were nonetheless valuable examples for their range of compositions, themes, and brush techniques.[7] The more sophisticated painters realized that many of these imported works were of lesser quality, and the few genuinely excellent works were celebrated for decades by the painters who would travel long distances to see them.

Some late eighteenth-century painters, such as Taiga's disciple Aoki Shukuya (1737–1802) and Hirose Taizan (1751–1813), a student of Taiga's student Fukuhara Gogaku (1730–99), achieved a deeper level of understanding of Ming and Qing literati painting. Yet largely self-taught eccentrics, such as Urakami Gyokudō (1745–1820), Okada Beisanjin (1744–1820), and Aoki Mokubei (1767–1833), came to prominence in the first decades of the nineteenth century. Gyokudō's son Urakami Shunkin (1779–1846) and Beisanjin's son Okada Hankō (1782–1846) also developed their own highly refined brushwork approaches quite different than their parents. Painters, including Nakabayashi Chikutō (1776–1853), Yamamoto Baiitsu (1783–1856), and Nukina Kaioku (1778–1863), all strengthened in various ways the connections between their own works and Chinese traditions.

Tanomura Chikuden (1777–1835) became the most revered exponent of this approach. In the last decade of his life, his numerous paintings were unparalleled in Japan for their mastery of certain styles of Chinese painting and their inclusion of complex forms of Chinese-style poetry that correctly followed the original tonal rhyme schemes. In the works of calligraphers and painters as Rai San'yō (1780–1832) and Fujimoto Tesseki (1816–63), literati painting became increasingly political in tone as the majority of these artists of the late Edo period opposed the Tokugawa system of rule. Kodōjin's landscapes show occasional similarities to the eccentric brushwork and structure of those by Gyokudō, Mokubei, and Tesseki.

In the first years of the Meiji era (1868–1912), the loyal opposition status of literati painters shifted to an insider stance that celebrated their earlier resistance to the Edo-period power structure. Many of their former patrons had now assumed positions in the evolving Meiji government. This rise in social standing coincided with greater access to China, with a growing number of Japanese artists traveling to China and more esteemed Chinese visiting Japan. Meiji literati painting in the 1870s became dominated by painters, including Yasuda Rōzan (1830–83), who had studied in Shanghai with the noted Hu Gongshou (1823–86), female painters such as Okuhara Seiko (1837–1913), who introduced the style of Zheng Xie's painting and calligraphy, or the somewhat later Noguchi Shōhin (1847–1917), whose refined brushwork received imperial patronage.

By the late Meiji era, the majority of literati painters were organizing their own exhibiting groups, such as the national Japan Nanga Association (Nihon Nanga Kyōkai, 1896) and the Japan Nanga Institute (Nihon Nangain, 1921) and, in the Tokyo region, the Japan Nanga Group (Nihon Nangakai, 1897) and the Japan Southern School Group (Nihon Nansō Gakkai, 1906). In the Taishō era (1912–26), Japanese and Chinese artists journeyed extensively to and from China, with the overarching popularity of the scholar artist Tomioka Tessai.

## PATRONAGE OF LITERATI PAINTERS

As noted above, the majority of early literati painters of the Yuan and Ming dynasties were *shidafu* with a measure of financial independence to pursue their "amateur" ideal. By the late Ming dynasty, however, the growing popularity of literati idealism had drawn in painters whose lower social backgrounds obliged them to earn a living by painting, despite their amateur ambitions. In the Qing dynasty, this semiprofessional activity became more standard; some even had imperial patronage. The "amateur" ideal finally became so widespread that even

merchants with little training in the arts painted as a hobby, including some of the first Nagasaki merchant painters from China.

As literati painting took root in Japan in the eighteenth century, it attracted people from diverse social positions, only a few of whom were independently wealthy. The majority of painters needed to make a living by selling their paintings. Even so, they maintained the "amateur" ideal, sometimes accepting payment in the form of food, lodging, and painting materials. The early theory of literati painting envisioned artists traveling widely and reading voluminously. Japanese painters traveled to Nagasaki or other art centers in order to hone their skills and to remote parts of Japan to cultivate patrons. Only a few literati artists were fully supported by the local populace, and most had far-flung patronage networks that made their full-time devotion to art possible. In the later part of the Edo period, many literati painters also received patronage from affluent individuals who appreciated their political opposition to the Edo shogunate and to abusive taxation by local governments.[8]

With the new policies and structures set up by the developing Meiji national and regional governments, some literati found powerful patrons. The creation of painting schools in Kyoto and Tokyo gave some artists a more stable income as teachers. Major artists established private academies, which were more formalized than the old workshop system that had dominated the Edo period. Originally, the exhibitions put on by literati artists were not primarily sales events, but by the late Meiji era local and national painting competitions were regularly tied indirectly to commercial sales. Except for some organizations, such as the Japan Nanga Association, the literati aspect of the painting world seemed to be in decline, yet many of the styles and attitudes common to literati painting had penetrated much of the broader world of the expanding *nihonga* groups. It even influenced some oil painters. Art magazines, such as *Daimai bijutsu*, included a sales section of the latest paintings in every issue. Although ostensibly the ultimate literatus who urged his viewers to read his complex inscriptions before considering the painting itself, Tessai's final years were intimately tied to the incessant promotion of his work by the Takashimaya department store, which held exhibitions with catalogues of his work and handled much of his sales network.[9] Although this commercial tie-in could be viewed as a rejection of the older literati ideal, it permitted the aging artist to work with the highest-quality imported Chinese pigments, inks, and paper. On the plus side, this confluence of wealthy patronage globally enabled certain artists to achieve aspects in their work that otherwise would have been impossible.

## KODŌJIN'S PATRONAGE NETWORKS

Throughout his life Kodōjin maintained a public allegiance to the romantic tradition of noncommercial amateurism in his poetry and painting activities. This contrasted sharply with the methods of the majority of his contemporaries, who continually sought fresh sources of publicity and income. Most literati painters of the time championed their work under such titles as "*shin nanga*" (new literati painting) in the hope of attracting interest. Kodōjin neither participated in the usual group exhibitions or painting competitions nor advertised in art magazines. His near total devotion to artistic activities meant that his outside income from articles about poetry in newspapers and journals was not enough to fund his increased painting production. Many painters taught numbers of students whose payments augmented their income, yet Kodōjin seems to have had only one disciple, Watase Ryōun (1904–80), whose works from 1924 to 1929 resembled his teacher's.[10]

Although patronage is usually considered to consist of financial or other material benefits, it is often prompted by the reputation of the recipient that can arise through noncommercial activities. In this regard, Kodōjin's involvement in the avant-garde

FIG. 21 Soejima Taneomi (1828–1905), *Two-Line Calligraphy on Blue Lotuses*, c. 1880s, hanging scroll, ink on satin, 57⅕ × 17⅓ in. (146.6 × 44 cm), The Metropolitan Museum of Art, Mary and Cheney Cowles Collection, Gift of Mary and Cheney Cowles, 2019 (2019.420.33)

movements to renovate haiku and *tanka* poetry brought him some acclaim. Additionally, his association with some of the top poets and calligraphers drew attention to his budding career. In the later Meiji era, Kodōjin most respected the poetry of the distinguished statesman and individualistic calligrapher Count Soejima Taneomi (fig. 21). Taneomi, in turn, was so impressed with Kodōjin that he praised him as the Tao Yuanming (Tao Qian, 365–427) of the present day. He also wrote a laudatory text that was later used as the preface for the 1912 collection of Kodōjin's Chinese verse, *Seisho's Mountain Studio Collection* (*Seisho sanbōshū*). Even though they convey the flavor of antiquity, Kodōjin's new poems were an appreciated form of contemporary art. Their embracing of each other helped to build an awareness of Kodōjin's art that would further widen his patronage circles.

Kodōjin's relative lack of funds was of concern to one of his backers, Ezaki Ken'ichi, who ran a painting gallery in Kyoto. Ezaki, a wealthy merchant from a *sake* brewing family in Fushimi, had taken over the Heian Gabō on Shijō Street in the Gion district in 1916. Before that, Ezaki was a patron of the eccentric Buddhist monk Amada Guan (1854–1904) whose Chinese verse he admired. He likewise became interested in Kodōjin, and the Heian Gabō became a key outlet for the sale of Kodōjin's work.[11] The Heian Gabō's general finances were so weak, however, that it closed in around 1929, even though Ezaki's name appeared in the lists of supporters for the 1929 exhibitions in Tokyo.

Kodōjin's works had long been known for their high-quality mountings, many of which were made by the Shunpōdō (est. 1856), which was now run by the third-generation head Fusehara Toshizō and his son Keiichirō. At this time, the studio was at the apex of its prestige in the diverse world of Kyoto mounting establishments, counting among its customers a number of leading artists, such as Takeuchi Seihō (1864–1942) and Dōmoto Inshō (1891–1975), and their affluent clientele. As was true for other major mounting studios, Shunpōdō also operated as a sales venue for contemporary artists with whom they had dealings. On March 9–10, 1927, Shunpōdō held an exhibition of Kodōjin's works at the Kyoto Art Club (Kyōto Bijutsu Kurabu), a prestigious location run by the association of top painting dealers. Titled as a *nanga* painting show, *Fukuda Seisho nanga tenrankai*, Shunpōdō issued a small accompanying catalogue, *Withered Trees and an Abundance of Spring* (*Koboku yoshun*), with illustrations of thirty-five works. This was the first sizable exhibition at a major location for the aging Kodōjin.

In addition to expanding Shunpōdō's repertory of contemporary paintings, this exhibition and the resultant sales would have helped the reclusive Kodōjin improve his finances. Only a few days after the show closed on March 10, 1927, Japan was hit by a financial crisis that led to a mass run on banks, causing many closures. Some of the wealthiest depositors, having been tipped off about upcoming events, were able to swiftly move their assets into the coffers of the five largest banks in Japan, including Mitsubishi, Mitsui, and Sumitomo. The crisis forced the resignation of Prime Minister Wakatsuki Reijirō and unsettled the country, yet it caused the reserves of these five banks to

swell, setting the stage for their dominance of the banking industry for decades to come.

These events had a dramatic impact on Kodōjin, whose savings were in the Jūgo Ginkō, one of the most high-profile banks to collapse. Jūgo Ginkō was popularly referred to as the "Kazoku Ginkō" (Nobility Bank) because it had been established in 1877 with the objective of being a special bank for the newly established *kazoku* system of nobility that integrated the old imperial nobility and the former daimyo rulers of the regional domains. Although now being placed together in the *kazoku* nobility system, the old imperially connected families and the samurai class of former daimyo did not share good relations. As the collapse of the bank drew near, word of the danger spread among the former samurai who quickly shifted their funds, while the old nobility were caught by surprise and lost heavily. The director of Jūgo Ginkō, Matsukata Iwao (1862–1942), took responsibility for this situation and resigned from the nobility. That Kodōjin had an account at the Jūgo Ginkō may have been linked to his friendship with Iwao's illustrious father Matsukata Masayoshi (1835–1924), twice prime minister in the Meiji era.[12]

According to Kodōjin's friend Sakaguchi Shichirōbei (1896–1976), Kodōjin was urged by Taiji Gorōsaku (1875–1957) to move his money immediately due to the Jūgo Ginkō's impending collapse.[13] Taiji was horrified when Kodōjin reportedly responded by sending a message to the bank instructing them not to withdraw his funds. Kodōjin simply explained that a bank collapses because everyone withdraws their money but people refusing to do so could still save the institution. Sakaguchi used this incident as further evidence of Kodōjin's rectitude, noting that even during the war years the elderly artist refused to buy scarce food on the black market.

It could be conjectured that the news that the sixty-one-year-old Kodōjin had lost his savings with the closure of Jūgo Ginkō on April 21, 1927, spread among his supporters, prompting a concern among prominent well-wishers from around the country.[14] This led to plans for two extensively promoted

exhibitions of his works to be held in Tokyo in 1929. The first was open to the public and took place on February 22–26 at the Mitsukoshi department store, which had cultivated the image of a high-end venue boasting deluxe merchandise and with it the expectation that customers would be comfortable paying more for items that might be cheaper elsewhere.

The second smaller exhibition on March 9–10 was at the much more exclusive domain of the Peers' Assembly Hall (Kazoku Kaikan), a special preserve for the members of the nobility. A book of Kodōjin's work, *Rock Slivers and Lonely Clouds* (*Koun henseki*; see pp. 186–203), was prepared in February in anticipation of the Tokyo exhibitions. The eighty-seven illustrations provide a range of insights into how Kodōjin's artwork was promoted and what may have motivated his patrons: almost half of the works display various themes that could best be described as quick sketches with poems.

Several documents provide a record of the people involved in arranging these shows. A longer list (*Kodōjinkai hakkisha narabi sanjosha*) records the names of fifty-three individuals, the most illustrious being: 1) members of the government, notably the then prime minister Tanaka Giichi, his predecessor Wakatsuki Reijirō, and four serving cabinet members, including the industrialist Kuhara Fusanosuke and Kawamura Takeji, the Japanese governor-general of Taiwan and former governor of Wakayama Prefecture; 2) leading figures of industrial conglomerates (*zaibatsu*), in particular, Yukawa Kankichi, fifth general director of Sumitomo, who like Kodōjin was born in Shingū;[15] 3) prominent administrators from major corporations, counted among Kurachi Masao, the managing director of the Mitsukoshi department store;[16] 4) major art collectors, such as Honma Mitsuya, whose collection formed the basis for the Honma Museum of Art in Sakata, and Ataka Yakichi, an industrialist who was the major patron of the Zen scholar Suzuki Daisetsu (1894–1968); 5) educators and scholars, notably Masaki Naohiko, principal of the Tokyo School of Fine Arts

(present-day Tokyo University of the Arts) and a pivotal person in Ministry of Education art circles; Nakagawa Kojūrō, a founder and later president of Kyoto's Ritsumeikan University; and Naitō Konan, a renowned authority on Chinese painting and art historian at Kyoto University; and 6) major art businesses, among others Kumagai Naoyuki, owner of Kyūkyodō, famous for their high-quality art materials since the eighteenth century, and Fusehara Toshizō, owner of the Shunpōdō mounting studio and sales outlet for contemporary *nihonga* painting.

This outpouring of endorsement from such a remarkably diverse collection of esteemed individuals is unparalleled, especially when we consider that Kodōjin was an artist largely unrecognized in the painting world of the time. What factors could have brought this confluence of prominent people together? Perhaps it was that some supporters had connections to Kodōjin's home prefecture of Wakayama and might have wanted to promote local figures; that many people of this status participated in major tea gatherings (*chanoyu* or *sencha*) and may have become aware of Kodōjin in those settings; that others may have been amateur poets or fans of new forms of haiku who admired Kodōjin's activities with Matsuoka Shiki and his group; or that most people of wealth had assembled collections of contemporary art, be they large or small scale, and were familiar with Kodōjin's work. The careers of these backers overlapped in interesting ways, often spilling over into multiple categories. It is also significant that the majority were born in the 1860s and 1870s and so had shared with Kodōjin the tumultuous transitions as Japan moved from Edo-period politics to the constantly shifting struggle to transform and modernize society in the Meiji era. The majority were conservative, or even extremely conservative, nationalists. There were some notable exceptions, such as the former prime minister Wakatsuki Reijirō and Kodōjin's longtime friend Nakagawa Kojūrō of Ritsumeikan University, both of whom had more liberal views on society.

Another shorter list, however, may provide a guide to the interpretation of the complex interactions of such noted individuals. Issued as a broadside in mid-December 1928 under the title "Kodōjin Society's Key Inspiration" (*Kodōjinkai shushi*), it begins by stating in honorific terms the artist's rare talent and some of his connections to the Zen community, with special emphasis on his close friendship with the aforementioned Amada Guan. This introduction was followed by a list of seventeen sponsors for the upcoming exhibition of Kodōjin's painting and calligraphy. These seventeen individuals also appear in the longer list noted above, which omits the names of prime ministers and cabinet members.

The leading figure in this document is Kokubu Saitō (Tanenori), who identified himself as the organizer of the support group for the upcoming exhibitions.[17] Kokubu abandoned his political science studies at Tokyo University to become a newspaper reporter in Niigata in northern Japan. In 1900, he left for a position on a newspaper in Taiwan, having been recommended by Naitō Konan. During his six months there, Kokubu met the Chinese revolutionary Sun Yat-sen (1866–1925) and helped persuade Kodama Gentarō (1852–1906), the Japanese governor-general of Taiwan, to provide arms for Sun's movement, although the ship carrying them was later lost at sea. On his return from Taiwan, Kokubu was employed by the Hakubunkan, the publisher of the widely read *Taiyō* journal.[18] His years at Hakubunkan were followed by his work as a journalist at a number of newspapers. At the same time, he continued to develop his skills in writing texts and poetry in Chinese.

Kokubu's skill in composing Chinese texts gradually led to him becoming a virtual ghostwriter for members of the cabinet and imperial circles. This activity introduced him to a variety of important people in government and the Imperial Household Agency, with Kokubu eventually accompanying the Taishō emperor on his visits to Shikoku and Taiwan. He also became the tutor in Chinese-style poetry for the former daimyo of Wakayama, Tokugawa Yorimichi

(1872–1925). These connections with high society brought him the broad range of contacts that are reflected in the larger list of Kodōjin supporters.

The industrial magnate Kuhara Fusanosuke had such extreme wealth and tremendous influence in government and industry that he was likely the driving force that would have convinced so many to enroll as promoters of Kodōjin.[19] His name is placed first on this shorter list of key members with his personal secretary Sasaki Daikichi listed thirteenth. Kuhara's extraordinary fortune was founded on his initial alliance with his uncle Fujita Denzaburō (1841–1912). Assigned to rehabilitate Fujita mining interests, Kuhara remade unproductive mines into the largest producers of copper in the nation. This achievement allowed him to separate from the Fujita group to become an independent industrialist with interests that stretched from mining to oil, shipping, steel, and life insurance. His vast means allowed him to promote prime ministers and right-wing causes in the 1930s at the same time he was establishing the Hitachi Company and laying the foundations for what was to become the Nissan Corporation. Although principally a member of the extreme right, Kuhara also gave money to Sun Yat-sen in 1911 and arranged a private meeting in Moscow with Stalin in 1927.[20] His financial largess was renowned: he helped to rescue other *zaibatsu* (even the Fujita group) and extended "loans" to people in government, politics, and other high places.

Kuhara built up an enormous art collection as did many wealthy industrialists of the day (his uncle's huge art collection formed basis for the Fujita Art Museum in Osaka). The contents of his holdings remain unclear since there was never an exhibition, an official listing, or public auction of it, although select works form the Kuhara Bunko at the Gotoh Museum in Tokyo. In August 1917, during convalescence from a serious illness, Kuhara began to study painting with Matsuda Kajō (1857–?),[21] and he became skilled in paintings that resemble Buson's *haiga* (fig. 22). His personal engagement in literati painting would have allowed him to more easily appreciate Kodōjin's unusual and often playful paintings. It is probable that it was Kuhara's influence that drew in prime minister Tanaka and other government ministers to endorse Kodōjin.[22] Once these major figures gave their imprimatur to the exhibition, there was likely a cascading effect on others who wished to ally themselves with this powerful group. In doing so, they were aligning themselves with an elite circle of patrons for an artist still largely unknown to the general public. The idea of an exclusive aesthetic world inhabited by influential individuals was a key factor in their social life.

It is noteworthy that after the apparent success of the two exhibitions in Tokyo, support for follow-up exhibitions of Kodōjin's work seems to have vanished. The reasons for this may have varied. Most simply, some of the principal figures died within a few years of the exhibitions. Among them was the death of the ill-fated prime minister Tanaka by heart disease in September 1929. Yukawa Kankichi, general director of Sumitomo, died in 1931 and the prominent sinologue Naitō Konan in 1934. More dramatically, Japan entered the Shōwa Depression of 1930–31, and Japan's Kwangtung Army seized control

FIG. 22 Kuhara Fusanosuke (1869–1965), *Fisherman Haiga*, April 1932, hanging scroll, ink and color on paper, 48⅘ × 13⅛ in (123.8 × 33.4 cm), Hakutakuan Collection (HT1601)

of Manchuria in 1931. The further development of Kodōjin's career was no longer a priority. From the beginning, it seems that the intent of the 1929 exhibitions was to lift the artist out of his immediate financial difficulties, and that mission had been accomplished.

Celebrated artists in prewar Japan often had extensive connections with highly placed individuals, including government, industry, and religious leaders. In such cases, the artists were themselves public figures, winning painting competitions and participating in national art exhibitions. Their activities were regularly discussed in newspapers, magazines, and specialty art journals. As Kodōjin's works and activities were known by very few, and his name was generally not recorded in the directories of active artists, the patronage of his art by a diverse group of prominent, wealthy, and socially powerful people is remarkable, especially at its pinnacle in the early Shōwa era. Kodōjin was temperamentally inclined to avoid publicity, yet his illustrious supporters were frequently in the news and could have easily promoted his career in the press had they wished to do so. It seems plausible that this prestigious circle was quite comfortable and took pride in being the patrons (and the cognoscenti) who recognized the merits of a unique painter largely unfamiliar to the public.

The most unusual feature for Kodōjin was the narrow beam of attention he received for a few years in the early Shōwa era. This attention did not seem to change the character or quantity of his art. Much of the historical patronage of literati painting involved the romanticism of city dwellers in idealizing a rustic life wandering through remote mountain landscapes. Similarly, in embracing the poetic simplicity of Kodōjin's art, this coterie of famous people may have harbored a fantasy of a life unencumbered by the financial and political complexities of their times.

# ENDNOTES

1 See Watson 2013. This chapter, *Tian zifang*, is now considered to have been composed in the second or third century BCE.

2 Although superseded by later scholarship and dated by the language and thoughts of his time, the most entertaining and readable introduction to the qualities of Su's life and thought is Lin 1947.

3 Bourdieu 1993, p. 128.

4 For further in-depth reading on literati painting and its relation to China, see Berry 1999, pp. 32–39; Berry 2008, pp. 16–27, 28–39; Berry 2020, pp. 147–53.

5 Akiyama 1964.

6 The last several decades have seen a rising number of scholarly studies on the history of the Ōbaku sect. Two recent groundbreaking studies by Wu (2008, 2014) have greatly advanced the knowledge of late Ming Chan lineage debates and the Ōbaku revival of older Chinese Chan traditions.

7 During his year of residence in Nagasaki (1826–27), Tanomura Chikuden wrote excitedly about the value of studying the recently imported Chinese paintings he saw, regardless of their authenticity. See Berry 1985, pp. 99–101.

8 Artists whose political stance benefited them include Rai San'yō, Tanomura Chikuden, Fujimoto Tesseki, Yanagawa Seigan (1789–1858), Chō Kōran (1804–79), and their friends and associates.

9 Kashiwagi 2016, pp. 192–95.

10 In 1930, Ryōun joined the Japan Nanga Institute and his style changed greatly. Yet Ryōun remained very close to Kodōjin and Taiji Gorōsaku until the end of their lives. Yamamoto and Tatsumi 2013, pp. 114–16.

11 See the detailed history of the gallery that corrects aspects of Matsumoto's earlier account, Matsumoto 2005b, pp. 108–13.

12 Correspondence with Matsukata Masayoshi remains in the possession of the Fukuda family (Matsumoto 2005b, p. 107).

13 Sakaguchi 1960. Sakaguchi was a leading figure in the Nachi region fishing industry and onetime major of the Nachi district. See also *Nachi Katsuura Choshi Hensan Iinkai, ed., Nachi Katsuura choshi* (Nachi Katsura Cho, 1975).

14 A concise account of the checkered history of Jūgo Ginkō and its attempts at reconstruction after 1928 is given in Schalow 1987. The bank's restructuring plan was supposed to reimburse depositors 30 percent of their funds with an additional 4 percent a year becoming available for a period of ten years, with the remaining 30 percent coming in a final lump payment. Actually, these payments were only completed in 1944 (Mitsui Ginkō Hachijūnenshi Hensaku Iinkai 1957, pp. 535–653). Even then, there were restrictions on who was entitled to be reimbursement. As a result, it can be assumed that Kodōjin had lost the bulk of his savings.

15 Others in this group were Ogura Masatsune, manager at Sumitomo; Hidaka Yutaka, director of Sumitomo construction responsible for important buildings made by the conglomerate; Fujioka Jōkichi, executive director of Mitsui Mining; and Akaboshi Rikuji, head of Mitsubishi Estate.

16 Others in this group were Hori Keijirō, director of Osaka Maritime Transport Co. or O.S.K. Lines and head of Hanshin Railway; Shimizu Yōnosuke, an influential member of the Shimizu Construction Company; Matsushima Hirosaburō, manager of the Shinkeihan Railway, and Kanamori Mataichirō, director of Osaka Electric Tramway that evolved into Kintetsu Railway.

17 The most detailed account of Kokubu Saitō's life is by his son (Kokubu 1970).

18 Kokubu was already a prolific writer in this twenties, most notable among his work of this period being his biography of the Osaka revolutionary Ōshio Heihachirō (1793–1837).

19 For the two most detailed accounts of Kuhara's life and career, see Yonemoto 1991; Furukawa 2004.

20 See an account of his relations with Sun Yat-sen in Yonemoto 1991, pp. 498–505, and that with Stalin in Yonemoto 1991, pp. 718–21.

21 Yonemoto 1991, pp. 619–20.

22 Yonemoto 1991, pp. 671–710, 737–66, 817–29; Furukawa 2004, pp. 305–10. For a less laudatory viewpoint, see Ōya 1957, pp. 3–18.

Japanese titles are included when they appear on the storage box of a particular work.

**1**

*MOON OVER AZURE MOUNTAINS*

January 1899

Hanging scroll, ink and color on paper

18⅘ × 13⅕ in. (47.6 × 33.7 cm)

Bachmann Eckenstein Japanese Art, Switzerland

SIGNATURE: 己亥初春古道人 (January 1899, Kodōjin)

SEALS: 吾拙 Gosetsu, 福田世耕 Fukuda Seikō [1], 山水知己 Sansui chiki

POEM: *Seisho sanbōshū*, no. 12

**2**

*BLUE-GREEN LANDSCAPE*

September 1901

Hanging scroll, ink and color on paper

58 × 32½ in. (147.3 × 82.6 cm)

Private collection, USA

SIGNATURE: 明治辛丑杪秋靜處詩畫

(September 1901, poetry and painting by Seisho)

SEALS: 明佳 Meika, 福田耕 Fukuda Kō, 子徳氏 Shitoku shi

**3**

*PLUM FOREST* (*BAIRIN* 梅林)

c. 1901–2

Hanging scroll, ink on paper

53½ × 24½ in. (135.9 × 62.2 cm)

Bachmann Eckenstein Japanese Art, Switzerland

SIGNATURE: 靜處 (Seisho)

SEALS: 藏 Zō, 福田耕 Fukuda Kō, 子徳氏 Shitoku shi

**4**

*QUIET SETTING OF A MOUNTAIN CREEK*

July 1902

Hanging scroll, ink on paper

50 × 13⅛ in. (127 × 33.7 cm)

Gitter-Yelen collection

SIGNATURE: 明治壬寅初秋於衡山寓居南海一布衣靜處 (July 1902 at the "Temporary Abode on Mount Heng," One-of-the-Southern-Sea in Simple-Clothes Seisho)

SEALS: 明佳 Meika, 古道人 Kodōjin [1], 靜處 Seisho [1], 山水知己 Sansui chiki

POEM: *Seisho sanbōshū*, no. 50

**5**

*ALBUM OF WHAT EXISTS* (*KAJŌ* 何有帖)

c. 1907

Album with 14 leaves, ink on paper

5⅞ × 9⅕ in. (15 × 23.5 cm) (each leaf)

The Kura Art Gallery, Kyoto

SEALS: 詩價 Shika, 福田世耕 Fukuda Seikō [4], 靜處 Seisho [4] (frontispiece); 吾拙 Gosetsu, 古道人 Kodōjin [2], 讀書萬卷笔有神 Dokusho mankan hitsu yūshin (leaf 2); 靜処 Sei-sho [2] (leaves 3, 9, 13); 无心 Mushin [1], 世耕 Seikō [1], 靜處 Seisho [17] (leaves 4, 10); 靜處 Sei-sho [1] (leaf 5); 大北山人 Ōkitayama hito, 樂在中 Raku zaichū (leaf 6); 靜處 Seisho [16] (leaf 7); 吾拙 Gosetsu, 无心 Mushin [1], 諒無 Ryōmu (leaf 8); 无心 Mushin [1] (leaf 11); 吾拙 Gosetsu, 靜處 Sei-sho [1] (leaf 12); 大北山人 Ōkitayama hito, 子徳 靜處 Shitoku Seisho (leaf 14)

**6**

*SECLUSION AT A STREAM*

April 1907

Hanging scroll, ink on silk

c. 41½ × 12⅞ in. (105.5 × 32.8 cm)

Oni Zazen collection

SIGNATURE: 丁未猶清和月靜處詩畫

(Still in April 1907, poetry and painting by Seisho)

SEALS: 无心 Mushin [1], 福田世耕 Fukuda Seikō [3], 靜処 Seisho [2], 大北山人 Ōkitayama hito, 讀書萬卷笔有神 Dokusho mankan hitsu yūshin

**7**

*RETIRING FROM THE WORLD AT A MOUNTAIN CREEK*

Summer 1907

Hanging scroll, ink on paper

54⅕ × 19⅘ in. (137.8 × 50.2 cm)

The Kura Art Gallery, Kyoto

SIGNATURE: 丁未夏日於望仙樓畫之并題古道人

(A summer's day in 1907 at the "Tower of Watching Out for Immortals," painting and inscription by Kodōjin)

SEALS: 忠我 Chūga [1], 福田世耕 Fukuda Seikō [4], 靜處 Seisho [4], 省事養神 Shoji yōshin, 大北山人 Ōkitayama hito

FACING PAGE: (DETAIL)

NO. 79 *Red Leaves and White Clouds*

**8**

*EVENING FISHING IN AN AUTUMN BAY*
c. 1907–9
Hanging scroll, ink on paper
50⅖ × 16⅘ in. (128 × 42.5 cm)
Oni Zazen collection
SIGNATURE: 古道人畫并題
  (Painting and inscription by Kodōjin)
SEALS: 忠我 Chūga [1], 福田世耕 Fukuda Seikō
  [3], 靜処 Seisho [2], 讀書萬卷笔有神
  Dokusho mankan hitsu yūshin

**9**

*BLUE-GREEN LANDSCAPE*
April 1907
Hanging scroll, ink and color xon paper
49⅕ × 14⅖ in. (125.2 × 36.5 cm)
Mary and Cheney Cowles collection
SIGNATURE: 丁未清和月於望仙樓靜處詩畫
  (April 1907 at the "Tower of Watching Out for
  Immortals," poetry and painting by Seisho)
SEALS: 无心 Mushin [1], 世耕 Seikō [1], 靜処
  Seisho [17], 讀書萬卷笔有神 Dokusho
  mankan hitsu yūshin, 大北山人 Ōkitayama
  hito

**10**

*PINE TREES BETWEEN CLIFFS*
August 1910
Hanging scroll, ink and color on paper
50⅘ × 13⅞ in. (129 × 35.2 cm)
Robert Mangold collection
SIGNATURE: 明治庚戌桂月下浣寫於白雲黄葉
  處并題南海一布衣古道人碧翁 (The last ten
  days of August 1910, drawn at "A Place with
  Yellow Leaves in White Clouds," inscription by
  One-of-the-Southern-Sea in Simple-Clothes
  Kodōjin Hekiō)
SEALS: 无心 Mushin [2], 福田世耕 Fukuda Seikō
  [4], 靜處 Seisho [4], 忠我 Chūga [1], 師在我
  Shi zai ga [1], 讀書萬卷笔有神 Dokusho
  mankan hitsu yūshin
POEM: *Seisho sanbōshū*, no. 31

**11**

*EXCURSION UNDER PINE TREES*
c. 1907–12
Hanging scroll, ink and color on silk
41⅘ × 18⅓ in. (106.1 × 46.3 cm)
Gitter-Yelen collection
SIGNATURE: 古道人 (Kodōjin)
SEALS: 忠我 Chūga [1], 福田世耕 Fukuda Seikō
  [4], 靜處 Seisho [4], 省事養神 Shoji yōshin

**12**

*LANDSCAPE IN PALE RED*
April 1912
Hanging scroll, ink and color on silk
44⅛ × 14⅖ in. (111.9 × 36.5 cm)
Minneapolis Institute of Art, Gift of the Clark
  Center for Japanese Art & Culture, formerly
  given to the Center by David Frank and
  Kazukuni Sugiyama (2013.29.341)
SIGNATURE: 壬子猶清和月古道人
  (Still in April 1912, Kodōjin)
SEALS: 无心 Mushin [2], 福田世耕 Fukuda
  Seikō [4], 靜處 Seisho [4]

**13**

*LANDSCAPE AFTER MI FU*
  (*BEI HŌ SANSUI* 米法山水)
Spring 1912
Hanging scroll, ink on paper
58⅘ × 13⅗ in. (149 × 34.5 cm)
Oni Zazen collection
SIGNATURE: 明治壬子春日寫於古座客舍并題
  南海一布衣古道人 (A spring day in 1912,
  drawn at a "Lodging in Koza," inscription by
  One-of-the-Southern-Sea in Simple-Clothes
  Kodōjin)
SEALS: 忠我 Chūga [1], 福田世耕 Fukuda Seikō
  [3], 靜処 Seisho [2], 讀書萬卷笔有神
  Dokusho mankan hitsu yūshin, 省事養神
  Shoji yōshin

**14**

*LANDSCAPE AFTER MI FU*
  (*BEI HŌ SANSUI* 米法山水)
October 1914
Hanging scroll, ink on satin
72⅗ × 20⅘ in. (184.5 × 52.9 cm)
Minneapolis Institute of Art, Gift of the Clark
  Center for Japanese Art & Culture
  (2013.29.1041)
SIGNATURE: 甲寅孟冬寫於高松客舍并題古道
  人田耕 (October 1914, drawn at a "Lodging in
  Takamatsu," inscription by Kodōjin Denkō)
SEALS: 无心 Mushin [2], 字曰子德 Azana iwaku
  Shitoku [1], 靜處 Seisho [3], 拙居 Sekkyo

**15**

*LANDSCAPE AFTER MI FU*
  (*BEI HŌ SANSUI* 米法山水)
c. 1921–40
Hanging scroll, ink on paper
52⅛ × 12⅞ in. (132.4 × 32.8 cm)
Minneapolis Institute of Art, Gift of David
  Tausig Frank and Kazukuni Sugiyama
  (2015.111.19)
SIGNATURE: 古人畫并題 (Painting and
  inscription by Kojin)
SEALS: 无心 Mushin [3], 字曰子德 Azana
  iwaku Shitoku [1], 靜處 Seisho [3]
POEM: *Kodōjin shiga*, no. 12; *Shōyōshū*, no. 130

**16**

*BEYOND MI FAMILY STYLE*
  (*BEI-KE IGAI* 米家以外)
Spring 1927
Hanging scroll, red ink on paper
23½ × 9⅘ in. (59.6 × 24.6 cm)
Private collection
SIGNATURE: 丁卯春日古道人畫
  (A spring day in 1927, painting by Kodōjin)
SEALS: 无心 Mushin [3], 靜處 Sei-sho [1],
  Stylized bat, 拙居 Sekkyo

**17**

*EXCURSION INTO THE MOUNTAINS*
September 1914
Hanging scroll, ink on paper
54½ × 19⅞ in. (138.5 × 50.5 cm)
The Kura Art Gallery, Kyoto
SIGNATURE: 甲寅晚秋寫于彈盡山下客舍并錄
  舊製古道人田耕 (September 1914, drawn
  at the "Temporary Lodging Beneath the
  Mountain of Exhausted Ammunition,"
  copying an old work, Kodōjin Denkō)
SEALS: 无心 Mushin [2], 字曰子德 Azana iwaku
  Shitoku [1], 靜處 Seisho [3], 拙居 Sekkyo
POEM: *Seisho sanbōshū*, no. 30

**18**

*QUIET MOUNTAINS ON A SLOW DAY*
  (*NITCHŌ SANSEI* 日長山靜)
October 1914
Hanging scroll, ink on satin
70⅘ × 20⅘ in. (179.7 × 52.6 cm)
Minneapolis Institute of Art, Gift of the Clark
  Center for Japanese Art & Culture
  (2013.29.1040)
SIGNATURE: 甲寅孟冬寫於高松客次并舊製图
  南海一布衣古道人 (October 1914, drawn at
  a "Guestroom in Takamatsu," picturing an
  old work, One-of-the-Southern-Sea in
  Simple-Clothes Kodōjin)
SEALS: 无心 Mushin [2], 福田世耕 Fukuda Seikō
  [4], 靜處 Seisho [4], 字曰子德 Azana iwaku
  Shitoku [1], 拙居 Sekkyo
POEM: *Seisho sanbōshū*, no. 15

**19a**

*LANDSCAPE WITH SPRING SCENERY*
(*SHUNKEI SANSUI* 春景山水)

April 1918

Hanging scroll, ink and color on silk

56 × 16.9 in. (142.2 × 43 cm)

Minneapolis Institute of Art, The Suzanne S.
Roberts Fund for Asian Art (2012.71.4)

SIGNATURE: 戊午清和月古道人 (April 1918,
Kodōjin)

SEALS: 无心 Mushin [2], 福田世耕 Fukuda Seikō
[4], 靜處 Seisho [4], 拙居 Sekkyo

POEM: *Yōsetsu hōshin*, no. 23

**19b**

*LANDSCAPE AFTER MI FU*
(*BEI FUTSU SANSUI* 米芾山水)

April 1918

Hanging scroll, ink on silk

56 × 16⅞ in. (142.2 × 43 cm)

Minneapolis Institute of Art, The Suzanne S.
Roberts Fund for Asian Art (2012.71.3)

SIGNATURE: 戊午清和月古道人 (April 1918,
Kodōjin)

SEALS: 无心 Mushin [2], 福田世耕 Fukuda
Seikō [4], 靜處 Seisho [4], 拙居 Sekkyo

POEM: *Yōsetsu hōshin*, no. 25

**19c**

*LANDSCAPE WITH AUTUMN SCENERY*
(*SHŪKEI SANSUI* 秋景山水)

April 1918

Hanging scroll, ink and color on silk

55⅞ × 16⅞ in. (142.1 × 43 cm)

Minneapolis Institute of Art, The Suzanne S.
Roberts Fund for Asian Art (2012.71.2)

SIGNATURE: 戊午清和月古道人 (April 1918,
Kodōjin)

SEALS: 无心 Mushin [2], 福田世耕 Fukuda Seikō
[4], 靜處 Seisho [4], 拙居 Sekkyo

POEM: *Seisho sanbōshū*, no. 164

**19d**

*LANDSCAPE WITH SNOW SCENERY*
(*SEKKEI SANSUI* 雪景山水)

April 1918

Hanging scroll, ink on silk

55⅞ × 16⅞ in. (142.1 × 43 cm)

Minneapolis Institute of Art, The Suzanne S.
Roberts Fund for Asian Art (2012.71.1)

SIGNATURE: 戊午清和月古道人 (April 1918,
Kodōjin)

SEALS: 无心 Mushin [2], 福田世耕 Fukuda Seikō
[4], 靜處 Seisho [4], 拙居 Sekkyo

POEM: *Seisho sanbōshū*, no. 234

**20**

*ALBUM OF WHITE CLOUDS*
(*HAKUUNJŌ* 白雲帖)

1918

Album with 14 leaves, ink on silk

12½ × 15.9 in. (31.7 × 40.5 cm) (each leaf)

Gitter-Yelen collection

SIGNATURES: 碧翁 Hekiō (frontispiece); 古道人
Kodōjin (leaves 2, 4, 6, 8, 10, 12); 靜處 Seisho
(leaves 3, 5, 7, 9, 11, 13); 西山小隱 Lesser
Recluse of the Western Mountains (postscript)

SEALS: 師在我 Shi zai ga [1], 福田世耕 Fukuda
Seikō [6], 靜處 Seisho [6] (frontispiece); 无心
Mushin [2], 福田世耕 Fukuda Seikō [4], 靜處
Seisho [4] (leaves 2, 4, 6, 8, 10, 12); 靜處
Sei-sho [1] (leaves 3, 5, 7, 9, 11, 13); 拙居
Sekkyo, 字曰子德 Azana iwaku Shitoku [1],
靜處 Seisho [3] (postscript)

POEMS: *Yōsetsu hōshin*, no. 17 / *Kodōjin shiga*, no.
44 (leaf 2); *Yōsetsu hōshin*, no. 14 (leaf 4); *Yōsetsu
hōshin*, no. 20 (leaf 6); *Yōsetsu hōshin*, no. 10
(leaf 8); *Yōsetsu hōshin*, no. 13 (leaf 10); *Yōsetsu
hōshin*, no. 2 (leaf 12)

**21**

*ALBUM OF COLORED CLOUDS*
(*SAIUNJŌ* 彩雲帖)

1918

Album with 14 leaves, ink and color on silk

12½ × 15.9 in. (31.7 × 40.5 cm) (each leaf)

Gitter-Yelen collection

SIGNATURES: 碧翁 Hekiō (frontispiece); 讀玄子
The One who Reads the Mysterious (leaves 2,
8, 12); 古道人 Kodōjin (leaves 4, 6, 10); 靜處
Seisho (leaves 3, 5, 7, 9, 11, 13); 西山小隱
Lesser Recluse of the Western Mountains
(postscript)

SEALS: 師在我 Shi zai ga [1], 福田世耕 Fukuda
Seikō [6], 靜處 Seisho [6] (frontispiece); 无心
Mushin [2], 福田世耕 Fukuda Seikō [4], 靜處
Seisho [4] (leaves 2, 4, 6, 8, 10, 12); 靜處
Sei-sho [1] (leaves 3, 5, 7, 9, 11, 13); 拙居
Sekkyo, 字曰子德 Azana iwaku Shitoku [1],
靜處 Seisho [3] (postscript)

POEMS: *Kodōjin shiga*, no. 40 (leaf 2); *Kodōjin shiga*,
no. 39 (leaf 4); *Kodōjin shiga*, no. 38 / *Seisho
sanbōshū*, no. 94 (leaf 6); *Kodōjin shiga*, no. 41 /
*Seisho sanbōshū*, no. 70 (leaf 8); *Kodōjin shiga*,
no. 42 / *Seisho sanbōshū*, no. 20 (leaf 10);
*Kodōjin shiga*, no. 43 / *Seisho sanbōshū*, no. 68
(leaf 12)

**22**

*ONE THOUSAND MOUNTAINS AND
TEN THOUSAND STREAMS*
(*SENZAN BANSUI* 千山萬水)

Autumn 1918, December 1935 (box)

Hanging scroll, ink and color on paper

54⅛ × 13⅔ in. (138 × 34 cm)

Minneapolis Institute of Art, Gift of David
Tausig Frank and Kazukuni Sugiyama
(2015.111.27)

SIGNATURE: 時在戊午秋日寫於拙居并題古道
人 (The time being an autumn day in 1918,
drawn at "Residing in Clumsiness," inscription
by Kodōjin)

SEALS: 師在我 Shi zai ga [1], Stylized bat, 福田世
耕 Fukuda Seikō [4], 靜處 Seisho [4], 无心
Mushin [2], 拙居 Sekkyo

POEMS: *Seisho sanbōshū*, no. 50.3, 50.4, 50.1, 50.2,
49, 47, 11, 8, 7, 5, 132

**23**

*LANDSCAPE WITH AUTUMN SCENERY*
(*SHŪKEI SANSUI* 秋景山水)

August 1918

Hanging scroll, ink and color on silk

49⅞ × 16⅖ in. (126.7 × 41.6 cm)

Seattle Art Museum, Gift of Griffith and Patricia
Way, in honor of the 75th Anniversary of the
Seattle Art Museum (2010.41.50); Photo:
Eduardo Calderon

SIGNATURES: 時在戊午桂月上浣寫於西山草堂
并題古道人 (The time being the first ten days
of August 1918, drawn at the "Thatched Hut at
the Western Mountains," inscription by
Kodōjin) (part 1); 是日秋有火燬讀書少洗乃
一氣畫山水未必擬古也七十二峰樵者碧翁
又識 (On this day there was an autumn fire
that destroyed my reading books. After
dousing the fire for a short time, with a great
burst of energy I painted this landscape, not
necessarily in the manner of the old masters.
Remembered by the Woodcutter of the
Seventy-Two Peaks Hekiō) (part 2)

SEALS: 師在我 Shi zai ga [1], 福田世耕 Fukuda
Seikō [4], 靜處 Seisho [4] (part 1); 福田世耕
Fukuda Seikō [6], 靜處 Seisho [6], 拙居
Sekkyo (part 2)

POEM: *Seisho sanbōshū*, no. 165

**24**

*RUNNING WATER AND PLUM BLOSSOMS*

c. 1913–21

Hanging scroll, ink and color on paper

54⅕ × 13⅔ in. (139.2 × 34 cm)

Minneapolis Institute of Art, Gift of David
Tausig Frank and Kazukuni Sugiyama
(2015.111.8)

SIGNATURE: 古人 (Kojin)

SEALS: 无心 Mushin [2], 福田世耕 Fukuda Seikō
[4], 靜處 Seisho [4]

**25**

*RETURNING SAILS IN COLORFUL TREES*

November 1919

Fan, ink and color over gold paint on silk

13⅖ × 16⅞ in. (34 × 43 cm)

Fukuda Kiyoko collection; Photo: Kioku Keizō

SIGNATURE: 己未復月古道人詩畫 (November 1919, poetry and painting by Kodōjin)

SEALS: 无心 Mushin [2], 福田世耕 Fukuda Seikō [4], 静處 Seisho [4]

**26**

*SOLITARY ORCHID WITH BIZARRE STONE*

December 1919

Hanging scroll, ink and color on silk

56½ × 14½ in. (143.5 × 36.8 cm)

Patricia S. Criticos collection

SIGNATURE: 己未嘉平月古道人詩畫 (December 1919, poetry and painting by Kodōjin)

SEALS: 无心 Mushin [2], 字曰子德 Azana iwaku Shitoku [1], 静處 Seisho [3], 拙居 Sekkyo

POEM: *Seisho sanbōshū*, no. 234

**27**

*GREEN BAMBOO AND WHITE CLOUDS*
(*HAKUUN RYOKUCHIKU* 白雲緑竹)

Spring 1920

Hanging scroll, ink and color on silk

56 × 17 in. (142.2 × 43.1 cm)

Sakuma Toshirō collection

SIGNATURE: 庚申春日古道人詩畫 (A spring day in 1920, poetry and painting by Kodōjin)

SEALS: 无心 Mushin [2], 福田世耕 Fukuda Seikō [4], 静處 Seisho [4], 冬日到門惟白雲 Shūjitsu tōmon yui shirakumo

POEM: *Seisho sanbōshū*, no. 187

**28**

*PURE ELEGANCE OF A MOUNTAIN WELLSPRING* (*SENSEKI SEIIN* 泉石清韻)

Spring 1920

Hanging scroll, ink and color on silk

62⅖ × 21 in. (158.5 × 53.3 cm)

SHINYA Japanese Art & Design

SIGNATURE: 庚申春日古道人 (A spring day in 1920, Kodōjin)

SEALS: 无心 Mushin [2], 福田世耕 Fukuda Seikō [4], 静處 Seisho [4], 拙居 Sekkyo

**29**

*PEACH-BLOSSOM SPRING OF WULING*
(*BURYŌ TŌGEN* 武陵桃源)

Spring 1920

Hanging scroll, ink and color on silk

62 × 20⅜ in. (157.5 × 52.2 cm)

SHINYA Japanese Art & Design

SIGNATURE: 庚申春日寫於鹿谷寓居并題南海一布衣古道人 (A spring day in 1920, drawn at the "Temporary Abode in Shishigatani," inscription by One-of-the-Southern-Sea in Simple-Clothes Kodōjin)

SEALS: 无心 Mushin [2], 福田世耕 Fukuda Seikō [4], 静處 Seisho [4], 冬日到門惟白雲 Shūjitsu tōmon yui shirakumo

**30a–d**

*PICTURES OF FOUR GENTLEMEN*
(*SHIKUNSHI ZU* 四君子図)

April 1920

Set of 4 sheets, ink and color on silk

8¼ × 7⅛ in. (21 × 18 cm) (each)

Oni Zazen collection

SIGNATURES: 古道人 (Kodōjin), spring, summer, autumn; 庚申清和月古道人 (April 1920, Kodōjin), winter

SEALS: 无心 Mushin [2], 静處 Sei-sho [1] (each)

POEM: *Shōyō shū*, no. 88.4 (no. 30a)

**31**

*QUIET SETTING OF A MOUNTAIN CREEK*

c. 1921

Hanging scroll, ink on paper

53⅖ × 13½ in. (136.2 × 34.4 cm)

Hakutakuan collection

SIGNATURE: 古道人 (Kodōjin)

SEALS: 无心 Mushin [2], 福田世耕 Fukuda Seikō [4], 静處 Seisho [4], 拙居 Sekkyo

POEM: *Seisho sanbōshū*, no. 234

**32**

*CLIFFS AND BIZARRE ROCKS*

April 1922

Hanging scroll, ink on paper

57⅘ × 12⅕ in. (146.7 × 31.1 cm)

The Metropolitan Museum of Art, Gift of Gitter-Yelen collection, 2009 (2009.510)

SIGNATURE: 壬戌初夏古道人詩畫 (April 1922, poetry and painting by Kodōjin)

SEALS: 无心 Mushin [3], 福田世耕 Fukuda Seikō [4], 静處 Seisho [4], 拙居 Sekkyo, 我有采芝齋 Wa yū saishisai

POEM: *Shōyō shū*, no. 72

**33**

*FISHING ALONE IN A PURE CREEK*

Spring 1924

Hanging scroll, ink on silk

51⅛ × 17 in. (129.9 × 43.2 cm)

Minneapolis Institute of Art, Gift of the Clark Center for Japanese Art & Culture (2013.29.840)

SIGNATURE: 古道人畫并題時甲子春日於綠陰畫學屋。此幅固非應需而既作也。自画自娛，聯以達真耳。不問巧拙不論家派，著吾家法直興化合矣。豈復他有哉々々碧翁述題 (Painting and inscription by Kodōjin, a spring day in 1924 at the "Studio for Studying Painting in Green Shade." This work was certainly not done under any compulsion. I paint myself for my own pleasure, simply to achieve Truth. For me there's no question of skill or clumsiness, no concern about schools of painting: I implement my own style under direct inspiration of harmonious transformation. How could there be anything more to it than that? Stated by Hekiō)

SEALS: 師在我 Shi zai ga [1], 福田世耕 Fukuda Seikō [4], 静處 Seisho [4], 我有采芝齋 Wa yū saishisai, stylized bat, 拙居 Sekkyo, 冬日到門惟白雲 Shūjitsu tōmon yui shirakumo

POEM: *Yōsetsu hōshin*, no. 16

**34**

*SECLUSION DEEP IN THE MOUNTAINS*
(*SHINZAN YŪKYO* 深山幽居)

c. 1922–37

Hanging scroll, ink on silk

54⅜ × 16½ in. (138.8 × 42 cm)

Oni Zazen collection

SIGNATURE: 古道人詩畫 (Poetry and painting by Kodōjin)

SEALS: 无心 Mushin [3], 福田世耕 Fukuda Seikō [4], 静處 Seisho [4], 拙居 Sekkyo

POEM: *Seisho sanbōshū*, no. 122

**35**

*FUJI ABOVE THE CLOUDS*

October 1925

Hanging scroll, ink on paper

38⅛ × 11⅗ in. (96.7 × 29.5 cm)

The Kura Art Gallery, Kyoto

SIGNATURE: 大正乙丑陽月仲旬古道人詩畫 (The middle ten days of October 1925, poetry and painting by Kodōjin)

SEALS: 无心 Mushin [3], Stylized bat, 福田世耕 Fukuda Seikō [4], 静處 Seisho [4], 拙居 Sekkyo, 我有采芝齋 Wa yū saishisai, 蓬萊山下人 Hōraisan genin

POEM: *Seisho sanbōshū* 2, no. 101

**36**

*SOLITARY JOURNEY OF A RECLUSE*

October 1925

Framed, ink on silk

15⅕ × 48.7 in. (38.7 × 123.8 cm)

Minneapolis Institute of Art, Anonymous gift in honor of Gordon Brodfuehrer (2017.144.3)

SIGNATURE: 大正乙丑陽月仲旬於東山寓居畫并題碧翁古人 (The middle ten days of October 1925 at the "Temporary Abode at the Eastern Mountains," painting and inscription by Hekiō Kojin)

SEALS: 无心 Mushin [3], 福田世耕 Fukuda Seikō [4], 静處 Seisho [4], 蓬萊山下人 Hōraisan genin, 拙居 Sekkyo

POEM: *Seisho sanbōshū* 2, no. 20

**37**

*PICTURE OF GYOKUJUNPŌ*
(*GYOKUJUNPŌ ZU* 玉筍峯図)

c. 1925–26

Hanging scroll, ink on paper

58.7 × 12⅜ in. (149 × 32 cm)

Oni Zazen collection

SIGNATURE: 古道人 (Kodōjin)

SEALS: 无心 Mushin [3], 福田世耕 Fukuda Seikō [4], 静處 Seisho [4], 我有采芝齋 Wa yū saishisai

**38**

EXCURSION IN CLOUDY MOUNTAINS

c. 1922–32

Hanging scroll, ink on paper

53⅖ × 13⅖ in. (135.6 × 34 cm)

Minneapolis Institute of Art, Gift of David
Tausig Frank and Kazukuni Sugiyama
(2015.111.1)

SIGNATURE: 古道人詩畫
(Poetry and painting by Kodōjin)

SEALS: 无心 Mushin [3], 福田世耕 Fukuda Seikō
[4], 靜處 Seisho [4], Stylized bat, 拙居
Sekkyo, 我有采芝齋 Wa yū saishisai

**39**

ONE THOUSAND MOUNTAINS AND
TEN THOUSAND RAVINES
(SENZAN BANGAKU 千山萬壑)

c. 1922–32

Hanging scroll, ink on paper

58⅞ × 13⅘ in. (149.5 × 34.8 cm)

Minneapolis Institute of Art, Gift of Willard
G. Clark (2017.145.6)

SIGNATURE: 古道人 (Kodōjin)

SEALS: 无心 Mushin [3], 福田世耕 Fukuda
Seikō [4], 靜處 Seisho [4], 我有采芝齋
Wa yū saishisai

POEM: Seisho sanbōshū, no. 207

**40**

LANDSCAPE WITH LAYERED PEAKS

c. 1925–29

Hanging scroll, ink on paper

51⅘ × 12⅘ in. (131.2 × 32.3 cm)

Hakutakuan collection

SIGNATURE: 南海一布衣古道人詩畫 (Poetry
and painting by One-of-the-Southern-Sea in
Simple-Clothes Kodōjin)

SEALS: 无心 Mushin [3], 福田世耕 Fukuda Seikō
[4], 靜處 Seisho [4], 蓬莱山下人 Hōraisan
genin

**41**

BAMBOO FOREST LANDSCAPE

c. 1925–29

Hanging scroll, ink on paper

51⅗ × 12 in. (131 × 30.5 cm)

Oni Zazen collection

SIGNATURE: 古道人 (Kodōjin)

SEALS: 无心 Mushin [3], 福田世耕 Fukuda Seikō
[4], 靜處 Seisho [4], 蓬莱山下人 Hōraisan
genin

POEM: Seisho sanbōshū, no. 187

**42**

WIND AND MOON BY THE RIVERSIDE
(KAHIN FŪGETSU 河濱風月)

c. 1922–24

Hanging scroll, ink and color on paper

51⅘ × 12⅘ in. (131.3 × 32.4 cm)

Minneapolis Institute of Art, Gift of the Clark
Center for Japanese Art & Culture
(2013.29.968)

SIGNATURE: 古道人詩畫
(Poetry and painting by Kodōjin)

SEALS: 无心 Mushin [3], 福田世耕 Fukuda Seikō
[4], 靜處 Seisho [4], 拙居 Sekkyo

POEM: Shōyō shū, no. 53

**43**

RETURNING SAILS AND COLORFUL TREE
(SHIKIJU KIHAN 色樹歸帆)

Spring 1926 (box)

Hanging scroll, ink and color on paper

52⅖ × 12⅕ in. (133 × 31 cm)

Seattle Art Museum, Gift of Griffith and Patricia
Way, in honor of the 75th Anniversary of the
Seattle Art Museum (2010.41.47)

SIGNATURE: 錄羅太經閒居交遊篇古道人
(Recorded in acquaintances of Luo Taijing
while living in retirement, Kodōjin)

SEALS: 无心 Mushin [3], 福田世耕 Fukuda Seikō
[4], 靜處 Seisho [4], 拙居 Sekkyo, 我有采芝
齋 Wa yū saishisai, 蓬莱山下人 Hōraisan
genin, 冬日到門惟白雲 Shūjitsu tōmon yui
shirakumo

**44**

WHITE CLOUDS EMERGING FROM THE
MOUNTAINS

c. 1921–30

Hanging scroll, ink and color on paper

52 × 12⅛ in. (132.2 × 30.7 cm)

Private collection

SIGNATURE: 靜處詩畫
(Poetry and painting by Seisho)

SEALS: 无心 Mushin [3], 福田世耕 Fukuda Seikō
[4], 靜處 Seisho [4], 拙居 Sekkyo, 冬日到門
惟白雲 Shūjitsu tōmon yui shirakumo, 蓬莱
山下人 Hōraisan genin, 我有采芝齋 Wa yū
saishisai

POEM: Seisho sanbōshū, no. 165

**45**

LANDSCAPE WITH PLUM FOREST
(BAIRIN SANSUI 梅林山水)

c. 1926

Hanging scroll, ink and color on silk

62 × 20½ in. (157.5 × 52.1 cm)

Stuart Katz collection

SIGNATURE: 吾唯寫我胸中山水以畫一時之興
耳。逸策來往，詩或有題。遂如千載後畫劣被
有失形，詩題足以傳神均幅。豈個不笑耶。古
道人碧翁 (I merely depict the mountains and
rivers of my heart, painting the inspiration of
a moment. Coming and going with liberated
hiking staff, I may also come up with a poetic
inscription. And then, a thousand years later,
should the painting suffer damage or loss,
this poem may serve to preserve its spirit, an
equivalent to the actual painting! Would that
not be worthy of just one laugh? Kodojin
Hekiō)

SEALS: 无心 Mushin [3], 福田世耕 Fukuda Seikō
[4], 靜處 Seisho [4], 拙居 Sekkyo

**46**

BOATING ON A CREEK AMID PLUM TREES
(BAIKEI HŌTŌ 梅溪放棹)

June 1927

Hanging scroll, ink and color on silk

52⅖ × 14⅞ in. (133.5 × 37.8 cm)

Harvard Art Museum, Promised gift of Robert S.
and Betsy G. Feinberg, Photo ©Photography:
John Tsantes and Neil Greentree © Robert
Feinberg (FEIN.168)

SIGNATURE: 時在丁卯林鐘東山隱士古道人詩
畫 (The time being June 1927, poetry and
painting by the Recluse of the Eastern
Mountains Kodōjin)

SEALS: 无心 Mushin [3], 福田世耕 Fukuda Seikō
[4], 靜處 Seisho [4], 今日樂 Konnichi raku,
蓬莱山下人 Hōraisan genin, 拙居 Sekkyo

**47**

RED TREE IN VERDANT MOUNTAINS
(SEIZAN KŌJU 青山紅樹)

c. 1921–30

Hanging scroll, ink and color on silk

59⅖ × 16⅗ in. (151 × 42.2 cm)

Freer Gallery of Art, Smithsonian Institution,
Washington DC: The Mary and Cheney
Cowles collection, Gift of Mary and Cheney
Cowles (F2019.3.4a-d)

SIGNATURE: 古道人畫并題 (Painting and
inscription by Kodōjin)

SEALS: 无心 Mushin [3], 福田世耕 Fukuda
Seikō [4], 靜處 Seisho [4], 冬日到門惟白雲
Shūjitsu tōmon yui shirakumo

POEM: Seisho sanbōshū, no. 207

**48**

*Landscape with Rice Fields*

Spring 1923

Hanging scroll, ink and color on silk

57⅞ × 14½ in. (147 × 36.8 cm)

Private collection

SIGNATURE: 癸亥春日於鹿谷寓居畫并題古道
人田耕 (A spring day in 1923 at the
"Temporary Abode in Shishigatani," painting
and inscription by Kodōjin Denkō)

SEALS: 无心 Mushin [3], 福田世耕 Fukuda
Seikō [4], 靜處 Seisho [4], 拙居 Sekkyo

POEM: *Seisho sanbōshū*, no. 87

**49**

*Excursion under Pine Trees*
(*Shōka kōraku* 松下行樂)

Summer 1927, December 1927 (box)

Hanging scroll, ink and color on silk

54⅖ × 16⅞ in. (138.1 × 42.9 cm)

Oni Zazen collection

SIGNATURE: 丁卯夏日於東山寓居碧翁詩畫
(A summer's day in 1927 at the "Temporary
Abode at the Eastern Mountains," poetry
and painting by Hekiō)

SEALS: 无心 Mushin [3], 福田世耕 Fukuda
Seikō [4], 靜處 Seisho [4], 我有采芝齋
Wa yū saishisai

POEM: *Seisho sanbōshū*, no. 95

**50**

*Retiring from the World at
a Mountain Creek*

c. 1922–40

Hanging scroll, ink and color on silk

50 × 16⅞ in. (127 × 43 cm)

Oni Zazen collection

SIGNATURE: 古道人詩畫
(Poetry and painting by Kodōjin)

SEALS: 无心 Mushin [3], 字曰子徳 Azana iwaku
Shitoku [1], 靜處 Seisho [3], 拙居 Sekkyo

POEM: *Yōsetsu hōshin*, no. 8

**51**

*Withered Trees and Winter Crows*
(*Kan'a koboku* 寒鴉枯木)

Spring 1927

Hanging scroll, ink on paper

53⅛ × 13⅓ in. (135 × 33.7 cm)

Harvard Art Museum, Promised gift of Robert S.
and Betsy G. Feinberg, Photo ©Photography:
John Tsantes and Neil Greentree © Robert
Feinberg (FEIN.169)

SIGNATURE: 丁卯春日於東山寓居古道人
(A spring day in 1927 at the "Temporary
Abode at the Eastern Mountains," Kodōjin)

SEALS: 无心 Mushin [3], 福田世耕 Fukuda Seikō
[4], 靜處 Seisho [4], 蓬萊山下人 Hōraisan
genin

POEM: *Yōsetsu hōshin*, no. 16

**52**

*Bamboo in Snow* (*Setchiku* 雪竹)

c. 1927

Hanging scroll, red and ink on paper

54 × 13⅘ in. (137.2 × 34.7 cm)

Minneapolis Institute of Art, Gift of David
Tausig Frank and Kazukuni Sugiyama
(2015.111.24)

SIGNATURE: 古道人 (Kodōjin)

SEALS: 无心 Mushin [3], 福田世耕 Fukuda
Seikō [4], 靜處 Seisho [4], 我有采芝齋
Wa yū saishisai

**53**

*Sponge Gourds* (*Itouri* 絲瓜)

c. 1927

Hanging scroll, ink on paper

19 × 11 in. (48.3 × 27.9 cm)

Bachmann Eckenstein Japanese Art, Switzerland

SIGNATURE: 古人 (Kojin)

SEAL: 拙居 Sekkyo

**54**

*Blue-Green Landscape* (*Seiryoku sansui*
青緑山水)

Spring 1921, January 1942 (box)

Hanging scroll, ink and color on silk

11½ × 17⅓ in. (29.2 × 43.8 cm)

David Tausig Frank and Kazukuni Sugiyama
collection

SIGNATURE: 辛酉春日於鹿谷寓居古道人詩畫
(A spring day in 1921 at the "Temporary
Abode in Shishigatani," poetry and painting
by Kodōjin)

SEALS: 无心 Mushin [2], 靜處 Sei-sho [1], 拙居
Sekkyo

**55**

*Blue-Green Landscape*

c. 1922–32

Hanging scroll, ink and color on silk

51⅖ × 10⅓ in. (130.6 × 27.5 cm)

Private collection

SIGNATURE: 碧翁詩畫
(Poetry and painting by Hekiō)

SEALS: 无心 Mushin [3], 福田世耕 Fukuda Seikō
[4], 靜處 Seisho [4], 蓬萊山下人 Hōraisan
genin

POEM: *Shōyō shū*, no. 69

**56**

*Blue-Green Landscape* (*Seiryoku sansui*
青緑山水)

February 1926

Hanging scroll, ink and color on silk

55 × 20⅓ in. (139.7 × 51.4 cm)

Minneapolis Institute of Art, Gift of the Clark
Center for Japanese Art & Culture (2013.29.902)

SIGNATURE: 大正丙寅如月於高遠客靜處詩畫
(February 1926 at the "Lofty Location," poetry
and painting by Seisho)

SEALS: 師在我 Shi zai ga [1], 字曰子徳 Azana
iwaku Shitoku [1], 靜處 Seisho [3], 我有采芝
齋 Wa yū saishisai

POEM: *Seisho sanbōshū*, no. 133

**57**

*Blue-Green Landscape*
(*Seiryoku sansui* 青緑山水)

Summer 1932 (box)

Hanging scroll, ink and color on silk

50⅘ × 13½ in. (128.9 × 34.4 cm)

Minneapolis Institute of Art, Gift of David
Tausig Frank and Kazukuni Sugiyama
(2015.111.6)

SIGNATURE: 鹿谷隱士古道人 (Recluse of
Shishigatani Kodōjin)

SEALS: 無邪 Muja, 福田世耕 Fukuda Seikō [4],
靜處 Seisho [4], 我有采芝齋 Wa yū saishisai

POEM: *Seisho sanbōshū*, no. 30

**58**

*Blue-Green Landscape*
(*Seiryoku sansui* 青緑山水)

April 1928

Hanging scroll, ink and color on silk

53⅞ × 16⅞ in. (137 × 43 cm)

Minneapolis Institute of Art, Gift of David Tausig
Frank and Kazukuni Sugiyama (2015.111.21)

SIGNATURE: 時在戊辰猶清和月上浣於東山寓
居古道人詩畫 (The time being still 1928,
the first ten days of April at the "Temporary
Abode at the Eastern Mountains," poetry
and painting by Kodōjin)

SEALS: 无心 Mushin [3], 福田世耕 Fukuda Seikō
[4], 靜處 Seisho [4], 我有采芝齋 Wa yū
saishisai

POEM: *Seisho sanbōshū*, no. 216

**59**

*Excursion of a Recluse*
(*Yūjin kōraku* 幽人行樂)

c. 1928

Hanging scroll, ink and color on gold-ground silk

57⅘ × 16⅖ in. (146.7 × 41.6 cm)

Seattle Art Museum, Gift of Griffith and Patricia
Way, in honor of the 75th Anniversary of the
Seattle Art Museum (2010.41.86); Photo:
Elizabeth Mann

SIGNATURE: 古道人詩畫
(Poetry and painting by Kodōjin)

SEALS: 无心 Mushin [3], 字曰子徳 Azana iwaku
Shitoku [1], 靜處 Seisho [3], 冬日到門惟白雲
Shūjitsu tōmon yui shirakumo

POEM: *Shōyō shū*, no. 109 (only first two verses)

**60**

*Silhouettes of Sails and Glowing Pine
Trees* (*Shōkō hokage* 松光帆影)

May 1928

Hanging scroll, ink on paper

53⅘ × 13⅓ in. (136.4 × 33.7 cm)

Minneapolis Institute of Art, Gift of the Clark
Center for Japanese Art & Culture
(2013.29.1004)

SIGNATURE: 時在昭和戊辰仲夏於東山草堂古
道人詩畫 (The time being May 1928, at the
"Thatched Hut at the Eastern Mountains,"
poetry and painting by Kodōjin)

SEALS: 无心 Mushin [3], 福田世耕 Fukuda Seikō
[4], 靜處 Seisho [4], 蓬萊山下人 Hōraisan
genin

**61**

*HIGH WATERFALL AND ROLLING PEAKS*
(*RENSHŌ HIBAKU* 連嶂飛瀑)

Summer 1928

Hanging scroll, ink on paper

53½ × 13⅖ in. (136 × 34 cm)

Minneapolis Institute of Art, Gift of David
  Tausig Frank and Kazukuni Sugiyama
  (2015.111.26)

SIGNATURE: 昭和戊辰夏日於東山寓居古道人
  詩畫 (A summer's day in 1928 at the
  "Temporary Abode at the Eastern Mountains,"
  poetry and painting by Kodōjin)

SEALS: 无心 Mushin [3], 字曰子徳 Azana iwaku
  Shitoku [1], 靜處 Seisho [3], 蓬莱山下人
  Hōraisan genin

**62**

*WITHERED TREE AND WINTER CROW*
(*KAN'A KOBOKU* 寒鴉枯木)

c. 1928

Hanging scroll, ink and color on paper

51½ × 12½ in. (130.8 × 31.8 cm)

Mary and Cheney Cowles collection

SIGNATURE: 南海一布衣古人 (One-of-the-
  Southern-Sea in Simple-Clothes Kojin)

SEALS: 无心 Mushin [3], 福田世耕 Fukuda Seikō
  [4], 靜處 Seisho [4]

POEM: *Shōyō shū*, no. 57

**63**

*CRABS WALKING SIDEWAYS*
(*ŌKŌ KAISHI* 横行介士)

c. 1928

Hanging scroll, ink and color on paper

53⅖ × 12⅞ in. (135.7 × 32.7 cm)

Minneapolis Institute of Art, Gift of David
  Tausig Frank and Kazukuni Sugiyama
  (2015.111.23)

SIGNATURE: 古人詩畫
  (Poetry and painting by Kojin)

SEALS: 无心 Mushin [3], 福田世耕 Fukuda
  Seikō [4], 靜處 Seisho [4], 蓬莱山下人
  Hōraisan genin

**64**

*MOON AND PINE TREE* (*SHŌGETSU* 松月)

c. 1928

Hanging scroll, ink on paper

54⅜ × 13⅛ in. (138.6 × 33.3 cm)

Minneapolis Institute of Art, Gift of David
  Tausig Frank and Kazukuni Sugiyama
  (2015.111.7)

SIGNATURE: 古人詩畫
  (Poetry and painting by Kojin)

SEALS: 无心 Mushin [3], 福田世耕 Fukuda
  Seikō [4], 靜處 Seisho [4]

**65**

*MORNING SUN OVER MOUNT FUJI*
(*FUGAKU CHŌYŌ* 富嶽朝陽)

c. 1929–32

Hanging scroll, ink and color on silk

16⅛ × 16⅞ in. (41.2 × 42.9 cm)

Minneapolis Institute of Art, Gift of David
  Tausig Frank and Kazukuni Sugiyama
  (2015.111.10)

SIGNATURE: 碧翁 (Hekiō)

SEALS: 无心 Mushin [3], 福田世耕 Fukuda
  Seikō [4], 靜處 Seisho [4]

**66**

*HIGH WATERFALL IN CLOUDY MOUNTAINS*
(*UNZAN HIBAKU* 雲山飛瀑)

June 1929

Hanging scroll, ink on paper

54⅘ × 14½ in. (138.2 × 34.2 cm)

Oni Zazen collection

SIGNATURE: 余老廢午睡畏日猶揮毫此幅即是
  焚香靜坐自覺涼味溢于紙上亦是銷夏法昭
  和己巳三伏節於東山寓居古道人畫并題
  (In my old age I am giving up my noontime
  nap, afraid of losing the daylight. I still wield
  my brush. This work simply flowed onto the
  paper as I burned incense, sat quietly, and
  enjoyed the feeling of cool flavor. This is
  indeed a technique for dissolving away the
  summer. June 1929 at Temporary Abode at the
  Eastern Mountains, painting and inscription
  by Kodōjin)

SEALS: 无心 Mushin [3], 福田世耕 Fukuda
  Seikō [4], 靜處 Seisho [4], 拙居 Sekkyo

POEM: *Shōyō shū*, no. 88.3

**67**

*A MAN OF NOBLE CHARACTER VIEWING A
  WATERFALL* (*KŌSHI KANBAKU* 高士観瀑)

Spring 1930 (box)

Hanging scroll, ink on paper

52½ × 13⅓ in. (133.4 × 33.8 cm)

Minneapolis Institute of Art, Gift of David
  Tausig Frank and Kazukuni Sugiyama
  (2015.111.15)

SIGNATURE: 南海一布衣古人詩畫 (Poetry and
  painting by One-of-the-Southern-Sea in
  Simple-Clothes Kojin)

SEALS: 師在我 Shi zai ga [1], 字曰子徳 Azana
  iwaku Shitoku [1], 靜處 Seisho [3], 我師造化
  Waga shi zōka

**68**

*WANDERER UNDER THE MOON*
(*GEKKA YŪJIN* 月下遊人)

c. 1913–37

Hanging scroll, ink on paper

32½ × 6⅘ in. (82.5 × 17 cm)

Minneapolis Institute of Art, Gift of David
  Tausig Frank and Kazukuni Sugiyama
  (2015.111.22)

SIGNATURE: 古人 (Kojin)

SEALS: 拙居 Sekkyo

**69**

*OLD PLUM* (*RŌBAI* 老梅)

Spring 1936

Hanging scroll, ink on paper

53½ × 12⅜ in. (136 × 32 cm)

Minneapolis Institute of Art, Gift of David
  Tausig Frank and Kazukuni Sugiyama
  (2015.111.25)

SIGNATURE: 丙子春日於鹿谷寓居古人畫并題
  (A spring day in 1936 at the "Temporary
  Abode in Shishigatani," painting and
  inscription by Kojin) (part 1); 拙則真々
  則古師古　不摸古道　吾家畫訣　豈復他
  有哉　碧翁題 ("Clumsy!" then it is truly real:
  / Take the past as your rule, take the past as
  your master. / Yet not to touch upon the past
  is / The secret of my school of painting! How
  could there be anything more to it than that?
  Inscription by Hekiō) (part 2)

SEALS: 筆補造化 Hippo zōka, 無邪 Muja, 福田
  世耕 Fukuda Seikō [4], 靜處 Seisho [4], 靜處
  Sei-sho [1]

POEM: *Seisho sanbōshū*, no. 84

**70**

*PEACEFUL GARDEN AND OLD TREE*
(*KOBOKU KANTEI* 古木閑庭)

January 1930 (box)

Hanging scroll, ink on silk

56⅛ × 16⅞ in. (143 × 43 cm)

Minneapolis Institute of Art, Gift of David
  Tausig Frank and Kazukuni Sugiyama
  (2015.111.12)

SIGNATURE: 古道人詩畫
  (Poetry and painting by Kodōjin)

SEALS: 師在我 Shi zai ga [1], 字曰子徳 Azana
  iwaku Shitoku [1], 靜處 Seisho [3], 冬日到門
  惟白雲 Shūjitsu tōmon yui shirakumo

**71**

*ONE THOUSAND MOUNTAINS AND
  TEN THOUSAND RAVINES*
(*SENZAN BANGAKU* 千山萬壑)

c. 1937

Hanging scroll, ink on silk

50⅛ × 11⅛ in. (127.8 × 28.4 cm)

Private collection

SIGNATURE: 古道人詩畫
  (Poetry and painting by Kodōjin)

SEALS: 無邪 Muja, 福田世耕 Fukuda Seikō
  [4], 靜處 Seisho [4], 拙居 Sekkyo

POEM: *Seisho sanbōshū*, no. 93

**72**

*HIGH WATERFALL IN CLOUDY MOUNTAINS*

Winter 1931

Hanging scroll, ink on paper

52⅖ × 13⅛ in. (133 × 33.4 cm)

Oni Zazen collection

SIGNATURE: 辛未冬日古人
  (A winter's day in 1931, Kojin)

SEALS: 無邪 Muja, 福田世耕 Fukuda Seikō [4],
  靜處 Seisho [4], 蓬莱山下人 Hōraisan genin

POEM: *Seisho sanbōshū*, no. 50.4

**73**

*PINE TREE AND RISING SUN BETWEEN CLIFFS* (*ZEPPEKI SHŌKYOKU* 絕壁松旭)

c. 1931–33

Hanging scroll, ink on paper

55⅘ × 15⅓ in. (141.5 × 38.7 cm)

Minneapolis Institute of Art, Gift of the Clark Center for Japanese Art & Culture (2013.29.1254)

SIGNATURE: 古道人 (Kodōjin)

SEALS: 無邪 Muja, 福田世耕 Fukuda Seikō [7], 靜處 Seisho [7]

POEM: *Seisho sanbōshū*, no. 195

**74**

*OLD PINES*

Autumn 1932 (right), October 1932 (left)

Six-panel folding screen pair, ink on paper

65⅞ × 145⅜ in. (167.3 × 369.7 cm) (each)

Minneapolis Institute of Art, Gift of the Clark Center for Japanese Art & Culture, formerly given to the Center by Elizabeth and Willard Clark (2013.29.842.1-2)

SIGNATURES: 壬申秋日於蕭山軒南海一布衣古人詩畫 (An autumn day in 1932 at the "Lonely Mountain House," poetry and painting by One-of-the-Southern-Sea in Simple-Clothes Kojin) right; 昭和七年十月吉南海一布衣古人詩畫 (A lucky day in October 1932, poetry and painting by One-of-the-Southern-Sea in Simple-Clothes Kojin) left

SEALS: 師在我 Shi zai ga [1], 福田世耕 Fukuda Seikō [6], 靜處 Seisho [6] (each)

**75**

*BAMBOO IN SNOW*

c. 1925–35

Six-panel folding screen pair, white on brown paper

148⅜ × 69⅓ in. (377.5 × 176 cm) (each)

The Kura Art Gallery, Kyoto

SIGNATURES: 古人 (Kojin) each

POEMS: *Seisho sanbōshū*, no. 37 (right); *Seisho sanbōshū*, no. 24 (left)

**76**

*LANDSCAPE IN PALE RED* (*SENGŌ SANSUI* 淺絳山水)

Spring 1929 (box)

Hanging scroll, ink and color on paper

53⅓ × 13⅛ in. (135.5 × 33.4 cm)

Private collection

SIGNATURE: 古道人畫并題 (Painting and inscription by Kodōjin)

SEALS: 師在我 Shi zai ga [1], 福田世耕 Fukuda Seikō [4], 靜處 Seisho [4], 我有采芝齋 Wa yū saishisai

POEM: *Seisho sanbōshū 2*, no. 19

**77**

*BOATING ON A PURE CREEK* (*SEIKEI HŌTŌ* 清溪放棹)

January 1930 (box)

Hanging scroll, ink and color on paper

52⅓ × 12⅘ in. (132.6 × 32.5 cm)

Minneapolis Institute of Art, Gift of the Clark Center for Japanese Art & Culture (2013.29.146)

SIGNATURE: 碧翁詩畫 (Poetry and painting by Hekiō)

SEALS: 無邪 Muja, 福田世耕 Fukuda Seikō [5], 靜處 Seisho [5], 拙居 Sekkyo

**78**

*PLUM-BLOSSOM LIBRARY*

c. 1922–37

Hanging scroll, ink and color on paper

55⅓ × 12½ in. (140.3 × 31.8 cm)

Gordon Brodfuehrer collection

SIGNATURE: 靜處詩畫 (Poetry and painting by Seisho)

SEALS: 无心 Mushin [3], 福田世耕 Fukuda Seikō [4], 靜處 Seisho [4]

**79**

*RED LEAVES AND WHITE CLOUDS* (*HAKUUN KŌYŌ* 白雲紅葉)

April 1934

Hanging scroll, ink and color on paper

53⅓ × 13⅛ in. (135.3 × 33.3 cm)

Stuart Katz collection

SIGNATURE: 甲戌猶清和月下旬於鹿谷幽居古道人詩畫 (Still in 1934, the last ten days of April at the "Deer Valley Hermitage," poetry and painting by Kodōjin)

SEALS: 無邪 Muja, 福田世耕 Fukuda Seikō [5], 靜處 Seisho [5], 筆補造化 Hippo zōka

**80**

*LANDSCAPE IN PALE RED* (*SENGŌ SANSUI* 淺絳山水)

c. 1930–35

Hanging scroll, ink and color on paper

52 × 13 in. (132.1 × 33 cm)

Private collection

SIGNATURE: 古道人詩畫 (Poetry and painting by Kodōjin)

SEALS: 無邪 Muja, 福田世耕 Fukuda Seikō [5], 靜處 Seisho [5]

POEM: *Kodōjin shiga*, no. 41 / *Seisho sanbōshū*, no. 70

**81**

*SECLUSION AT A STREAM AND BAMBOO*

c. 1933

Hanging scroll, ink and color on paper

53½ × 13.1 in. (135.9 × 33.3 cm)

Private collection

SIGNATURE: 鹿門隱士畫并題 (Painting and inscription by the Recluse of Deer Gate)

SEALS: 无心 Mushin [3], 福田世耕 Fukuda Seikō [7], 靜處 Seisho [7], 拙居 Sekkyo

POEM: *Seisho sanbōshū*, no. 37

**82**

*ALBUM OF UNTRAMMELED LIVING* (*JITEKIJŌ* 自適帖)

March 1933

Album with 14 leaves, ink on paper

7⅗ × 11⅞ in. (19.4 × 30.1 cm) (each leaf)

Minneapolis Institute of Art, Gift of the Clark Center for Japanese Art & Culture (2013.29.935)

SIGNATURE: 古人 Kojin (frontispiece, leaves 2, 4, 6, 8, 10, 12); 癸酉載陽吉日南海一布衣 A lucky day in March 1933, One-of-the-Southern-Sea in Simple-Clothes (postscript)

SEALS: 師在我 Shi zai ga [1], 字曰子德 Azana iwaku Shitoku [1], 靜處 Seisho [3] (frontispiece); 無邪 Muja, 福田世耕 Fukuda Seikō [5], 靜處 Seisho [5] (leaves 2, 4, 6, 8, 10, 12); 靜處 Sei-sho [1] (leaves 3, 7, 11); 靜處 Sei-sho [1] (leaves 5, 9, 13); 无心 Mushin [3], 福田世耕 Fukuda Seikō [7], 靜處 Seisho [7] (postscript)

POEMS: *Yōsetsu hōshin*, nos. 5–9, 16

**83**

*ALBUM OF JOY IN HEAVEN* (*RAKUTENJŌ* 樂天帖)

April 1937

Album with 26 leaves, ink on paper

11⅞ × 20½ in. (30.2 × 52 cm) (frontispiece, postscript); 11⅞ × 9½ in. (30.2 × 24.2 cm) (each leaf)

Shingū City Museum of History and Folklore

SIGNATURE: 古道人 Kodōjin (frontispiece); 丁丑清和月於東山寓居碧翁居士識 (April 1937 at the "Temporary Abode at the Eastern Mountains," written by layman Hekiō) (postscript)

SEALS: 師在我 Shi zai ga [1], 字曰子德 Azana iwaku Shitoku 1, 靜處 Seisho [3] (frontispiece); 無邪 Muja, 福田世耕 Fukuda Seikō [5], 靜處 Seisho [5] (leaves 2, 4, 6, 8, 10, 12, 14, 16, 18, 20, 22, 24); 靜處 Sei-sho [1] (leaves 3, 5, 7, 9, 11, 13, 15, 17, 19, 21, 23, 25); 无心 Mushin [3], 古道人 Kodōjin [4], 筆補造化 Hippo zōka (postscript)

POEMS: *Yōsetsu hōshin*, no. 1 (leaf 2); *Yōsetsu hōshin*, no. 2 (leaf 4); *Yōsetsu hōshin*, no. 3 (leaf 6); *Yōsetsu hōshin*,, no. 5 (leaf 8); *Yōsetsu hōshin*, no. 8 (leaf 10); *Yōsetsu hōshin*, no. 6 (leaf 12); *Yōsetsu hōshin*, no. 9 (leaf 14); *Yōsetsu hōshin*, no. 7 (leaf 16); *Yōsetsu hōshin*, no. 13 (leaf 18); *Yōsetsu hōshin*, no. 16 (leaf 20); *Yōsetsu hōshin*, no. 18 (leaf 22); *Yōsetsu hōshin*, no. 20 (leaf 24)

**84**

*SHARING ONE MIND* (*DŌSHIN ICHIMI* 道心一味)

c. 1922–24

Hanging scroll, ink on paper

54⅓ × 13⅓ in. (137.8 × 33.7 cm)

Private collection, USA

SIGNATURE: はりつ (Haritsu)

SEAL: 靜處 Seisho [8]

**85**

*NANDINA TREE (NANTENKI* 南天樹*)*

c. 1929–32

Hanging scroll, ink and color on paper

48⅞ × 8⅘ in. (124.3 × 22.1 cm)

Minneapolis Institute of Art, Gift of the
   Clark Center for Japanese Art & Culture,
   formerly given to the Center by Elizabeth
   and Willard Clark (2013.29.837)

SIGNATURE: 古人 (Kojin)

SEAL: 福田世耕 Fukuda Seikō [4]

POEM: *Haritsu kushū*, winter, no. 26

**86**

*CRIMSON LOTUS FLOWER (GUREN* 紅蓮*)*

April 1931 (box)

Hanging scroll, ink and color on paper

132.3 × 26.7 cm (52.1 × 10.5 in.)

Minneapolis Institute of Art, Gift of David
   Tausig Frank and Kazukuni Sugiyama
   (2015.111.16)

SIGNATURE: 古人 (Kojin)

SEALS: 靜處 Sei-sho [1]

**87**

*SNOW DARUMA*

c. 1943

Hanging scroll, white on red paper

24⅖ × 9.1 in. (62 × 23.2 cm)

Private collection

SIGNATURE: はりつ (Haritsu)

SEAL: Unread

**88**

*SMOKING OUT INSECTS*

c. 1927–41

Hanging scroll, ink and color on paper

51½ × 12⅘ in. (130.8 × 32.4 cm)

Minneapolis Institute of Art, Gift of the
   Clark Center for Japanese Art & Culture
   (2013.29.967)

SIGNATURE: 古人 (Kojin)

SEAL: 今日樂 Konnichi raku

**89**

*CLEARING AFTER SNOW, FIVE-CHARACTER
   VERSE*

1910s

Hanging scroll, ink on paper

69.7 × 35⅗ in. (177 × 90.5 cm)

Minneapolis Institute of Art, Gift of the
   Clark Center for Japanese Art & Culture
   (2013.29.1015)

SIGNATURE: 古人 (Kojin)

SEALS: 師在我 Shi zai ga [1], 福田世耕
   Fukuda Seikō [6], 靜處 Seisho [6]

POEM: *Seisho sanbōshū*, no. 106

**90**

*FISHERMAN, FIVE-CHARACTER VERSE
   (GYOFU GOZETSU* 漁父五絶*)*

January 1922 (box)

Hanging scroll, ink on satin

53½ × 11 in. (135.9 × 27.9 cm)

Private collection, USA

SIGNATURE: 古道人 (Kodōjin)

SEALS: 无心 Mushin [3], 字曰子德 Azana
   iwaku Shitoku [1], 靜處 Seisho [3]

POEM: *Seisho sanbōshū*, no. 209

**91**

*MOUNT KAMAYAMA, FIVE-CHARACTER
   VERSE (KAMAYAMA GOZETSU* 竈山五絶*)*

April 1940 (box)

Hanging scroll, ink on paper

51⅖ × 10⅞ in. (130.6 × 27.8 cm)

Minneapolis Institute of Art, Gift of David
   Tausig Frank and Kazukuni Sugiyama
   (2015.111.9)

SIGNATURE: 古人 (Kojin)

SEALS: 无心 Mushin [3], 字曰子德 Azana
   iwaku Shitoku [1], 靜處 Seisho [3]

**92**

*I TAKE REFUGE IN AMIDA BUDDHA
   (NAMU AMIDA BUTSU* 南無阿弥陀佛*)*

Winter 1942 (box)

Hanging scroll, white ink on black paper

47⅞ × 10 ⅕ in. (121.6 × 26.2 cm)

Private collection

SEALS: 字曰子德 Azana iwaku Shitoku [1],
   靜處 Seisho [3]

**93**

*QUIET SETTING OF A MOUNTAIN CREEK
   (KEIZAN YŪSHU* 溪山幽趣*)*

Spring 1940

Hanging scroll, ink on paper

55 × 14⅕ in. (139.7 × 36.3 cm)

Minneapolis Institute of Art, Gift of David
   Tausig Frank and Kazukuni Sugiyama
   (2015.111.20)

SIGNATURE: 庚辰春日古道人
   (A spring day in 1940, Kodōjin)

SEALS: 无心 Mushin [3], 字曰子德 Azana iwaku
   Shitoku [1], 靜處 Seisho [3], 古道人 Kodōjin
   [3]

POEM: *Kodōjin shiga*, no. 38; *Seisho sanbōshū*,
   no. 94

**94**

*SELF-PORTRAIT OF THE VENERABLE SEISHO
   (SEISHO-Ō JIGAZŌ* 靜處翁自畫像*)*

1941

Hanging scroll, ink on paper

29⅕ × 11⅘ in. (74.3 × 29.9 cm)

Minneapolis Institute of Art, Gift of the
   Clark Center for Japanese Art & Culture
   (2013.29.1005)

SIGNATURE: 古人寫 (Drawn by Kojin)

SEAL: 今日樂 Konnichi raku

**95**

*PINE TREE AND RISING SUN*

c. 1942

Hanging scroll, ink and color on paper

53⅘ × 12⅕ in. (136.5 × 31.3 cm)

Minneapolis Institute of Art, Gift of the Clark
   Center for Japanese Art & Culture, formerly
   given to the Center by Audrey Seo and
   Stephen Addiss (2013.29.230)

SIGNATURE: 古人 (Kojin)

SEAL: 古道人 Kodōjin [5]

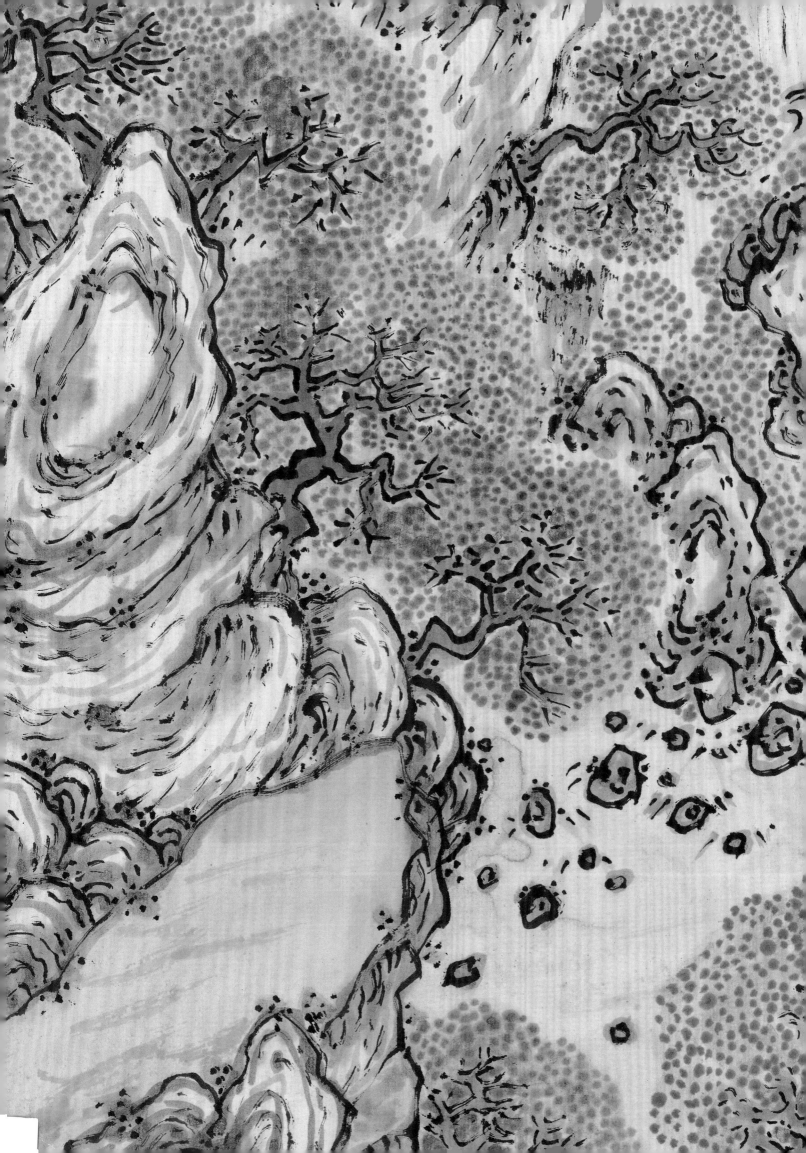

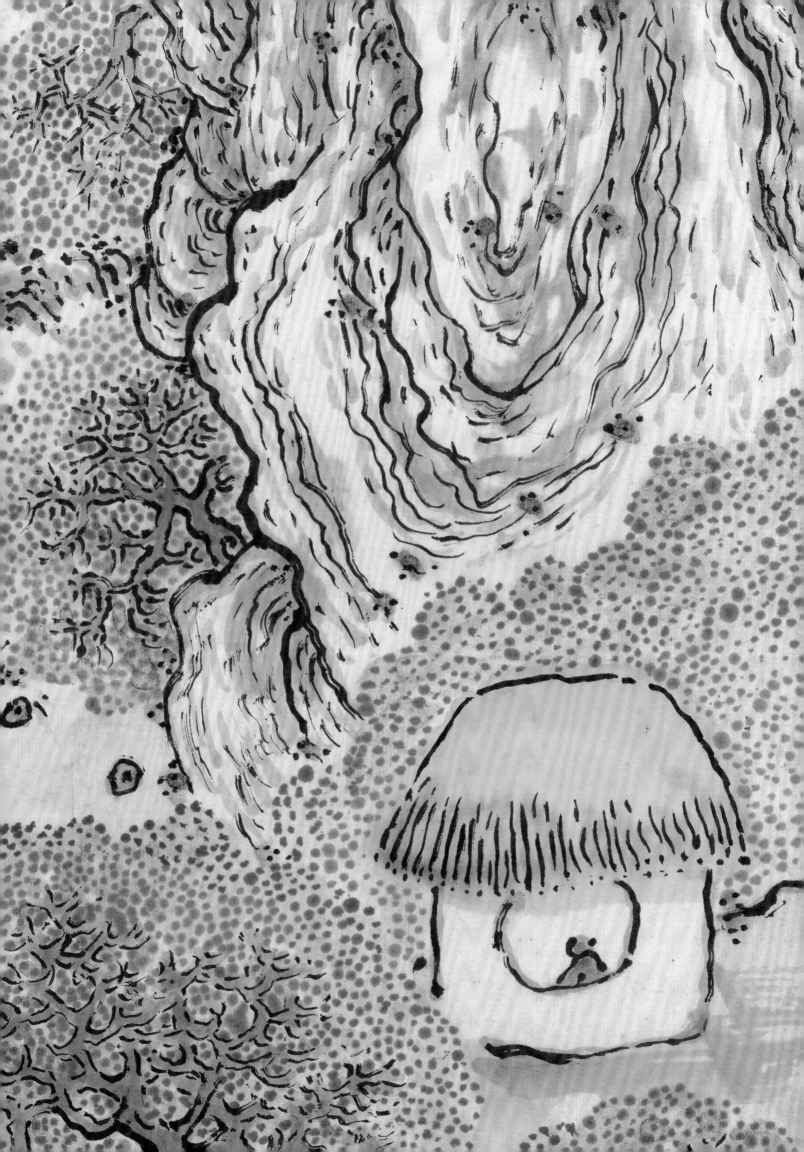

The following is a chronological list of the names of the various "poetic locations" that Kodōjin inscribed on his paintings to indicate where he created an artwork. The actual sites of some have yet to be identified, and others appear twice due to the lapse of time between visits. The latter group is designated by an asterisk and corresponding number.

| POETIC LOCATION/ TRANSCRIPTION/ TRANSLATION | DATE/ ACTUAL LOCATION/ OCCURRENCE |
|---|---|
| 衡山寓居 Kōzan gūkyo Temporary Abode on Mount Heng | July 1902 Ichijōji (Kyoto)? 1 |
| 丹鶴城西寓居 Tankakujō sai gūkyo Temporary Abode West of Shingū Castle | Feb. 1906 Shingū (Wakayama) 1 |
| 松巖精居 Shōgan seikyo Abode of Essence at Shōgan | 1906 Shingū (Wakayama) 1 |
| 栖碧山房 Seiheki sanbō Perched in Azure Mountain Hut | Apr. 1907 Takagishi (Kyoto)? 1 |
| 望仙樓 Bōsenrō Tower of Watching Out for Immortals | Apr. 1907 Takagishi (Kyoto)? 2 |
| 碧樓 Hekirō Azure Tower | Summer (Apr.–June) 1907 Takagishi (Kyoto)? 1 |
| 白雲高岸處 Hakuun Takagishi sho In the White Clouds at Takagishi | July 1907 Takagishi (Kyoto) 1 |
| 樂是幽居 Gakuze yūkyo Hermitage Taking Pleasure in All of This | Aug.–Oct. 1908 Takagishi (Kyoto)? 2 |
| 白雲黄葉處 *1 Hakuun kōyō sho A Place with Yellow Leaves in White Clouds | Aug. 1910 Takagishi (Kyoto)? 1 |
| 古座客舍 Koza kyakusha Lodging in Koza | Spring (Jan.–Mar.) 1912 Koza (Wakayama) 1 |

| POETIC LOCATION/ TRANSCRIPTION/ TRANSLATION | DATE/ ACTUAL LOCATION/ OCCURRENCE |
|---|---|
| 彈盡山下寓舍 Danjinsan-ka gūsha Temporary Lodging Beneath the Mountain of Exhausted Ammunition | Sep. 1914 Matsuomura (Kyoto)? 1 |
| 高松客次 Takamatsu kyakuji Guestroom in Takamatsu | Oct. 1914 Takamatsu (Kagawa) 2 |
| 高松住居 Takamatsu jūkyo House in Takamatsu | Oct. 1914 Takamatsu (Kagawa) 2 |
| 高松客舍 Takamatsu kyakusha Lodging in Takamatsu | Oct.–Dec. 1914 Takamatsu (Kagawa) 2 |
| 西山草堂 *1 Seizan sōdō Thatched Hut at the Western Mountains | Oct. 1915 Matsuomura (Kyoto) 1 |
| 瀬見寓居 Semi gūkyo Temporary Abode in Semi | Apr.–May 1918 Semi (Kyoto)? 2 |
| 西山草堂 *2 Seizan sōdō Thatched Hut at the Western Mountains | June–Aug. 1918 Matsuomura (Kyoto) 2 |
| 拙居 Sekkyo Residing in Clumsiness | Autumn (July–Sep.) 1918 Matsuomura (Kyoto)? 1 |
| 忘言家 *1 Bōgenka House of Forgetting Words | Sep.–Oct. 1918 Matsuomura (Kyoto)? 2 |
| 鹿谷寓居 *1 Rokkoku gūkyo Temporary Abode in Shishigatani | Mar. 1919– Autumn (July–Sep.) 1924 Shishigatani no. 27 (Kyoto) 14 |
| [undeciphered] | ? 1922 1 |

綠陰畫學屋
*Ryokuin gagakuoku*
Studio for Studying
    Painting in Green Shade

Spring (Jan.–Mar.) 1924
Shishigatani no. 27 (Kyoto)?
1

三十六峯白雲深處
*Sanjūroppō hakuun shinsho*
Deep in the White Clouds
    of the Thirty-Six Peaks

Autumn (July–Sep.) 1924
Shishigatani no. 27 (Kyoto)?
1

忘言閣
*Bōgenkaku*
Palace of Forgetting Words

Spring–Autumn (Jan.–Sep.) 1924
Shishigatani no. 27 (Kyoto)?
2

白雲黄葉處 *2
*Hakuun kōyō sho*
Place with Yellow Leaves
    in White Clouds

Autumn (July–Sep.) 1924
Shishigatani no. 27 (Kyoto)?
1

東山寓居 *1
*Tōsan gūkyo*
Temporary Abode at the
    Eastern Mountains

Jan. 1925–June 1929
Shimokawarachō (Kyoto)
16

高遠客
*Kōenkyo*
Lofty Location

Feb.–Summer (Apr.–June) 1926
Shimokawarachō (Kyoto)?
2

枕瀑堂
*Chinbakudō*
Pillow Falls Hall

Summer (Apr.–June) 1926
Shimokawarachō (Kyoto)?
1

到處吾家
*Tōsho goka*
Everywhere is My House

Jan.–May 1927
Shimokawarachō (Kyoto)?
3

○○深處
*(?) shinsho*
Deep in (?)

Spring (Jan.–Mar.) 1927
Shimokawarachō (Kyoto)?
1

東山草堂
*Tōsan sōdō*
Thatched Hut at the
    Eastern Mountains

May 1928
Shimokawarachō (Kyoto)?
1

吾子知意蕭山軒
*Goshi chii shōsanken*
Lonely Mountain House
    "Where My Sons
    Grasp Meaning"

Autumn (July–Sep.) 1929
4

蕭山軒
*Shōsanken*
Lonely Mountain House

Autumn (July–Sep.) 1929–
Autumn (July–Sep.) 1932
1

鹿谷幽居
*Rokkoku yūkyo*
Shishigatani Hermitage

Summer (Apr.–June) 1932–
Spring (Jan.–Mar.) 1936
Shishigatani no. 65 (Kyoto)
5

好風亭
*Kōfūtei*
Fine Wind Pavilion

Summer (Apr.–June) 1933
Nanrinji (Nakatsugawa, Gifu)?
1

忘言家 *2
*Bōgenka*
House of Forgetting Words

Spring (Jan.–Mar.) 1934
Shishigatani no. 65 (Kyoto)?
1

鹿門幽居
*Rokumon yūkyo*
Hermitage at Deer Gate

Spring (Jan.–Mar.)–
Autumn (July–Sep.) 1934
Shishigatani no. 65 (Kyoto)
2

古澤在砌
*Furusawa zaisai*
Sojourn at the Furusawa's

May 1935
Sagae (Yamagata)
1

鹿谷寓居 *2
*Rokkoku gūkyo*
Temporary Abode in
    Shishigatani

Apr. 1936
Shishigatani 65 (Kyoto)
1

東山寓居 *2
*Tōsan gūkyo*
Temporary Abode at the
    Eastern Mountains

Apr. 1937
Shishigatani 65 (Kyoto)
1

臥虎城下寓
*Gakojō-ka gū*
Temporary Abode Beneath
    Wakayama Castle

Nov. 1937
Wakayama City (Wakayama)
1

# APPENDIX II

## SEALS ON KODŌJIN'S WORK

### SEAL TYPES

*kanbō-in* 冠帽印／関防印: placed at the beginning (top right) of a calligraphic inscription

*rakkan-in* 落款印: seal with artist name

*yū-in* 遊印: lower seal conveying an auspicious word

## A. SEALS ON KODŌJIN'S PAINTINGS IN ALPHABETICAL ORDER BASED ON JAPANESE READINGS

SEAL
TRANSCRIPTION
TRANSLATION
DATE
TYPE
SIZE

字曰子徳
*Azana iwaku Shitoku* [1]
My Courtesy Name is Shitoku
1913–40
*rakkan-in*
2 × 2.1 cm

字曰子徳
*Azana iwaku Shitoku* [2]
My Courtesy Name is Shitoku
c. 1912–13
*rakkan-in*
1.6 × 1.7 cm

字曰子徳
*Azana iwaku Shitoku* [3]
My Courtesy Name is Shitoku
1912
*rakkan-in*
2.5 × 2.6 cm

字曰子徳
*Azana iwaku Shitoku* [4]
My Courtesy Name is Shitoku
1927
*rakkan-in*
2.4 × 2.5 cm

字曰子徳
*Azana iwaku Shitoku* [5]
My Courtesy Name is Shitoku
c. 1928
*rakkan-in*
1.6 × 1.7 cm

字子徳
*Azana Shitoku*
My Courtesy Name Shitoku
c. 1907–12
*rakkan-in*
1.5 × 2.4 cm

別號碧翁
*Betsugō Hekiō*
Other Pseudonym, Hekiō
1915
*rakkan-in*
2.5 × 2.6 cm

忠我
*Chūga* [1]
Me, The Loyal One
1906–12
*kanbō-in*
1.4 × 0.8 cm

忠我
*Chūga* [2]
Me, The Loyal One
1928–30
*kanbō-in*
1.4 × 0.7 cm

獨樂
*Dokuraku*
Solitary Joy
c. 1912–13
*yū-in*
4 × 2 cm

讀書萬卷笔有神
*Dokusho mankan hitsu yūshin*
Having Read Ten Thousand Volumes,
The Brush has Divine Power
1907–12
*yū-in*
3.4 × 2.2 cm

不知
*Fuchi*
Not Knowing
1928
*yū-in*
2.1 × 1.2 cm

福田耕
*Fukuda Kō*
Fukuda Kō
1901
*rakkan-in*
2.4 × 2.6 cm

福田世耕
*Fukuda Seikō* [1]
Fukuda Seikō
1899
*rakkan-in*
2.1 × 2 cm

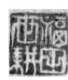
福田世耕
*Fukuda Seikō* [2]
Fukuda Seikō
1901–2
*rakkan-in*
1.8 × 1.7 cm

福田世耕
*Fukuda Seikō* [3]
Fukuda Seikō
1906–12
*rakkan-in*
1.5 × 1.5 cm

福田世耕
*Fukuda Seikō* [4]
Fukuda Seikō
1907–37
*rakkan-in*
1.3 × 1.3 cm

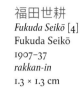

福田世耕
*Fukuda Seikō* [5]
Fukuda Seikō
1930–39
*rakkan-in*
1.2 × 1.2 cm

福田凵耕
*Fukuda Seikō* [6]
Fukuda Seikō
1903–34
*rakkan-in*
2.8 × 2.9 cm

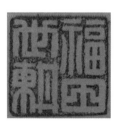

福田世耕
*Fukuda Seikō* [7]
Fukuda Seikō
1931–33
*rakkan-in*
1.6 × 1.6 cm

福田世耕
*Fukuda Seikō* [8]
Fukuda Seikō
1901
*rakkan-in*
3.4 × 3.7 cm

福田世耕
*Fukuda Seikō* [9]
Fukuda Seikō
1906
*rakkan-in*
3.5 × 3.6 cm

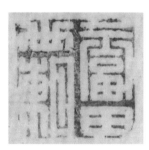

福田世耕
*Fukuda Seikō* [10]
Fukuda Seikō
c. 1928
*rakkan-in*
1.6 × 1.7 cm

福田世耕
*Fukuda Seikō* [11]
Fukuda Seikō
1944
*rakkan-in*
2.1 × 2.2 cm

吾拙
*Gosetsu*
My Clumsiness
1899–1907
*kanbō-in*
0.6 × 0.5 cm

筆補造化
*Hippo zōka*
My Brush Completes Creation
1932–37
*yū-in*
3.7 × 2.2 cm

蓬莱山下人
*Hōraisan genin*
Low-Ranking Person
on Mount Hōrai
1918–33
*yū-in*
2.4 × 2.6 cm

弌心千古
*Isshin senko*
Unified Mind for All Antiquity
1915
*kanbō-in*
2.4 × 1.2 cm

自適
*Jiteki*
Living Free
c. 1901–2
*kanbō-in*
2 × 0.8 cm

金在井
*Kinzaisei*
Gold in a Well
c. 1900s
*kanbō-in*
1.8 × 1.8 cm

高
*Kō*
High-minded
c. 1913–37
*kanbō-in*
0.6 × 0.4 cm

古道人
*Kodōjin* [1]
Kodōjin
1902
*rakkan-in*
1.4 × 0.9 cm

古道人
*Kodōjin* [2]
Kodōjin
1906–7
*rakkan-in*
1.9 × 1.3 cm

古道人
*Kodōjin* [3]
Kodōjin
1938–40
*rakkan-in*
1.6 × 1.1 cm

古道人
*Kodōjin* [4]
Kodōjin
1932–38
*rakkan-in*
1.2 × 1.2 cm

古道人
*Kodōjin* [5]
Kodōjin
c. 1942
*rakkan-in*
1.7 × 0.7 cm

古道人
*Kodōjin* [6]
Kodōjin
1940
*rakkan-in*
1.5 × 1.5 cm

今日樂
*Konnichi raku*
Today's Pleasure
1927–41
*yū-in*
2.3 × 2.1 cm

明佳
*Meika*
Bright and Excellent
1901–2
*kanbō-in*
2.1 × 0.6 cm

無邪
*Muja*
Innocent
1930–37
*kanbō-in*
1.6 × 0.7 cm

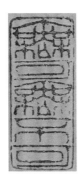
無可無不可
*Muka mufuka* [1]
Nothing I May Do,
Nothing I May Not Do
1928
*yū-in*
4.2 × 1.8 cm

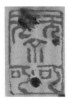
无可无不可
*Muka mufuka* [2]
Nothing I May Do,
Nothing I May Not Do
1936
*yū-in*
2.4 × 1.7 cm

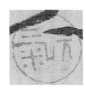
无氣
*Muki*
Breathless
early–mid-1900s
*yū-in*
2 × 2 cm

无心
*Mushin* [1]
Unintentionally
1907–9
*kanbō-in*
0.9 × 0.5 cm

无心
*Mushin* [2]
Unintentionally
1910–21
*kanbō-in*
1.8 × 0.7 cm

无心
*Mushin* [3]
Unintentionally
1921–40
*kanbō-in*
1.8 × 0.7 cm

無心
*Mushin* [4]
Unintentionally
1944
*kanbō-in*
1.9 × 0.8 cm

大北山人
*Ōkitayama hito*
Man from Ōkitayama
1907
*yū-in*
1.4 × 1.4 cm

樂在中
*Raku zaichū*
Within Joy
c. 1907
*yū-in*
2.1 × 1.9 cm

諒無
*Ryōmu*
Certainly There is
Nothing
1907–8
*kanbō-in*
2.2 × 0.9 cm

山水知己
*Sansui chiki*
Confidant of Landscapes
1899–1902
*yū-in*
1.6 × 1.4 cm

世耕
*Sei-kō*
(joined seal)
Tiller of the Generations
c. 1913–40
*rakkan-in*
2.8 × 1.2 cm

世耕
*Seikō* [1]
Tiller of the Generations
1907–9
*rakkan-in*
0.9 × 0.9 cm

世耕
*Seikō* [2]
Tiller of the Generations
1915
*rakkan-in*
2.5 × 2.6 cm

靜處
*Sei-sho* [1] (joined seal)
Quiet Place
1906–37
*rakkan-in*
1.7 × 0.6 cm

靜処
*Sei-sho* [2] (joined seal)
Quiet Place
c. 1907
*rakkan-in*
0.9 × 0.4 cm

靜処
*Sei-sho* [3]
(joined seal)
Quiet Place
1918–36
*rakkan-in*
1.1 × 0.5 cm

靜處
*Seisho* [1]
Quiet Place
1901–2
*rakkan-in*
1.8 × 1.7 cm

靜処
*Seisho* [2]
Quiet Place
1906–12
*rakkan-in*
1.5 × 1.5 cm

靜處
*Seisho* [3]
Quiet Place
1913–40
*rakkan-in*
2 × 2.1 cm

靜處
*Seisho* [4]
Quiet Place
1907–37
*rakkan-in*
1.3 × 1.3 cm

靜處
*Seisho* [5]
Quiet Place
1930–39
*rakkan-in*
1.2 × 1.2 cm

靜處
*Seisho* [6]
Quiet Place
1903–34
*rakkan-in*
2.9 × 2.9 cm

靜處
*Seisho* [7]
Quiet Place
1931–33
*rakkan-in*
1.6 × 1.6 cm

靜處
*Seisho* [8]
Quiet Place
c. 1922–38
*rakkan-in*
2.4 × 1.5 cm

靜處
*Seisho* [9]
Quiet Place
c. 1912–13
*rakkan-in*
1.6 × 1.7 cm

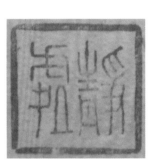

靜處
*Seisho* [10]
Quiet Place
1901
*rakkan-in*
3.7 × 3.8 cm

靜處
*Seisho* [11]
Quiet Place
1912
*rakkan-in*
2.5 × 2.6 cm

靜處
*Seisho* [12]
Quiet Place
1927
*rakkan-in*
2.4 × 2.5 cm

靜處
*Seisho* [13]
Quiet Place
c. 1907–12
*rakkan-in*
1.5 × 2.4 cm

靜處
*Seisho* [14]
Quiet Place
1906
*rakkan-in*
3.5 × 3.6 cm

靜處
*Seisho* [15]
Quiet Place
1944
*rakkan-in*
2.1 × 2.2 cm

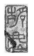

靜處
*Seisho* [16]
Quiet Place
c. 1907
*rakkan-in*
1.3 × 0.7 cm

靜処
*Seisho* [17]
Quiet Place
1907–9
*rakkan-in*
0.9 × 0.9 cm

拙居
*Sekkyo*
Residing in Clumsiness
1913–37
*yū-in*
2 × 1.5 cm

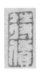

詩價
*Shika*
The Price for Writing Poetry
1907
*kanbō-in*
1.6 × 0.7 cm

子德 靜処
*Shitoku Seisho*
(joined seal)
Shitoku, Quiet Place
c. 1907
*rakkan-in*
1.8 × 1.4 cm

子德氏
*Shitoku shi*
Named Shitoku
1901
*rakkan-in*
2.4 × 2.6 cm

師在我
*Shi zai ga* [1]
The Teacher Lies
Within Me
1903–37
*kanbō-in*
2.8 × 1.2 cm

師v在我
*Shi zai ga* [2]
The Teacher Lies
Within Me
1927
*kanbō-in*
3 × 1.6 cm

省事養神
*Shoji yōshin*
Saving Trouble and
Nurturing My Spirit
1906–12
*yū-in*
2.3 × 1.4 cm

冬日到門惟白雲
*Shūjitsu tōmon yui
shirakumo*
All Day Long,
Only White Clouds
Visit My Gate
1920–30
*yū-in*
3 × 2.8 cm

埽門
*Sōmon*
Swept Gate
1902
*yū-in*
2.3 × 2.1 cm

天下之拙筆
*Tenka no seppitsu*
A Clumsy Brush
Beneath Heaven
c. 1906–12
*yū-in*
3.6 × 2.4 cm

佃山
*Tensan*
Tenant Farmer of
the Mountain
c. 1913–21
*rakkan-in*
2.5 × 2.1 cm

我師造化
*Waga shi zōka*
I Take Creation as
My Master
1926–30
*yū-in*
3.8 × 3.8 cm

我有采芝齋
*Wa yū saishisai*
I Have a Studio for
Gathering Magic
Mushrooms
1921–32
*yū-in*
2.5 × 2.5 cm

餘閒
*Yokan*
I Have More Than
Enough Leisure
c. 1912–13
*kanbō-in*
1.7 × 0.8 cm

藏
*Zō*
My Collection
1902
*kanbō-in, yū-in*
1.5 × 1.2 cm

[Stylized bamboo]
1943
*kanbō-in*
1.6 × 0.5 cm

[Stylized bat]
1918–35
*yū-in*
0.7 × 1.3 cm

[Stylized Mount Fuji]
1943
*rakkan-in*
0.8 × 0.8 cm

[Stylized sun disk]
1943
*rakkan-in*
0.7 × 0.9 cm

In the 1930s, Kodōjin occasionally added a hand-drawn, teardrop-shaped sign (*kao* 花押) to a *haiga* after the poem:

0.4 × 0.5 cm
1930s
Minneapolis Institute of Art
(2013.29.898.3)

1.8 × 1.5 cm
1932
Minneapolis Institute of Art
(RB2015.7.5)

## B. SEAL COMBINATIONS IN CHRONOLOGICAL ORDER

| | |
|---|---|
| Fukuda Kō + Shitoku shi | 1901 (rare) |
| Fukuda Seikō [8] + Seisho [10] | 1901 (rare) |
| Fukuda Seikō [2] + Seisho [1] | 1901–2 (rare) |
| Kodōjin [1] + Seisho [1] | 1902 (rare) |
| Fukuda Seikō [6] + Seisho [6] | 1903–34 (frequently encountered) |
| Fukuda Seikō [9] + Seisho [14] | 1906 (rare) |
| Fukuda Seikō [3] + Seisho [2] | 1906–12 |
| Seikō [1] + Seisho [17] | 1907–9 (rare) |
| Azana Shitoku + Seisho [13] | c. 1907–12 (rare) |
| Fukuda Seikō [4] + Seisho [4] | 1907–38 (very frequently encountered) |
| Azana iwaku Shitoku [3] + Seisho [11] | 1912 (rare) |
| Azana iwaku Shitoku [2] + Seisho [9] | c. 1912–13 (frequently encountered) |
| Azana iwaku Shitoku [1] + Seisho [3] | 1913–42 (frequently encountered) |
| Seikō [2] + Betsugō Hekiō | 1915 (rare) |
| Fukuda Seikō [4] + Azana iwaku Shitoku [1] | c. 1918 (rare) |
| Azana iwaku Shitoku [4] + Seisho [12] | 1927 (rare) |
| Fukuda Seikō [10] + Azana iwaku Shitoku [5] | c. 1928 (rare) |
| Fukuda Seikō [5] + Seisho [5] | 1930–39 (frequently encountered) |
| Fukuda Seikō [7] + Seisho [7] | 1931–33 |
| Fukuda Seikō [11] + Seisho [15] | 1944 (rare) |

APPENDIX III

Kodōjin

Society

Members

and

Collectors,

1928–29

This directory of ninety-four names is compiled from five sources: *Kodōjin Society Founders and Supporters* (*Kodōjinkai hakkisha narabi sanjosha* 古道人會發起者並賛助者) from December 1928 [12/1928] and February 1929 [02/1929]; *Initiators of the Painting and Calligraphy Exhibition of the Venerable Kodōjin Fukuda Seisho* (*Kodōjin Fukuda Seisho-ō shoga tenrankai hakkisha* 古道人福田静處翁書画展覧會發起者) from December 1928 [exhibition]; the book/exhibition catalogue *Rock Slivers and Lonely Clouds* (*Koun henseki*) from February 1929 [collector]; and *Kodōjin Society Patrons* (*Kodōjinkai kōensha* 古道人會後援者) from March 1929 that accompanied the exhibition at the Kazoku Kaikan [Peers' Assembly Hall]. Although this directory is arranged alphabetically by last name, the original lists in these documents were in no particular order; they began with the prime minister or otherwise the highest-ranking politician. These lists provided details about the respective positions for the majority of the individuals at the time of their release.

| | | | | |
|---|---|---|---|---|
| Akaboshi Rikuji | 赤星陸治 | 1874–1942 | Department Head, Mitsubishi Estate | [12/1928] |
| Ataka Yakichi | 安宅彌吉 | 1873–1949 | Director, Ataka & Co. | [12/1928] [02/1929] |
| Ezaki Ken'ichi | 江崎權一 | 1873–? | Owner, Heian Gabō | [12/1928] [02/1929] |
| Fujioka Jōkichi | 藤岡淨吉 | 1873–? | Executive Director, Mitsui Mining Company | [12/1928] |
| Fujita Kanesuke | 藤田包助 | 1869–1945 | Secretary, Minister of Communications | [12/1928] [02/1929] [exhibition] |
| Fukushima Kashizō | 福島甲子三 | 1859–? | Director, Keijo Electric | [12/1928] [02/1929] |
| Fukuzawa Sanpachi | 福澤三八 | 1881–1962 | Executive Director, Jiji Shinpō | [02/1929] |
| Fusehara Keiichirō | 伏原佳一郎 | unknown | Owner, Shunpōdō | [02/1929] |
| Fusehara Toshizō | 伏原利造 | unknown | Owner, Shunpōdō | [12/1928] |
| Hachisuka Masaaki | 蜂須賀正（茂）韶 | 1871–1932 | Marquis | [02/1929] |
| Hara Yoshimichi | 原嘉道 | 1867–1944 | Minister of Justice | [02/1929] |
| Hasegawa Takeo | 長谷川赴夫 | 1886–1980 | Cabinet General Manager | [02/1929] |
| Hatoyama Ichirō | 鳩山一郎 | 1883–1959 | Chief Cabinet Secretary | [02/1929] |
| Hayashi Ichizō | 林市蔵 | 1867–1952 | Chairman, Dōjima Rice Exchange | [12/1928] [02/1929] |
| Hayashi Yasushige | 林安繁 | 1876–1948 | Director, Ujigawa Electric | [12/1928] [02/1929] |
| Hidaka Yutaka | 日高胖 | 1875–1952 | Director, Sumitomo Building Department | [12/1928] [02/1929] [collector] |
| Honma Mitsuya | 本間光彌 | 1876–1929 | President, Honritsu Bank | [12/1928] [02/1929] |
| Hori Itaru | 堀達 | 1860–1932 | Former Executive Director, Nippon Yusen | [02/1929] |
| Hori Keijirō | 堀啓次郎 | 1867–1944 | Director, O.S.K. Lines | [12/1928] |
| Hotta Masatsune | 堀田正恒 | 1887–1951 | Count | [02/1929] |
| Ichikawa Seiji | 市川誠次 | 1872–1947 | Executive Director, Chisso | [12/1928] [02/1929] [collector] |
| Iguchi Nobujirō | 井口延次郎 | 1882–1965 | Secretary to the Prime Minister | [12/1928] [02/1929] [exhibition] |
| Inoke Toshie | 猪野毛利榮 | 1886–1952 | Former Councilor | [12/1928] [exhibition] |
| Ishikawa Yoshijirō | 石川芳次郎 | 1881–1969 | Managing Director, Kyoto Electric Light | [collector] |
| Itō Toyonosuke | 伊藤豊之助 | unknown | Owner, Shunpōdō | [02/1929] |

| | | | | |
|---|---|---|---|---|
| Izumi Kichijirō | 泉吉次郎 | 1874–? | Lead pipe manufacturer | [12/1928]<br>[02/1929]<br>[collector] |
| Kamata Eikichi | 鎌田榮吉 | 1857–1934 | Councilor, Privy Council | [12/1928]<br>[02/1929]<br>[exhibition] |
| Kanamori Mataichirō | 金森又一郎 | 1873–1937 | Director, Osaka Electric Tramway | [12/1928]<br>[02/1929]<br>[collector] |
| Katō Chinnosuke | 加藤鎭之助 | 1869–1927 | Publisher of the agriculture magazine Dainōen | [12/1928]<br>[02/1929]<br>[collector] |
| Katō Yasunosuke | 加藤安之助 | unknown | President, Katō Yasunosuke Shoten | [collector] |
| Kawabe Rikichi | 川部利吉 | 1855–1948 | Director, Tokyo Art Club | [02/1929] |
| Kawamura Takeji | 川村竹治 | 1871–1955 | Governor-General of Taiwan | [12/1928]<br>[02/1929] |
| Kitani Ichirōemon | 喜谷一<br>郎右衛門 | 1847–1907 | Owner, Jitsubosan | [02/1929] |
| Kitano Yūichi | 北野右一 | unknown | Cabinet Official | [12/1928]<br>[02/1929]<br>[exhibition] |
| Kojima Kazuo | 古島一雄 | 1865–1952 | Former Deputy Minister of Communications | [12/1928] |
| Kokubu Saitō / Tanenori | 国府種徳<br>／犀東 | 1873–1950 | Cabinet and Home Ministry Official | [12/1928]<br>[02/1929]<br>[exhibition]<br>[collector]<br>[Peers' Assembly Hall] |
| Kōno Masayoshi | 河野正義 | 1879–1944 | Member, House of Representatives | [12/1928] |
| Kuhara Fusanosuke | 久原房之助 | 1869–1965 | Minister of Communications | [12/1928]<br>[02/1929]<br>[exhibition]<br>[collector] |
| Kumagai Naoyuki | 熊谷直之 | 1876–? | Owner, Kyūkyodō | [12/1928]<br>[02/1929] |
| Kurachi Masao | 倉知誠夫 | 1867–1935 | Managing Director, Mitsukoshi | [12/1928]<br>[exhibition] |
| Machida Tokunosuke | 町田徳之助 | 1866–1952 | Director, Tokyo Synthetic Silk | [12/1928]<br>[02/1929] |
| Maeda Yonezō | 前田米藏 | 1882–1954 | Director-General, Cabinet Legislation Bureau | [02/1929] |
| Makidera Sanju | 牧寺三樹 | unknown | position unknown | [02/1929] |
| Masaki Naohiko | 正木直彦 | 1862–1940 | Principal, Tokyo School of Fine Arts | [12/1928] |
| Matsudaira Ichisaburō | 松平市三郎 | 1871–1945 | Former Executive Director, Nippon Yusen | [02/1929] |
| Matsudaira Naoaki | 松平直亮 | 1865–1940 | Count | [02/1929] |
| Matsudaira Yorinaga | 松平賴壽 | 1874–1944 | Count | [02/1929] |
| Matsura Atsushi | 松浦厚 | 1864–1934 | Count | [02/1929] |
| Matsushima Hirosaburō | 松島寛三郎 | 1875–1956 | Manager, Shinkeihan Railway | [12/1928]<br>[02/1929] |

| | | | | |
|---|---|---|---|---|
| Minami Hiroshi | 南弘 | 1869–1946 | Member, House of Lords | [12/1928] [exhibition] |
| Minami Kusutarō | 南楠太郎 | 1861–1936 | President, Wakayama Bōshoku | [02/1929] |
| Minegishi Keizō | 峯岸慶藏 | 1875–? | Director, Nihon Kenshibōseki | [02/1929] |
| Mitsuchi Chūzō | 三土忠造 | 1871–1948 | Minister of Finance | [12/1928] [02/1929] |
| Mizuno Rentarō | 水野錬太郎 | 1868–1949 | Former Minister of Education | [02/1929] |
| Murata Shōzō | 村田省藏 | 1878–1957 | Executive Director, O.S.K. Lines | [12/1928] |
| Naitō Torajirō / Konan | 内藤虎次郎 ／湖南 | 1866–1934 | Historian | [12/1928] [exhibition] |
| Nakagawa Kojūrō | 中川小十郎 | 1866–1944 | Member, House of Lords | [12/1928] [exhibition] |
| Nakajima Ihei V | 中島伊平 | 1865–1940 | Silk fabric wholesaler | [02/1929] |
| Nakanomikado Tsuneyasu | 中御門経恭 | 1888–1954 | Marquis | [02/1929] |
| Nanba Reikichi | 南波禮吉 | 1873–1953 | Director, Chūō Shōken | [02/1929] |
| Ogawa Heikichi | 小川平吉 | 1870–1942 | Minister of Railways | [12/1928] [02/1929] |
| Ogura Masatsune | 小倉正恒 | 1875–1961 | Manager, Sumitomo | [12/1928] [02/1929] [exhibition] [collector] |
| Okahashi Seizaemon | 岡橋清 左衛門 | 1871–? | President, Sanjūshi Bank | [collector] |
| Ōta Isoji | 太田亥十二 | unknown | Director, Tokyo Gas | [12/1928] [02/1929] |
| Ōta Mitsuhiro | 太田光凞 | 1874–1939 | Director, Keihan Electric Railway | [12/1928] [02/1929] [collector] |
| Ōta Shinjirō | 太田信次郎 | 1873–1957 | Owner, Ohta Isan | [02/1929] |
| Saigō Jūtoku | 西郷從徳 | 1878–1946 | Marquis | [02/1929] |
| Sakamoto Senji | 阪本仙次 | 1869–1934 | Director, Yoshino Railway | [12/1928] [02/1929] [collector] |
| Sakamoto Takako | 阪本高子 | unknown | Owner, Kyoto Tan'ei | [12/1928] [02/1929] [exhibition] |
| Sasaki Daikichi | 佐々木第吉 | unknown | Private Secretary, Kuhara Family | [12/1928] [02/1929] [exhibition] |
| Satō Shinko | 佐藤信吉 | 1873–1942 | Member, House of Lords | [12/1928] |
| Satō Yasunosuke | 佐藤安之助 | 1871–1944 | Member, House of Representatives | [12/1928] [exhibition] |
| Sawai Jun'ichi | 澤井準一 | unknown | Section Head, Osaka City Bureau of Waterworks | [collector] |
| Shimada Sadatomo | 島田定知 | 1874–? | Auditor, Osaka Pottery Commerce Association | [12/1928] [02/1929] [exhibition] |
| Shimizu Tatsusaburō | 清水辰三郎 | 1864–? | Owner, Tōkyō Seishinten | [02/1929] |

| | | | | |
|---|---|---|---|---|
| Shimizu Yōnosuke | 清水揚之助 | 1887–1957 | Vice Director, Shimizu Corporation | [12/1928] [Peers' Assembly Hall] |
| Shin Denta | 神傳太 | unknown | Owner, Kyōkadō | [02/1929] |
| Shōda Kazue | 勝田主計 | 1869–1948 | Minister of Education | [02/1929] |
| Suzuki Kisaburō | 鈴木喜三郎 | 1867–1940 | Former Home Minister | [02/1929] |
| Takenaka Gensuke | 竹中源助 | 1877–1958 | President, Takenaka Shōten | [02/1929] |
| Takeuchi Riichi | 竹内理一 | 1878–? | Section Head, Osaka City Bureau of Waterworks | [collector] |
| Tanaka Giichi | 田中義一 | 1864–1929 | Prime Minister | [12/1928] [02/1929] |
| Tanaka Hiroshi | 田中博 | 1866–1957 | Director, Kyoto Electric Light | [12/1928] [02/1929] |
| Tokuda Kōhei | 徳田昴平 | 1878–1951 | Director, Tokuda Shokai | [02/1929] |
| Tokugawa Satotaka | 徳川達孝 | 1865–1941 | Count | [Peers' Assembly Hall] |
| Tokugawa Yorisada | 徳川頼貞 | 1892–1954 | Marquis | [02/1929] |
| Tsumura Jūsha | 津村重舎 | 1871–1941 | Member, House of Lords | [02/1929] |
| Wakatsuki Reijirō | 若槻禮次郎 | 1866–1949 | Former Prime Minister | [12/1928], [02/1929] |
| Yagyū Toshinaka | 柳生俊久 | 1867–1941 | Viscount | [12/1928] [Peers' Assembly Hall] |
| Yamaguchi Seitarō | 山口誠太郎 | 1885–1958 | President, Tokyo Yamaguchi Bank | [02/1929] |
| Yamamoto Teijirō | 山本悌二郎 | 1870–1937 | Minister of Agriculture and Forestry | [12/1928] [02/1929] |
| Yamamoto Washichi | 山本和七 | 1883–? | Executive Director, Kyoto Electric Light | [12/1928] [02/1929] [exhibition] [collector] |
| Yanagiwara Yoshimitsu | 柳原義光 | 1876–1946 | Count, Cousin of Emperor Taishō | [02/1929] |
| Yukawa Kankichi | 湯川寛吉 | 1868–1931 | Director-General, Sumitomo | [12/1928] [collector] |

| | | | |
|---|---|---|---|
| Amada Guan | 天田愚庵 | Jūgo Ginkō | 十五銀行 |
| *ankō soei* | 暗香疎影 | Kakinomoto Hitomaro | 柿本人麻呂 |
| Aoki Mokubei | 青木木米 | Kanzan | 寒山 |
| Aoki Shukuya | 青木夙夜 | Kawahigashi Hekigōtō | 河東碧梧桐 |
| Bada Shanren | 八大山人 | Kazoku Kaikan | 華族会館 |
| Bo Juyi | 白居易 | Kinmata Ryokan | 近又旅館 |
| *bunjinga* | 文人画 | Kita Ikki | 北一輝 |
| Chō Kōran | 張紅蘭 | Kō | こう |
| *Dai Nihon jinbutsushi* | 大日本人物誌 | *Koboku yoshun* | 古木餘春 |
| *dokusho yoji* | 讀書餘事 | *Kodōjin eisō* | 古道人詠草 |
| Dong Qichang | 董其昌 | *Kodōjin Fukuda Seisho-ō shoga tenrankai* | |
| Eishō-juku | 永昌塾 | | 古道人福田靜處翁書畫展覧会 |
| Ezaki Ken'ichi | 江崎権一 | *Kodōjin Seisho-ō shoga tenrankai* | |
| Fujimoto Tesseki | 藤本鉄石 | | 古道人靜處翁書畫展覧会 |
| Fujioka Kōeidō | 藤岡光影堂 | *Kodōjin shiga* | 古道人詩画 |
| Fujita Denzaburō | 藤田伝三郎 | Kodōjinkai | 古道人会 |
| Fukuda Kodōjin | 福田古道人 | Komuro Suiun | 小室翠雲 |
| Fukuda Tokuzō | 福田徳蔵 | Kondō Ryōgen | 近藤亮厳 |
| Furusawa Tokuji | 古澤徳治 | Kōno Bairei | 幸野楳嶺 |
| Gasan Jōseki | 峨山韶碩 | *Koun henseki* | 孤雲片石 |
| Gong Xian | 龔賢 | Kozagawa | 古座川 |
| *gosei* | 五清 | Kōzō | 行蔵 |
| Hana | はな | Kubota Beisen | 久保田米僊 |
| Haritsu | 把栗 or はりつ | Kurata Isao | 倉田績 |
| *Haritsu kushū* | 把栗句集 | Kyōkadō | 京華堂 |
| *hatsuboku* | 潑墨 | Li Shan | 李鱓 |
| *Haya* | 甲矢 | Lin Bu | 林逋 |
| Hayashi Sōkyō | 林雙橋 | Luo Dajing | 羅大經 |
| Heian Gabō | 平安画房 | Masaoka Shiki | 正岡子規 |
| *Helin yulu* | 鶴林玉露 | Matsuda Kajō | 松田霞城 |
| *hinkyū* | 貧窮 | Matsue Shigeyori | 松江重頼 |
| Hirose Taizan | 広瀬臺山 | Matsukata Iwao | 松方巌 |
| Hong Ren | 弘仁 | Matsukata Masayoshi | 松方正義 |
| Hu Gongshou | 胡公壽 | Mei Qing | 梅清 |
| Huang Gongwang | 黃公望 | Meshimori-iwa | 飯盛岩 |
| Huang Shen | 黃慎 | Mi Fu | 米黻 |
| Huang Tingjian | 黃庭堅 | Minoru | 稔 |
| Huiyuan | 慧遠 | Misu | 美寿 |
| I Fukyū | 伊孚九 | *Mokkō* | 没骨 |
| Ike Taiga | 池大雅 | Naitō Meisetsu | 内藤鳴雪 |
| Imao Keinen | 今尾景年 | Nakabayash Chikutō | 中林竹洞 |
| Irie Shikai | 入江之介 | Nakamura Jun'ichi | 中村淳一 |
| Isajirō | 伊佐次郎 | Nakatsuchō | 中津町 |
| Ishi | いし | Nakatsugawa | 中津川 |

| | | | |
|---|---|---|---|
| *nanga* | 南画 | *taisō no rei* | 大喪の礼 |
| Nanga Kanshōkai | 南画鑑賞会 | Takahama Kyoshi | 高浜虚子 |
| Nanrinji | 南林寺 | Takamatsu | 高松 |
| *nansonghua* | 南宗画 | Tanomura Chikuden | 田能村竹田 |
| Ni Zan | 倪瓚 | Tao Yuanming | 陶淵明 |
| Nihon Nanga Kyōkai | 日本南画協会 | Tenryūji | 天龍寺 |
| Nihon Nangain | 日本南画院 | Tō Enmei | 陶淵明 |
| Nihon Nangakai | 日本南画会 | Tokuda Shūsei | 徳田秋聲 |
| Nihon Nansō Gakai | 日本南宗画会 | Tokugawa Yorimichi | 徳川頼倫 |
| Noguchi Shōhin | 野口小蘋 | Tomioka Tessai | 富岡鉄斎 |
| Nukina Kaioku | 貫名海屋 | Unsōdō | 芸艸堂 |
| Oka Tōri | 岡橙里 | Urakami Gyokudō | 浦上玉堂 |
| Okada Beisanjin | 岡田米山人 | Urakami Shunkin | 浦上春琴 |
| Okada Hankō | 岡田半江 | Wang Meng | 王蒙 |
| Okuhara Seiko | 奥原晴湖 | Wang Wei | 王維 |
| Ōnuma no Ukishima | 大沼の浮島 | Wang Xizhi | 王羲之 |
| Ōshio Heihachirō | 大塩平八郎 | Wang Yangming | 王陽明 |
| Ōtani Kubutsu | 大谷句仏 | Wang Yuanqi | 王原祁 |
| Ozaki Sakujirō | 尾崎作次郎 | Watase Ryōun | 渡瀬凌雲 |
| Rai San'yō | 頼山陽 | Wen Zhengming | 文徵明 |
| *risshi* | 律詩 | Wu Zhen | 呉鎮 |
| Ryōkan | 良寛 | Yamada Heiandō | 平安堂山田 |
| Sakaguchi Shichirōbei | 坂口七郎平 | Yamakawa Shōbidō | 山川頌美堂 |
| Sakaki Hyakusen | 彭城百川 | Yamamoto Baiitsu | 山本梅逸 |
| *seihin* | 清貧 | Yanagawa Seigan | 梁川星巖 |
| *Seisho sanbōshū* | 靜處山房集 | Yanagisawa Kien | 柳沢淇園 |
| *senkotsu* | 仙骨 | Yano Tetsuzan | 矢野鉄山 |
| *sennin* | 仙人 | Yasuda Rōzan | 安田老山 |
| *Shanyuan xiaomei* | 山園小梅 | *yimin* | 遺民 |
| Shen Nanping | 沈南蘋 | Yosa Buson | 与謝蕪村 |
| Shen Zhou | 沈周 | *Yōsetsu hōshin* | 養拙葆真 |
| *shidafu* | 士大夫 | Yoshiko | 芳子 |
| Shimizu Jirochō | 清水次郎長 | Yoshiyama Sakuzō | 吉山作蔵 |
| Shingū | 新宮 | Yun Shouping | 惲壽平 |
| Shirakura Jihō | 白倉二峰 | Yutaka | 豊 |
| Shitao | 石濤 | *zekku* | 絶句 |
| *Shōyōshū* | 逍遥集 | Zhang Ruitu | 張瑞圖 |
| Shunpōdō | 春芳堂 | Zhao Jiren | 趙季仁 |
| Soejima Taneomi | 副島種臣 | Zheng Xie | 鄭燮 |
| *sokui no rei* | 即位の礼 | Zhu Da | 朱耷 |
| Su Shi (Dongpo) | 蘇軾（東坡） | Zhu Wengong | 朱文公 |
| Suzuki Hyakunen | 鈴木百年 | | |
| Suzuki Shōnen | 鈴木松年 | | |
| Taiji Gorōsaku | 太地五郎作 | | |

# References

Names of Japanese and Chinese authors appear in conventional order, family name first, unless given otherwise on an author's English-language publications.

Addiss, Stephen. 2000. *The Life, Art and Poetry of Kodōjin. Orientations* 31, no. 2: pp. 360–67.

———, Jonathan Chaves, and J. Thomas Rimer. 2000. *Old Taoist: The Life, Art, and Poetry of Kodōjin (1865–1944).* New York: Columbia University Press.

Akiyama Terukazu. 1964. *Heian jidai sezokuga no kenkyū.* Tokyo: Yoshikawa Kōbunkan.

Berry, Paul. 1985. *Tanomura Chikuden 1777–1835: Man Amidst the Mountains.* PhD diss., University of Michigan.

———. 1999. "The Relation of Japanese Literati Painting to Nihonga." In Michiyo Morioka and Paul Berry, *Modern Masters of Kyoto: The Transformation of Japanese Painting Traditions: Nihonga from the Griffith and Patricia Way Collection,* pp. 32–39. Seattle: University of Washington Press.

———. 2001. *Unexplored Avenues for Japanese Painting: The Hakutakuan Collection.* Seattle: University of Washington Press.

———. 2008. "The Meeting of Chinese and Japanese Literati." In Paul Berry and Michiyo Morioka, *Literati Modern: Bunjinga from Late Edo to Twentieth-Century Japan, The Terry Welch Collection at the Honolulu Academy of Arts,* pp. 16–27. Honolulu: Honolulu Academy of Arts.

———. 2020. "Japanese Literati Painting and Its Relationship to Chinese Culture." In *Poetic Imagination in Japanese Art,* edited by Maribeth Graybill, Jeannie Kenmotsu, and Michiyo Morioka, pp. 147–53. Portland: Portland Art Museum.

Bourdieu, Pierre. 1993. *The Field of Cultural Production.* Cambridge: Polity Press.

Chiba Kōtarō. 2010a. *Ryakkai "Seisho sanbōshū."* Tanabe: Insatsuyasan.

———. 2010b. *Ryakkai "Shōyōshū."* Tanabe: Insatsuyasan.

———. 2011. *Gassatsu Fukuda Seisho kanshishū ryakkai: Seisho sanbōshū (kōhen), Yōsetsu hōshin, Kodōjin shiga.* Tanabe: Insatsuyasan.

FitzHugh, Elisabeth W., Marco Leona, and John Winter. 2003. *Studies Using Scientific Methods: Pigments in Later Japanese Paintings.* Washington DC: Smithsonian Institution.

Fukuda Hideko. 1960. "Chichi o shinobite." *Kumanoshi* 8: p. 13.

Furukawa Kaoru. 2004. *Wakusei ga yuku Kuhara Fusanosuke.* Tokyo: Nikkei BP Sha.

Hamahata Eizō. 1975. *Kumano yoi toko.* Shingū: Hamahata Eizō.

Hitachi-shi Kyōdo Hakubutsukan, ed. *Kuhara-ke kyūzō Mito-han kankei shoga.* Hitachi: Hitachi-shi Kyōdo Hakubutsukan, 1988.

Kasekitei Kaisho, ed. 1960. *Kodōjin Fukuda Seisho-ō isakuhin tenrankai.* Self-published.

Kashiwagi Tomoko. 2016. "Tessai to Takashimaya bijutsubu tenrankai." In Hyōgo Kenritsu Bijutsukan et al., *Tomioka Tessai—Kindai e no kakehashi ten,* pp. 192–95. Kobe: Tomioka Tessai Ten Jitsugyō Iinkai.

Keene, Donald. 2012. *The Winter Sun Shines In: A Life of Matsuoka Shiki.* New York: Columbia University Press.

Kokubu Tanenori. 1896. *Ōshio Heihachirō.* Tokyo: Shōka Shobō.

Kokubu Tanetake. 1970. "Kokubu Saitō." *Nihon bungaku shiyō* 22 (March 27): pp. 27–31.

Lin Yutang. 1947. *The Gay Genius: The Life and Times of Su Tungpo.* New York: John Day Company.

Maekawa Masui. 1960. "Seisho sensei no itsuwa." *Kumanoshi* 8: pp. 20–24.

Matsumoto Akira. 2004. "Kumano Shingū no Kodōjin. Haritsu, Seisho, Kodōjin." *Kumanoshi* 50: pp. 81–98.

———. 2005a. "Momoyama Taichōrō no Mino Ryūtei shujin. Nakagawa Kojūrō to sakka, bunjin bokkaku tachi." *Ritsumeikan hyakunenshi kiyō* 13: pp. 77–154.

———. 2005b. "Seisho Fukuda Isajirō. Zoku, Kumano Shingū no Kodōjin." *Kumanoshi* 51: pp. 97–119.

———. 2007. "Mino Ryūtei, Guan, Kodōjin kenkyū 1: Tokushū, Haritsu haiku shūgō." *Ritsumeikan, Nakagawa Kojūrō kenkyūkai kaihō* 13.

———. 2008a. "Kokō no hito, haijin de atta koro no Haritsu. Zokuzoku, Kumano Shingū no Kodōjin." *Kumanoshi* 55: pp. 138–58.

———. 2008b. "Mino Ryūtei, Guan, Kodōjin kenkyū 2: Tokushū, Haritsu no aforizumu." *Ritsumeikan, Nakagawa Kojūrō kenkyūkai kaihō* 14.

———. 2009. "Mino Ryūtei, Guan, Kodōjin kenkyū 3: Tokushū, Sachio, Seisho, Raien." *Ritsumeikan, Nakagawa Kojūrō kenkyūkai kaihō* 15.

Mitsui Ginkō Hachijūnenshi Hensaku Iinkai. 1957. "Jūgo Ginkō shōshi." In *Mitsui Ginkō hachijūnenshi*, edited by Mitsui Ginkō Hachijūnenshi Hensaku Iinkai, pp. 535–653. Tokyo: Mitsui Ginkō.

Morioka, Michiyo. 2008. "The Transformation of Japanese Literati Painting in the Twentieth Century." In Paul Berry and Michiyo Morioka, *Literati Modern: Bunjinga from Late Edo to Twentieth-Century Japan, The Terry Welch Collection at the Honolulu Academy of Arts*, pp. 28–39. Honolulu: Honolulu Academy of Arts.

Naruse Rin and Tsuchiya Shūtarō, eds. 1913. *Dai Nihon jinbutsushi: ichimei gendai jinmei jisho*. Tokyo: Hakkōsha.

Nihon Kōgyō Kabushikigaisha, ed. 1991. *Kuhara Fusanosuke shōden*. Tokyo: Nihon Kōgyō.

Owen, Stephen, ed. 2016. *The Poetry of Du Fu*. Vol. 3 of 6. Boston: De Gruyter.

Ōya Sōichi. 1957. "Kuhara Fusanosuke." In *Shōwa kaibutsu den*, pp. 3–26. Tokyo: Kadokawa Shoten.

Ozaki Sakujirō. 1960. "Fukuda-sensei wo shinobite." *Kumanoshi* 8: pp. 7–12.

Sakaguchi Shichirōbei. 1960. "Takai okimochi." *Kumanoshi* 8: pp. 18–20.

Schalow, Thomas Richard. 1987. "Transforming Railroads into Steamships: Banking with the Matsukata Family at the 15th Bank." *Hitotsubashi Journal of Commerce and Management* 22, no. 1: pp. 55–67.

Tahara Keikichi. 1929. "Fukuda Seisho-sensei no kodomo." *Kumano kenkyū* 5: pp. 38–46.

Watase Ryōun. 1960. "Fukuda Seisho-sensei." *Kumanoshi* 8: pp. 1–6.

Watson, Burton, trans. 2013. *The Complete Works of Zhuangzi*. New York: Columbia University Press.

Wu, Jiang. 2008. *Enlightenment in Dispute*. New York: Oxford University Press.

———. 2014. *Leaving for the Rising Sun*. New York: Oxford University Press.

Yamamoto Hiroyo and Tatsumi Takashi, eds. 2013. *Watase Ryoun ten*. Tanabe-shi: Kumanokodo Nakahechi Museum of Art and Tanabe City Museum of Art.

Yamamoto Shirō. 1993. "*Fukuda Seisho (Haritsu, Kodōjin) shōden: sono zen hansei.*" *Bulletin of Kobe Women's College* 26, no. 3: pp. 105–26.

Yonemoto Jirō. 1991. *Denki Kuhara Fusanosuke-o o kataru*. Tokyo: Riiburu.

## "Books to Span the East and West"

**Tuttle Publishing** was founded in 1832 in the small New England town of Rutland, Vermont [USA]. Our core values remain as strong today as they were then—to publish best-in-class books which bring people together one page at a time. In 1948, we established a publishing outpost in Japan—and Tuttle is now a leader in publishing English-language books about the arts, languages and cultures of Asia. The world has become a much smaller place today and Asia's economic and cultural influence has grown. Yet the need for meaningful dialogue and information about this diverse region has never been greater. Over the past seven decades, Tuttle has published thousands of books on subjects ranging from martial arts and paper crafts to language learning and literature—and our talented authors, illustrators, designers and photographers have won many prestigious awards. We welcome you to explore the wealth of information available on Asia at www.tuttlepublishing.com

Published by

Minneapolis Institute of Art
© The Minneapolis Institute of Art
2400 Third Avenue South
Minneapolis, MN 55404
www.artsmia.org

The publisher wishes to thank the museums, galleries and collectors mentioned in the captions and in the credits for their kind assistance.

Generous support is provided by the Gale Family Endowment—named for a generous gift from Alfred P. Gale—which strengthens the Minneapolis Institute of Art's efforts to reach a spectrum of audiences through a variety of programs, events, exhibitions, and publications focused on the museum's renowned collection of Asian Art.

EDITOR: Amy Reigle Newland

DESIGNER: John Hubbard | emks.fi

CATALOGUE PHOTOGRAPHERS: Charles Walbridge, Dan Dennehy

DIGITAL IMAGE PRODUCTION: Joshua Lynn

COVER PHOTOGRAPH: Charles Walbridge

PUBLISHING AND PRODUCTION MANAGEMENT: Jim Bindas, Books & Projects LLC

Library of Congress Control Number: 2023901368

ISBN: 978-4-8053-1777-8

PRINTED IN CANADA

26 25 24 23    10 9 8 7 6 5 4 3 2 1

Distributed by

**North America, Latin America & Europe**
Tuttle Publishing
364 Innovation Drive
North Clarendon, VT 05759-9436 U.S.A.
Tel: 1 (802) 773-8930
Fax: 1 (802) 773-6993
info@tuttlepublishing.com
www.tuttlepublishing.com

**Japan**
Tuttle Publishing
Yaekari Building 3rd Floor
5-4-12 Osaki
Shinagawa-ku
Tokyo 141-0032
Tel: (81) 3 5437-0171
Fax: (81) 3 5437-0755
sales@tuttle.co.jp
www.tuttle.co.jp

**Asia Pacific**
Berkeley Books Pte. Ltd.
3 Kallang Sector #04-01
Singapore 349278
Tel: (65) 6741-2178
Fax: (65) 6741-2179
inquiries@periplus.com.sg
www.tuttlepublishing.com

COVER: (DETAIL) NO. 13 *Landscape after Mi Fu*

BACK COVER, P. 2, P. 4–5: (DETAIL) NO. 58 *Blue-Green Landscape*

P. 1: *Fukuda Kodōjin, c. 1930*

P. 6: (DETAIL) NO. 77 *Boating on a Pure Creek*

P. 8: (DETAIL) NO. 42 *Wind and Moon by the Riverside*

P. 10: (DETAIL) NO. 22 *One Thousand Mountains and Ten Thousand Streams*

P. 12: (DETAIL) NO. 39 *One Thousand Mountains and Ten Thousand Ravines*

P. 14: (DETAIL) NO. 64 *Moon and Pine Tree*

PP. 16–17: (DETAIL) NO. 56 *Blue-Green Landscape*

PP. 326–27: (DETAIL) NO. 80 *Landscape in Pale Red*

Minneapolis Institute of Art